Using QuarkXPress 5.0

Suzanne Sayegh Thomas

D1305050

THOMSON ™

DELMAR LEARNING

Australia Canada Mexico Singapore Spain
United Kingdom United States

THOMSON

™

DELMAR LEARNING

Using QuarkXPress 5.0
Suzanne Thomas

Business Unit Director:
Alar Elken

Executive Editor:
Sandy Clark

Acquisitions Editor:
James Gish

Editorial Assistant:
Jaimie Wetzel

Executive Marketing Manager:
Maura Theriault

Channel Manager:
Fair Huntoon

Marketing Coordinator:
Karen Smith

Executive Production Manager:
Mary Ellen Black

Production Manager:
Larry Main

Production Editor:
Tom Stover

Library of Congress Cataloging-in-Publication Data
Thomas, Suzanne Sayegh.
 Using QuarkXPress 5 / Suzanne Thomas.
 p. cm.
 Includes index.
 ISBN 0-7668-3924-9
 1. QuarkXPress (Computer file)
 2. Desktop publishing. I. Title

Z253.532.Q37 T475 2002
686.2′25445369--dc21

 2001055284

Dedication

For my cousin, Jacqueline Sayegh Duggan, and for Mark Hindy
who died in New York City on September 11, 2001,
and for all of us who grieve the loss of those we will love forever.
Long after this book becomes obsolete, their memory
will heal our sorrow and their blessings upon us
will enrich our lives until we are reunited with them.

*"Tell them that now I am more alive than I was when they saw me in the flesh,
and that now I see them and know them better,
and can and want to help them more."*

St. Angela Merici, Fifth Counsel

Table of Contents

UNIT 1 ✦ QUARKXPRESS BASICS ..1

LESSON 1: INTRODUCTION2
Welcome to QuarkXPress 5.0!2
What Is QuarkXPress?2
 What Do You Need?3
 What Do You Get in QuarkXPress 5.0? ..3
Using This Book .4
Macintosh/Windows Issues4
 File Transfer .4
 Keystrokes .5
Font Choices .5
Menu Bar Conventions6
Tough Stuff .6
Exercises .6
Review Projects .6
Active Documents .7
Projects Folder .7
History of Electronic Typesetting7
 First-Generation Typesetting7
 Second-Generation Typesetting8
 Third-Generation Typesetting8
 Fourth-Generation Typesetting8
Fonts .9
 Printer Fonts and Screen Fonts9
 TrueType Fonts .9
Troubleshooting .9
Play Time .10
LESSON 2: QUARKXPRESS BASICS11
How QuarkXPress "Thinks"11
 Items .11
 Contents .11
QuarkXPress Documents11
Launching QuarkXPress 5.011
Opening and Saving Documents (Files) . . .11
 Saving Files .12
 Revert to Saved12
 Menu Commands12
 Keyboard Shortcuts13
 File Extensions13
Tool Palette .13

Tools .13
 Default Tool Palette14
 Show Tool Tips15
Item Tool .15
Content Tool .16
 Rotation Tool .16
 Standard-Shape vs. Bézier Tools16
 Text Box Pop-Out Tools17
 Picture Box Pop-Out Tools18
 Line Tool Pop-Out Tools18
 Text-Path Pop-Out tools19
 Linking and Unlinking Tools19
 Scissors Tool .20
 Modifying the Tools20
 Default Tool Palette20
LESSON 3: PAGES and PALETTES22
Creating a New Document22
 Pages .22
 Margin and Column Guides23
Facing and Nonfacing Pages24
Pasteboard .24
Viewing Pages .25
 Zoom Tool .25
 View Percent Field25
 View Menu .26
 Document Windows26
Palettes .26
 Working with Palettes27
 Palette Icons .27
 Palette Options28
Moving Around a Page29
New Document Command31
New Document Dialog Box32
 Page Size .33
 Automatic Text Box Option33
 When to Select the Automatic Text Box
 Option .34
 Columns .34
 Changing Column Guides34
 Facing Pages .35
REVIEW PROJECT .35

UNIT 2 ✦ FORMATTING TEXT39

LESSON 1: WORKING with TEXT40
Importing Text .40
Entering Text .40
Selecting Text .40
Formatting Text .41
Formatting Text from the Measurements
 Palette .41
Editing Text .44
 Copy and Paste Selections44
Removing Text Selections46
 Cutting Text .46
 Deleting Text .46
Text Modify Dialog Box47
 Text Angle .48
 Text Skew .48
 Text Inset .48
 First Baseline .49
 Vertical Alignment49
Text Box Shapes .51

LESSON 2: WORD PROCESSING53
Text from Word Processors53
 Import/Export Filters53
 XTensions Manager53
Exporting Text .53
XPress Tags .54
Invisibles .54
Paragraph Alignment58
Indent Here Command59
Line Spacing (Leading)59
Specifying Leading60
 Auto Leading .60
 Absolute Leading61

LESSON 3: PRINT DIALOG BOX63
Printing .63
 Selecting the Printer63
 Print Command63
 Copies .64
 Page Sequence .64
Setup Tab .64
 PostScript Printer Description Files65
 Page Options .65
 Orientation .65

Fit in Print Area .66
The Colors Palette67
Applying Colors .68
Assigning Colors from the Colors Palette .70
Making Boxes Transparent70
Contentless Boxes71
 Box Contents .71
REVIEW PROJECT71

UNIT 3 ✦ GRAPHICS73

LESSON 1: WORKING with PICTURE BOXES . .74
Why Picture Boxes?74
 Types of Picture Boxes74
Drawing Picture Boxes75
Modifying Picture Boxes75
 Resizing Picture Boxes75
 Measurements Palette for Picture Boxes .76
 Rotating Picture Boxes76
 Moving a Picture Box76
 Skewing a Picture Box76
Importing Pictures into a Picture Box78
Graphic File Formats78
 EPS Images .79
 TIFF Files .79
 TIFF Format Attributes80
 DCS (Desktop Color Separation) Format . .80
 JPEG (Joint Photographic Experts Group)
 Images .80
 Photo-CD Images81
 Paint and PICT Files81
 Necessary XTensions81
 Bitmap Image Issues81
Auto Picture Import81

LESSON 2: IMPORTING GRAPHICS84
Importing Pictures84
 Importing TIFF and EPS Images84
 Displaying an Image85
Modifying Pictures85
 Measurements Palette for Pictures85
Picture Modify Dialog Box87
Linking Pictures .88
 Picture Usage Dialog box89
 Missing Pictures89
Positioning Images92

Resizing Images .93
Cropping Images .96
Flipping Images .98
REVIEW PROJECTS .100

UNIT 4 ✦ MULTIPLE-PAGE DOCUMENTS .105

LESSON 1: MULTIPLE-PAGE DOCUMENTS . . .106
Working with Multiple-Page Documents 106
The Document Layout Palette106
 Displaying the Document Layout
 Palette .106
 Document Layout Panels107
 Facing Pages and Nonfacing Pages
 Icons .107
Adding Document Pages107
 Displaying Page Numbers108
Deleting Document Pages110
Auto Page Insertion112
LESSON 2: NAVIGATING a DOCUMENT113
Getting Around a Multiple-Page
 Document .113
How Pages Are Numbered113
 Absolute Page Numbers113
Getting from Page to Page114
LESSON 3: NUMBERING PAGES117
Specifying Custom Page Numbers117
Section Command .117
 Section Dialog Box118
 Removing the Section Command118
Consecutive Page Number Command . . .118
Page Numbers and Master Pages119
LESSON 4: LINKING TEXT BOXES125
What Is Linking? .125
 Automatic Linking125
 Manual Linking125
Interrupting Text Flow126
Creating an Automatic Text Box Link130
Linking Random Text Boxes132
Unlinking Text Boxes134
Creating Jump Lines135
REVIEW PROJECTS .137

UNIT 5 ✦ MASTER PAGES145

LESSON 1: UNDERSTANDING MASTER PAGES 146
What Is a Master Page?146
 Multiple Master Pages146
Creating Master Pages146
Document Layout Palette and
 Master Pages .147
Placing Items on the Master Page147
Inserting Document Pages Based
 on Master Pages150
LESSON 2: WORKING with MASTER PAGES . .153
Inserting Document Pages153
Multiple Master Pages155
Duplicating and Deleting Master Pages . .157
Working with Left and Right
 Master Pages .160
Master Pages and Document Pages162
 Copying Pages Between Documents . .162
 Copying Items Between Documents . .162
 Moving Document Pages162
LESSON 3: EDITING MASTER PAGES165
Editing a Document from the Master
 Page .165
Changing Margin Guides165
 Master Guides Dialog Box165
Editing Master Items168
Applying Master Pages172
Keep Changes/Delete Changes172
 Keep Changes .172
 Delete Changes173
Working with Left and Right
 Master Pages .175
REVIEW PROJECTS .177

UNIT 6 ✦ FORMATTING PARAGRAPHS .195

LESSON 1: PARAGRAPH FORMATS196
Paragraph Attributes196
 Assigning Paragraph Attributes196
 Selecting a Paragraph197
Paragraph Indents .197
Setting Leading and Spacing Values200
 Space Before and Space After200
Drop Caps .202

Drop Cap Size .202
Paragraph Alignment204
 Paragraph Alignment Options205
LESSON 2: PARAGRAPH RELATIONSHIPS . . .206
Controlling Paragraphs206
 Widows and Orphans206
Keep Lines Together Command207
Keep with Next ¶ (Paragraph)
 Command .209
 Keeping Paragraphs and Lines
 Together .209
Lock to Baseline Grid210
 Baseline Grid and Paragraph Spacing .211
Setting the Baseline Grid212
 Maintain Leading212
LESSON 3: HYPHENATION METHODS214
Hyphenation .214
 Standard Hyphenation214
 Discretionary Hyphens214
LESSON 4: USING TABS216
Tab Stops .216
 Right-Aligned Tabs217
 Inserting Tab Stops217
 Deleting Tab Stops218
Copying Paragraph Attributes221
REVIEW PROJECTS .222

UNIT 7 ⟡ STYLE SHEETS227

LESSON 1: PARAGRAPH STYLES228
What Are Style Sheets?228
 Styles Are Not an Option228
 What Is a Paragraph?228
 Selecting Paragraphs229
 Splitting Paragraph Lines with the
 New Line Command229
 Paragraph Styles229
 Character Styles230
 Keyboard Shortcuts for Styles230
Style Sheets Palette230
Global and Local Formatting231
Editing Paragraph Styles235
LESSON 2: CHARACTER STYLES237
Creating and Editing Character Styles . . .237
 Applying Character Styles237

Local Formatting .237
Normal Style .239
No Style .240
 Applying *No Style*240
LESSON 3: STYLE SHEETS PALETTE243
Applying Commands from the Style
 Sheets Palette .243
 Deleting Style Sheets243
Appending Style Sheets245
 Rename .245
 Auto-Rename .246
 Use New .246
 Use Existing .246
REVIEW PROJECT .248

UNIT 8 ⟡ TYPOGRAPHY & TEXT UTILITIES .253

LESSON 1: TYPOGRAPHY254
Typographic Preferences254
Kerning .254
 Auto Kern Above254
Tracking .257
Baseline Shift .258
Horizontal/Vertical Scale259
Hyphenation and Justification260
 Hyphenation .261
 Word Spacing Options261
 Character Spacing Options262
 Appending and Deleting H&Js262
LESSON 2: SPELL CHECKING264
Checking and Correcting Spelling264
 Word Count .264
Spell Check Dialog Box265
 Lookup .265
 Done .265
 Skip .265
 Add .265
Auxiliary Dictionaries266
Special Text Characters267
Jabber .267
Line Check .267
LESSON 3: FIND/CHANGE268
Find/Change Command268
 Finding and Changing Words268

Find/Change Palette268
Find Next .268
Find First .269
Change .269
Change All .269
Change, Then Find269
Whole Word .269
Ignore Case .269
Ignore Attributes269
Finding and Changing Nonprinting
 Characters .272
Finding and Changing Text Attributes . .274
Text Search .274
Deleting Found Text275
Finding and Changing Style Sheets276
REVIEW PROJECT .278

UNIT 9 ⟐ BÉZIER ITEMS279
LESSON 1: WORKING with BÉZIERS280
Creating Bézier Boxes280
Bézier Picture Box Tool280
Editing Bézier Boxes280
Importing Pictures into Bézier Picture
 Boxes .281
Converting Standard-Shape Boxes to
 Bézier Boxes282
Reshaping Smooth and Symmetrical
 Points .283
Adding and Deleting Bézier Points285
Converting Bézier Points286
Freehand Bézier Picture Box Tool286
LESSON 2: TEXT to BOXES288
Converting Text to Graphics288
Splitting Boxes .289
Split Outside Paths289
Split All Paths .289
Converting Boxes291
Reshaping Boxes292
Converting Lines to Text Paths293
LESSON 3: MERGE and SPLIT COMMANDS . .295
Merging and Splitting Items295
Stacking Order296
Merge Commands296
Intersection Merge Command296

Union Merge Command296
Difference and Reverse Difference
 Merge Commands296
Exclusive Or and Combine Merge
 Commands296
Split Commands298
Split Outside Paths298
Split All Paths .298
Scissors Tool .298
REVIEW PROJECTS300

**UNIT 10 ⟐ LINE & FRAME
ITEMS** .303
LESSON 1: WORKING with LINES304
Types of Lines .304
Freehand Lines .305
Bézier Lines .306
Measuring Lines307
Reshaping and Converting Line310
LESSON 2: DRAWING FRAMES312
Framing Boxes .312
Frame Specifications312
Frame Location312
LESSON 3: DASHES and STRIPES314
Creating Dashes and Stripes314
Dashes .314
Stripes .317
Deleting Dashes and Stripes318
Duplicating Dashes and Stripes318
LESSON 4: TEXT PATHS319
Text on a Path .319
The Line Text-Path Tool319
Editing Line Text Paths319
The Orthogonal Text-Path Tool321
The Bézier Text-Path Tool322
Editing Bézier Text Paths322
The Freehand Text-Path Tool324
Text Path Modify Dialog Box325
Text Alignment326
REVIEW PROJECT326

UNIT 11 ⟐ WORKING WITH ITEMS 327
LESSON 1: DUPLICATING ITEMS328
Duplicating Methods328

Copy and Paste .328
Duplicate Command328
Step and Repeat .329
 Horizontal and Vertical Offsets330
LESSON 2: WORKING with LAYERS332
Layers Palette .332
 Layer Rules .332
 Creating Layers333
 Visual Indicators333
Layer Preferences333
 Visible .333
 Locked .334
 Suppress Printout334
 Keep Runaround334
Editing Layers .334
Duplicating Layers334
Deleting Layers .335
 Delete All Unused Layers335
Arranging Layers335
 Changing the Stacking Order of Layers 335
Placing and Moving Items on Layers336
Stacking Items on Layers338
LESSON 3: WORKING with GROUPS339
Grouping Items .339
 Modifying Groups339
The Group Modify Dialog Box342
 Individual Grouped Items343
 Nested Groups344
REVIEW PROJECT .345

UNIT 12 ⭢ ANCHORED ITEMS &
RUNAROUND**347**
LESSON 1: STORING ITEMS in LIBRARIES . .348
Using Libraries .348
 Accessing Libraries348
 Labels .348
LESSON 2: ANCHORING ITEMS350
Why Anchor? .350
 Anchoring Items350
 Anchored Rules350
Anchored Items .352
Aligning Anchored Items354
LESSON 3: RUNAROUND355
Text Wrap or Runaround355

None Runaround .356
 Item Runaround357
Image Runaround358
 Auto Image .359
 Noise .359
 Smoothness .360
 Threshold .360
 Embedded Path360
 Alpha Channel360
 Non-White Areas361
 Same As Clipping361
 Picture Bounds362
Clipping Paths .365
Single-Column Runaround368
LESSON 4: ALIGNING ITEMS370
Horizontal and Vertical Item Alignment .370
Ruler Guides .372
 Guide Manager373
REVIEW PROJECT .374

UNIT 13 ⭢ TABLES**375**
LESSON 1: CREATING TABLES376
Tables .376
Creating a New Table376
Inserting Rows and Columns376
Selecting Cells .377
Modifying a Table379
 Adding Rows .379
 Adding Columns379
 Merging Cells .380
Formatting Tables381
Changing Table Dimensions382
 Runaround .382
Gridline Formatting382
Resizing Rows or Columns383
 Resizing Tables Manually383
Converting Text to Tables383
Copying Cell Content384
Converting Tables to Text384
LESSON 2: TABLES in WEB DOCUMENTS387
Tables on the Web387
 Exporting Tables in Web Documents . .387
REVIEW PROJECT .389

UNIT 14 ❖ COLOR **391**

LESSON 1: COLOR PRINCIPLES392
What You Know Already392
 Adding and Editing Colors392
 High-End Color Models392
 Web-Safe Colors393
 Web-Named Colors393
 Editing Colors .393
Deleting Colors .395
Duplicating and Appending Colors396
LESSON 2: CREATING BLENDS398
Blends (Gradients)398
 Accurate Blends398
LESSON 3: COLOR TRANSPARENCY400
Making Boxes Transparent400
LESSON 4: TRAPPING402
Color Trapping .402
 Spread .402
 Choke .403
 Overprint .403
 Knockout .403
 How Much Trapping?403
 Trapping Type .403
Default Trapping .404
 Trapping Method404
 Process Trapping404
 Auto Amount .404
 Indeterminate .405
 Knockout Limit405
 Overprint Limit405
 Ignore White .405
Color-Specific Trapping406
Item-Specific Trapping408
LESSON 5: COLOR MANAGEMENT409
Printing in Color .409
Device-Dependent Color409
Creating Device-Independent Color409
 Source Profiles and Destination
 Profiles .409
 Rendering Intents410
Installing Quark CMS Components410
Web-Safe and Web-Named Colors411

**LESSON 6: COLOR from ILLUSTRATOR
 and PHOTOSHOP**412
Color from Photoshop Files412
Color from Illustrator EPS Files413
Trapping Photoshop and Illustrator Files 413
REVIEW PROJECT .**414**

UNIT 15 ❖ PRINTING**415**

LESSON 1: PRINTING DOCUMENTS416
How Printing Happens416
 Creating the Illusion of Color416
Linescreen Values416
Device and Image Resolution417
 Output Resolution417
 Image Resolution417
 File Formats .417
 PostScript Printer Description
 Files (PPDs)418
Printing Bleeds .419
Crop Marks and Registration Marks419
Tiling .420
 Manual Tiling .420
 Automatic Tiling420
Output Settings .420
Halftoning .421
 LPI Values .421
Printing Color Separations421
Plate List .422
 Print Column .422
 Plate Column .422
 Halftoning for Spot Colors422
 Frequency and Angle Columns422
Options Tab .422
 PostScript Error Handler423
 Page Flip .423
 Negative Print .423
 Pictures .423
Preview Tab .424
LESSON 2: PRINT STYLES425
Creating Print Styles425
Creating a PostScript File425
Confirming Fonts .426
 Fonts Usage Dialog Box427
Collect for Output427
REVIEW PROJECT .428

UNIT 16 ✦ QUARKXPRESS ON THE INTERNET 429

LESSON 1: CREATING INTERACTIVE WEB DOCUMENTS 430
Web Documents 430
Creating a Web Document 430
 Page Width 431
 Background Picture 431
Setting Web Preferences 432
Raster Text Boxes 432
HTML Text Boxes 433
Interactive Elements 434
Hyperlinks 435
 Absolute and Relative Hyperlinks 435
Hyperlinks Palette 435
Rollovers 436
 Editing Rollovers 436
Anchors 436
Image Maps 436
Meta Tags 437
 Creating the Rollover 438
 Creating the Hyperlinks 440
 Creating an Image Map 441
 Adding Anchors 442
 Exporting the File 443
Editing Interactive Elements 444
Editing a Hyperlink 444
 Deleting Hyperlinks 445
 Styling Hyperlinks 445
 Page Properties 445
Editing Anchors 446
 Deleting an Anchor 446
Editing a Destination (URL) 446
LESSON 2: FORMS 447
Why Forms? 447
 How an HTML Form Works 447
Form Controls 447
Form Controls in the Web Tools Palette .. 448
 Image Map Tools 449
 Form Box Tool 449
 File Selection Tool 449
 Text Field Tool 449
 Button Tool 449
 Image Button Tool 450

 Pop-Up Menu Tool 450
 List Box Tool 450
 Radio Button Tool 450
 Check Box Tool 450
Radio Buttons and Check Boxes 455
Image Button Control 459
LESSON 3: AVENUE.QUARK 461
Repurposing QuarkXPress Documents .. 461
XML 461
 Document Type Definitions 461
Cascading Style Sheets (CSS) 462
 On Your Own 462
REVIEW PROJECT 462

UNIT 17 ✦ LONG DOCUMENT CONSTRUCTION 463

LESSON 1: CREATING COMPLEX DOCUMENTS 464
Long Document Components 464
 Lists 464
LESSON 2: CREATING A BOOK 470
What Is a Book? 470
LESSON 3: SYNCHRONIZING CHAPTERS 472
Putting It All Together 472
LESSON 4: CREATING AN INDEX 474
Types of Indexes 474
 Cross References 474
 Index Options 474
Index Preparation 475
 Index Preferences 475
 Index Styles 476
 Linked Master Pages 476
The Index Palette 477
Building the Index 482
Add All 484
Creating Cross-References 484
Reversing Names in the Index 485
Cleaning Out the Index Palette 485
Indexing a Book 486
REVIEW PROJECT 486

GLOSSARY 487

INDEX 494

Preface

With the release of version 5.0, QuarkXPress becomes a vehicle for both print and broadcast documents. The combination of powerful typographic, graphics, and layout tools and a robust Internet engine make this a formidable program to master. Still, it retains the intuitive user interface and economy of tools that has made it the premier publishing program.

In attempting to organize the enormous amount of material for this book, I've emphasized the basic functions of the program and repeated them throughout all the exercises in the book. Once you understand how QuarkXPress "thinks," you can do anything with it. Writers, designers, graphic artists, and publishers have always found that this remarkable application can be made to do almost anything with text and graphics. You'll find many of these tips and tricks in the minor column of the book pages. At the heart of this book, however, are the exercises which take you through each function step-by-step, making you comfortable with the program and confident enough to try the exercises again using different values for the various page elements. Real-world review projects for each unit will help you pull all the material together and give you a good idea of how QuarkXPress is used in a production environment. The repetitive nature of these exercises, which build skills, in tandem with a student's eagerness to fly solo, create the expertise demanded by today's deadline-driven environment.

Those of us who teach QuarkXPress in a world of semester hours know that those hours have not increased with the multitude of program functions. Just the addition of Internet features imposes an additional burden on instructors, requiring them to cover the color and graphic format issues for Web display along with all the complex print functions. To accommodate these needs, I've tried to give basic background information about these topics while incorporating them into the exercises and projects. The glossary of terms is also useful in helping students understand the language of both print and broadcast.

In preparing this manuscript, I am indebted to Quark, Inc. for giving me access to the early versions of the program and for answering my questions about an application that was constantly evolving. I'm also grateful to Randi Munn. Instructor at the Art Institute of Los Angeles for her intelligent technical review of the manuscript; and to Jaimie Wetzel at Delmar, who was graciously helpful in so many ways. And, as always, my thanks to Brooke Graves of Graves Editorial Service, mistress of style and syntax, whose editing kept the manuscript intelligible to the English-speaking world.

Unit 1
QuarkXPress Basics

OVERVIEW
In this unit you will learn:

How to use this book
About Macintosh and Windows issues
Making font choices
The history of electronic typesetting
How QuarkXPress "thinks"
About QuarkXPress documents
How to launch, open, and save documents
About the Tool Palette and tools
How to create a new document
About facing and nonfacing pages
About the pasteboard
How to use palettes
About viewing and navigating pages

TERMS

facing pages
nonfacing pages
Open
pasteboard
Preview
Revert to Saved
Save
Save as

LESSON 1: INTRODUCTION

WELCOME TO QUARKXPRESS 5.0!

QuarkXPress 5.0 represents a radical departure from earlier versions of XPress by allowing users to create pages for both print and screen distribution. Powerful tools for styling text and manipulating graphics, strong typographical functions, and flexible layout commands have made QuarkXPress the choice of professional typesetters, page layout designers, and graphic artists who learned very early that you can print almost any image from XPress.

Likewise, a powerful graphics suite capable of drawing Bézier lines, paths, and boxes and creating clipping paths around images lets XPress users perform many graphic functions directly in QuarkXPress without recourse to dedicated graphic programs. QuarkXPress won't replace graphics applications, but gives users wider flexibility within XPress.

Among other features in version 5.0 are the Book, List, and Index functions, which make the production of long documents far more efficient and error-proof than was possible in earlier versions. Anyone working in the journalism, publishing, or advertising industry will welcome the ability to synchronize multiple project documents and create a table of contents and index within XPress.

With version 5.0 QuarkXPress includes a powerful Web engine, allowing you to create pages for display in a Web browser. You can create these pages from scratch or drag QuarkXPress items onto a Web document page. Interactive forms with menus and buttons give Web designers multiple controls over their Web pages.

If, at first, you feel that there is too much in version 5.0 to learn in this lifetime, relax! You will be learning one function at a time. If you have used earlier versions of XPress, much of the material will be familiar to you.

WHAT IS QUARKXPRESS?

QuarkXPress is an electronic tool for laying out pages in which PostScript text and PostScript and rasterized graphics exist in (one hopes!) harmonious and intelligent relationship with one another. These pages are intended to be printed on desktop printers or from film on different kinds of printing presses. QuarkXPress Web documents export as HTML pages for display in a Web browser and print documents export as PDF (Portable Document Format) files.

WHAT DO YOU NEED?

To create pages on a computer that will print as designed, you need an application that can:

▲ Create and import text and format that text with typographical accuracy to meet design specifications.

▲ Import and manipulate graphics from major image-editing programs, such as Adobe Photoshop, and vector-based drawing programs, such as Adobe Illustrator and MacroMedia Free-Hand.

▲ Provide printing functions that allow the pages to be reproduced on a variety of printing devices.

▲ Apply color to text and objects and have the material print appropriately.

▲ Provide cross-platform compatibility.

WHAT DO YOU GET IN QUARKXPRESS 5.0?

▲ A powerful word processor for entering and editing text and filters that let you import text files from other word processors, such as Microsoft Word and Corel Word Perfect, among others.

▲ Extraordinary typographical controls that let you position text characters precisely; apply proper hyphenation, especially of justified text; and kern and track text so that it is visually perfect.

▲ Strong color controls for applying and editing color and creating color trapping.

▲ The ability to import files in many formats (such as TIFF, PICT, and BMP) from image-editing programs and in EPS format from vector-based drawing programs.

▲ Bézier tools for drawing and editing vector paths that can be used to hold either text or graphics and layers for organizing page items.

▲ Powerful printing functions that make it easy to print pages on desktop printers, create film on imagesetters, and print on a variety of printing presses.

▲ The ability to create HTML and XML documents for Internet, CD-ROM, and PDF publication.

▲ The ability to use the same QuarkXPress files on Macintosh and Windows platforms.

What's a Bézier?

Pierre Bézier (pronounced bay-zee-ay) was a French mathematician who developed the method of using points and curves to facilitate the process of drawing car bodies.

USING THIS BOOK

This book is divided into units covering the major functions in QuarkXPress 5.0. It's a good idea to start with the first few chapters to get a feel for how the program works. Once you're comfortable with creating items (boxes and lines) and styling text, you can learn pretty much anything else.

Each unit is divided into lessons that include exercises on the particular function covered in the lesson. Since "perfect practice makes perfect," doing these exercise a few times but changing the values and dimensions of text and objects is a good way to become comfortable with a function. Keep in mind that there is more than one way to accomplish many of the functions in XPress. Some ways may be more elegant than others, but no way that works is wrong. There are very few wrong things you can do in XPress and breaking the program is not one of them.

At the beginning of each unit is a list of terms covered in the unit. The terms are explained in the text and are defined in the glossary at the end of the book. Learning the meaning of these terms will make you more comfortable with QuarkXPress terminology as it relates to the printing and publishing industries.

MACINTOSH/WINDOWS ISSUES

QuarkXPress 5.0 for Macintosh and Windows behave seamlessly across both platforms. Each platform reads a few different types of graphic formats and installs and accesses printers differently, but the functionality is exactly the same. Even most of the keystrokes are the same—with two exceptions. The Command key on the Macintosh is the Ctrl key in Windows; the Option key on the Macintosh is the Alt key in Windows. That's just about it! Master those two differences and you can work in any shop.

FILE TRANSFER

You may encounter some problems when creating files on one platform and then working with them on the other, so it's best to be aware of how to do this with a minimum of trouble:

▲ If you are working on a Macintosh, be sure that the PC Exchange Control Panel is installed in your system. This will allow you to open an XPress PC file on your Macintosh.

▲ The Macintosh can read a PC-formatted disk, but the PC can't read a Macintosh-formatted disk. To open a Macintosh XPress file on the PC, save it on a PC-formatted disk.

Now you don't...

EPS files saved with a PICT preview on Mac OS won't display the preview in the Windows picture box. Instead, a gray box appears in the Windows picture box. To avoid this, Macintosh users should save EPS files with a TIFF preview that can be read by both platforms.

▲ Always add the proper extension for Macintosh files, because Windows is fussy about file extensions. Add *.qxd* for a QuarkXPress document, *.qxl* for a QuarkXPress Library, and *.qxt* for a QuarkXPress template. If you forget to do this on the Macintosh, when you are opening the file in Windows, select Display All Files from the Files of type pull-down menu in the Open dialog box.

▲ Use only alphanumeric characters when naming files on the the Macintosh. Windows can't read file names with /, \, ", ?, <, > , *, or :.

▲ When opening a PC file on the Macintosh, you can't double-click on the file icon to open the file. Instead, launch QuarkXPress on the Macintosh and use the Open command under the File menu to display the file on the PC-formatted disk.

▲ When creating graphic files, always use the appropriate extension in the file name. Use *.jpg* for JPEG files, *.tif* for TIFF files, and *.eps* for Encapsulated PostScript files. TIFF and EPS usually give the best results across both platforms.

KEYSTROKES

All the keystrokes are printed in boldface type whenever a command is given. For example, **Command-Option-Shift-F** (Macintosh) or **Ctrl-Alt-Shift-F** (Windows) provides commands for both platforms. Where Windows users press the Enter key on the keyboard to end a paragraph or select a bordered option in a dialog box, Macintosh users can press the Return and Enter keys interchangeably. The sooner you start using keyboard commands, the freer you'll become from menus and dialog boxes.

FONT CHOICES

The only two fonts referred to in this text are Times and Helvetica. Windows users can substitute Arial and Times New Roman. Feel free to substitute *any* font installed in your system. It rarely makes any difference which typeface you use—as long as you are working on only one platform—although point size might make a difference in some of the exercises.

Templates

When you open a document saved as a template, Quark creates a duplicate of that template file with the name "Document." You can save this file, but not the template file.

PICT problems

Some PICT files generated on the Mac OS may not display or print correctly on Windows 95 or Windows NT.

Sticky menus

On Mac OS 8x and on Windows, click on a menu and release the mouse. The menu stays open while you locate the function you want. Click on it to execute that menu command.

Although QuarkXPress for Macintosh OS and QuarkXPress for Windows can read each other's files, font selection for each platform is a significant issue. To avoid conflicts, use the same version of each font from the same font vendor on both platforms.

MENU BAR CONVENTIONS

Rather than clutter up the text with arrows to direct you to the correct sequence of accessing functions, I've chosen to use the / mark. When you're told, "Choose Style/Font/Helvetica," you should pull down the Style menu at the top of the screen, drag down to select Font, and drag to the right to select Helvetica. Windows users can just click the underlined character to navigate the menus.

TOUGH STUFF

Two areas that can appear complex are printing documents and specifying color. Rather than leave these functions to units at the back of the book, so you can spend the whole time living in fear, these functions are covered throughout the units. The more esoteric color commands are left to a later unit, but creating, editing, and applying color from different color models appear early in the text so you can enjoy using color in your exercises. Many printing functions, however, are covered individually throughout the book, so you can see what your documents look like in the real world.

EXERCISES

Many of the exercises involve working with one or two functions. Unless you're specifically told to save a file, you can close it without saving your changes. However, if the next exercise asks you to open a file without any specific attributes like facing pages or an automatic text box, you can use the same document you created for the previous exercise. Delete the previous items or add a new page to the original document. Otherwise, you're going to get a lot of practice creating new documents.

REVIEW PROJECTS

Each unit contains at least one review project to help reinforce what you learned in that unit. Feel free to experiment with the text and graphics. Getting comfortable with Quark is part of the learning process.

A check mark in a menu indicates that a feature is turned on or a format from a list has been applied.

FYI

Menu arrows in an options box indicate a pull-down menu. Click on the arrows to drop the menu, then drag to select an option. Release the mouse button when you've made your selection.

ACTIVE DOCUMENTS

You can have as many documents open on the desktop as your computer memory allows. However, only one document can be the active document, that is, the document that can be edited, saved, or closed. When an exercise tells you to "Activate the Newsletter document," for example, click on the title bar at the top of the page that displays the document's name to activate the document. Any editing now occurs in that (selected) document.

PROJECTS FOLDER

Before you begin working with this book, create a file called something like Projects or My Work on your hard drive or on an external drive. When you save working files from the exercises, save them to this folder, because you won't be able to save them to the CD-ROM.

HISTORY OF ELECTRONIC TYPESETTING

From scrolls to leaved books—the forerunners of our modern publications—written communication was achieved one letter at a time, one copy at a time. Scribes and monks, specialists in text and graphics, established publishing as a definable activity—essentially a trade.

In 1450, Johannes Guttenberg changed the world of published communication when he invented moveable type. Only then did it become practical to make multiple copies of documents. The written word truly became the published word, available to the public at large.

Originally, letters were fashioned much as the scribes had handlettered for years. The type (cut from wood or cast in lead) was beautiful, but not particularly easy to read. For more than 400 years, type was hand-picked to be literally set in place.

FIRST-GENERATION TYPESETTING

Ottmar Merganthaler changed all that in 1886. He developed a key-operated linesetting and typecasting machine that employed reusable brass matrices. Because it set a line of type at a time, it was called the Linotype. This was the first generation of automated typesetting systems.

This material is taken from *Pathways to Print: The Complete Series for Desktop Publishing*, by Robin Mcallister, Delmar Publishers, 1997. For more information about this book and other books on graphics and printing technologies, log on to the Desktop Café at **www.desktopcafe.com**

SECOND-GENERATION TYPESETTING

In the early 1950s, Varityper and Compugraphic Corporation each introduced a reasonably-priced standalone photocomposition system. These were second-generation typesetters (electromechanical, photo-optical machines); they used glass, plastic, and film masters that were designed to run in a particular device. Light was flashed through the master and onto photosensitive material, which was then developed and eventually contact-printed to a printing plate.

THIRD-GENERATION TYPESETTING

Third-generation typesetters (digital cathode ray tube or laser character generators) used electronically stored type font data. They "drew" the image onto the photosensitive material.

Neither of these could incorporate graphics more complex than horizontal or vertical rules—and that was a result of their having the ruling routines stored as font data.

FOURTH-GENERATION TYPESETTING

Fourth-generation imagesetters (digital laser or other technology) also used electronically stored type fonts, but have the added ability to output line art and halftones with the type (an entire composed page). You may have noticed that these machines are called "imagesetters" as opposed to "typesetters." They're essentially the same machines we use to output pages today, with a different front-end system.

Other than old Intertype and Linotype linecaster matrices, type fonts have never been interchangeable from typesetter to typesetter, although some second-generation fonts did run on multiple models.

This meant that every time a compositor changed equipment, an entire type library had to be purchased. Even when equipment was upgraded with the same manufacturer, a new library was often required. Manufacturers of typesetting equipment were also the font foundries; an upgrade could mean a new means of attaching the font to the machine—and additional income for the manufacturer. Other companies allowed more reasonable upgrade paths. Regardless of the upgrade path, though, every time an upgrade passed through a generation, it meant purchasing a new font library.

The Times suitcase (top) contains the screen font (center). The printer font (below) combined with the screen font creates the PostScript font.

FONTS

PostScript type fonts are interchangeable. That is what makes them unique. All characters and symbols are stored as Bézier outlines. This allows them to be expanded, condensed, and elongated. Their basic shape may also be altered using special programs. They may even be disassembled as fonts and retained as artwork using standard illustration programs. No matter where they are stored, they must eventually be stored in the output device.

PRINTER FONTS AND SCREEN FONTS

PostScript fonts exist in two forms:

Printer fonts are ultimately stored in the printout devices. These are sent to the printer or imagesetter using a utility program or the page layout program. If the printer font is missing, the printer will draw a bitmapped image of the type. This is ugly and also takes a long time.

Screen fonts are stored in the workstation. Screen fonts are loaded by version (Bold, Italic, etc.) and by point size. You must have the screen font in use in order to access the printer font. If the screen font is not loaded, the publishing program will usually substitute this "delightful" font, Courier.

TRUETYPE FONTS

These fonts, introduced by Microsoft and Apple, produce another solution. The computer generates a screen image from the outline of the printer font itself. There are occasional problems when using TrueType fonts in conjunction with PostScript fonts and in certain applications. Consult your imagesetting vendor regarding compatibility issues. Generally, there will be no problems when imaging to a low-resolution printer such as a 300 to 600 dpi laser printer.

TROUBLESHOOTING

If you should find QuarkXPress misbehaving (it's not called "QuirkXPress" for nothing), chances are a font is corrupted or the XPress Preferences file has been corrupted. This file, located in the QuarkXPress folder, contains information you type into the various Preferences dialog boxes, your hyphenation exceptions, and changes you made to the kerning and tracking tables. When the program is not behaving properly, quit out of QuarkXPress, drag the XPress Preferences file to the trash, and relaunch QuarkXPress. This forces XPress to create a new, clean Preferences file. If the problem persists, you probably have an XTension conflict. Quit QuarkXPress and drag the QuarkXPress icon out of the QuarkXPress folder onto the desk-

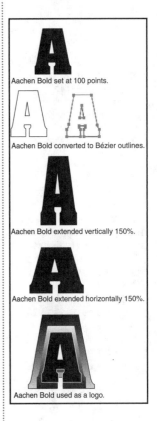

Aachen Bold set at 100 points.

Aachen Bold converted to Bézier outlines.

Aachen Bold extended vertically 150%.

Aachen Bold extended horizontally 150%.

Aachen Bold used as a logo.

A TrueType font displays the triple A in its icon.

top. Relaunch QuarkXPress. This not only forces XPress to create a new Preferences file, but also launches it without any xtensions, which usually solves the problem.

PLAY TIME

QuarkXPress is basically an electronic playground filled with dozens of toys like text, graphics, design, and layout functions. Use these tools and commands to create spectacular pages that communicate information in an orderly, intelligent, and exciting manner. Take your time in learning how to use these functions; some are amazingly simple, but even the more complex ones can be mastered with a little practice. The important thing is to take each function step-by-step. Repeat an exercise that you found difficult and soon you'll find yourself doing things automatically while concentrating on learning something new. Enjoy experimenting with different text and graphics commands. You can't break the program and you'll be surprised at what you'll be learning. Like thousands of students before you, you'll find yourself becoming a devoted—and talented—"Quarkie."

What's in the XPress Preferences file?

The XPress Preferences file is stored in the QuarkXPress folder on the computer's hard drive. Kerning and tracking tables, hyphenation exceptions, default style sheets, colors, dashes, frames, lists, hyphenation and justification settings, and path information to the default auxiliary dictionary are all stored in the XPress Preferences file—if no documents are open when you set these values. Some are saved only with a document. If you get a non-matching Preferences alert when you open a document, click the Keep Document Settings button if you want the document to look on your computer exactly as it did on another machine.

LESSON 2: QUARKXPRESS BASICS

HOW QUARKXPRESS "THINKS"

For such a powerful program, QuarkXPress "thinks" in only two tracks: items and contents. This means that everything in XPress is either an item or the contents of that item. Text and graphics do not exist outside of their boxes. Only lines and text paths can be created directly on the page. Everything else must be placed in an appropriate box.

ITEMS

An *item* is a box or a line. A box can be a picture box, a text box, or a contentless box. A line can be a horizontal, vertical, or diagonal line or a Bézier path. Items are moved with the Item tool.

CONTENTS

The contents of a picture box is a picture. The contents of a text box is text. A contentless box holds nothing and is used only as a placeholder. Contents are manipulated with the Content tool.

QUARKXPRESS DOCUMENTS

QuarkXPress is the application (program) that creates QuarkXPress print and HTML documents (files). You use the commands and tools in the application to create and edit document pages. Each QuarkXPress document contains at least one page on which text and/or graphics usually appear.

LAUNCHING QUARKXPRESS 5.0

If you've installed QuarkXPress properly, the QuarkXPress 5.0 folder should be on your hard drive. Double-click on that folder and scroll to locate the QuarkXPress application icon. Double-click on that icon to launch the program. Only two things appear on the screen, the Menu Bar and the default Tool palette.

OPENING AND SAVING DOCUMENTS (FILES)

Choose File/Open and navigate to any folder or to any QuarkXPress file and click Open. If you get a missing font alert and click the Continue button, XPress will substitute system fonts for the missing fonts. Clicking the Preview button (Mac OS only) displays a thumbnail of the document's first page.

CD-ROM files

The data and graphics files on the CD-ROM can't be saved to the CD-ROM. If you open a file from the Student Files folder on the CD-ROM, you won't be able to save it to the CD-ROM. Before beginning work on a unit, drag the unit folder from the Student Files folder to your hard drive or to an external drive.

Click the Preview button in the Open dialog box (Mac OS only) to display a thumbnail of the first page of the document.

On the Macintosh, select Desktop from the pull-down menu in the Save as dialog box.

QuarkXPress versions

Choose version 4.0 in the Save as dialog box to save the document in an earlier version. Some features of version 5.0 may be lost. For example, items placed on different layers in 5.0 will appear on the single page layer in version 4.0.

Select Include Preview in the Save as dialog box (Mac OS only) to display a preview of the first page of the document the next time you open it.

SAVING FILES

File destination is something you really want to be in charge of. It's awkward to locate a file when you don't know where you saved it.

▲ **Macintosh** users choose File/Save and click Desktop in the Save or Save as dialog box. On the Desktop you'll see icons for all the storage devices currently available to your system—the hard drive, the CD-ROM, the Zip drive, and the floppy drive— and any folders on the hard drive. Double-click on a drive or folder icon to open it. From there you can either click the Save button or navigate to another folder on the storage device.

▲ **Windows** users choose File/Save and click the Desktop button, which lists all the disks and folders that are stored on the Desktop. Drag the slider at the bottom to scroll through the list to see all the items that don't fit in the window. Double-click the name of the storage device or highlight the disk's name and click on Open. This displays all the folders and files stored on that selected disk. Type the name of the file in the File name field and select Document or Template from the Type field. Windows automatically adds the .qxd or .qxt file extension, depending on which option you choose from the Type field.

REVERT TO SAVED

Sometimes you open a file, make changes, and realize that you've done things that are just too much trouble to edit or delete. If you haven't saved the file since you opened it, you can use the Revert to Saved command under the File menu to close the file and automatically open the original file, the one you last saved. When you choose the Revert to Saved command, an alert appears telling you that any changes made to the file since you opened it will be lost. Click OK to close the file and revert to the last saved version of the file. If you click the Cancel button, the Revert to Saved command is canceled and you're returned to the document.

MENU COMMANDS

Menu commands and their keyboard shortcuts (where available), like File/Open (**Command-O**/Macintosh or **Ctrl-O**/Windows) or File/Get Text/Picture (**Command-E**/Macintosh or **Ctrl-E**/Windows), are printed in boldface whenever a command is specified in an exercise.

KEYBOARD SHORTCUTS

QuarkXPress contains hundreds of commands, most of which can be accessed from the function keys at the top of the keyboard or by typing keyboard shortcuts. Pressing **Command-N** (Macintosh) or **Ctrl-N** (Windows) to create a new document, for example, saves you the work of moving the mouse to the top of the page, dragging down on the File menu, dragging down to select New, and dragging over to select Document. Instead, with one keystroke you can display the New Document dialog box. Likewise, pressing **F9** on the function keypad displays or hides the Measurements palette without requiring you to do so from the View menu. Learning and using the keyboard and function key shortcuts will have you working more easily and efficiently in XPress. You will find most of them in the text of the lessons when they occur in an exercise.

FILE EXTENSIONS

When saving files, always use the correct file extension. For example, when saving a QuarkXPress document, add the .qxd extension to label it as a QuarkXPress document or .txt to indicate that the file is a text file. Graphic files should also be saved with identifying extensions such as .tif or .jpg for TIFF and JPEG files. This makes it easier for you and for anyone accessing your files to know what they are, as well as labeling your files according to usual industry practice. You do want to make money using QuarkXPress, don't you?

TOOL PALETTE

The QuarkXPress 5.0 Tool palette for print documents (Figure 1.1) contains tools for creating and editing items (boxes, lines, text paths, and groups) and contents (text and graphics). If the Tool palette is hidden, display it by choosing View/Show Tools (**F8**). Select a tool by clicking on it. The tool remains active while you use it. Only the Item tool and Content tool remain active (selected) after use. When a Web document is active, the Web Tools palette is available.

TOOLS

The QuarkXPress 5.0 default Tool palette contains twelve visible tools and eighteen pop-out tools. An arrow next to a tool indicates that there are pop-out tools associated with the displayed tool. Click on the arrow to see the other available tools.

Context menus

Context menus are dynamic menus that display commands specific to the task you're performing. In Mac OS, Control-click on an item to display the commands that affect that item. In Windows, right-click to display the context menu.

Sticky tool

Press the Option key (Macintosh) or Alt key (Windows) when clicking on a tool to select it. This keeps the tool active until you select another tool.

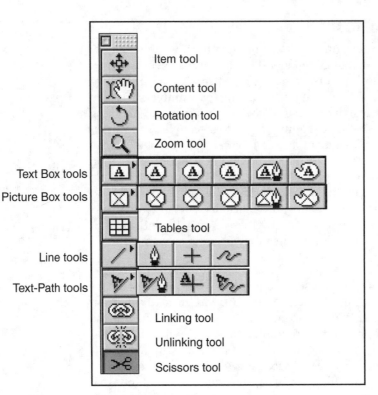

Figure 1.1. The QuarkXPress 5.0 default Tool palette for print documents

Text Box tools

Picture Box tools

Line tools

Text-Path tools

Item tool

Content tool

Rotation tool

Zoom tool

Tables tool

Linking tool

Unlinking tool

Scissors tool

DEFAULT TOOL PALETTE

Item tool is used to select, move, resize, and reshape items. Boxes, lines, text paths, and groups are items.

Content tool imports and edits text and graphics.

Rotation tool rotates items visually.

Zoom tool enlarges or reduces the document view.

Text Box tools (standard-shape) create a rectangular text box. They also provide access to other text box tools, including the Bézier Text Box tools.

Picture Box tools (standard-shape) create a rectangular picture box. They also provide access to other picture box tools, including the Bézier Picture Box tools.

Tables tool creates tables using text boxes and/or picture boxes.

Line tools draw lines at any angle and include the Orthogonal Line tool and the Bézier Line tool.

Text-Path tools create a straight line at any angle, contain text, and provide access to other text-path tools, including the Bézier Text-Path tool.

Linking tool links text chains to flow text among text boxes.

Unlinking tool breaks links among linked text boxes.

Scissors tool cuts boxes, lines, and Bézier paths.

SHOW TOOL TIPS

Set your Preferences so that when you move the cursor over a tool in the Tool palette, the name of the tool is displayed. Choose Edit/Preferences/Preferences. Click Interactive and select the Show Tool Tips check box. Click OK or press Return to exit the dialog box and return to the document.

ITEM TOOL

In QuarkXPress, *items* are boxes, lines, text paths, and groups. Select the Item tool to move, cut, copy, and paste items. Clicking on an item with the Item tool selects it. An item must be selected before it can modified by any tool or command. Once an item is selected, it can be moved with the Item tool without resizing or reshaping it (Figure 1.2).

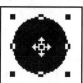

Figure 1.2. The Item tool, the first tool in the Tool palette, displays the Move pointer when placed on a selected item. The Item tool is also used to select items such as boxes and lines.

Before you can delete an item such as a box, line, group, or text path, you must select the item. If you use the Item tool, you can delete the item with the Delete key (Macintosh) or either the Delete or Backspace keys (Windows). Otherwise, when an item is selected with another tool, you must use the Item/Delete command.

Select Show Tool Tips in the Interactive tab of the Application Preferences dialog box.

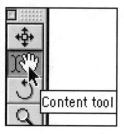

When Show Tool Tips is selected in the Interactive Preferences dialog box, the name of the tool appears when you move the cursor over it.

CONTENT TOOL

When the Content tool is active (selected), you can cut, copy, paste, clear, and edit text and pictures (Figure 1.3). The Content tool must be active before you can type in a text box or import text into any text box.

Figure 1.3. When the Content tool is active, you can type in any kind of text box.

ROTATION TOOL

When you select this tool, the pointer changes to the Rotation pointer. Click on any resizing handle of a selected item and drag to rotate the item visually (Figure 1.4). Once you start dragging, the Rotation pointer changes to the Arrowhead pointer. The longer the handle you drag out, the easier it is to rotate the item. Once you release the mouse button, the cursor reverts to the Item tool or to the Content tool.

Figure 1.4. Clicking on a resizing handle with the Rotation tool specifies that point as the point of rotation.

STANDARD-SHAPE VS. BÉZIER TOOLS

The standard-shape tools are the conventional drawing tools used to create items with resizing handles. You can't arbitrarily reshape these items, only resize them. Any reshaping is limited to the options under the Shape menu (Item/Shape) if the Shape command is selected (Item/Edit/Shape).

Bézier items, however, contain Bézier points—what the rest of the world calls *anchor points*—that can be edited and deleted. Anchor points can also be added to an item, making it possible to shape it any way you want (Figure 1.5).

Any standard-shape item can be converted to a Bézier item via the Shape menu. Once you do that, the item displays the Bézier points and allows you to reshape the item by dragging the points and the direction handles that the points display.

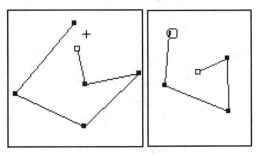

Figure 1.5. Click with the Bézier Text Box tool to create text boxes of any shape. Click on top of the first Bézier point to close the shape.

No escape!

Learning the Bézier tools in QuarkXPress doesn't exempt you from learning Adobe Illustrator, the industry-standard drawing tool.

TEXT BOX POP-OUT TOOLS

The first three Text Box pop-out tools are also standard-shape text box tools. The Rounded-Corner Text Box tool creates rectangular boxes with curved corners. The Concave-Corner Text Box tool creates rectangular text boxes with corners rounded inward. The Beveled-Corner Text Box tool creates rectangular text boxes with beveled corners. The Oval Text Box tool creates oval or circular text boxes. To use these tools, click on the tool to select it. If the tool isn't displayed, click on the triangle for the displayed tool and drag to select the hidden tool.

The Bézier Text Box tool creates a text box of any desired shape. Unlike the standard-shape tools, you don't click and drag with this tool. Click to set the first Bézier point, release the mouse button, and move to another area; then click to create a second Bézier point and a line between those two Bézier points. Click on top of the first Bézier point to close the box. Figure 1.6 displays the standard-shape and Bézier Text Box tools.

 The Freehand Text Box tool creates text boxes in any shape by dragging the crosshair pointer. Once the box is drawn, you can type inside the box.

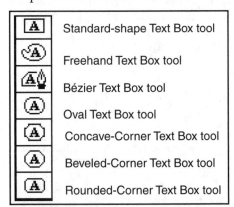

Figure 1.6. The standard-shape and Bézier Text Box tools

Icon	Tool
	Standard-shape Text Box tool
	Freehand Text Box tool
	Bézier Text Box tool
	Oval Text Box tool
	Concave-Corner Text Box tool
	Beveled-Corner Text Box tool
	Rounded-Corner Text Box tool

The Freehand Text Box tool works like a pencil. Click and drag to draw any shape. When you close the shape by clicking on the first Bézier point, the I-beam cursor appears, allowing you to type inside the text box.

PICTURE BOX POP-OUT TOOLS

Picture boxes are used to hold graphics that you import into XPress. The first two Picture Box pop-out tools, the Concave-Corner and Beveled-Corner Picture Box tools, draw picture boxes with corners rounded inward and outward, respectively. The Freehand Picture Box tool draws picture boxes in any shape. Unlike the other Picture Box tools where you drag to create a picture box, use the Freehand Picture Box tool as a pencil to draw irregularly shaped picture boxes. Figure 1.7 displays the standard-shape and Bézier Picture Box tools.

The standard-shape picture box (top) contains only eight resizing handles. Changing its shape from the Item menu (center) still limits the shaping to what you can do with the eight resizing handles. Converting the standard-shape box to a Bézier box (bottom) replaces the eight resizing handles with Bézier points that can be reshaped in any direction.

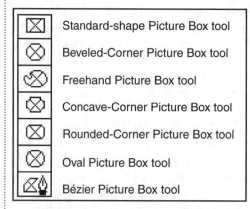

⊠	Standard-shape Picture Box tool
⊗	Beveled-Corner Picture Box tool
	Freehand Picture Box tool
	Concave-Corner Picture Box tool
	Rounded-Corner Picture Box tool
⊘	Oval Picture Box tool
	Bézier Picture Box tool

Figure 1.7. The standard-shape and Bézier Picture Box tools. The Freehand Picture Box tool creates Bézier picture boxes in any shape.

LINE TOOL POP-OUT TOOLS

Line tools create lines, or open items. Any open item in XPress is called a *line*. Any closed item such as a box is called a *shape*. Use the Orthogonal Line tool to draw only horizontal or vertical lines. The Line tool, however, can draw straight lines at any angle. Figure 1.8 displays the standard-shape and Bézier Line tools.

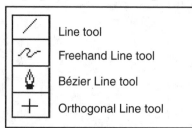

/	Line tool
~	Freehand Line tool
	Bézier Line tool
+	Orthogonal Line tool

Figure 1.8. The standard-shape and Bézier Line tools.

The Bézier Line tool draws lines with Bézier points that can be manipulated to change the shape of the line. Like the Bézier Text Box tool and Bézier Picture Box tool, you click with the Bézier Line tool to create the first Bézier point, move to another area, and click to create the second point and the line between the two points. When you have finished dragging the line, click on any other tool to deselect the Bézier Line tool.

The Freehand Line tool works like a pencil. Click and drag once and draw the line. Click on any other tool to deselect the Bézier Freehand Line tool. Select the Item tool or Content tool and click and drag on any of the Bézier points or direction handles to reshape the line.

TEXT-PATH POP-OUT TOOLS

All text must be typed in or imported into some kind of text box or typed on a text path. The four Text-Path tools (Figure 1.9) include the Freehand Text-Path tool, which works like a pencil and creates an irregularly-shaped text path; the Line Text-Path tool, used to create text on a line at any angle; the Orthogonal Text-Path tool, used to create horizontal or vertical text paths; and the Bézier Text-Path tool, for creating Bézier text paths that can be reshaped by dragging the Bézier points and control handles. After drawing with any of these tools, the I-beam cursor appears on the line and you're ready to type.

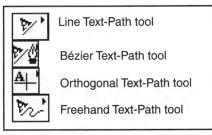

Line Text-Path tool

Bézier Text-Path tool

Orthogonal Text-Path tool

Freehand Text-Path tool

Figure 1.9. Four Text-Path tools

LINKING AND UNLINKING TOOLS

Because all text in XPress must be typed in a text box, on a text path, or imported into a text box, you may need more than one text box to hold all the text. In this case, you want the text to flow properly from one text box to another. In other words, you want the text boxes linked. If you create a new document with the Automatic Text Box option selected, XPress will automatically flow the text from the text box on one page to the text box on the subsequent pages. The text is automatically linked because the text boxes are linked. If you don't select the Automatic Text Box option in the New Document dialog box, or if you want the text in an automatic

Use the Freehand Picture Box tool to draw irregularly shaped picture boxes around graphics.

Select this option in the New Document dialog box to have XPress automatically flow text from the text on one page to the text boxes on subsequent pages.

Scissors tool

text box to flow somewhere other than to the text box on the next page, you will have to link those text boxes manually with the Linking tool. To unlink any text box from its text chain, use the Unlinking tool.

SCISSORS TOOL

The Scissors tool cuts lines and Bézier paths, creating two Bézier points where the original line existed. If you snip a non-Bézier item, it's converted to a Bézier item.

MODIFYING THE TOOLS

You can modify many of the tools so they will always behave in a certain way when you use them. For example, you can modify any of the box tools so that they're drawn with a frame (border around them) or change the Zoom tool's magnification to percentages different from the default magnifications. To modify a tool, double-click the tool; this displays the Tools Preferences dialog box in Preferences. Click the Modify button and make changes.

You can also access this dialog box by choosing Edit/Preferences/Preferences and clicking on Tools. Then click a tool, click the Modify button, and make your selections. If you display this dialog box when no documents are open, your changes will apply to every document you work with in XPress.

DEFAULT TOOL PALETTE

To return the Tool palette to its default tools, double-click any tool to get to the Tools Preferences dialog box. Click the Default Tool Palette button and click OK.

Rectangle Text Box tool

EXERCISE A

1. Launch QuarkXPress. When the menu appears, choose File/New and drag to select Document. Or, type **Command-N**/Macintosh or **Ctrl-N**/Windows. Accept the default values, but make sure that Automatic Text Box is unchecked. Click OK. The document page appears surrounded by its margin lines.

Item tool

To move an item on the page, click on it with the Item tool and drag it around the page. Keep the mouse button pressed as you drag.

2. Click on the Rectangle Text Box tool to select that tool. Click and drag on the page to create a text box (Figure 1.10). When you release the mouse, the text box appears with the blinking text cursor in the upper right corner if the Content tool was selected before you drew the box. If the Content tool isn't selected, choose it and type your name in the box.

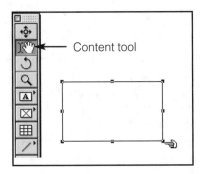
Content tool

Line tool

Figure 1.10. Once you release the mouse button, the text box appears. Click on a handle to resize the box.

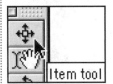
Item tool

3. Click on the Item tool to select it. Click on the text box and drag it to a different position on the page.

4. Click on the Zoom tool to select it and click on the box to increase the magnification. The item doesn't change, just the display size of the item.

5. Click on the Line tool to select it. Click and drag on the page to draw a line. The line appears with its two end handles selected.

6. Click on one of those handles and notice that the cursor changes to the Finger cursor. Drag with the Finger cursor to resize the line and reposition that endpoint (Figure 1.11).

Click and drag with the Zoom tool to select all items within the zoom marquee.

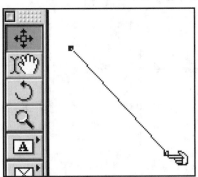

Figure 1.11. Click on the end handle of a line to resize it and reposition that endpoint.

7. Choose File and drag to select Close (**Command-W**/Macintosh or **Ctrl-F4**/Windows). At the alert for saving the changes, click No. The file is closed and you're still in QuarkXPress.

The Brush Off

We're the Cleanup Crew and we'd like to make your building shine! We're a property maintenance service with nearly 20 years of janitorial experience. But here's the best part: we think we can save you both time and money! Because the Cleanup Crew offers an unusually wide range of services, one call to us can usually take care of all your cleaning problems. Since there's no need to bring in several contractors, your apartment or office can often be ready for the next tenant within 24 hours. And your satisfaction is always guaranteed. Call us today at 1-800-CLEANUP.

A typical QuarkXPress page contains text and graphics. Here the text runs around the outside of the brush graphic, the headline is formatted in a larger type size, and a small graphic logo appears in the lower right corner.

To create a new document, click on File, select New, and drag to select (highlight) Document.

LESSON 3: PAGES AND PALETTES

CREATING A NEW DOCUMENT

To create a new document, choose File/New Document from the menu to display the New Document dialog box. Here you select options that determine what kind of pages you will have in your document.

PAGES

Any page in QuarkXPress can:

▲ Be a conventional size, such as letter or legal size, or it can be a custom size page.

▲ Be positioned vertically (portrait orientation) or horizontally (landscape orientation).

▲ Contain margins of any width.

▲ Be divided into columns.

Figure 1.12 displays the New Document dialog box and the page created based on the options selected. The Facing Pages and Automatic Text Box options are discussed later.

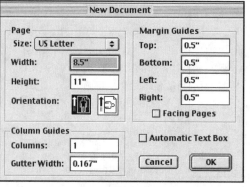

Figure 1.12. The New Document dialog box is where you select options about the pages in a document.

Once you click OK in the New Document dialog box, you've created a QuarkXPress document or file. You can enter and/or flow text, add rules and graphics, change the number of columns—do any of a thousand things with the document—but the most important thing to do is to save it. Figure 1.13 displays a typical QuarkXPress page.

Figure 1.13. This document was created with three columns. When you first create a document, the menu appears across the top of the page, the horizontal and vertical rulers display, and the Tool palette appears on the page.

MARGIN AND COLUMN GUIDES

Margin guides are nonprinting guidelines that separate the text and graphics area from the rest of the page. Column guides are also nonprinting lines that separate a multi-column page. Text normally flows from one column to another.

Big tip!

In Mac OS, if you have more than one window open, press the Shift key while clicking on any title bar. A drop-down menu lists all the open documents and you can select another document from that menu.

FACING AND NONFACING PAGES

Pages that will be printed on both sides of the paper, as in a book or newsletter, are called *facing pages*. Their icons in the Document Layout palette display a turned corner and appear on either side of a "spine." If you're printing a flier or brochure, don't select this option. By deselecting Facing Pages you create a document where pages flow directly under one another (Figure 1.14).

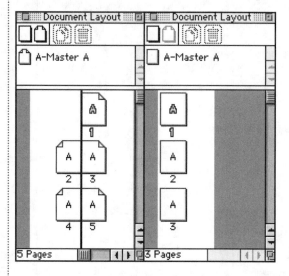

Figure 1.14. The icons in the Document Layout palette (View/Show Document Layout) on the left display turned corners, indicating that the document was created with the Facing Pages options selected. The icons on the right have straight corners, because that document was created without facing pages.

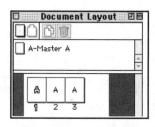

This document contains a three-page spread.

PASTEBOARD

Two areas constitute a QuarkXPress page, the printable area that exists between the page guides and the pasteboard. The pasteboard is the white, nonprinting area that surrounds a page or page spread. Nothing positioned entirely on the pasteboard will print, so you can use it to store items (boxes, lines, groups, and text paths) while you're working on a page. If you're creating a bleed (text or graphics that run off the page), the bleed area will print, but nothing that is entirely on the pasteboard will print (Figure 1.15).

Figure 1.15. The pasteboard is the white area surrounding the two pages. Only the three-column pages will print. The two graphics on the pasteboard will not print.

VIEWING PAGES

There are three ways to view your pages at different levels of magnification:

▲ **Click with the Zoom tool** to enlarge or reduce the document view. *Or*

▲ **Enter a custom percentage in the View Percent field** in the lower left corner of the document page. *Or*

▲ **Select a specified viewing percentage from the View menu.**

ZOOM TOOL

Using the Zoom tool doesn't change the size of text or items, just the view of those elements. The Zoom tool defaults to increasing the magnification level in 25% increments, but you can change this value in the Tool Preferences dialog box. You can access the Zoom tool when another tool is active by pressing the Control key (Macintosh) or Ctrl-Spacebar (Windows). Keep it pressed while zooming in on the page. Each time you click, you increase the view percentage by the Increment amount specified in the Tools Preferences dialog box (Edit/Preferences/Preferences). Pressing the Option key (Macintosh) or the Ctrl-Alt-Spacebar keys (Windows) while clicking with the Zoom tool reduces the view percentages.

VIEW PERCENT FIELD

Drag to select the value in the View Percent field in the lower left corner of the document window. Type any value between 10 and 800 and press the Return/Enter key to change the view percentage. You don't have to type the % sign.

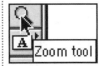

To use the Control or Ctrl-Spacebar keys, Zoom must be selected in the Interactive Preferences dialog box (Edit/Preferences/Preferences/Interactive). Otherwise, the Control key (Mac OS) or Ctrl key (Windows) will display the Contextual Menu.

View Percent field in the lower left corner of the document window

Stack Documents
Tile Documents

When multiple documents are open, you can stack them on top of one another or tile them across the screen. Choose these options from the View/Windows menu.

Hide Tools	F8
Hide Measurements	F9
Hide Document Layout	F10
Show Style Sheets	F11
Hide Colors	F12

Use the View menu or keyboard shortcut to hide and display palettes. In Windows, F4 hides and displays the Document Layout palette.

VIEW MENU

Use the View menu to select specified viewing percentages. Select Fit in Window to scale the view to center and fit the entire page in the document window, regardless of the size of your screen. To fit the largest spread and its pasteboard in the document window, press the Alt/Option key before selecting Fit in Window.

DOCUMENT WINDOWS

On the Macintosh, select Windows under the View menu and choose either Stack Documents or Tile Documents when you have more than one document open. Stack Documents layers multiple documents, displaying only a portion of each document. Tile Documents resizes all open document windows so that equal portions of each document are displayed on the screen. Below these options are listed the names of all the open documents. In Windows 95/98, you can use the Windows menu to select Cascade, Tile Horizontally, or Tile Vertically.

PALETTES

Many of the functions in XPress can be accessed from floating palettes (Figure 1.16). The most important palettes are the Tool palette, Document Layout palette, and the Measurements palette. Other palettes include the Layers, Style Sheets, Colors, Trap Information, Find/Change, Lists, and Web Tools palettes. If you have the avenue.quark xtension installed, the XML palette will display, as will the Index palette if the Index xtension is installed in the XTension folder.

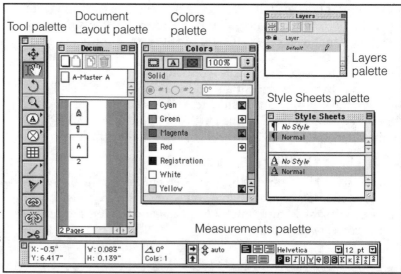

Figure 1.16. QuarkXpress palettes. Use the palette icons to specify what happens to selected objects. Use the palette scroll bars to move through the contents of the palette.

WORKING WITH PALETTES

If a palette isn't displayed when you create or open a document, choose Show [palette] from the View menu. Most palettes can be resized by dragging the Resize Box in the lower right corner. To close a palette, choose Hide [palette] from the View menu or click the Close Box in the upper left corner of the palette (Mac OS) or on the right side of the palette (Windows) (Figure 1.17).

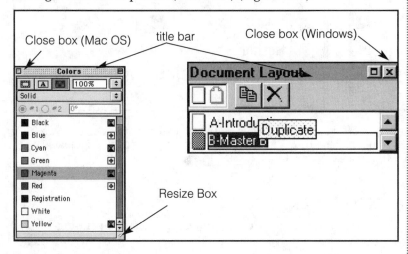

Figure 1.17. Click the Resize box to resize the palette horizontally and vertically. Click the Close box to close the palette. Drag on the title bar to move the palette.

PALETTE ICONS

Most of the palettes contain icons that specify how a palette command is applied. For example, the Colors palette contains three icons, one for the frame (border) of a box, one for text, and one for the background color of the box. If you have a picture box selected that contains a bitmap image, an icon will appear for the color of the picture. You must select the appropriate icon before applying color to an object. If a line is selected, the only icon available is the Line icon (Figure 1.18).

Palette function keys

F8 Tool palette
F9 Measurements palette
F10 Document Layout palette (Macintosh)
F4 Document Layout palette (Windows)
F11 Style Sheets palette
F12 Colors palette

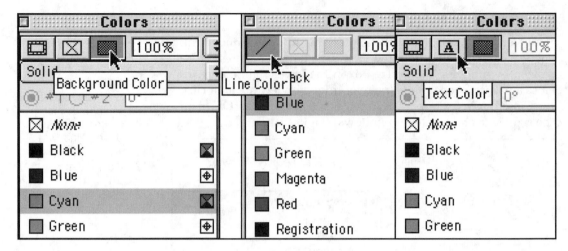

Figure 1.18. The Background Color icon in the Colors palette (left) indicates that the selected cyan color will be applied to the background of the box. The selected Line Color icon (center) indicates that the selected line is a blue line. The Text Color icon (right) is used to apply color to selected text.

PALETTE OPTIONS

Several of the palettes display different objects depending on the type of object you've selected. For example, the Measurements palette displays one set of options for text boxes, another for picture boxes, and another for lines (Figure 1.19).

Figure 1.19. When a picture box is selected, the Measurements palette (top) displays options for modifying the picture box and the picture. When a text box is selected, the Measurements palette (center) displays options for formatting the text box and the text. When a line is selected, the Measurements palette displays line options (bottom).

MOVING AROUND A PAGE

There are several ways to move around the page around without disrupting any of the items on that page:

▲ Use the horizontal and vertical scroll bars on the right and bottom sides of the document window to move up and down on the page.

▲ Click directly in the scroll bar to move up or down in large increments.

▲ Drag the vertical scroll slider up and down or the horizontal scroll slider to the right or left to move the page around.

▲ Click the arrows to move in smaller increments (Figure 1.20).

▲ Make sure the Caps Lock key is off and press the Option key (Macintosh) or Alt key (Windows) to turn the cursor into the Grabber Hand. Keep the modifier key depressed while dragging around the page.

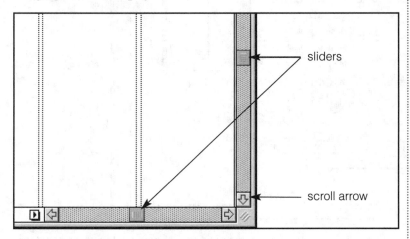

Figure 1.20. Use the slider and scroll bars to move the page around the document window.

1. Create a new document (File/New or **Command-N**/Macintosh or **Ctrl-N**/Windows). In the New Document dialog box, select the Facing Pages option. Type 2 in the columns field. Leave the other options at their default values. Click OK to create the first page of the document (Figure 1.21).

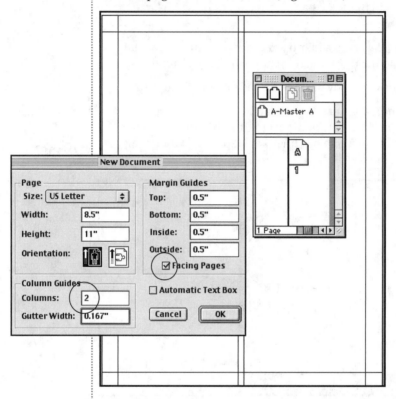

Figure 1.21. The New Document dialog box creates a facing pages document with two columns.

2. Display the Document Layout palette (Window/Show Document Layout or **F10**/Macintosh or **F4**/Windows). Notice that it displays only one facing page icon (a page icon with a curled edge).

3. Display the Measurements palette (Window/Show Measurements or **F9**) and the Colors palette (Window/Show Colors or **F12**). Use the Rectangle Picture Box tool to draw a picture box.

Keep it selected. Notice how its dimensions and position are displayed in the Measurements palette.

4. With the box still selected, click the Background Color icon in the Colors palette and click on a color swatch or on a color's name to fill the box with color.

5. Close this file (File/Close) or **Command-W**/Macintosh or **Ctrl-F4**/Windows). Don't save your changes.

NEW DOCUMENT COMMAND

A new document is created from the File menu (File/New/Document) or by pressing the keyboard shortcut keys, **Command-N** (Macintosh) or **Ctrl-N** (Windows). When you choose File/New/Document, the New Document dialog box appears (Figure 1.22).

When you create a new QuarkXPress document, you make selections that determine what kind of document will be printed. Remember: QuarkXPress documents are designed for printing, not for screen display. If you are going to use your XPress pages on the Internet or on a CD as part of a multimedia program, then select New Web Document from the File menu. Right now, let's think of our XPress documents as destined for a professional printing press.

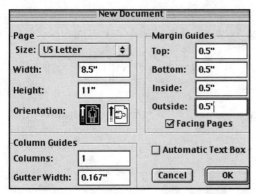

Figure 1.22. The New Document dialog box is where you specify the size and type of pages in the document, margin width, and number of columns. If the document is to be printed on both sides of the paper, select the Facing Pages option. If you will be importing text into the document, select the Automatic Text Box option.

NEW DOCUMENT DIALOG BOX

The New Document dialog box contains four areas:

▲ **Page area,** where you specify page size and orientation. The Page Size is is the size of the paper. Standard 8½" by 11" paper is US Letter size. Select Portrait Orientation to print on the long side of the page. Select Landscape orientation to print on the wide side of the page.

▲ **Margin Guides,** where you specify the width of the margins on the page. Select the Facing Pages check box if this document will be printed on both sides of the page, as with a book or magazine. If you select Facing Pages, the Left and Right margin guides are replaced by Inside and Outside (Figure 1.23). It's always a good idea to make the Inside margin a little wider than the Outside margin to allow for binding when printing a long document. Otherwise, the text may come too close to the binding and be difficult to read.

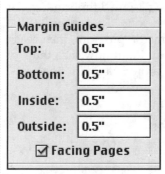

Figure 1.23. When Facing Pages is selected, the Left and Right margins become Inside and Outside.

▲ **Column Guides,** where you specify the number of columns in the document and the distance between multiple columns, called the *gutter*.

▲ Automatic Text Box option, where you can tell XPress to create a text box automatically on the master page of the document and on all subsequent pages based on that master page.

PAGE SIZE

The Page Size option refers to the size of the paper you will be printing on. If you create a document with a specific page size in the New Document dialog box, you can change the page size later, as long as the new page size is large enough to accommodate all the text and graphics elements you have already created. To change the page size, select Document Setup from the File menu and select a new size from the Size pull-down menu. You can also change the Width and Height dimensions for any page size.

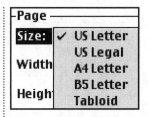

The Size menu lets you select a page (paper) size for the document. A4 and B5 are sizes commonly used in Europe.

AUTOMATIC TEXT BOX OPTION

When you create a new document, two things happen automatically: A single master page called Master Page A is created and a single document page based on that master page is also created. If you add more pages to the document, or if you create text or import text that needs more than one page, those new pages will automatically contain a text box.

A *master page* is a nonprinting page that contains all the items that will appear on document pages based on that master page. For example, a newsletter may contain rules between the columns and the company's logo on every page. Instead of creating all these items on every page in the newsletter, create them only once on the master page and they will appear on every document page based on that master page (Figure 1.24). This means that every newly created QuarkXPress document comes into this world with one master page and one document page.

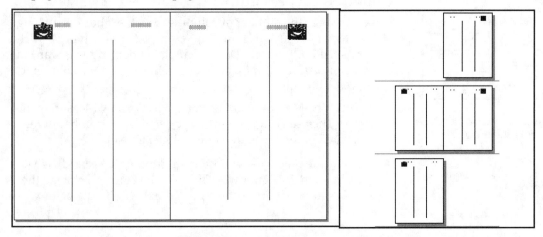

Figure 1.24. A logo and header were placed on the left and right master pages. Rules were also drawn between the columns of the automatic text box. These three items, the logo, header, and rules, then appear on every left and right document page based on that master page.

Specify the number of columns for a new document in the Column Guides field. You can always change the number of columns on any document page or on a master page later on.

Margin Guides

Top: 0.5"

Bottom: 0.5"

Left: 0.5"

Right: 0.5"

☐ Facing Pages

Margin Guides

Top: 0.5"

Bottom: 0.5"

Inside: 0.5"

Outside: 0.5"

☑ Facing Pages

When a check box is empty, the option is disabled. Click inside the box to display the check mark and activate the option.

WHEN TO SELECT THE AUTOMATIC TEXT BOX OPTION

If you're creating a text-intensive document like a book chapter or magazine article, select the Automatic Text Box option. When you select the Automatic Text Box option in the New Document dialog box, you tell XPress to create a text box automatically on that default Master Page A. And because the default document page 1 is based on Master Page A, it will also have a text box. It's a genetic thing. If both parents have black eyes and black hair, the offspring will have black eyes and black hair. Any default document page takes on the characteristics of the default master page.

Furthermore, if you select the Automatic Text Box option, not only will the default document page 1 display a text box, but every new page you insert in the document that is based on that default Master Page A will have an automatic text box. We seldom know how many pages it takes to flow a text file, but with Automatic Text Box selected, if you import or type more text than will fit into the text box on the first page, any pages that XPress adds will automatically contain a text box into which the additional text will flow.

COLUMNS

The New Document dialog box defaults to creating the new document with just one column. You can type any number in the Columns field in the Column Guides area of the dialog box to set the number of columns for the automatic text box that appears on Master Page A and on document page 1.

CHANGING COLUMN GUIDES

You can change the number of columns of any text box on any page of the document at any time. For example, if you type 4 in the Columns field of the New Document dialog box and you want the text box on page 10 of the document to have only one column, do one of the following:

▲ Display the Measurements palette (View/Show Measurements or **F9**). Then select a text box and type the new number in the Cols field of the Measurements palette. *Or*

▲ Select the text box and choose Item/Modify (**Command-M**/Macintosh or **Ctrl-M**/Windows). Click the Text tab and change the number in the Columns field of the Text Modify dialog box.

Whenever you change the number of columns of a selected text box (a text box must be selected before you can do anything with it), that new column number is displayed in both the Text Modify dialog box and in the Measurements palette.

FACING PAGES

The Facing Pages option is selected when you will be printing the document on both sides of the paper, such as for a book or magazine. Deselect this option if you will be printing on only one side of the paper, such as for a flyer or product label. You can change a document from non-facing pages to facing pages in the Document Setup dialog box (File/Document Setup), but you cannot change a facing-pages document to a nonfacing-pages document.

REVIEW PROJECT

1. Create a new document. Choose File/New/Document to display the New Document dialog box (**Command-N**/Macintosh or **Ctrl-N**/Windows).

2. Choose US Letter, Portrait orientation, 3 columns, and one-inch margins (1"). If your preferences are set to inches, you don't have to type the inch mark. Deselect Facing Pages so that its option box is empty. If there is a check mark, click inside the box to remove the check mark and deselect the option. Make sure that Automatic Text Box is selected. If its option box is empty, click inside the box to display the check mark and select the option. Click on OK (Figure 1.25).

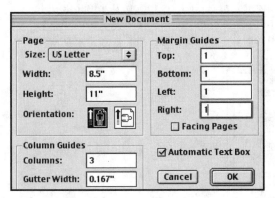

Where text comes from

Text can be typed directly into a text box or imported from another application such as a word processor, provided the filter for that word processor is present in the Xtension folder in the QuarkXPress folder.

Figure 1.25. This New Document dialog box will create a nonfacing-pages document with one-inch margins and three columns in the automatic text box.

3. Choose View/Show Document Layout (**F10**/Macintosh; **F4**/Windows) to display the Document Layout palette. The palette for this new document displays only two page icons, one for Master Page A in the center panel and another icon for document page 1 in the lower panel (Figure 1.26).

Figure 1.26. The Document Layout palette for a new document displays one master page (A-Master A) and one document page based on Master Page A.

4. Click on the page (document page 1) and notice that the automatic text box appears selected and the I-beam cursor is displayed at the top of the box. The Content tool is also selected. Whenever the I-beam cursor appears, you know you're in a selected text box and anything you type will appear inside the box. Type *Headline* and press the Return/Enter key.

5. Double-click on *Headline* to highlight the word. Then choose Style/Size/36 to make the type larger.

6. With the text box still selected (the eight handles appear around the four sides of the box), and the Content tool selected, choose File/Get Text (**Command-E**/Macintosh or **Ctrl-E**/Windows). Navigate to the Unit 01 folder in the Student Files folder on the CD-ROM. Open this folder and locate the file named *Atext.txt*. Click on it to highlight it and click on Open. (Or just double-click on the file's name to open the file.) It flows into the selected text box beneath the Headline text from one column to the next (Figure 1.27).

Figure 1.27. Text is imported into the selected text box.

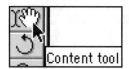
Content tool

Style menu

You can select type attributes (typeface, type size, etc.) from either the Style menu or from the Measurements palette.

7. With the text box still selected, choose Item/Modify (**Command-M**/Macintosh or **Ctrl-M**/Windows) and click on the Text tab. Type 2 in the Columns field and click on OK (Figure 1.28).

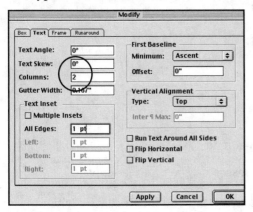

Figure 1.28. You can change the number of columns on any page at any time.

8. Notice that now the text flows into the two columns even though the margin guides for a three-column page still appear (Figure 1.29). You can only change the margin guides for the entire document from the master page.

Figure 1.29. When you change the number of columns in a text box, the original column guides still appear.

9. Double-click on the A-Master A icon in the Document Layout palette to get to the master page. Choose Page/Master Guides and type 2 in the Columns field of the Master Guides dialog box (Figure 1.30). Click OK.

When Automatic isn't automatic

If you turn off Auto Page Insertion in the General Preferences dialog box (Edit/Preferences/Preferences/General), XPress won't automatically add new pages when the text overflow occurs. This is a good feature to activate when you're creating documents with a specific page count such as a four-page newsletter. Not adding pages automatically forces you to edit the text and graphics to fit the limited number of pages.

Figure 1.30. Change column guides in the Master Guides dialog box. This dialog box is accessed only from the master page.

10. Double-click on document page 1 in the Document Layout palette to return to the document page and notice that the margin guides have been realigned to match the two-column text box (Figure 1.31). Your Document Layout palette may also display two document pages, even though page 2 is probably empty. Sometimes Quark thinks it needs another page to hold the overflow text.

Figure 1.31. Once the column guides are changed in the Master Guides dialog box, they appear that way on the document page.

11. Close this file (File/Close or **Command-W**/Macintosh or **Ctrl-F4**/Windows). Save your changes.

Unit 2
Formatting Text

OVERVIEW

In this unit you will learn how to:

Import, enter, select, and format text
Format text from the Measurements palette
Edit text
Clear text
Use the Text Modify dialog box
Change text box shapes
Export text
Show and hide Invisibles
Assign paragraph formatting
Print a document
Use the Colors palette
Make boxes transparent
Create contentless boxes

TERMS

absolute leading
Auto leading
baseline
Clear
contentless box
Copy
Cut
filters
greeking
leading
orientation
PostScript Printer Description
story
Undo
unit of measure

LESSON 1: WORKING WITH TEXT

IMPORTING TEXT

Because QuarkXPress is primarily a page layout program, one that marries text to graphics, getting the text into XPress is an important task. All text in XPress, whether it's imported from a text file, copied and pasted from another document, or typed directly into an XPress document, must be typed in a text box, imported into a text box, or typed on a text path. You can't have text floating around a page as you might in an illustration program. Text in XPress can only live in a text box or on a text path. To import text into a selected text box, choose File/Get Text and navigate to a text file or to a word processor file. XPress ships with filters for the most popular word processors. Drag the appropriate filters to the XTension folder before launching XPress and you'll be able to import files from those word processors. You can also import ASCII text files directly into a selected text box.

Name
MS-Word 6-2000
WordPerfect Filter
XPress Tags Filter

Some of the Macintosh word processor filters that ship with QuarkXPress 5.0. Similar filters ship with the Windows version.

ENTERING TEXT

Once you create any kind of text box or text path, you use the Content tool to type the text inside the box or on the text path. It usually appears formatted in 12-point Helvetica or Arial type, but you can apply your own formatting to any text character by selecting the text and making selections from either the Style menu or the Measurements palette.

SELECTING TEXT

To apply any kind of formatting to text, it must first be selected (highlighted). There are three ways to select text areas:

▲ Select a **single word** by double-clicking on the word.

▲ Select a **single line** by triple-clicking on the line of text.

▲ Select all the characters in a **paragraph** by quadruple-clicking on the paragraph.

You can also drag to select a single text character or a range of text. And you can Shift-select text by placing the insertion point (I-beam) where you want the selection to start, pressing the Shift key and clicking where you want the text selection to end. All the text between the insertion point and the last mouse click will be selected.

FORMATTING TEXT

Once you've selected the text you want to format, use either the Style menu or the Measurements palette to make formatting choices. You can apply a typeface (font), type size, color, and/or horizontal or vertical scale to text. You can also change its position on the baseline and its alignment. Later on you'll learn how to apply multiple formatting commands to text with one click or keystroke using style sheets.

Although XPress includes a Type Style option under the Style menu and styles in the Measurements palette, there are several you should never use. These include the Bold, Italic, Underline, Outline, and Shadow styles (Figure 2.1). When you select these type styles, the printer creates them, and rather poorly at that. Instead, use the bold and italic fonts that come with the font family. For example, instead of choosing Italic from the Style menu or clicking the I button on the Measurements palette to create italicized type for Times, use Times Italic.

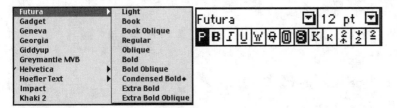

Figure 2.1. The type styles available from the Style menu and on the Measurements palette—they're the same—should not be used, because they force the printer to create the style and no one ever said a printer is a typesetter.

FORMATTING TEXT FROM THE MEASUREMENTS PALETTE

An easy way to apply many specifications to text is to use the Measurements palette (Figure 2.2). Press **F9** to display and hide the Measurements palette. You can also click in the Close box of the palette to hide it. If the palette appears empty, that's because nothing is selected and there are no measurements to display. When a text box is selected and the Measurements palette is displayed, all the values to the left of the center line apply to the text box. All the values to the right of the line apply to the text.

Greeked text

Text displays as gray bars for faster screen redraw. Greeking affects only display, not output.

No italic typeface?

If the typeface you've chosen doesn't have a bold or italic (sometimes called *oblique*) type style, choose another typeface rather than selecting Bold or Italic from the Style menu.

Speed demon!

Press the Tab key to move from one field to another in the Measurements palette. The new field is highlighted and ready for you to enter new values without having to manually delete the original values.

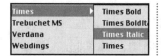

Times	▶	Times Bold
Trebuchet MS		Times BoldIt
Verdana		Times Italic
Webdings		Times

Always use the style of a particular font instead of applying the style from the Style menu or Measurements palette.

leading arrows

Flipping arrows, leading arrows, and kerning/tracking arrows on the Measurements palette

Paragraph alignment icons on the Measurements palette

Select a unit of measure in the Measurements Preferences dialog box.

Rectangle Text Box tool

☐ X: 1"	W: 6.5"	△ 0°	➡ ⬍ auto	☰☷☰ Times	▽ 14 pt ▽
Y: 1"	H: 9"	Cols: 2	⬆ ⬌ 0	☰☰ P B I U W ⊕ ⊘ 8 K K ⬆⬇	

Figure 2.2. The Measurements palette for a selected text box

It's important to remember that when you type values in the Measurements palette, you must press the Return/Enter key to execute the command. Or, press the Tab key to get to the next field in the Measurements palette. Or, click on the Document page. If you don't do either of these or press the Return/Enter key, nothing will happen to your selection.

The Measurements palette provides seven options for formatting text:

1. **Flipping arrows** flip the text—not the text box— in the text box horizontally and vertically.

2. **Leading arrows** increase and decrease leading. *Leading* is the vertical space between lines of type.

3. **Kerning** and **Tracking** arrows increase or decrease space between text characters.

4. **Paragraph alignment** icons.

5. **Font** menu.

6. **Type size** menu.

7. **Type styles** icons.

EXERCISE A

1. In this exercise you will create a business card. Create a new document (File/New [**Command-N**/Macintosh or **Ctrl-N**/Windows] with one-inch margins and one column. You don't want facing pages and you don't want an automatic text box. Display the Measurements palette (View/Show Measurements or **F9**).

2. Use the Rectangle Text Box tool and draw a small text box. Look at the values in the Measurements palette. If the W(idth) and H(eight) values are displayed as inches (Figure 2.3), go to the next step. If they're displayed in picas or in another unit of measure, choose Edit/Preferences/Preferences. Select Measurements from the list on the left side of the dialog box and use the Horizontal Measurements and Vertical Measurements menus to select inches. Click OK to return to the document.

| X : 1" | W : 3" | X : 3p | W : 45p |
| Y : 2" | H : 2" | Y : 3p | H : 60p |

Figure 2.3. The Measurements palette on the left displays values in inches. The one on the right displays the same values in picas.

3. Double-click to select the W(idth) value and type 3.5. Press the Tab key to automatically highlight the H(eight) value and type 2. Press Return/Enter to execute the command and resize the text box.

4. The I-beam appears in the text box. Type your name and press the Return/Enter key. Type your address, pressing the Return/Enter key after the street and city/state line. Type your telephone and fax numbers, pressing the Return/Enter key after each. Type your e-mail address if you have one. Don't press the Return/Enter key after the last line.

5. Triple-click to select the first line of text, your name. To format the text, do one of the following:

 ▲ Choose Style/Font and select a bold typeface. *Or,*

 ▲ Use the typeface menu on the Measurements palette to select a font.

6. With the first line still selected, choose Style/Type Style/Small Caps (**Command Shift-H**/Macintosh or **Ctrl-Shift-H** windows) or press the small **k** in the type styles bar on the Measurements palette. Then choose Style/Size/14 pt or choose 14 pt from the Size menu on the Measurements palette. Regardless of where you make your selection, the option is displayed in the Measurements palette.

7. Triple-click on the second line and format it in the same typeface as the first line, but in the roman (plain) version. Use the Measurements palette to set the size at 10 points. Repeat this process until all the lines are formatted.

☑ **Drag and Drop Text**

Select the Drag and Drop Text option in the Interactive Preferences dialog box to drag selected text from one place in the document to another. Pressing the Shift key as you drag creates a duplicate of the dragged text. As with all modifier keys, release the mouse button, *then* release the Shift key. Be careful when using this feature, as you can end up dragging text when you just want to select a range of text by dragging across the text.

Small caps

THESE ARE SMALL CAPS. CREATE SMALL CAPS BY SELECTING THE TEXT AND:

▲ CLICKING THE SMALL CAPS ICON IN THE MEASUREMENTS PALETTE. *OR,*

▲ CHOOSING STYLE/TYPE STYLE/SMALL CAPS. *OR,*

▲ PRESSING COMMAND-SHIFT-H/MACINTOSH OR CTRL-SHIFT-H/WINDOWS.

THESE ARE REGULAR CAPS.

Up Leading arrow

8. Drag to select at least part of every line except the first line. Click the Up Leading arrow in the Measurements palette to increase the leading (space between the lines) until the text fits in the box. Click the Centered icon on the Measurements palette to center the text in the box (Figure 2.4).

9. Close the file (File/Close or **Command-W**/Macintosh or **Ctrl-F4**/Windows). Don't save your changes.

JONATHAN MONTGOMERY

32 Linwood Plaza

Irvington, TX 12345

Tel: 713-123-4567

Fax 713-123-7890

E-mail jmontgomery@bingo.com

Figure 2.4. The card displays formatted text.

EDITING TEXT

You can edit text as you create it by making selections from the Style menu before you begin to type or as you are typing. You can also edit text by selecting it and applying format commands to it. It's important to remember that you must select text characters before you can edit them. If, for example, you want to change the font or size of a word, that word must be highlighted (selected). If you find that nothing is happening when you're making selections from the Style menu, that's because you haven't selected any text. If you find yourself typing away and no text appears, that's because you're not typing in a text box.

COPY AND PASTE SELECTIONS

When you copy selected text or items (boxes and lines), they're copied to the Clipboard. The Clipboard is a special area of memory designed to hold anything copied with the Copy command (Edit/Copy) or with the Cut command (Edit/Cut). When you select text or items and choose Edit/Copy, that selection is placed on the Clipboard and remains there until you copy something else with the Copy command. Copying doesn't remove the selection, it just copies it to the Clipboard.

Once a selection is on the Clipboard, it can be pasted anywhere in the document (if it's an item or inside a text box or on a text path if it's a text selection) by choosing the Paste command (Edit/Paste [**Command-V**/Macintosh or **Ctrl-V**/Windows]) and the appropriate tool. The selection remains on the Clipboard after it has been pasted, allowing you to paste it again until something else is copied and overrides the first selection on the Clipboard.

Keyboard shortcuts

Cut: **Command-X**/Macintosh or **Ctrl-X**/Windows
Copy: **Command-C**/Macintosh or **Ctrl-C**/Windows

FYI

Select text and copy and paste it using the Contextual menu. Control-click inside the text box (Mac OS) or right-click (Windows).

1. Choose File/Open (**Command-O**/Macintosh or **Ctrl-O**/Windows). Navigate to the *File.qxd* file in the Unit 02 folder in the Student Files folder on the CD-ROM. Double-click on it to open it. Choose View/Actual Size (**Command-1**/Macintosh or **Ctrl-1**/Windows) to display the document at 100% magnification. You have already used the Style menu to edit the *Headline* text. Now you'll edit the body of the text.

2. Triple-click anywhere in the first line of the body of the text (below *Headline*) to select just that line. Just as double-clicking selects one word, triple-clicking selects one line. Choose Style/Color and drag to select red. The black text becomes red. Choose Edit/Copy (**Command-C**/Macintosh or **Ctrl-C**/Windows) to copy that first line of red text to the Clipboard.

3. Choose Edit/Show Clipboard and notice that the selected red text you copied appears in the Clipboard window. Click in the document's Close box to close it.

4. Click at the beginning of the next paragraph, just before the words *I give Pirrip* and choose Edit/Paste (**Command-V**/Macintosh or **Ctrl-V**/Windows). The red text appears at the beginning of the paragraph.

5. Choose Edit/Undo (**Command-Z**/Macintosh or **Ctrl-Z**/Windows) to undo the Paste command. This removes the red text from the paragraph but keeps it on the Clipboard where it's available for pasting. Choose Edit/Paste (**Command-V**/Macintosh or **Ctrl-V**/Windows) again to paste the red text back in the paragraph or anywhere else you click.

6. Close the file (File/Close or **Command-W**/Macintosh or **Ctrl-F4**/Windows). Don't save your changes.

Undo command

QuarkXPress allows you to undo only one action (sometimes!). That's why it's a good idea to save your file frequently. This way you can revert to the last saved version of the file.

REMOVING TEXT SELECTIONS

There are two ways to remove text: cut it or delete it. Each method removes the text but does something different with it.

CUTTING TEXT

When you cut a text selection, that text is not only removed from the text box, but also placed on the Clipboard. Because it's on the Clipboard, it can be pasted back into the document as long as nothing else is copied to the Clipboard thereafter.

DELETING TEXT

Deleting a selection with the Delete or Backspace key removes selected text from the document but doesn't place it on the Clipboard. This is useful when you want to remove text from the document without overriding what you have on the Clipboard. For example, you may have used the Copy command to copy a name to the Clipboard so you could paste it in different locations in the document. While doing this, you may want to remove a word from a paragraph. If you used the Cut command to remove the word, that word would override the name on the Clipboard. However, if you delete the text, the word is removed without touching anything on the Clipboard. If you use the Edit/Clear (Macintosh) or Edit/Delete (Windows) command, both the text and its text box are removed from the document but not placed on the Clipboard.

Your undoing

To undo almost any action, choose Edit/Undo *before* performing another action like typing or choosing a command from the main menu.

EXERCISE C

1. Create a new file (File/New/Document [**Command-N**/Macintosh or **Ctrl-N**/Windows]) with an automatic text box. Type your name in the text box. Press the Return/Enter key, type the first line of your address, and press the Return/Enter key.

2. Drag to select all the words in your name. Choose Edit/Copy (**Command-C**/Macintosh or **Ctrl-C**/Windows). Click in the line after your address and choose Edit/Paste (**Command-V**/Macintosh or **Ctrl-V**/Windows). Press the Return/Enter key and choose Edit/Paste again.

3. Triple-click in the address line to select the entire line of text. Choose Edit/Cut (**Command-X**/Macintosh or **Ctrl-X**/Windows). Click after the last line of text and choose Edit/Paste (**Command-V**/Macintosh or **Ctrl-V**/Windows). The address line appears because the Cut command places the selection on the Clipboard.

4. Triple-click to select any line of your name. Choose Edit/Clear (**Command-K**/Macintosh) or Edit/Delete (**Ctrl-K**/Windows). Choose Edit/Show Clipboard and notice that the address line is still available on the Clipboard, but your name line is not. The Clear/Delete command removes a selection without placing it on the Clipboard.

5. Continue to use the Copy, Paste, Cut, and Clear/Delete commands until you are comfortable with them. Close this file. Don't save your changes.

TEXT MODIFY DIALOG BOX

You've seen that many text formatting functions are accessed from the Style menu and from the Measurements palette when a text box is selected. You can also format text from the Text Modify dialog box (Figure 2.5). In fact, you have even more options there than from the menu or palette.

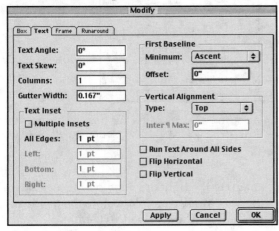

Figure 2.5. The Text Modify dialog box contains fields for formatting text within the text box.

On the left side of the dialog box:

▲ Change the **angle of the text** without rotating the text box itself.

▲ **Skew (slant) the text** without skewing the text box itself.

▲ Change the **number of columns and gutter width** between those columns.

▲ **Inset the text at different values** around all the sides of the text box.

On the right side of the dialog box, specify:

▲ The **first baseline** in the text box. This value determines how far down the first line sits from the top of the text box.

▲ **Vertical alignment,** which runs from the top to the bottom of the text box (as opposed to paragraph alignment, which runs the text from the left side of the text box to the right side of the box).

▲ **Runaround,** or how the text runs around an item such as a picture box, picture, or clipping path.

▲ **Flipping text** horizontally or vertically.

TEXT ANGLE

You can rotate the text without rotating the box itself. Type a value in the Text Angle field and click the Apply button to see the rotated text (Figure 2.6).

Figure 2.6. Text is inset 4 points on all sides of the text box (Text Inset) and rotated 45° from the Text Angle field in the Text Modify dialog box.

TEXT SKEW

Text can be skewed (slanted) to the right or left by typing a value in the Text Skew field of the Text Modify box. To restore the text to its original position, change the Text Skew value to 0 (zero).

TEXT INSET

When you select a text box and choose Item/Modify, click on the Text tab to get to the Text Inset field. Text defaults to being inset from all the sides of a text box by one point. If you want to change this value—to give your text more white space on all four sides, for example—increase the value in the Text Offset field. Just remember that the Text Offset value applies the space to all sides of the text box, not just to the top and bottom or left and right sides of the box. To apply different inset values, select the Multiple Insets option in the Text Modify dialog box.

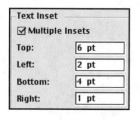

Check the Multiple Insets option in the Text Modify dialog box to inset the text in a selected text box with different values around the sides of the box.

FIRST BASELINE

Ordinarily, text starts at the top of the text box with the baseline established at the point needed to fit the line of type. The baseline is an invisible horizontal line on which type sits. You can specify that the type should start further down in the text box than directly at the top by typing a value in the Offset field. XPress will add this value to any Text Inset value when positioning the text. The Minimum menu specifies that the first baseline will start at the largest Cap Height, Cap + Accent (mark), or Ascent (the top of the highest letter in the line (Figure 2.7).

Use the Text Modify dialog box to drop the first line of text 2 picas from the top of the text box.

Figure 2.7. Set the First Baseline value to 1" in the Text Modify dialog box to start the text flow 1" from the top of the text box.

Changing the First Baseline value is the appropriate way to drop text in a text box. *Never*—and this means never—use the paragraph return to drop text. Paragraph returns carry all kinds of typographic baggage with them that can throw off a document and make it difficult to troubleshoot.

VERTICAL ALIGNMENT

Paragraph alignment defines the relationship of type in a paragraph, whether that paragraph is one line or several lines, to the left and right edges of the text box. Vertical alignment defines the position of the type relative to the top and bottom edges of the text box. Vertical alignment positions the text:

▲ From the first baseline at the top of the text box down into the text box.

▲ Flowing from the center of the box up to the top and down to the bottom of the text box.

▲ At the bottom of the text box flowing up toward the top of the text box.

It also adds enough space to vertically justify the text, that is, spread it evenly from the top to bottom sides of the text box.

Apply Button

You can click the Apply button in a dialog box to see the formatting change in the document. If you don't like what you see, change the values in the dialog box and click the Apply button again. The change doesn't go into effect until you click OK.

To keep the Apply button active, press the Option key (Macintosh) or Alt key (Windows) when you click on the Apply button.

Inter ¶ Max option

This value tells XPress the maximum amount of space it can insert between vertically justified paragraphs to justify them and make them fit from the top to the bottom of the box with equal amounts of space between each paragraph. Leaving the Inter ¶ Max default value at 0" means that if all the vertically justified paragraphs in a text box still do not extend from the top to the bottom of the text box, XPress will override the leading values and insert an equal amount of space between the lines of the paragraph to vertically justify the paragraphs.

Center

Left

Up Leading arrow

EXERCISE D

1. In this exercise you'll create an invitation. Open the *Invite.qxd* file (File/Open [**Command-O**/Macintosh or **Ctrl-O**/Windows]) in the Unit 02 folder in the Student Files folder on the CD-ROM. This document contains two items, a picture box with the flower border and a text box with unformatted text. The text box has a background color of None, which makes it transparent against the flower border.

2. Select the text box and choose Item/Modify (**Command-M**/Macintosh or **Ctrl-M**/Windows). Click the Text tab. Use the Vertical Align menu on the right side of the dialog box to select Bottom. Click on Apply. The text flows from the bottom of the text box to the top of the box.

3. Select Justified from the Vertical Align menu and click on Apply. The text fits vertically between the top and bottom sides of the text box. Click on Cancel to leave the text unchanged and return to the document.

4. With the Content tool selected, click in the text box and choose Edit/Select All (**Command-A**/Macintosh or **Ctrl-A**/Windows) to select all of the text. Choose a font from the Style menu or from the Measurements palette. Select a type size of about 18 points.

5. With the text box still selected, choose Item/Modify (**Command-M**/Macintosh or **Ctrl-M**/Windows) and click the Text tab. Type 72 in the All Edges box of the Text Inset field to inset the text 72 points or 1" from all four sides of the text box. Click the Apply button. This could work, but there's an easier way. Click the Cancel button to leave the text unchanged and return to the document.

6. With all the text still selected, click the Center align icon on the Measurements palette to center the text relative to the left and right sides of the text box. Click the Up Leading arrow on the Measurements palette to increase the leading (space between lines of type) to about 25 points.

7. Select the last two lines, the RSVP text, and click the Left align icon on the Measurements palette to move just those 2 lines to the left side of the text box.

8. Choose Item/Modify (**Command-M**/Macintosh or **Ctrl-M**/Windows) and click on the Text tab. Use the Vertical Alignment menu on the right side of the dialog box to select Centered. Click on Apply and drag the window to view the vertically centered text. Click on OK. The text appears centered between the top and bottom sides of the text box (Figure 2.8).

9. Close this file (File/Close [**Command-W**/Macintosh or **Ctrl-F4**/Windows]). Don't save your changes.

You are cordially invited
to attend a reception
in honor of
Mary Mardany
on the occasion of her
Ninetieth Birthday
Saturday, February 27th, 2001
Two O'clock in the Afternoon
Sloan House
West Terrace Lane
Wndsmouth, NH
RSVP Andrea Warren
321-567-1234

Figure 2.8. The text is formatted, center aligned from the left and right sides of the text box, and vertically aligned from the top and bottom sides of the text box.

TEXT BOX SHAPES

Thus far we have worked with text in text boxes created with the Rectangle Text Box tool. However, XPress has other text box options:

▲ There are seven Text Box tools used to create text boxes of different shapes. Five of these boxes are standard-shape text boxes. There are also two Bézier text boxes. Bézier text boxes have anchor points and direction handles that allow you to reshape the box any way you want.

▲ You can also select a text box and choose a different shape from the Item/Shape menu (Figure 2.9).

Text Box tools

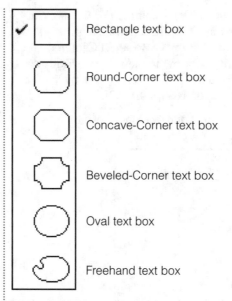

Rectangle text box

Round-Corner text box

Concave-Corner text box

Beveled-Corner text box

Oval text box

Freehand text box

Shape must be selected (Item/Edit/Shape) before you can change a box's shape. It's selected by default.

Figure 2.9. Choose a different shape for a selected text box from the Item/Shape menu.

EXERCISE E

1. Create a new document (File/New Document [**Command-N**/Macintosh or **Ctrl-N**/Windows]) without an automatic text box. Use the Rectangle Text Box tool to create a text box on the page, about 2" wide and 3" high.

2. Type a few lines of text in the box. With the box still selected and either the Content tool or Item tool active, choose Item/Shape to display the different box shapes. Drag to select another shape and release the mouse. Notice how the box changes its shape and the text flows within the new contours of the box.

3. With the box still selected (you can't activate the Shape menu unless a box is selected), use the Item/Shape menu to select another box shape.

4. Choose Item/Shape again and select the rectangle box, the first one in the list, to restore the box to its original shape.

5. Continue to reshape and restore the text box until you're comfortable with the process.

6. Close the file (File/Close [**Command-W**/Macintosh or **Ctrl-F4**/Windows]). Don't save your changes.

Rectangle Text Box tool

TEXT FROM WORD PROCESSORS

Most of the time, text imported into a QuarkXPress text box will come from a word processor. If you're importing text from Microsoft Word, Quark will read and import any style sheets used in the Word document, as well as convert the inch-mark quotes (") to curly quotes (") if you select those options in the Get Text dialog box. In most cases, the text imported from word processors will contain the basic formatting (bold, italics, etc.) applied in the word processing application.

IMPORT/EXPORT FILTERS

To import text created in word processing files into QuarkXPress, the correct filter for that word processor must be present in the Xtension folder in the QuarkXPress 5.0 folder on the hard drive. For example, if you want to import a Microsoft Word file into an XPress document, the MS Word xtension must be in the Xtension folder. If it isn't, drag the MS Word filter from the XTension disabled folder in the QuarkXPress 5.0 folder into the XTension folder. You must relaunch QuarkXPress for the filter to be recognized by the program. Likewise, using the Save Text command, you can export text from XPress in formats that can be read by most word processors.

XTENSIONS MANAGER

QuarkXPress 5.0 includes an XTensions Manager (Utilities/XTensions Manager) that lets you create sets of different xtensions for different kinds of work. For example, you can select all the word processing filters you use, click the Save As button and save them as a set of filters. Then use the Set pull-down menu to select the set of xtensions you want to use for a particular project. Any changes you make in the XTensions Manager dialog box take effect the next time you launch XPress.

EXPORTING TEXT

Any text imported into or created in XPress can be exported as a text file in one of three formats. The Save Text command lets you export either selected text in the XPress document or the entire story as an ASCII text file, as a Microsoft Word file, or as text with XPress tags. Text exported in the ASCII format can be opened as raw text in many word processing, page layout, and graphic appli-

The XTensions Manager is available under the Utilities menu. Use it to turn XTensions on and off and to create sets of frequently used XTensions.

Story time

A *story* is text in a linked chain of text boxes. Every new word processing file you import is a new story.

cations, and then formatted in those applications. If you have applied paragraph styles to the text in XPress and export it in Microsoft Word format, Microsoft Word will read those styles and keep them with the Microsoft Word document.

XPRESS TAGS

QuarkXPress lets you import and export text in the ASCII format. If you have the XPress Tags filter loaded in the XTension folder *before* launching QuarkXPress, you can export text in the XPress Tags format. This format lets you embed the codes XPress uses to display character and paragraph attribute information in the ASCII file when you export it. Any text exported in the XPress Tags format can be imported into an active text box in XPress. Check the Include Style Sheets option in the Get Text dialog box to translate the XPress Tags codes to character and paragraph attributes.

EXERCISE F

1. Create a new document with an automatic text box (File/ New/Document [**Command-N**/Macintosh or **Ctrl-N**/Windows]). Click inside the text box on page 1 and choose File/Get Text (**Command-E**/Macintosh or **Ctrl-E**/Windows). Double-click on the *Sample.txt* file in the Unit 02 folder in the Student Files folder on the CD-ROM to import the text.

2. Choose File/Save Text (**Command-Option-E**/Macintosh or **Ctrl-Alt-E**/Windows). Navigate to your Projects folder. Type *Export.txt* in the Save text as field (Macintosh) or in the Save as type field (Windows). Use the Format pull-down menu to select ASCII or a Microsoft Word format. Click on Save.

3. Close this file (File/Close [**Command-W**/Macintosh or **Ctrl-W**/Windows]). Don't save your changes. If you have Microsoft Word on your hard drive, launch it and use the File/Open command to open the *Export.txt* file in Microsoft Word.

INVISIBLES

While you're typing, XPress places the following invisible code marks in your text:

▲ A **raised dot** indicates that you pressed the Spacebar.

▲ A **right-pointing arrow** indicates that you pressed the Tab key.

Hide Guides	F7
Show Baseline Grid	⌥F7
✓ Snap to Guides	⇧F7
Hide Rulers	⌘R
Show Invisibles	⌘I
Hide Visual Indicators	

These·are→ invisibles.¶

Use these options under the View menu to hide and display guides and rulers. Show and hide Invisibles, the invisible text codes XPress inserts when you type. The dot between the words indicates the Spacebar was pressed; the arrow, that the Tab key was pressed, and the ¶ mark that the Return/Enter key was pressed at the end of a paragraph.

▲ The **¶ mark** indicates that you pressed the Return/Enter key at the end of the paragraph.

▲ The **down-arrow mark** indicates that you pressed the Enter key on the numeric keypad to create the New Column mark.

▲ A **left-pointing arrow** indicates a New Line Marker created by pressing Shift-Return.

You can display these code marks, called Invisibles (Figure 2.10), by choosing View/Show Invisibles (**Command-I**/Macintosh or **Ctrl-I**/Windows). Choosing View/Hide Invisibles hides the code marks. It's always a good idea to display Invisibles when working with text. Sometimes a tab stop, an extra paragraph return, or an extra space between words is the reason your text isn't formatting properly and you'll be able to instantly assess and correct the problem.

Space, tab→ ¶

The dot, arrow, and ¶ are Invisibles.

Invisibles ¶

▲→This·dot·between·the·words·indicates·that·the·
Spacebar·was·pressed.

▲ The·vertical·dotted·line·before·the·first·character·
of·each·paragraph·moves·all·the·subsequent·
lines·in·the·paragraph·under·that·dotted·line.

▲→A·right-pointing·arrow→indicates·that·the·Tab·key·
was·pressed.

▲→The·paragraph·mark·appears·every·time·you·
press·the·Return/Enter·key¶

▲→The·New·Line·Marker·indicates·that·you·pressed·
Shift-Return·to·move·a·line·down·but·keep·it·con-
nected·to·its·original·paragraph↵
This·is·the·next·(new)·line·in·the·paragraph.

▲→The·down-pointing·arrow·indicates·that·you·
pressed·the·Enter·key·on·the·numeric·keypad·to·
move·subsequent·text·to·the·next·column·or·to·
the·next·text·box↓

Figure 2.10. Invisibles are non-printing marks that appear when you format text.

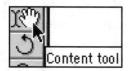

1. Create a new, nonfacing-pages document without an automatic text box (File/New/Document [**Command-N**/Macintosh or **Ctrl-N**/Windows]). Display the Measurements palette (View/Show Measurements or **F9**). Make sure inches is the unit of measure (Edit/Preferences/Preferences [**Command-Y**/Macintosh or **Ctrl-Y**/Windows]).

2. Use the Rectangle Text Box tool to draw a text box by clicking and dragging on the page. Use the Measurements palette and type 2 in the W(idth) field; press the Tab key and type 3 in the H(eight) field. Press Return/Enter to resize the selected text box. Make sure the Content tool is selected.

3. Notice the I-beam cursor at the top of the text box. This tells you that you can start typing at this point. Type *This is a text box.* Press the Return/Enter key.

4. Choose View/Show Invisibles (**Command-I**/Macintosh or **Ctrl-I**/Windows). Select the Zoom tool and click twice on the text you just typed to magnify your view to 150%. Notice the ¶ mark at the end of the paragraph, indicating that you pressed the Return/Enter key to end the paragraph. Also notice the raised dots between each word that indicate where the Spacebar was pressed (Figure 2.11).

Do it this way!

Always quadruple-click to select a paragraph instead of dragging. Quadruple-clicking selects the entire paragraph, even text hidden by the Overflow Indicator.

This·is·a·text·box.¶

Figure 2.11. The raised dots (they're higher than the period dot) indicate that the Spacebar was pressed, and the ¶ indicates that the Return/Enter key was pressed to end the paragraph.

5. Select the Content tool. Double-click on the word *This*. Use the Style menu or the Measurements palette to select a font and a type size to format the single word.

6. Click below the line of type and choose File/Get Text (**Command-E**/Macintosh or **Ctrl-E**/Windows). Because you have a text box selected and the Content tool active, the Get Text command is available. Navigate to the Unit 02 folder in the Student Files folder on the CD-ROM and click on Open. Double-click on the file named *Sample.txt.* to import the text into the selected text box. It appears in the same font and type size as the last word in the previous paragraph. That's because the ¶ mark carries that information with it. Notice the box with an X in the lower right corner of the text box. This is called the Overflow Indicator and tells you that you imported more text than will fit in the text box.

7. Triple-click anywhere in the first line of the imported text. Use the Measurements palette or the Style menu to format the selected text in a different font and a smaller type size.

8. Quadruple-click anywhere in the paragraph of the imported text to select the entire paragraph and notice that the Font and Size fields on the Measurements palette are blank (Figure 2.12). This is because you have selected type with more than one font and in more than one size.

Important info

Macintosh users cannot press the Enter key to end a paragraph, only the Return key. Windows users must press the Enter key on the keyboard, not the Enter key on the numeric keypad.

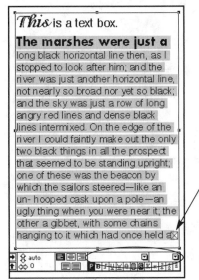

Overflow Indicator

Figure 2.12. The blank Font and Size fields in the Measurements palette indicate that more than one typeface and type size have been selected.

9. With all the text still selected, choose another font from the Font menu and a font size from the Size menu. The font size should be small enough to allow all the text to fit in the box, causing the Overflow Indicator to disappear.

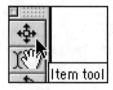

Item tool

The five paragraph alignment icons on the Measurements palette: Left align, Center align, and Right align on top; Justify and Force Justify below.

10. With the text box still selected, click on the Item tool to select it and press the Delete key (Macintosh) or Backspace key (Windows) to delete the text box. Because you are deleting an item (the text box) and not its contents (text), you must use the Item tool. Choose Edit/Undo (**Command-Z**/Macintosh or **Ctrl-Z**/Windows) to restore the deleted text box.

11. Close this file (File/Close [**Command-W**/Macintosh or **Ctrl-F4**/Windows]). Don't save your changes.

PARAGRAPH ALIGNMENT

Paragraph alignment defines the relation of type in a paragraph to the left and right sides of the text box (Figure 2.13). Type can be left aligned, right aligned, centered, justified, or force justified. Again, because paragraph alignment is a paragraph-level attribute, it applies to the entire paragraph and not to individual characters or lines in a paragraph.

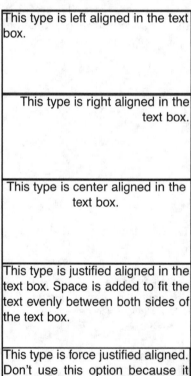

Figure 2.13. Click anywhere in the paragraph to select it and click one of the paragraph alignment icons on the Measurements palette to align the text between the left and right sides of the text box.

INDENT HERE COMMAND

To indent part of the paragraph under any text character in the paragraph, use the Indent Here command. This inserts an invisible vertical line under which all subsequent text in the paragraph is aligned (Figure 2.14). To insert the Indent Here marker, press **Command-** (backslash) on the Macintosh or **Ctrl-** in Windows. To remove the Indent Here marker, place the cursor immediately after the marker and press the Delete/Backspace key.

Because the Indent Here marker is an invisible, you won't be able to see it unless you turn invisibles on (View/Show Invisibles).

<table>
<tr>
<td>Facts: I can cater to only one person per day. Today is not your day. Tomorrow doesn't look too good either.</td>
<td>Facts: I can cater to only one person per day. Today is not your day. Tomorrow doesn't look too good either.

Indent Here marker</td>
</tr>
</table>

Figure 2.14. The Indent Here command moves all subsequent lines under the invisible vertical marker.

To hang a dropped character to the left of a paragraph, enter the Indent Here command: **Command-** [backslash] (Macintosh) or **Ctrl-** [backslash] (Windows) after the last drop character.

LINE SPACING (LEADING)

In a word processing program you have options to single-space, double-space, or triple-space a line. In typesetting, this vertical space between lines of type is called *leading* and is set in points.

In the old days (a few years ago), typesetters used bars of different widths of hot lead to separate lines of type, which is why the vertical space between lines of type is called *leading* (pronounced "ledding"). Leading is the distance measured in points from the baseline of one line of type to the baseline of the line of type above or below it. The more leading between lines, the more elegant and open the type looks. Less leading creates a crowded, jumbled look, but is often used to produce interesting type effects. When designers and editors say something like, "Make it 10 on 12," they are specifying 10-point type with 12 points of leading.

Thus far we have been talking about character-level attributes—typeface and type size. A paragraph can have any number of typefaces at different type sizes, but it can have only one leading value. This is because leading is not a character-level attribute, but a paragraph-level attribute. And unlike specifying character-level attributes, where you must select every text character you want to affect, you need only click anywhere inside a paragraph to select the whole paragraph when specifying paragraph-level attributes.

Use the Leading arrows to increase or decrease paragraph leading.

Leading keyboard shortcuts:

Command-Shift-E/ Macintosh
Ctrl-Shift-E/Windows

SPECIFYING LEADING

There are two places to specify paragraph leading: in the Formats tab of the Paragraph Attributes dialog box and in the Measurements palette. Selecting Formats and Leading from the Style menu displays the Paragraph Attributes dialog box, where you type a value in the Leading field. You can also type a value in the leading field of the Measurements palette. Because this is QuarkXPress, there are also keyboard shortcuts for applying leading.

AUTO LEADING

When you first create a document, the Leading value defaults to Auto, which is always 20% of the largest font size on a given line of type. For example, if the largest font size on a given line is 10 points, the Auto(matic) leading value will become 12 points (10 X .20 = 2; 10 + 2 = 12). The problem with automatic leading is that you have no control over it—it's automatic—so always specify an absolute leading value for your type.

You can change the Auto Leading value in the Paragraph Preferences dialog box (Edit/Preferences/Preferences). Auto Leading values will vary in a paragraph depending on the type size of characters in that paragraph. For example, in a paragraph with 11-point type applied to the paragraph and 18-point type applied to individual characters in the same paragraph, the Auto Leading value will apply the percentage value based on the larger type size to those larger characters, thus giving you two different Auto Leading values in the same paragraph (Figure 2.15).

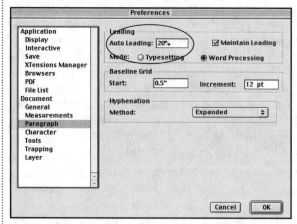

Figure 2.15. Change the Auto Leading value in the Paragraph Preferences dialog box.

ABSOLUTE LEADING

An absolute leading value is a fixed value applied to every line in the paragraph regardless of the type size of any character in that paragraph. Figure 2.16 displays the difference between auto leading and absolute leading.

The use of leading distinguishes the screaming ads of car dealers from the elegant advertisements of stores like Tiffany and Cartier. Lots of leading gives a document an openess, making it inviting to read. Tight leading makes the type scream at you and is often very difficult to read.

The use of leading distinguishes the screaming ads of car dealers from the elegant advertisements of stores like Tiffany and Cartier. Lots of leading gives a document an openess, making it inviting to read. Tight leading makes the type scream at you and is often very difficult to read.

Figure 2.16. The top paragraph is formatted with auto leading, which applies more leading to those lines with the large type characters. The paragraph in the lower box was assigned 22 points of absolute leading, which is applied to every line in the paragraph, regardless of the different type size of any one character.

EXERCISE H

1. Open the *Leading.qxd* file in the Unit 02 folder in the Student Files folder on the CD-ROM. Choose View/Actual Size (**Command-1**/Macintosh or **Ctrl-1**/Windows). Display the Measurements palette (Window/Show Measurements or **F9**). To select the first paragraph, quadruple-click on it. Click on the arrow in the Typeface field on the Measurements palette and drag to select Times Bold (or any other font installed in your system). Click on the arrow in the Size field of the Measurements palette and drag to select 18. Click anywhere to deselect the paragraph.

2. Click once anywhere inside the first paragraph (the one you just formatted), and double-click on auto in the Measurements palette. Type 24 and press Return/Enter. Your type for that paragraph is now 18/24 (18 on 24) or 18 point type on 24 points of leading.

Select a typeface from the Font field of the Measurements palette.

3. Drag to select the first three words of the paragraph. Use the Measurements palette to specify a different typeface and different type size. You don't have to press Return/Enter because you used a menu instead of typing a value.

4. Double-click on 24 in the Leading field of the Measurements palette and type 26. Press Return/Enter. Click on the up arrow in the leading field four times until the leading value measures 30. Your paragraph should resemble Figure 2.17.

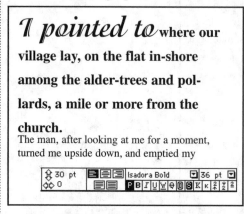

Figure 2.17. Paragraphs with several different leading values

5. With the cursor anywhere in that first paragraph, use the leading arrows to increase and decrease the leading values.

6. Choose Style/Formats (**Command-Shift-F**/Macintosh or **Ctrl-Shift-F**/Windows) to display the Paragraph Attributes dialog box and notice that the leading value displayed in the Leading field of the Measurements palette is also displayed in the Leading field of the Paragraph Attributes dialog box. Type 36 in the Leading field and click on OK. Notice that 36 also appears in the Leading field of the Measurements palette.

7. Choose Style/Leading to display the Paragraph Attributes dialog box and notice that it displays 36 in the Leading field. Click on Cancel. Close this file (File/Close [**Command-W**/Macintosh or **Ctrl-F4**/Windows]). Don't save your changes.

LESSON 3: PRINT DIALOG BOX

PRINTING

Although QuarkXPress 5.0 contains many printing options, most documents require only a few selections to print a document that accurately reflects your text, graphics, and design specifications. You must first specify a printer, then tell XPress which pages you want to print to that printer, in what order, at what size, and how you want the color images printed. You make all these selections from the Print Document dialog box.

SELECTING THE PRINTER

Before you can print a document, you must specify a printer for your computer:

▲ **Macintosh** users pull down the Apple menu on the far left side of the screen and select Chooser. Click on the printer icon for your printer and highlight it in the scroll box on the right to select it. Close the Chooser box.

▲ **Windows** users choose File/Print and specify the printer from the list of available printers in the pull-down menu at the top of the dialog box.

PRINT COMMAND

Once you've turned the printer on, choose the Print command from the File menu. This displays the Print dialog box with seven Options tabs (Figure 2.18). In the Document tab, specify the number of copies you want to print and the range of pages to be printed.

Figure 2.18. The Print dialog box is where you access dialog boxes to specify how your document will print and which pages will print. The default is to print one copy of every page.

Select a Page Sequence in the Print Document dialog box.

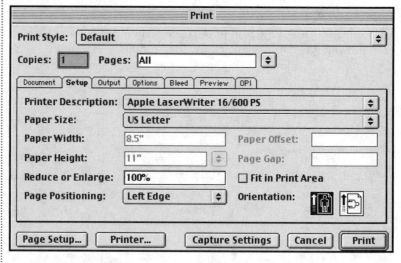

Select the Thumbnails check box in the Print dialog box to print many document pages on one sheet of paper as thumbnails, or icons of the page.

COPIES

The Copies field defaults to 1, but you can change this value to print any number of copies. If you choose to print more than one copy, the Collate check box becomes active. Click this box to collate the pages in all the copies. For example, if you want to print five copies of a three-page document and you select Collate, XPress will print pages 1–3 five times. This makes it convenient for you, but it slows down the printing because each page has to be imaged five times.

PAGE SEQUENCE

If you are printing only odd or even pages in a document, select Odd or Even from the Page Sequence menu. This selection remains in effect for every document you print unless you manually select All to restore printing to both odd and even numbered pages.

SETUP TAB

The options in the Setup tab (Figure 2.19) set up the document and the printer for printing. Here you select a PostScript Printer Description (PPD), make selections about paper size, and choose the way you want the page to print. This is the same dialog box you see when you choose Page Setup from the File menu.

Figure 2.19. The Print dialog box is where you click a different tab to access dialog boxes for making print specifications.

POSTSCRIPT PRINTER DESCRIPTION FILES

Once you've selected your printer, you must give XPress information about it. That information is found in the PostScript Printer Description file (PPD). PPDs are PostScript Printer Description files. Select the appropriate PPD for your printer to ensure that the default information in the Print dialog box matches your output device. You can customize this list of PPDs by selecting PPD Manager from the Utilities menu and clicking on the check mark for any unneeded devices to remove them from the Include field. Click the Update button to execute the command.

Select the PPD that corresponds to your printer.

PAGE OPTIONS

When you select a paper size, its width and height (the physical size of the paper) appear in the appropriate fields (Figure 2.20). If these fields are grayed out, XPress is telling you that the printer takes only one size of paper or that you are printing to a roll-fed device. Unless you change the Page Positioning option, printing will start at the left edge of the paper.

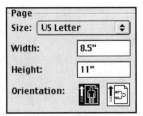

The Width and Height values change to reflect the selected Paper Size option.

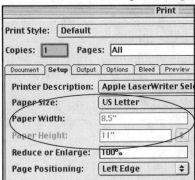

Figure 2.20. The Paper Size selection automatically displays the width and height of the paper.

The page will print exactly as you have prepared it and as it displays in the Actual Size view on the screen unless you change the percentage value in the Reduce or Enlarge field. You can reduce or enlarge a page from 25% to 400%. For example, typing 50% in the Reduce or Enlarge field prints pages at half their actual size.

ORIENTATION

If you select Portrait Orientation in the New Document dialog box, this is the option that is selected in the Setup tab of the Print dialog box. You can click the Landscape icon to change the page orientation from vertical to horizontal.

FIT IN PRINT AREA

This option tells XPress to calculate how much enlargement or reduction is necessary to print the document on the paper size you selected. This value begins printing from the center of the paper outward, so you wouldn't select it unless you were printing over-sized pages.

EXERCISE I

1. Make sure you have specified a printer and that it is turned on. Open the *Print.qxd* document in the Student Files folder in the Unit 02 folder on the CD-ROM. It displays three pages of text with a picture on the first page.

2. Choose File/Print (**Command-P**/Macintosh or **Ctrl-P**/Windows). Click the Setup tab and make sure your printer is selected from the Printer Description menu.

3. Leave Copies set to 1. Type 1-2 in the Pages field (1 hyphen 2) to print only pages 1 and 2 (Figure 2.21). Click the Range Separators button and make sure the Continuous separator is a hyphen. If you want, type 1,3 (1 comma 3) to print only pages 1 and 3. Again, click the Range Separators button and make sure the Noncontinuous character is a comma.

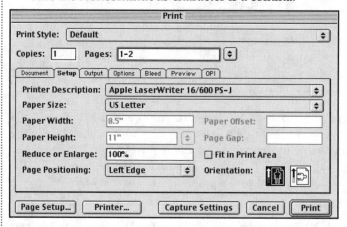

Figure 2.21. Type a hyphen between continuous page numbers in the Print dialog box.

4. Still in the Setup tab, make sure the Portrait Orientation icon is selected. Click Print to print the document.

5. Close this file (File/Close [**Command-W**/Macintosh or **Ctrl-F4**/Windows]). Don't save your changes.

THE COLORS PALETTE

The Colors palette is a floating palette that you can use instead of the menu commands and dialog boxes to apply color to boxes, box frames, lines, and text. Display the Colors palette by choosing View/Show Colors (**F12**). This palette has four panels (Figure 2.22) that are used to perform the following tasks:

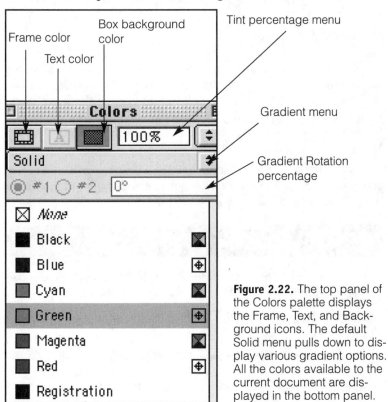

Figure 2.22. The top panel of the Colors palette displays the Frame, Text, and Background icons. The default Solid menu pulls down to display various gradient options. All the colors available to the current document are displayed in the bottom panel.

Colors palette icons

The default Colors palette displays icons for process colors (colors made up of percentages of cyan, magenta, yellow, and black) and for spot colors, custom colors that print on a separate plate.

▲ The top panel contains icons for applying color to a selected box's frame, its text, and its background. When a color is applied, the Shade menu on the right side of the panel is available for selecting a percentage (screen) of that color.

▲ The second panel contains a menu for selecting a type of blend or gradient for two colors. It defaults to Solid, which applies solid color instead of graduated color to a selected item. This panel appears only when the Background Color icon is selected, because only a box can contain a gradient. You can't apply gradients to text characters or to lines.

Process color

Process color, sometimes called color separations, are colors created with percentages of cyan, magenta, yellow, and black. Another name for process color is CMYK color, with the K standing for black. Each process color prints on a separate plate, allowing you to print an unlimited number of colors on only four plates.

▲ The third panel is where you select the two colors used in a gradient fill. Again, this panel appears only when the Background Color icon is selected.

▲ The fourth panel lists all the available colors in a document. It defaults to the RGB colors, the four process colors (cyan, magenta, yellow, and black), white, and a registration color. When you create new colors, they appear in this panel.

APPLYING COLORS

To apply a color, select an item, select its icon in the top panel of the Colors palette, and click on the color's name or swatch. You can also drag a swatch onto a selected box to change the box's background color. To apply a tint of that color, use the Shade menu on the right side of the Colors palette to select a percentage value for that color.

Colors are listed under the Color option in the Style menu. To color an object or text, select the box, line, or text and choose Style/Color. Then use the Shade menu to select a tint of that color.

Spot color

A spot color, sometimes called a custom color, is a single color that prints on its own plate.

EXERCISE J

1. Create a new document without an automatic text box. Choose View/Show Colors (**F12**) to display the Colors palette.

2. Use the Rectangle Text Box tool to draw a rectangle about six inches long.

3. Choose Item/Frame (**Command-B**/Macintosh or **Ctrl-B**/Windows) and in the frame dialog box select 2 from the Width menu and solid from the Style menu. Click OK (Figure 2.23).

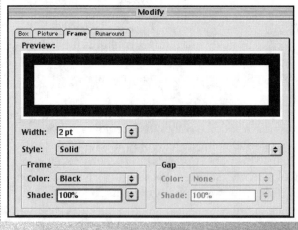

Figure 2.23. Select a Width from the pull-down menu and a style for the box frame (border).

4. Type a few words in the text box. Select the type and format it in a large type size. You may have to resize the box to fit the text.

5. Select the text box and click on the Background Color icon in the Colors palette. Click on any color to color the background of the box.

6. With the box still selected, use the Gradient menu and select Linear Blend (Figure 2.24).

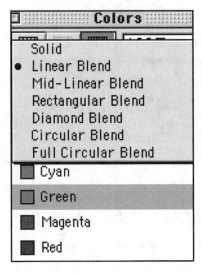

Figure 2.24. Use the Gradient menu to select a blend type.

7. When you select a blend color, the button panel appears on the Colors palette. It displays button #1 and button #2. Next to the buttons is the angle of rotation for the blend. Click on Button #1 and click on a color (Figure 2.25). Use the Percentage menu to select 50%.

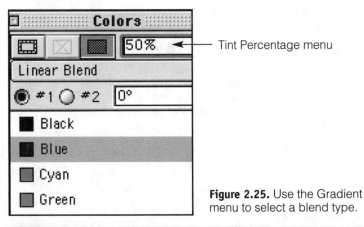

Figure 2.25. Use the Gradient menu to select a blend type.

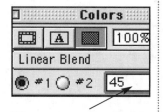

When you create a blend, the Angle field is available for each of the two colors in the blend.

8. Click on button #2 and click on another color. Type 45 in the Angle field to rotate the blend 45 degrees to the right. To rotate the blend to the left, type a negative number in the Angle field.

9. With the box still selected, click on the Frame button in the top panel of the Colors palette. Click on another color in the palette to apply that color to the frame.

10. Click inside the text box with the Content tool and choose Edit/Select All (**Command-A**/Macintosh or **Ctrl-A**/Windows) to select all the text. Click on the Text Color icon in the Colors palette and click on another color in the palette to apply that color to the text. Your screen should resemble Figure 2.26.

Behind every successful man is a surprised mother-in-law.

Figure 2.26. The text box displays a background gradient color, a frame color, and a text color.

ASSIGNING COLORS FROM THE COLORS PALETTE

There are two ways to assign colors to items and text from the Colors palette:

▲ Select the item, click on the appropriate icon in the Colors palette, and click on a color swatch or its name in the palette. *Or*

▲ Select the item, click on the appropriate icon in the Colors palette, and drag the color swatch or its name onto the item (box or line).

MAKING BOXES TRANSPARENT

If you want to make a box (usually a text box) transparent against a colored background or image in a picture box, assign it a background color of None. This affects only the box's background, not its contents.

CONTENTLESS BOXES

Thus far we've seen that the QuarkXPress Tool palette contains various text box tools and picture box tools. A text box contains text and a picture box contains pictures. But sometimes you need a box as a placeholder or as a design element. In that case, change the contents of the box from text or picture to None. You can apply color to the box's background, frame it, reposition and resize it; you just can't fill it with text or a picture. The advantage of using boxes with no content is that you'll never confuse the text flow of the document by inadvertently flowing text in that box or linking text to that box. And this does happen! To create a box with no content, draw any kind of text box or picture box and, keeping the box selected, choose Item/Content/ None.

BOX CONTENTS

You can also use this command (Item/Content) to convert any box from one kind of a box to another kind of box. If you convert a picture box to a text box or to a none box, you'll lose the picture. Likewise, converting a text box to a picture box or to a none box removes the text.

Select Content from the Item menu and drag to select a box content.

REVIEW PROJECT

Figure 2.28 displays a label comprised of several boxes. There's a large background box, a smaller picture box, and four text boxes positioned around the picture box. The text is tracked—that is, space is added between the characters to expand it so it fits between the left and right sides of the text box. Three of the text boxes are rotated around the picture box.

1. To begin, display the Measurements palette (Window/Show Measurements [**F9**]) and the Colors palette (Window/Show Colors [**F12**]). Create one large square for the outer box and a smaller square for the inner box. The outer box can be any kind of box, but because it's only a placeholder for the picture box, assign it a content of None (Item/Content/None).

2. Position the smaller box, the picture box, in front of and in the center of the larger box. Frame the smaller box with a 2-point frame (Item/Frame). Fill both boxes with the same color. Use the Colors palette to create a circular blend for the picture box. If your colors are too dark, use the Tint Percentage menu to reduce the shade (Figure 2.27).

large outer picture box that will be converted to a contentless box

smaller framed picture box

Figure 2.27. Position the two boxes on top of each other and fill the smaller picture box with a circular blend.

When a picture is loaded into a picture box, the Style menu contains options for that graphic.

3. Import a graphic into the smaller box. Click on the smaller picture box with the Content tool to select it. Choose File/Get Picture. Navigate to the Student Files folder in the Unit 02 folder on the CD-ROM. Click on the *Seaside.eps* file to select it and click on Open. When the picture appears in the picture box, choose Style/Fit Picture to Box (Proportionally) (**Command-Option-Shift-F**/Macintosh or **Ctrl-Alt-Shift-F**/Windows).

4. Type one word in a text box that will fit over the smaller box and position it on top of the larger, outer box. Format the type and select it, then click the Text Color icon in the Colors palette and apply a contrasting color. Track the text to spread it out in the text box. To track the type, select all the characters and click the right tracking arrows on the Measurements palette to add space between all the selected text characters.

Select the text and click the right tracking arrow to add space between the characters. Click the left arrow to delete space. Pressing the Option key (Macintosh) or Alt key (Windows) when clicking adds or deletes space in 1-unit increments.

5. Duplicate the small box by selecting it and choosing Item/Duplicate. Position it at the bottom of the larger box. Duplicate the text box again. Rotate it 90° to the right by typing -90 in the Measurements palette or by typing -90 in the Angle field of the Text Modify dialog box (Item/Modify). Position it on the right side of the outer box. Repeat to create another box positioned around the outer box.

Type a negative value in the Box Rotation field of the Measurements palette to rotate the selected object to the right.

Figure 2.28. This label contains several boxes, one of which is framed and one of which contains an EPS graphic. The text in the surrounding text boxes is tracked to fit from the left to the right sides of the text box.

Unit 3
Graphics

OVERVIEW

In this unit you will learn how to:
Create and modify standard-shape picture boxes
Import pictures into a picture box
Understand graphic file formats
Modify pictures
Link pictures
Position, resize, crop, and flip images

TERMS
aspect ratio
Auto Picture Import
bitmap images
EPS
image resolution
linked image
Offset Across/Offset Down
Scale Across/Scale Down
TIFF
vector images

LESSON 1: WORKING WITH PICTURE BOXES

WHY PICTURE BOXES?

Any graphic image (picture) used in a QuarkXPress document must be imported into a selected picture box. This can be a standard-shape picture box or a Bézier box. Either the Content tool or the Item tool must be selected before the Get Picture command is available under the File menu. If you find the Get Picture command is dimmed, that's because

▲ **You haven't selected a picture box** into which you want to import the picture. *Or*

▲ You didn't **select an appropriate tool**.

TYPES OF PICTURE BOXES

QuarkXPress provides two sets of tools for creating picture boxes:

▲ **Standard-shape picture box toolset.** This includes the Rectangle Picture Box tool, the Rounded-Corner Picture Box tool, the Concave-Corner Picture Box tool, the Beveled-Corner Picture Box tool, and the Oval Picture Box tool (Figure 3.1). The tools in the standard-shape set draw boxes with eight resizing handles. Clicking and dragging on these handles makes the box larger or smaller. You can't reshape these boxes, only resize them. To reshape a standard-shape picture box, select it, and choose Item/Shape. Drag to select another box shape.

A picture box always has a black X inside it.

Figure 3.1. The standard-shape picture box tools in QuarkXPress 5.0: Rectangle Picture Box, Concave-Corner Picture Box, and Beveled-Corner Picture Box tools (top); and the Rounded-Corner and Oval picture box tools (below).

▲ **Bézier picture box toolset**. This contains the Freehand Bézier Picture Box tool and the Bézier Picture Box tool (Figure 3.2). Bézier picture boxes contain Bézier points—called *anchor points* in the PostScript illustration world. These boxes can be resized and reshaped without transforming the pictures they contain.

Figure 3.2. The Bézier picture box tools include the Freehand Bézier Picture Box tool (left) and the Bézier Picture Box tool (right).

DRAWING PICTURE BOXES

To draw a picture box, select any picture box tool and click and drag on the page. If you're drawing with any of the rectangle picture tools, press the Shift key to constrain the box to a square. When drawing with the Oval Picture Box tool, press the Shift key to constrain the box to a circle.

MODIFYING PICTURE BOXES

Once a picture box is drawn, it can be edited so that it displays a totally different size, shape, and orientation.

RESIZING PICTURE BOXES

You can resize a picture box by dragging any of the box handles with the Pointer cursor:

▲ Press the Command-Option-Shift keys (Macintosh) or Ctrl-Alt-Shift keys (Windows) to constrain the box's aspect ratio, that is, the height-to-width proportions of the box (Figure 3.3).

▲ Choose Style/Fit Box to Picture.

| X: 1.75" | W: 3.306" | △ 0° |
| Y: 1.528" | H: 0.972" | ∡ 0.25" |

A selected picture box's values are displayed to the left of the divider in the Measurements palette. The values to the right of the divider apply to the picture itself.

Figure 3.3. Resize a picture box by clicking on any of the eight box handles and dragging. A picture box always has a black X going through it.

MEASUREMENTS PALETTE FOR PICTURE BOXES

When a picture box is selected, the Measurements palette displays the attributes of the box on the left side of the palette and the attributes of the picture inside the box on the right side of the palette. The size of the selected picture box is displayed in the W and H fields. As always with values typed in the Measurements palette, you must press the Return/Enter key to execute any typed command (Figure 3.4).

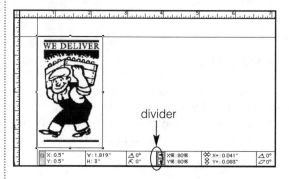

divider

Figure 3.4. When a picture box is selected, the Measurements palette displays the values for the picture box (left of the black divider) and for the picture (right of the black divider).

ROTATING PICTURE BOXES

To rotate a *selected* picture box, select the Rotate tool, click on one of the handles of the box, and drag to rotate. As you drag the box, a line appears jutting out of the box handle. The longer the handle, the more control you have over the box's rotation. You can also rotate a box by typing a value in the Angle field of the Box Modify dialog box. Typing a negative number rotates the item to the right.

MOVING A PICTURE BOX

To move a picture box, select the Item tool and click on the box. Drag to a new location. Remember that before any item such as a picture box can be transformed, it must first be selected.

SKEWING A PICTURE BOX

Skewing slants a box to the right or left. To skew a picture box, type a value in the Skew field of the Measurements palette or in the Picture Skew field of the Picture Modify dialog box. Just as with the Rotate command, typing a negative number skews a box to the right.

1. Create a new document without facing pages and without an automatic text box (File/New/Document [**Command-N**/Macintosh or **Ctrl-N**/Windows]). Click on the standard-shape Rectangle Picture Box tool. The cursor changes to a crosshair. Click and drag on the page to draw a small box. With the box selected, choose Item/Modify (**Command-M**/Macintosh or **Ctrl-M**/Windows) to display the Modify dialog box. Click the Box tab (Figure 3.5). Type 2 in the Width field. Press the Tab key once and type 3 in the Height field. Click OK and notice that the box has been resized.

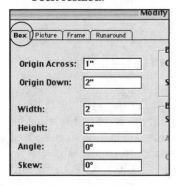

Figure 3.5. The Modify dialog box displays the Box tab. Typing values in the Width, Height, and Angle fields will resize and rotate the selected box.

2. Display the Measurements palette (View/Show Measurements or **F9**) and notice that the W and H fields on the left side of the palette reflect the values you typed in the Modify dialog box.

3. With the box still selected, choose Item/Modify (**Command-M**/Macintosh or **Ctrl-M**/Windows)—the Box tab is automatically active—and type 25 in the Angle field to rotate the box 25 degrees to the left. Press the Tab key and type -30 in the Skew field to slant the box 30 degrees to the left. Click OK. Notice that the left side of the Measurements palette displays the same height, width, and rotation values that you typed in the Modify dialog box (Figure 3.6). The Skew value is not displayed in the Measurements palette.

Figure 3.6. The Measurements palette for the selected picture box displays its position, size, and angle of rotation (25 degrees).

Tip

Press the Tab key to get to a field in any dialog box. Then press the Tab key to get to the next box and select the value in that box. This saves you the trouble of selecting one value before typing another value.

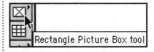

Clicking on the handle of a selected picture box turns the cursor into the Pointer cursor. Use this cursor to resize the box.

4. Type 2 in the Corner Radius field of the Measurements palette to make the box corners round. Your box should resemble Figure 3.7. Save this file (File/Save [**Command-S**/Macintosh or **Ctrl-S**/Windows]) as *Box.qxd*. Because this file was not previously saved, the Save as dialog box appears. Type the file name and save the file in your Projects folder.

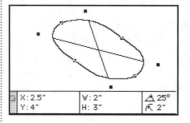

Figure 3.7. The Measurements palette for the selected picture box displays its position, size, angle of rotation (25 degrees), and corner radius (2 inches).

IMPORTING PICTURES INTO A PICTURE BOX

Once a picture box is created, you can import a picture into that box and resize, rotate, skew, and move the picture with or without transforming the box. To import a picture, the picture box must be selected and the image to be imported must be in a file format that QuarkXPress recognizes. The most commonly used images in an QuarkXPress document are TIFF, EPS, JPEG, PICT, BMP, Paint, and PhotoCD files.

GRAPHIC FILE FORMATS

Although QuarkXPress imports many different file types, the most common ones are:

▲ **EPS (Encapsulated PostScript)** files created in PostScript drawing programs like Adobe Illustrator, Corel Draw, and Macromedia FreeHand.

▲ **TIFF (Tagged Image File Format)** files created in bitmap image manipulation programs such as Photoshop and Painter.

▲ **DCS 2.0 (Desktop Color Separation)** files in which the four process color pages and the preview image are combined into one large file.

▲ **JPEG (Joint Photographic Experts Group)** files created in Photoshop or saved as scanned images.

Other file formats are Paint (Mac OS) and BMP (Windows paint files), PhotoCD, JPEG, PCX, and GIF (Windows only). All of these file formats have attributes that make them the appropriate choice for different kinds of images.

EPS IMAGES

EPS files, called *object-oriented* or *vector* graphics, are described by mathematical instructions rather than by pixel dots as with TIFF files. EPS files can be resized in XPress without affecting their display. Because they handle type as a mathematical set of lines and curves, EPS files are ideal for images that contain type, especially type at small point sizes. When you import an EPS file into an XPress picture box, XPress creates a low-resolution Pict preview of the image and displays that preview. When you go to print the file, XPress applies any changes you made to the preview version of the image to the high-resolution EPS image. Of course, to enjoy all the functionality of an EPS image, you must print the file to a PostScript printer or to an imagesetter.

TIFF FILES

TIFF files created in bitmap image manipulation programs like Adobe Photoshop and Fractal Design Painter can also be imported into XPress documents. When you scan an image into Photoshop, you're translating the color or grayscale information into pixels, and thus creating a bitmapped image. A bit is a tiny piece of information, a dot that can be turned on or off (Figure 3.8).

Figure 3.8. The black pixels are "turned on," that is, their color or grayscale information is visible.

Magnify a photograph or zoom in on a scanned image in Photoshop and you'll see hundreds or thousands of pixels (bits) instead of the continuous tone of the image (Figure 3.9). Each of these pixels is mapped to a grid on the computer screen. A pixel that's on is visible; if it's off, it's invisible (Figure 3.8).

Bitmap images should be resized in the image application, because enlarging them in XPress causes them to become pixelated when XPress creates the pixels necessary to make the image larger.

Figure 3.9. Zoom in on a bitmap image to see the pixels. Zoom out to see the continuous tone image.

Save Page as EPS	OPI	
Page:	1	
Scale:	100%	

☐ **Spread**
☑ **Transparent Page**
Size: 8.5" x 11"

Saving pages as EPS images

You can save a page as an EPS image by going to that page and choosing File/Save Page as EPS (**Command-Option-Shift-S**/Macintosh or **Ctrl-Alt-Shift-S**/Windows). The page, now a graphic, can then be imported into any kind of picture box, just as you would with any other high-resolution image.

Select the Transparent Page option in the dialog box to suppress the printing of the bounding box when the page is printed.

The DCS and DCS 2.0 options are available from the Save Page as EPS dialog box.

TIFF FORMAT ATTRIBUTES

There are many good reasons to import TIFF files into XPress:

▲ TIFF files tend to be smaller than EPS files.

▲ TIFF files are more flexible. For example, you can apply color to a grayscale TIFF image in XPress, something you can't do to a color EPS image. However, if you want to create a duotone, you must do that in Photoshop and save it as a Photoshop EPS file, because Quark will only import a duotone image, not color one.

▲ If you recrop a TIFF image in XPress, only the visible part of the image is sent to the printer. When you crop an EPS image, XPress sends the whole image, even the part that you cropped out, to the printer. This can cause problems with a large EPS file. To avoid this headache, crop the EPS image in Illustrator before importing it into XPress.

▲ QuarkXPress 4/5 can read a clipping path saved with a TIFF image. This means that if you save a Photoshop file with a clipping path as a TIFF file, XPress can run text around that path.

DCS (DESKTOP COLOR SEPARATION) FORMAT

When you save the page as an EPS file and select DCS or DCS 2.0 from the Format menu, DCS separates the Quark file into five separate EPS files. Four of the files are the high-resolution cyan, magenta, yellow, and black files. The fifth file, sometimes called the *master file*, is a low-resolution composite file that's imported into the QuarkXPress picture box. When you print this file to the imagesetter, XPress replaces the master file with the high-resolution separations. You don't have to use this format to color separate from Quark—TIFF and EPS files will separate perfectly—but DCS files tend to print faster from XPress.

JPEG (JOINT PHOTOGRAPHIC EXPERT GROUP) IMAGES

JPEG is a bitmapped compressed file format that decompresses when imported into a Quark picture box. Therefore, it can take a while to load JPEG images. Also, Quark prints the JPEG image as if it were a TIFF file. This file option is really useful only when you're trying to save disk space. Otherwise, stick with the TIFF format for bitmapped images.

PHOTOCD IMAGES

PhotoCD images are a proprietary Kodak format and are really designed for video viewing. If you must use a PhotoCD image, open it in Photoshop first and make the necessary color corrections. Typically, these images tend to be oversaturated and fuzzy and have to be desaturated and sharpened.

PAINT AND PICT FILES

Although you can import PICT and Paint images (low-resolution bitmap images) into XPress, it's not a good idea to use PICT files, as XPress doesn't always behave politely when processing PICT images.

NECESSARY XTENSIONS

Certain graphic formats like JPEG and PhotoCD files can be imported into a picture box only if the appropriate XTension is available in the XTension folder and selected in the XTensions Manager (Utilities/XTensions Manager). Select the JPEG Import and PhotoCD Import filters, making sure a check mark appears next to the filter's name in the Enable column.

BITMAP IMAGE ISSUES

Every bitmapped image is either rectangular or square and is divided into a grid of so many pixels. This grid is specified by the number of pixels per inch, or its *resolution*. The Macintosh computer monitor can display only 72 pixels per inch (ppi), whereas, the PC computer monitor can display 96 ppi. This is a low resolution and not suitable for print work, where image resolution can go as high as 300 ppi or even higher depending on the capability of the output device.

Because the picture's resolution is a function of its size, enlarging or reducing the size of the image affects the image resolution. For example, if you decide to double the size of a 150 ppi image either in Photoshop or in XPress, you'll reduce the image resolution by one half. So enlarging a 150 ppi image that's 2" x 2" to one that is 4" x 4" reduces the image resolution to 75 ppi—much too low a resolution for print work. However, if you reduce a 150 ppi 2" x 2" image to 1" x 1", you double its resolution, creating an image with 300 ppi, suitable for printing. The moral of the story is to avoid enlarging images by more than 10% in QuarkXPress.

AUTO PICTURE IMPORT

Turn on Auto Picture Import in the General Preferences dialog box to let XPress warn you when a linked image has been modified in the originating graphics application.

Make sure a check mark appears next to the selected xtension. Any inactive xtension remains inactive until you relaunch QuarkXPress.

Select On to automatically load an edited image. Select Verify to display a dialog box where you can choose to load the original unmodified image or update the image to the modified version.

Rectangle Picture Box tool

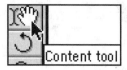
Content tool

Colors
90%

0%
10%
20%
30%
40%
50%
60%
70%
80%
90%
100%

Use the Tint Percentage menu to apply a tint (shade) to a color.

1. Create a new document with 1" margins and without an automatic text box. Display the Measurements palette (View/Show Measurements or **F9**).

2. Use the Rectangle Picture Box tool to draw a picture box at the top of the page between the margins. Make sure the W value on the Measurements palette is 2.5".

3. Choose File/Get Picture (**Command-E**/Macintosh or **Ctrl-E**/Windows). Navigate to the Unit 03 folder in the Student Files folder on the CD-ROM and highlight the *Piggy.tif* file. Click on Open or double-click on the file to import it into the picture box. It appears on the left side of the picture box.

4. Select the Content tool (you always use the Content tool to manipulate an image) and drag the pig to the center of the box or choose one of of the image options from the Style menu.

5. Display the Colors palette (View/Show Colors or **F12**) and click on the Background Color icon in the top panel of the palette. Assign the box background and a percentage of color from the Percentage menu on the Colors palette.

6. Select the picture box and choose Item/Shape. Select the round-corner shape. Choose Item/Shape again and select the circle shape. Choose Item/Shape once more and select the rectangle shape, the first on the list, to return the box to its original shape (Figure 3.10).

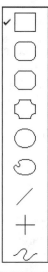

Figure 3.10. Choose Item/Shape and slide the mouse over a box shape to select it and apply the new shape to the selected item.

7. Use the Rectangle Text Box tool to draw a text box beneath the picture box. Type some words in the box. With the box selected, choose Item/Modify (**Command-M**/Macintosh or **Ctrl-M**/Windows). Click on the Text tab. Select Centered from the Vertical Alignment menu to center the text vertically inside the text box.

8. Use the Colors palette to assign the box a background color in a lighter tint than used for the picture box.

9. Click on the picture box to select it, press the Shift key, and click on the the text box to select both items. Choose Item/Frame (**Command-B**/Macintosh or **Ctrl-B**/Windows). Choose 1 from the Width menu and black from the Frame Color menu. Click on OK. Your screen should resemble Figure 3.11.

10. Close this file (**Command-W**/Macintosh or **Ctrl F4**/Windows). Don't save your changes.

Figure 3.11. The picture is centered in the picture box and a background color is applied to both the picture box and the text box.

LESSON 2: IMPORTING GRAPHICS

IMPORTING PICTURES

Once you create a picture box, you can import a picture into that box and resize, rotate, skew, and move the picture with or without transforming the box. If the picture is a black-and-white bitmap image, you can apply color to the black pixels. Otherwise, TIFF and EPS images, the usual kinds of image used in XPress documents, can't be colorized inside XPress. Their color definitions remain the same as specified in the graphics programs where they were created.

To import a picture, you must select the picture box and the image to be imported must be in a file format that QuarkXPress recognizes. The most commonly used images in an XPress document are TIFF, EPS, JPEG, PICT, BMP, Paint, and PhotoCD files.

IMPORTING TIFF AND EPS IMAGES

TIFF images created in programs such as Painter and Photoshop come into the picture box with a white background. That's because these bitmapped programs must map every pixel in the file to a color. This means that when you import the image, you're also importing the colored (white) background with it.

An EPS image saved in a vector drawing program, such as Illustrator or Draw, does not have pixels that have to be colored. This means that any space around the image or any open areas of the image will display the background color of the picture box in XPress (Figure 3.12).

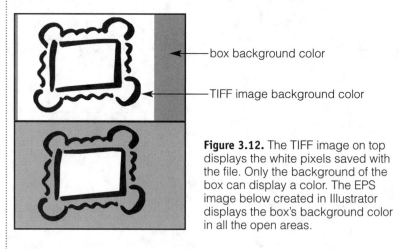

box background color

TIFF image background color

Figure 3.12. The TIFF image on top displays the white pixels saved with the file. Only the background of the box can display a color. The EPS image below created in Illustrator displays the box's background color in all the open areas.

Sorry

You can't import a Photoshop (.psd), Painter (.riff), or Illustrator (.ai) file directly into XPress. Save the Photoshop and Painter files as TIFF files and the Illustrator files in the EPS format.

DISPLAYING AN IMAGE

If you import an image and only white space appears in the picture box (Figure 3.13), that's because the image was saved with a white background. Click on the image with the Content tool and drag it around the box until the image itself appears. You can also center the image by:

▲ Pressing **Command-Shift-M** (Macintosh) or **Ctrl-Shift-M** (Windows). *Or*

▲ Choosing Style/Center Image.

MODIFYING PICTURES

To reposition a picture in a picture, box select the Content tool and click inside the picture box. This changes the cursor into the Picture Mover pointer and lets you drag the image around the picture box. Drag to reposition the picture. For more accurate positioning of an image, or to resize the image, use either the Measurements palette or the Modify dialog box.

MEASUREMENTS PALETTE FOR PICTURES

Whenever you select any kind of picture box containing a picture, every value to the left of the dividing line (before the Flip arrows) on the Measurements palette refers to the picture box; every value to the right of the divider refers to the contents of the box, which is the picture (Figure 3.14).

Figure 3.13. When the image is imported into an XPress picture box, it may have to be moved to the center of the box.

A selected picture box's values are displayed to the left of the divider in the Measurements palette. The values to the right of the divider apply to the picture itself.

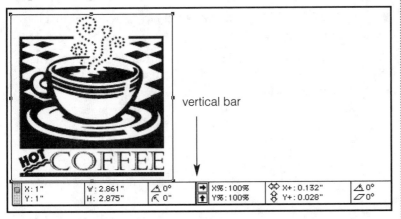

vertical bar

Figure 3.14. The Measurements palette for a selected picture box displays information about the box on the left side of the vertical bar and information about the picture on the right side of the bar.

Rotate field for pictures
and picture boxes

Corner Radius field for
picture boxes

Picture Rotation field for
pictures

Picture Skew field for pic-
tures

These values apply to the selected **picture box:**

▲ The **X and Y values** refer to the picture box's position on the horizontal and vertical rulers.

▲ The **W and H** values specify the width and height of the picture box.

▲ Type a value in the **Rotate field** to rotate both the picture box and the picture.

▲ Type a value in the **Corner Radius field** to round out the corners of the picture box. The higher the value, the more rounded are the corners.

The following fields in the Measurements palette apply to the **graphic** in the selected picture box:

▲ Use the **Flip arrows** to the right of the divider bar to flip the picture horizontally or vertically.

▲ Type a value in the **X% and Y% fields** to reduce or enlarge the picture. Any value over 100% enlarges the picture. A value less than 100% reduces the picture. To keep the picture's height and width ratio intact, both the X% and Y% values must be the same number.

▲ Use the horizontal and vertical **X and Y arrows** to move (offset) the picture to the right and left or up and down. These are called the Offset Across and Offset Down values.

▲ Type a value in the **Picture Rotation field** to rotate just the picture, not the picture box.

▲ Type a value in the **Picture Skew field** to skew (slant) just the picture, not the picture box.

Whenever you type a value in the Measurements palette, whether it's a box value or a picture value, you must press the Return/Enter key to execute the command.

PICTURE MODIFY DIALOG BOX

Select the picture box and choose Item/Modify to display the Modify dialog boxes for all the attributes that affect a picture and its picture box (Figure 3.15). Here you can make all the adjustments available in the Measurements palette and many more.

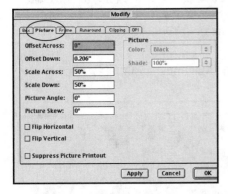

Figure 3.15. The Picture Modify dialog box

EXERCISE C

1. Create a new document (File/New/Document [**Command-N**/Macintosh or **Ctrl-N**/Windows]) without an automatic text box. Click on the standard-shape Rectangle Picture Box tool to select it. Click on the page and drag to draw a small picture box. Release the mouse when the box is drawn.

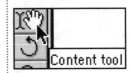

2. With the picture box still selected (it displays eight handles), choose Item/Modify (**Command-M**/Macintosh or **Ctrl-M**/Windows). The Modify dialog box appears with the Box tab in front.

3. Type 2 in the Width field; press the Tab key and type 2 in the Height field. Make sure the Color pull-down menu in the Box field is set to white. Click OK to resize the box.

4. With the picture box still selected, click on the Content tool or on the Item tool and choose File/Get Picture (**Command-E**/Macintosh or **Ctrl-E**/Windows). Navigate to the Unit 03 folder in the Student Files folder on the CD-ROM and click on the *Marble* image. This is a file created in Photoshop and saved in the TIFF format. Double-click on the file name or click on Open to import the picture into the selected picture box. Notice that the picture is smaller than the box.

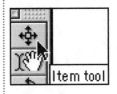

5. Click on the picture box handle in the lower right corner and drag to resize the box so that it fits snugly against the picture.

6. With the picture box still selected, choose Item/Frame (**Command-B**/Macintosh or **Ctrl-B**/Windows). Choose 4 from the Width pull-down menu. Leave the Style as Solid, and select a color from the Style pull-down menu. Click on OK to apply a frame (border) to the picture box. Your screen should resemble Figure 3.16.

7. Close this file (**Command-W**/Macintosh or **Ctrl-F4**/Windows). Don't save your changes.

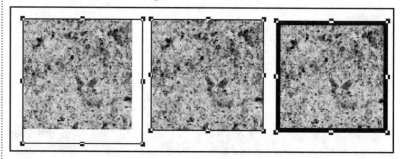

Figure 3.16. The original picture box (left), the resized picture box (center), and the framed picture box (right).

LINKING PICTURES

Whenever you import a high-resolution image like a TIFF or EPS image into a QuarkXPress picture box, XPress creates a low-resolution PICT version of that image and links that low-resolution image to the original high-resolution image in the folder on the drive from which you imported that picture. When you go to print the file with the picture, XPress scurries to the original location (drive and folder), locates the high-resolution image, applies any editing you made to the image in the document, and prints the edited high-resolution image. If it can't find that high-resolution image, it alerts you and gives you the opportunity to update the file by specifying the new location for that high-resolution image.

PICTURE USAGE DIALOG BOX

To avoid any delays at printing, use the Picture Usage dialog box. Choose Utilities/Usage and click on the Picture tab. The status of all the images used in the file appear. If OK appears, then XPress can access the high-resolution image. If it can't, it will display Missing in the Status field. Click the Update button to establish a link to that image at its new location. If you can't remember what the image looked like, click on the image name to select it and click the Show button. XPress jumps to the page with that image and selects its picture box. If you click the More Information check box, the original location of the image, as well as its size, resolution, and modification date, will appear in the display box.

MISSING PICTURES

What happens when you can't locate the original high-resolution file and print the document anyway? XPress will always print the low-resolution PICT image it created when it imported the original high-resolution TIFF or EPS image. Of course, you won't get the same quality from a low-resolution image that you can expect from TIFF and EPS images, and you may find your graphic printing with the jagged outline of a pixelated image.

EXERCISE D

1. Create a new document without an automatic text box and one column. Display the Measurements palette (View/Show Measurements or **F9**).

2. Use the Rectangle Picture Box tool to draw a small picture box. Choose File/Get Picture (**Command-E**/Macintosh or **Ctrl-E**/Windows) and navigate to the Unit 03 folder in the Student Files folder on the CD-ROM. When you open the folder, highlight the *Leaves.jpg* file and make sure the Preview check box in the upper left corner is checked. If the image file was saved with a thumbnail preview in the originating graphics application (like Photoshop or Illustrator), a thumbnail of the selected image will appear in the Preview box. If the image wasn't saved with a preview thumbnail, the Preview box in Quark is gray. Notice the information Quark provides in the Get Picture dialog box (Figure 3.17).

Windows info

Picture boxes with embedded and linked objects are named "embedded object" and "linked object" with no path displayed in the Picture Usage dialog box.

More Windows info

To update a linked image, use the Links command in the Edit menu. The Usage dialog box is used only to manipulate images that were imported via the Get Picture command or dragged from the Windows desktop or from Windows Explorer.

Rectangle Picture Box tool

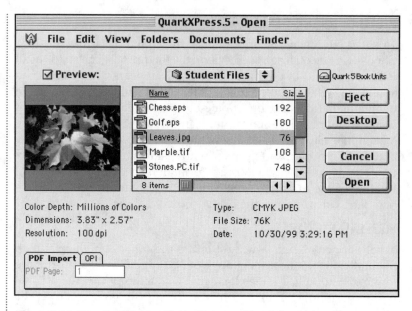

Figure 3.17. The Get Picture dialog box provides information about an image, including its color mode, size and resolution.

3. Click on Open to import the picture into the picture box.

4. You may have to resize the box to fit the picture. Or, you could resize the picture to fit the box. Or, you could resize the picture and the box simultaneously. There are a few ways to do all this depending on how you want to resize. You can resize the image to fit in the box regardless of the width and height ratios. Or, you can resize so that the aspect ratio is maintained. This is called *resizing proportionally*. You can resize by dragging the box or by using the menu commands. Right now we're just interested in resizing the box without touching the image.

5. Click on the picture box with either the Content tool or Item tool to select the box. Click on the right center handle. When the cursor changes to the Pointer cursor, drag the side of the box down until the whole image is revealed. Drag one of the side handles on the picture box to make the box wide enough to display the entire image. You're resizing only the box, not the image inside the box.

6. Notice that the X% and Y% values on the Measurements palette display 100%, because an image is always imported at 100% of the size (exactly the same size) as it was saved in the graphic application where it was created.

7. Change the X% and Y% values in the Measurements palette and notice how the picture becomes smaller—*proportionally*. Make the X% and Y% values different and notice how the picture becomes distorted. Unless you're trying to achieve a design effect, the X% and Y% values should always be the same number. Otherwise, the image will be distorted.

8. Choose Utilities/Usage and click on the Pictures tab. The dialog box lists every image in the document. If it's a high-resolution image, as the *Leaves* image is, it's linked to that high-resolution image (Figure 3.18). The Usage dialog box tells you that the link status is OK and the check mark under the Print column indicates that the picture will print with the document. If you're just proofing text, you can click the check mark to deselect the Print option. Just remember to turn it on for the final printing.

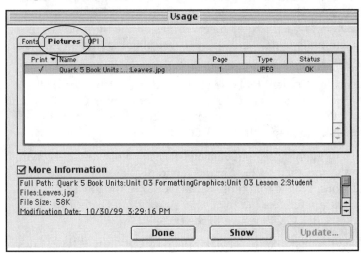

Figure 3.18. The Pictures Usage dialog box displays the path of the high-resolution JPEG image from the hard drive to the document's picture box. It also indicates whether XPress can follow that link (Status column) and if that picture should be printed (Print column) when you print the document.

9. Save this file as *Leaves.qxd* in your Projects folder (File/Save (**Command-S**/Macintosh or **Ctrl-S**/Windows). You'll need it for the next exercise.

POSITIONING IMAGES

When you import an image into a picture box, the image appears at the same size and in the same location on the page as it was when it was saved in the graphic application. This means that if an image was created in a program like Illustrator, Photoshop, FreeHand, or Painter and was four inches high and five inches wide when it was saved as an EPS or TIFF file, it will come into an XPress picture box at that same size and be positioned in the upper left corner of the picture box. To center the image in the picture box, press **Command-Shift-M** (Macintosh) or **Ctrl-Shift-M** (Windows). You can also use the X+ and Y+ fields in the Measurements palette or the Offset Across and Offset Down fields in the Modify dialog box.

EXERCISE E

1. If necessary, open the *Leaves.qxd* file you just created or draw a picture box and import any image into it. Display the Measurements palette (View/Show Measurements or **F9**). Notice that the X+ and Y+ (Picture Offset) values on the right side of the Measurements palette display 0, meaning that the picture has not yet been moved.

2. Select the Content tool and click inside the picture box, where the cursor changes to the Picture Mover pointer. Click and drag the image around the box. Notice that the Picture Offset values change to reflect the new position of the image.

Content tool

3. Choose Item/Modify (**Command-M**/Macintosh or **Ctrl-M**/Windows) and click on the Picture tab to display the picture specifications. Notice that those same values in the Measurements palette are reflected in the Offset Across and Offset Down fields. Click OK to return to the image.

4. Press **Command-Shift-M** (Macintosh) or **Ctrl-Shift-M** (Windows) to center the image in the picture box. Its new position is reflected in the Picture Offset fields of the Measurements palette.

5. Close this file (File/Close [**Command-W**/Macintosh or **Ctrl-F4**/Windows]). Don't save your changes.

RESIZING IMAGES

You can resize an image in a variety of ways:

▲ **Measurements palette,** by typing values in the X% and Y% fields.

▲ **Picture tab of the Modify dialog box,** using the Scale Across and Scale Down fields. Any values you type in these fields appear in the Measurements palette.

▲ **Menu,** by choosing an option from the Style menu.

▲ **Keyboard.**

1. Press **Command-Shift-F**/Macintosh or **Ctrl-Shift-F**/Windows to fit the picture into the box. This will adjust the height and width of the picture to fit the box and usually results in distorting the image.

2. Press **Command-Option-Shift-F** (Macintosh) or **Ctrl-Alt-Shift-F** (Windows) to fit the image proportionally in the picture box.

3. Press **Command-Option-Shift-<** or **>** (Macintosh) or **Ctrl-Alt-Shift-<** or **>** (Windows) to to reduce or enlarge the image in 5% increments.

> | Center Picture |
> | Fit Picture To Box |
> | Fit Picture To Box (Proportionally) ⎯ |
> | Fit Box To Picture |

When you select a picture box that contains a picture, you can edit both the box and the picture from the Style menu.

The important thing to remember is that to maintain the aspect ratio (the same relationship between the height and width of the graphic's dimensions), the Scale Across and Scale Down fields in the Modify dialog box or the X% and Y% fields in the Measurements palette must be exactly the same. For example, if you resize an image by typing 75 in the X% field and 150 in the Y% field, you will have an image that is disproportionately longer than it is wide. There may be times when you want this to achieve a certain effect, but ordinarily you will want your pictures to be proportionately scaled.

1. Create a new document (File/New Document [**Command-O**/Macintosh or **Ctrl-O**/Windows) and display the Measurements palette (View/Show Measurements or **F9**). Use the Rectangle Picture Box tool to draw a picture box.

2. With the picture box selected, choose File/Get Picture (**Command-E**/Macintosh or **Ctrl-E**/Windows) and navigate to the Student Files folder in the Unit 03 folder on the CD-ROM. Highlight the *Window.tif* file and click on Open. Resize the box by dragging its handles so that the box is larger than the picture.

3. Click on the resized picture box that displays the entire image and press **Command-Shift-M** (Macintosh) or **Ctrl-Shift-M** (Windows) to center the graphic in the picture box. You can also double-click on the picture box with the Item tool to display the Modify dialog box.

4. Type 50 in the X% field, press the Tab key, and type 50 in the Y% field. Press the Return/Enter key. The image is scaled down to half its size.

5. With the picture box still selected, choose Item/Modify (**Command-M**/Macintosh or **Ctrl-M**/Windows). Because you're modifying the *picture*, not the box, click on the Picture tab. Type 200 in the Scale Across field and click on OK. Resize the box to fit the enlarged image. The image is now wider than it is high (Figure 3.19).

Figure 3.19. The top picture at 100% of its original size is disproportionally scaled horizontally (below).

6. Type 100 in the X% and Y% fields of the Measurements palette to restore the image to its original size. Save the file in your Projects folder (File/Save [**Command-S**/Macintosh or **Ctrl-S**/Windows]).

7. Type 45 in the Picture Rotation field on the right side of the Measurements palette to rotate the *picture* 45 degrees. Press the Tab key and type -20 in the Picture Skew field of the Measurements palette to skew the *picture* 20 degrees to the left. Press Return/Enter to execute the commands. Your screen should resemble Figure 3.20.

Picture Rotation field for pictures

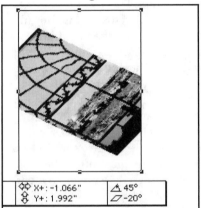

Picture Skew field for pictures

Figure 3.20. A graphic is rotated and skewed. Only the image, not its picture box, is modified.

8. Choose File/Revert to Saved. Click OK in the alert box to revert to the last saved version of the file. When the original image appears, select the Content tool and click on the picture box. Press **Command-Shift-F** (Macintosh) or **Ctrl-Shift-F** (Windows) to fit the picture into the picture box. Notice, however, that to fit the box, it was disproportionately resized, as indicated by the different values in the X% and Y% fields on the Measurements palette. Choose Edit/Undo (**Command-Z**/ Macintosh or **Ctrl-Z**/Windows) to restore the original image.

9. With the picture box still selected and the Content tool active, press **Command-Option-Shift-F** (Macintosh) or **Ctrl-Alt-Shift-F** (Windows) to resize the image proportionately. Notice that now the X% and Y% values in the Measurements palette are the same.

10. Choose Item/Modify (**Command-M**/Macintosh or **Ctrl-M**/Windows) and click on the Picture tab. The proportional values are displayed in the Scale Across and Scale Down fields.

11. Close this file (File/Close [**Command-W**/Macintosh or **Ctrl-F4**/Windows]). Don't save your changes.

Tip

Convert any tool to a temporary Item tool by pressing the Command key (Macintosh) or Ctrl key (Windows). Keep the modifier key pressed until you have moved the item. When you release the modifier key, the Item tool cursor returns to the original tool cursor.

CROPPING IMAGES

You will usually import only vector EPS files from programs such as Adobe Illustrator or Corel Draw and bitmapped TIFF files from programs such as Photoshop and Painter. When you crop these images in XPress, different things happen:

▲ **Vector EPS images**: When you import a vector EPS image from a vector drawing program such as Illustrator or Draw into QuarkXPress and then crop it, you only *display less of the image*; you don't remove any part of the image. This means that although only part of the image appears in the picture box, the entire vector EPS image must be processed when the file is printed. For example, if you import a 10 MB EPS image with artwork and type from Illustrator and move the image in the picture box so only the artwork displays, only the 2 MB artwork will print, but the entire 10 MB file will be processed by the printer. If the image is very large, and if you have many graphics in a document, especially vector EPS graphics, you may run into problems when printing the image either to your laser printer or to an imagesetter. If an image requires heavy cropping, do it in the vector application where it was created and import the cropped image into XPress.

▲ **Bitmapped images:** If you crop a TIFF image, Quark prints only what is displayed, and ignores the rest of the image when the document is printed. For example, if you import an image of a flock of geese flying over an environmentally protected area and you use the Picture Mover pointer to move the image so that only one goose appears in the picture box, only one goose will print and only one goose will be processed. The rest are probably living on someone's lawn!

EXERCISE G

1. You'll create a small sticker for a golf bag. Create a new document with 1 column, without facing pages, and without an automatic text box. Display the Measurements palette (**F9**). Make sure the unit of measure is inches (Edit/Preferences/Preferences [**Command-Y**/Macintosh or **Ctrl-Y**/Windows]).

Rectangle Picture Box tool

2. Select the Rectangle Picture Box tool and drag to draw a small picture box. Type 1.5 in the W field of the Measurements palette. Press the Tab key and type 1.5 in the H field to create a square. Press Return/Enter.

3. Select the Content tool or Item tool and with the picture box selected, choose File/Get Picture (**Command-E**/Macintosh or **Ctrl-E**/Windows). Navigate to the Unit 03 folder in the Student Files folder on the CD-ROM and click on Open. Double-click on the *Golf.eps* file (an EPS file) to import it into the selected picture box. Click inside the picture box with the Content tool and notice that the graphic, which consists of three designs, is larger than the box.

4. Use the Picture Mover pointer, which appears when you click with the Content tool on the picture, to move the image around the box until the crossed golf clubs are positioned in the center of the image. Draw a small text box on top of the graphic and type *MEMBER*. Press the Return key and type the year. Select the text and format it appropriately.

5. With the text box still selected, choose Item/Modify (**Command-M**/Macintosh or **Ctrl-M**/Windows) and in the Box tab assign the box a background of None. Use the Item tool to position the text box on top of the clubs.

6. Select the picture box and choose Item/Modify (**Command-M**/Macintosh or **Ctrl-M**/Windows) and in the Frame tab assign it a 1-point frame. In Figure 3.21, although only one set of clubs is displayed and is the only design which will be printed, the other two designs will be processed even though they won't be printed, because they're still part of the EPS image.

The Frame tab in the Modify dialog box takes you to the Frame dialog box.

7. Close this file (File/Close [**Command-W**/Macintosh or **Ctrl-F4**/Windows]). Don't save your changes.

Figure 3.21. Crop an image in a picture box and add a text box with a background of None.

Tip

Once you position the image, lock the picture box and image by selecting the box and choosing Item/Lock.

FLIPPING IMAGES

Images can be flipped horizontally or vertically inside the picture box. This is a handy function when you want to create facing images or a mirror image. To flip an image, select the picture box and click on the Horizontal flipping arrow to flip the image from right to left. Click on the arrow again to restore the image. To flip the image vertically, click on the Vertical flipping arrow, and click on that arrow again to restore the image.

EXERCISE H

Rectangle Picture Box tool

1. In this exercise you'll create a letterhead logo for a chess club. Create a new document (File/New/Document [**Command-N**/Macintosh or **Ctrl-N**/Windows]) without facing pages and without an automatic text box. Display the Measurements palette (View/Show Measurements or **F9**).

2. Use the Rectangle Picture Box tool to draw a rectangle about 2.4" square. With the picture box selected, choose File/Get Picture (**Command-E**/Macintosh or **Ctrl-E**/Windows). Navigate to the Unit 03 folder in the Student Files folder on the CD-ROM and open the *Chess.eps* image.

3. With the picture box still selected, choose Item/Duplicate (**Command-D**/Macintosh or **Ctrl-D**/Windows). Position the duplicate box next to the original. Use the Measurements palette to make sure that both boxes are on the same Y axis.

Shift-selecting

When you press the Shift key to select another item, keep it pressed until both items are selected.

4. Shift-select both boxes (select the first box, press the Shift key, and click on the second box). Choose Item/Duplicate (**Command/Ctrl-D**) again to duplicate both boxes. Use the Item tool to drag the two duplicates down below the originals.

5. Use the Measurements palette to make sure the top left image and the bottom left image are at the same position on the X axis. The easiest way to do this is to select the top left image, drag to select its X value in the Measurements palette and choose Edit/Copy (**Command-C**/Macintosh or **Ctrl-C**/Windows). Then click on the lower left image to select it, drag to select its X value in the Measurements palette, and choose Edit/Paste (**Command-V**/Macintosh or **Ctrl-V**/Windows). Repeat this process to position the top right image and bottom right image at the same position on the X axis (Figure 3.22).

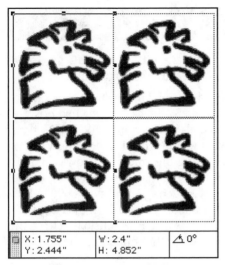

Figure 3.22. The top left and bottom left images are positioned at the same position on the X axis, as are the top and bottom right images.

6. Use the Content tool and click inside the top right image. Click both the Horizontal and Vertical flipping arrows in the Measurements palette.

7. Click in the lower right image and click only the Vertical Flipping arrow in the Measurements palette.

8. Select the Orthogonal Line tool and draw a horizontal line between the upper and lower images. Repeat to draw a vertical line between the left and right images.

9. Use the Rectangle Text Box tool and draw a text box below the second row of images. Type a name and address in the box and center the text. Format it appropriately. Your screen should resemble Figure 3.23.

10. Close this file (File/Close [**Command-W**/Macintosh or **Ctrl-F4**/Windows]). Don't save your changes.

Figure 3.23. Use the flipped images and text box to create a letterhead logo.

About the review projects

The directions for review projects are not as explicit as those for the exercises. This is because you should be able to select the right tool, go to the correct menu item, or use the necessary palette without having it all spelled out for you. If you encounter something you don't understand, go back to the unit for more information. In the real world, there won't be explicit directions. You can do this!

Option-click (Macintosh) or Alt-click (Windows) on the Tracking arrows to track selected type in 1-unit increments.

Use the Leading arrows to move selected text up or down on its baseline.

For this project you'll create a name tag with a corporate logo. Display the Colors palette (**F12**) and Measurements palette (**F9**).

1. Draw a box about 3 inches wide and 2 inches high. Assign it a content of None and a shade of 25% black. Draw a text box about 3 inches wide and 2 inches high, enter the VISITOR type, and make it about 60 points and 100% black. Select the VISITOR type and track it by pressing the Tracking arrows on the Measurements palette until the type fits the entire width of the box. Rotate the text box 90° by selecting it and typing 90 in the Box angle field of the Measurements palette or in the Angle field of the Text Modify dialog box (Item/Modify). Position the VISITOR text box on the left side of the contentless box.

2. Draw another text box and enter your name and title. Format the text and adjust the leading so that the title isn't too far below the name.

3. Draw a small picture box and import the *VLogo.eps* graphic from the Student Files folder in the Unit 03 folder on the CD-ROM. Fit it to the box. You can do this by selecting the picture box and choosing Style/Fit Picture to Box (Proportionally). Draw another text box below the logo, enter the company name, and center the text box beneath the logo. Your screen should resemble Figure 3.24.

Figure 3.24. The completed name tag displays text boxes and a picture box.

For this project you'll create a stationery set consisting of a letterhead, envelope, and business card. Use any typeface you like and feel free to substitute your own graphics for the logo art. We've used a graphic typeface for the house art, so it sits in a text box. If you use a TIFF or EPS image instead, import it into a picture box and use the Style menu to fit it in the box.

1. To create the stationery sheet, create a new document with .5" margins. Don't select an automatic text box or facing pages.

2. To create the logo, draw a text box across the top of the page about 2" high. Select a picture font such as Zaph Dingbats or Webbings. The house used in this sample is the upper case B in the Webbings font. For class purposes, select any type character. Format it in 100 points on 120 points of leading.

3. Press the Return/Enter key after the text character and type *The Househunter*. Format the type in 18-point type (Figure 3.25).

Figure 3.25. Treat the graphic character as text and center-align it in the text box.

4. Draw another text box across the bottom of the box about 1" high. In the Text tab of the Item/Modify dialog box, select Bottom from the Vertical Alignment menu. Type the name, *The Househunter*, address, and phone and fax numbers. Select all the text and format it in a condensed typeface, at 14 points, preferably in the same font family as used for *The Househunter* in the logo box.You may have to fiddle with the type size to fit the type. Center-align the type in the text box. Format *The Househunter* in a bold version of the type. Your screen should resemble Figure 3.26.

Figure 3.26. Enter the contact text in a separate text box.

Contentless boxes

A box with a content of None is just an empty box that can hold neither text nor pictures. It's good to use as a placeholder because you don't have to worry about text flowing into it and disrupting the text flow of the document.

Use the Text tab of the Item/Modify dialog box to vertically align the text from the bottom of the text box.

5. Display the Document Layout palette (**F10**/Macintosh or **F4**/Windows). Insert another page in the document by dragging a master page icon down on the Document Layout palette (Figure 3.27).

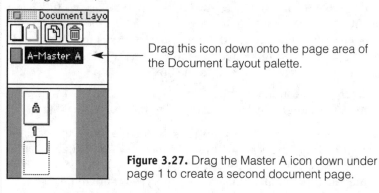

Drag this icon down onto the page area of the Document Layout palette.

Figure 3.27. Drag the Master A icon down under page 1 to create a second document page.

6. To create the **business card**, draw any kind of box 3.5" wide and 2" high. Assign it a content of None. Assign it a 1-point frame (Item/Frame) so you can see it easily.

7. Draw another, smaller text box about 1.5" square inside the larger one. Select the text and copy the graphic text character (Edit/Copy) from the first page and paste it into the smaller text box on the business card (Edit/Paste). Choose Edit/Select All and reduce the size of the text character to 72 points or to whatever size fits in the text box. If you're working with an EPS or TIFF graphic, click inside the picture box with the Content tool and use the Measurements palette to reduce the X% and Y% values.

8. Draw another text box next to the graphic text box. Copy and paste the name, title, address, and telephone information from the lower text box on the stationery page. Press the Return/Enter key after the appropriate lines to format the information properly. Draw another text box below the graphic and add the *Househunter* text. Use the Measurements palette to assign both boxes the same X value so they'll both be left-aligned at the same point on the X axis (Figure 3.28).

You must type a value in the Width field for the frame to display. The default value is 0 and won't frame the item.

Figure 3.28. Align the two boxes on the left axis and add the contact information in another text box.

9. To create the **envelope,** draw any kind of box 7" wide by 3.5" high. Assign it a black frame (Item/Frame) to make it more visible. Click on the graphic text box in the business card and choose Item/Duplicate. Use the Item tool to drag the duplicate down onto the left side of the envelope.

To create outline type, select the type and click the Outline style on the Measurements palette. Then reduce the color percentage in the Colors palette to lighten the design.

10. Select the name and address text box on the business card and duplicate it (Item/Duplicate). Drag the duplicate down below the graphic box on the envelope. Use the Measurements palette to align both the graphic box and the name box at the same point on the X axis. Select the telephone information and delete it (Edit/Cut). Your screen should resemble Figure 3.29.

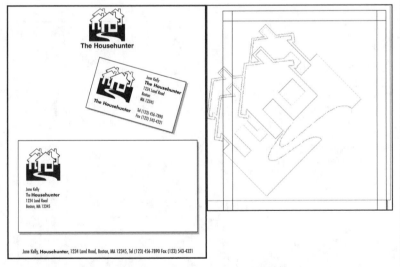

Position text boxes over the graphic to create the letterhead and body of the letter. Give those text boxes a background color of None so the graphic will appear behind them.

Figure 3.29. The stationery set on the left displays the letterhead, business card and envelope. The page on the right displays an enlarged graphic (500-point type) at 40% black, outlined and rotated 45°. The graphic is now the background for the text on the page.

For this project you'll use a TIFF file as the background for the letterhead. You could also use it for the business card. The *Granite.tif* file, created in Photoshop, is 9 inches wide and 12 inches high to allow for the bleed on an 8½ x 11 page. Because the TIFF file is a bitmap image, you can't enlarge it without pixelating the image, so it must be scanned or created at the final printing size.

1. In a new document without facing pages and without an automatic text box, draw a picture box that bleeds off the page (Figure 3.30).

2. Import the *Granite.tif* file and position it in the box.

3. Create a text box for the letterhead information and type the name, address, etc. in that box. Format it with a strong typeface that won't get lost on the granite background.

4. Draw a small picture box on the right side of the page and import the *Granite.Logo* file. Use the Content tool to position it in the box. Your screen should resemble Figure 3.31.

Figure 3.30. Draw a picture box that extends beyond the bounds of the page. When the page is printed, the entire page will be filled with the graphic.

Figure 3.31. The graphic is placed in a picture box behind another text box for contact information and a smaller picture box for the logo.

Unit 4
Multiple-Page Documents

OVERVIEW

In this unit you will learn how to:
Work with multiple-page documents
Use the Document Layout palette
Add and delete document pages
Navigate a multiple-page document
Number pages
Link and unlink text boxes
Create an Automatic Text Box link
Link random text boxes
Create jump lines

TERMS
absolute page number
Auto Page Insertion
Consecutive Page Number symbol
default
Document Layout palette
folio
jump lines
link
Page Number box
Section
unlink

LESSON 1: MULTIPLE-PAGE DOCUMENTS

WORKING WITH MULTIPLE-PAGE DOCUMENTS

If you're creating a flyer or invitation, a business card or letterhead, you will usually work with only one page, the default document page that appears when you create a new document. But many projects, such as newsletters, book chapters, magazine articles, and annual reports, require more than one page in the document. It's important that you know how to add additional pages to a document and how to navigate a multiple-page document. The easiest way to do both of these things is through the Document Layout palette.

THE DOCUMENT LAYOUT PALETTE

As soon as you create a new XPress document, two things happen: a single document page appears and a master page, Master Page A, is created (Figure 4.1). You will learn more about master pages later. To display the Document Layout palette, choose View/Show Document Layout (**F10**/Macintosh or **F4**/Windows).

Figure 4.1. When a new document is created, one master page, Master Page A, and one document page based on Master Page A are automatically created. This document was created without selecting the Facing Pages option.

DISPLAYING THE DOCUMENT LAYOUT PALETTE

The Document Layout palette is a floating palette that stays open on your page until you close it by either choosing View/Hide Document Layout or pressing the function key (**F10**/Macintosh or **F4**/Windows). When working with multiple-page documents, it's best to keep this palette open, as it provides the quickest access to document pages.

DOCUMENT LAYOUT PANELS

The Document Layout palette (View/Show Document Layout [**F10**/Macintosh or **F4**/Windows]) displays three panels:

▲ **Icon panel** at the top where icons for blank master pages and for duplicating and deleting master pages appear. The Delete icon can also be used to delete document pages.

▲ **Master Page panel**, the center panel, displays icons for all the master pages in the document.

▲ **Document Page panel**, the lowest panel, displays icons for all the document pages in the file. The Document Layout palette makes it easy to navigate a document. Just double-click on any master page or on any document page and you'll be on that page.

FACING PAGES AND NONFACING PAGES ICONS

If you selected the Facing Pages option in the New Document dialog box, the icons for that document's default Master Page A and default document page 1 will display a turned corner. If you didn't select the Facing Pages option, the master page icon and default document page will display straight corners (Figure 4.2).

ADDING DOCUMENT PAGES

The easiest way to add document pages is to select a Master Page icon and drag it down onto the Document Page panel in the Document Layout palette. In Figure 4.2, there is only one document page, and it's the first page in the file. Figure 4.3 displays the Document Layout palette for a two-page document.

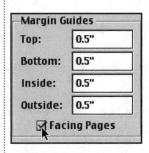

Select the Facing Pages option in the New Document dialog box.

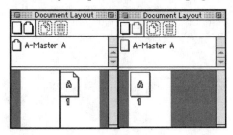

Figure 4.2. The Document Layout palette on the left indicates that the Facing Pages option was selected in the New Document dialog box. The unturned corner of the document page icon on the right indicates that the document was created without selecting the Facing Pages option.

DISPLAYING PAGE NUMBERS

In Figure 4.3 the Page Number box in the lower left corner of the Document Layout palette for the two-page document displays 2 Pages, indicating that there are two document pages in this file. If you click once on any page icon, the Page Number box will display the actual page number for that document page. Figure 4.4 shows the Document Layout palette with the second document page highlighted (selected) and Page 2 displayed in the Page box.

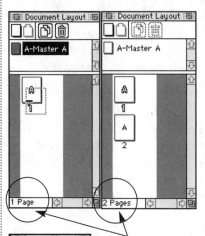

Figure 4.3. The Master A icon was dragged down onto the page panel of the Document Layout palette (left). The Document Layout palette now displays one master page and two document pages (right). The number of pages in a document appears in the Page Number box in the lower left corner of the palette.

Page Number box

Figure 4.4. Double-clicking on document page 2 highlights the icon for that page, displays its page number in the Page Number box on the Document Layout palette, and takes you to that page.

1. Choose File/New/Document (**Command-N**/Macintosh or **Ctrl-N**/Windows) and create a new document without facing pages but with an automatic text box. When the document page appears, choose View/Show Document Layout (**F10**/Macintosh or **F4**/Windows) to display the Document Layout palette. This palette displays icons for the two default pages, Master Page A and document page 1 based on Master Page A.

2. Click on the Master Page A icon and drag it down onto the document page panel below page 1. Release the mouse button (Figure 4.3). You now have two document pages based on Master Page A.

3. Choose View/Fit in Window (**Command-0** [zero]/Macintosh or **Ctrl-0** [zero]/Windows) to fit the document to the screen. Click in the pasteboard area outside of the document area to deselect everything. Choose Page/Insert to display the Insert Pages dialog box (Figure 4.5). Type 2 in the Insert field and click on the "at end of document" button to insert two pages after page 2. Leave the Master Page pull-down menu set to A-Master A. Click OK.

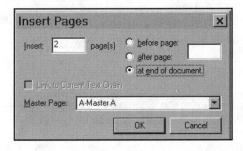

Figure 4.5. Use the Insert command to insert pages at a specific position in the document.

Drag the Resize box on the Document Layout palette to display all the pages in the document.

4. The Document Layout palette now displays four document pages (Figure 4.6). You might have to use the resize box in the lower right corner of the palette to see all four page icons.

5. Choose File/Save (**Command-S**/Macintosh or **Ctrl-S**/Windows) and save this file as *Pages.qxd* in your Projects folder. You'll be using it in the next exercise.

Figure 4.6. Two pages are added to the document.

Tip

You can Shift-select a range of pages in the Document Layout palette and then click the Trash icon (Macintosh) or ✗ icon (Windows) to delete those pages.

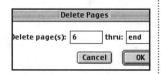

FYI

If you want to delete all the pages after the first one and you don't know the page number of the last page of the document, type *end* in the thru field. XPress will delete every page after and including the page specified in the Delete page(s) field.

FYI

Deleting pages in the Document Layout palette cannot be undone. Always save your document before deleting document pages or master pages.

DELETING DOCUMENT PAGES

QuarkXPress requires that you have at least one document page in a file. You can, however, delete any other document pages you inserted in the document, and you can delete the default document page as long as you leave one document page in the file. Pages can be deleted:

▲ **From the Document Layout palette** by selecting a page icon or Shift-selecting a range of pages and clicking the Trash icon (Macintosh) or the ✗ icon (Windows) in the Icon panel of the Document Layout palette.

▲ **From the Page Menu** by using the Delete Pages command.

EXERCISE B

1. If necessary, open the *Pages.qxd* file you just created or open the *Pages.qxd* file in the Unit 04 folder on the CD-ROM. Display the Document Layout palette (View/Show Document Layout [**F10**/Macintosh or **F4**/Windows]). The Document Layout palette displays a document with one master page and four document pages.

2. Click once on the Page 1 icon in the Document Layout palette to select it. Then click once on the Trash icon (Macintosh) or on the ✗ icon (Windows) in the Icon panel of the palette (Figure 4.7). At the alert, click OK. Page 1 is removed, leaving three pages in the document.

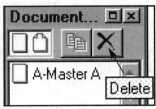

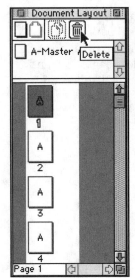

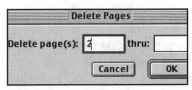

Figure 4.7. Click on a page to select it and click on the Trash icon (Macintosh) or **✗** icon (Windows) in the Document Layout palette to delete the page.

3. Double-click on the Page 2 icon in the palette to select it and to go to that page. Double-clicking on a page icon in the Document Layout palette takes you to that page. Choose Page/Delete to display the Delete Pages dialog box (Figure 4.8). Because Page 2 was selected in the palette, the Delete page(s) field displays 2. Click on OK. There are now two document pages left.

FYI

You must double-click on a page to get to that page and have its page number appear in the Delete Pages dialog box.

Figure 4.8. You can delete a single page or a range of pages in the Delete Pages dialog box. Typing *end* in the thru field will delete every page from the selected page (2) to the end of the document.

4. Click in the pasteboard area to deselect everything. The pasteboard is the white area that surrounds the page. Choose Page/ Insert. Type 4 in the Insert field and click on the "at end of document" button. Click OK to add four pages based on Master Page A. You now have six document pages.

5. Double-click on the document page 3 icon in the Document Layout palette. Choose Page/Delete to display the Delete Pages dialog box. Leave 3 in the Delete page(s) field, press the Tab key, and type 5 in the thru field to delete pages 3, 4, and 5. Click OK. The Document Layout palette now displays only three document pages (Figure 4.9).

6. Close this file (File/Close). Don't save your changes.

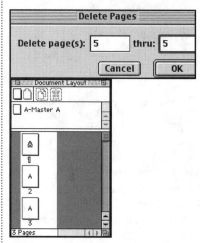

Figure 4.9. Use the Delete Pages dialog box to delete a range of pages.

AUTO PAGE INSERTION

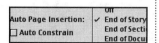

Select an Auto Page Insertion method in the General Preferences dialog box.

If you selected the Automatic Text Box option in the New Document dialog box and you import or type more text than can fit into that single text box on document page 1, QuarkXPress will automatically add pages to hold the overflow text, depending on the option you selected in the General Preferences dialog box. Unless Auto Page Insertion is set to Off, new pages will be added to the document.

If, for example, you're working on a four-page newsletter, add three additional pages to the default single document page, then choose Edit/Preferences/Preferences. In the General area, choose Off from the Auto Page Insertion menu. This forces you to edit the text and graphics to fit within the four-page document.

LESSON 2: NAVIGATING A DOCUMENT

GETTING AROUND A MULTIPLE-PAGE DOCUMENT

Working with multiple-page documents requires navigational skills if you are to find a specific page quickly. Unless you double-click on the page icon in the Document Layout palette, you must know the page number of the page you want to get to.

HOW PAGES ARE NUMBERED

When you create a document, the first page is automatically numbered page 1. If you add nine more pages to the document, those pages are pages 2, 3, and so on. Not only are the pages numbered sequentially from 1 to 10, but they are also positioned in the document in that order. This is called *absolute page numbering.*

But what if the first page your magazine article begins on is page 37? It still begins on document page 1, but displays a folio number of 37. You create folios (custom page numbers) with the Section command. You'll learn how to use the Section command later. For now, just keep in mind that you can assign any page number to a document page. However, these custom page numbers are not absolute numbers and bear no relation to a page's position in the document. Page 37 of your magazine article is really absolute page number 1 in the document.

ABSOLUTE PAGE NUMBERS

The absolute page number refers to a page's *position* in the document regardless of any custom numbering applied with the Section command. The magazine article that begins on the first page of the document can have any custom page number. The absolute page number is 1 regardless of the custom folio number (Figure 4.10).

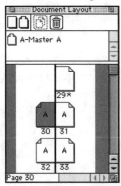

Figure 4.10. Page 30 is the custom page number (folio) for the second page in the document. Its absolute page number is 2, because it is the second document page.

GETTING FROM PAGE TO PAGE

There are four ways of getting around an XPress document:

▲ **Double-click on the page icon** for any page in the Document Layout palette to display that page on the screen.

▲ **Use the Go to command** from the Page menu and type the page number in the dialog box to display that page. You can type the actual page number, which is the custom folio number you applied to the page; or type the absolute page number, which is the page's position in the document. When typing an absolute page number, type a + (plus sign) before the number (Figure 4.11).

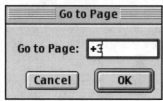

Figure 4.11. Typing a + before the absolute page number (3) takes you to the third page in the document regardless of its folio number.

▲ Type a page number in the Page Number field in the lower left corner of the Document window (Figure 4.12). Again, type either the absolute page number with the +, or type the actual folio number. Click anywhere on the page or press Return/Enter to get to that page.

Figure 4.12. Typing a + before the absolute page number (4) takes you to the page regardless of its custom folio number.

▲ Use the Go-to-Page icons at the bottom of the document page (Figure 4.13). The pages display the actual page number, but the position of the icon tells you whether it's the first, second, third, etc. page in the document.

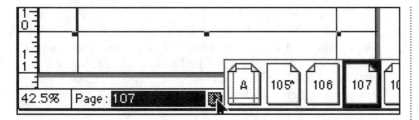

Figure 4.13. Click on the page arrow to display all the document page icons. Then drag to select a page to navigate to that page. Page A is Master Page A.

EXERCISE C

1. Create a new document (**Command-N**/Macintosh or **Ctrl-N**/Windows) without facing pages, with 1 column, with half-inch margins, and with an automatic text box (Figure 4.14).

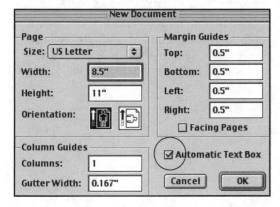

Figure 4.14. Create a new document with an automatic text box.

Select All

When you choose Edit/Select All, XPress selects all the text in the linked text boxes, including any text hidden by the Overflow Indicator.

2. Display the Document Layout palette (**F10**/Macintosh or **F4**/Windows) and the Measurements palette (View/Show Measurements or **F9**).

3. Click inside the text box on page 1 and choose File/Get Text (**Command-E**/Macintosh or **Ctrl-E**/Windows). Navigate to the Student Files folder in the Unit 04 folder on the CD-ROM and double-click on the *Web.txt* file to import it into the document.

4. Choose Edit/Select All (**Command-A**/Macintosh or **Ctrl-A**/Windows) and format the text in 24-point type. This should add two more pages to the document.

5. Double-click on page 2 to get to that page. Choose Page/Go to (**Command-J**/Macintosh or **Ctrl-J**/Windows) and type 3 in the Go to Page field. Click OK to move to page 3 of the document. Notice that Page 3 appears in the Page field in the lower left corner, not the Document Layout palette. Because you haven't applied any custom folio numbers to these pages, you are using absolute page numbers and don't have to type the + before the page number.

6. Type 1 in the Page Number field in the lower left corner of the document window and press Return/Enter to get to page 1. Notice that the number 1 on the document icon in the Document Layout palette for page 1 is outlined, indicating that you're on that page. Click on the document icon for page 1 to highlight it. Page 1 appears in the Page field at the bottom of the Document Layout palette.

7. Click on the black triangle in the Page Number field at the bottom of the document window to to display the Go-to-Page icons and drag to select another page.

8. Continue navigating though the document until you're familiar with the process. Close the document (File/Close [**Command-W**/Macintosh or **Ctrl-F4**/Windows]). Don't save your changes.

LESSON 3: NUMBERING PAGES

SPECIFYING CUSTOM PAGE NUMBERS

If you could leave page numbers as they are assigned when you insert pages in a document, life would be much easier. But when working on long documents such as books, newspapers, and magazines, you're forced to section off your document and number the pages accordingly.

For example, in a work environment on a magazine, you could be laying out an article on fiberglass shoes and someone else could be laying out another article on lapel sizes in men's jackets. Your article will start on page 27 of the issue and the other article will start on page 64 of the same issue. In between there will be other articles and advertising pages. Most likely, the advertising pages won't be numbered, but the articles will be. To further complicate the issue, a corporate mucky-muck has paid the magazine big bucks to run an advertising supplement in the middle of the issue promoting his company's men's hair-loss remedy. This supplement will be numbered in Roman numerals while the rest of the issue's pages will be numbered with Arabic numbers. To number all these pages properly, you must use the Section command.

SECTION COMMAND

In a long document like a book, the first few pages (called *front matter*) that include copyright information, a preface, and table of contents, are usually numbered with Roman numerals. The first chapter of the book then begins with Arabic number 1. To display these two numbering styles in XPress, use the Section command.

The Section dialog box (Figure 4.15) lets you specify the page number (folio) for a page. XPress will then continue to number the pages from that number until it encounters another page to which the Section command was applied.

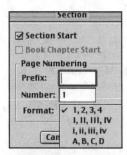

Figure 4.15. The Section dialog box is where you specify custom page numbers.

SECTION DIALOG BOX

You must be on the page where you want to start a new section and then choose Page/Section to display the Section Start dialog box. Click the Section Start field to section the pages. Then type the page number you want that page to start with. When you click OK, that page in the Document Layout palette displays an asterisk, indicating that you applied the Section command (Figure 4.16).

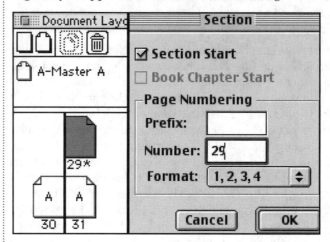

Figure 4.16. Because we typed 29 in the Number field of the Section dialog box, the selected page icon in the Document Layout palette displays an asterisk indicating that a new section starts at that page.

REMOVING THE SECTION COMMAND

Once the Section command is applied to a page, all pages are numbered consecutively from that page number. To remove the Section command, go to the sectioned page, display the Section dialog box and deselect the Section Start check box. When you click OK, all pages are numbered consecutively from the last sectioned page.

CONSECUTIVE PAGE NUMBER COMMAND

Although XPress numbers the pages consecutively on the Document Layout palette, it's only helpful when you're creating documents that don't display the page number on the printed page. When you're printing documents that display page numbers, use the Consecutive Page Number command on the master page for the document. This command appears as a *code* on the master page but translates to a page *number* on the document pages (Figure 4.17).

Figure 4.17. The Consecutive Pages command appears as code on the master page (top) but translates to the appropriate page number on the document pages (bottom).

PAGE NUMBERS AND MASTER PAGES

Unless you want to number pages manually—and you don't want to do this—you need to put the code for the consecutive page number on a master page so that every document based on that master page displays the actual page number. A master page is a non-printing page on which you place items that you want to appear on every document page based on that master page. You'll learn more about master pages later, but for now just keep in mind that if you place the code for the consecutive page numbers on a master page, the actual page number will appear on the document pages.

EXERCISE D

1. Open the *Pages.qxd* file in the Unit 04 folder in the Student Files folder on the CD-ROM (File/Open [**Command-O**/Macintosh or **Ctrl-O**/Windows]). Display the Document Layout palette (**F10**/Macintosh or **F4**/Windows) This document contains 15 pages of text on nonfacing pages. Let's assume it's the document for a small booklet or magazine. You will need to section it off for the front matter (table of contents), body (articles and advertisements), and back matter (index of advertisers). To do this you need to create page numbers on the master page, then use the Section command to section the document.

2. Double-click on the Master Page A icon in the center panel of the Document Layout palette (Figure 4.18).

Double-click on the master page icon to get to the master page.

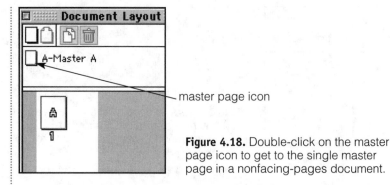

master page icon

Figure 4.18. Double-click on the master page icon to get to the single master page in a nonfacing-pages document.

3. Because this is a nonfacing-pages document, it contains only one master page. It displays only the margin guides for the three columns specified when the document was created. Master pages are nonprinting pages where you create items that will appear on every document page based on that master page. We want page numbers on every document page based on Master Page A, so we'll put the page number command (code) on the master page.

4. Draw a text box across the width of the page at the top of the master page. Make it about 1" high.

5. Type **Command-3** (Macintosh) or **Ctrl-3** (Windows) to display the Consecutive Page Number command in the text box (Figure 4.19). You must keep the modifier key (Command or Ctrl) pressed while pressing the number 3 to generate the symbol.

Figure 4.19. Pressing Command-3 or Ctrl-3 in a text box creates the Consecutive Page Number command (<#>).

6. Select the Consecutive Page Number symbol and format it in a large type size. Center it in the text box (Style/Alignment/ Centered [**Command-Shift-C**/Macintosh or **Ctrl-Shift-C**/Windows]).

7. Double-click on document page 1 to get to that page. Notice that the code for the page number translates as the actual page number on the document page (Figure 4.20). Double-click on the other pages of the document and notice that they are all numbered consecutively.

Figure 4.20. The code for the page number on the master page displays as the actual page number on the document page.

8. Double-click on page 1 in the Document Layout palette to get to that page. Choose Page/Section to display the Section dialog box. Click the Section Start check box to activate the Section command. Leave the Number field at 1, but pull down the Format menu and select lower-case Roman Numerals (Figure 4.21). Click OK and notice that three things happen:

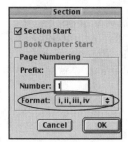

Figure 4.21. The Section dialog box

▲ All the pages are now numbered consecutively with lower-case Roman numerals.

▲ The icon for document page 1 in the Document Layout palette displays an asterisk, indicating that the document was sectioned at that page (Figure 4.22).

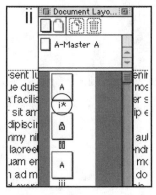

Figure 4.22. The asterisk next to page 1 indicates that the document was sectioned at that page.

▲ The pages are numbered using Roman numerals in the Document Layout palette.

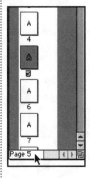

Click the Page Number box in the Document Layout palette to display the Section dialog box.

9. Double-click on page 4 (iv) in the Document Layout palette to get to that page. Choose Page/Section. Click the Section Start check box to activate the command. Type 1 in the Number field, but choose Arabic numbers from the Format menu (Figure 4.23). Click OK to return to the document.

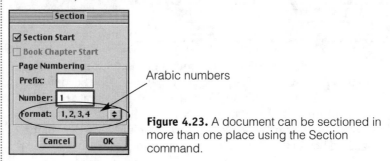

Arabic numbers

Figure 4.23. A document can be sectioned in more than one place using the Section command.

10. Notice that all the pages from the fourth document page to the end are now numbered consecutively with Arabic numerals from number 1 and that the page icon for document page 4 displays an asterisk, indicating that the document was sectioned at that page (Figure 4.24).

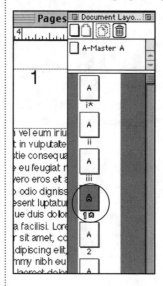

Figure 4.24. The asterisk after the page number for document page 4 indicates that the document was sectioned at that page.

11. Double-click on document page 5, the eighth page in the document) to get to that page. Click the Page Number box in the lower left corner of the Document Layout palette to display the Section dialog box. Click the Section Start check box, type 36 in the Number field, and leave the Format menu at Arabic numbers. Click OK. Again, the page icon for that page in the Document Layout palette displays an asterisk, indicating that the document was sectioned at that page. The sixth document page (absolute page number 6) becomes folio page number 36 and all subsequent pages in the document are numbered consecutively from 36 (Figure 4.25).

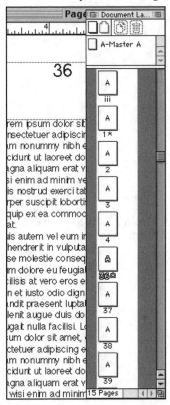

Figure 4.25. Document pages are numbered consecutively from the last sectioned page.

12. To remove the section command, double-click on page 1, the page you sectioned with Roman numeral 1. Click on the Page Number box in the lower left corner of the Document Layout palette to display the Section dialog box. Deselect the Section Start check box and click OK. The page is renumbered using the next consecutive Roman numeral. Pages are numbered with Roman numerals until they encounter the sectioned page 36 (Figure 4.26).

13. Close this file (**Command-W**/Macintosh or **Ctrl-F4**/Windows). Don't save your changes.

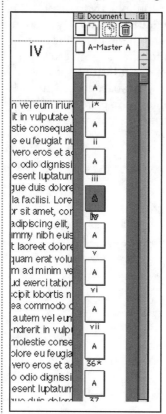

Figure 4.26. Removing the Section command from a page numbers it consecutively from the previous Section command.

WHAT IS LINKING?

Linking is the process of flowing text from one text box to another text box anywhere in the document. When you create a document with the Automatic Text Box option selected, any text you import into that document or create in that document will automatically flow from page 1 to page 2 and so on. No matter where you add text in the document, the text will continue to flow from that page to the following page.

AUTOMATIC LINKING

Documents created with the Automatic Text Box option selected in the New Document dialog box have a linked text box on the master page. Any document pages added to the document based on that master page will also contain linked text boxes.

Another way to create linked text boxes in a document created without the Automatic Text Box option is to draw a text box on the master page, select the Linking tool, click on the Linking Arrow in the upper right corner of the master page, and click on the the text box you just created. Now any pages you add to the document will also contain a linked text box.

MANUAL LINKING

If you create a document without an automatic text box and want to link text from one text box to another text box anywhere in the document, you must manually link those text boxes. You do this by selecting the Linking tool, clicking in the source text box, and then clicking in the target text box. However, this works only if the target text box is empty of any text. You can't link a text box containing text to another text box containing text.

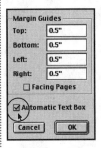

Select the Automatic Text Box option in the New Document dialog box.

INTERRUPTING TEXT FLOW

However, there are times when you will interrupt that text automatic flow and flow text into different boxes or onto different pages:

▲ **Manual text boxes** created in a document that does not have an automatic text box require text boxes to be linked if text is to flow from one box to another.

▲ **Periodicals** such as newspapers and magazines often continue text from one page to another page further on in the document. For example, you may start a newspaper article on page 1 of the document but continue it on page 12 of the same document. To do this, you must link the text on page 1 with the text box on page 12.

▲ **"Designer" text boxes** (Figure 4.27) frequently use linking to flow text from one box to another.

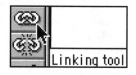

Figure 4.27. The two text boxes above are linked using the Linking tool. When you click on a linked text box, an arrow shoots from the source text box to the target text box.

EXERCISE E

1. Create a new document (**Command-N**/Macintosh or **Ctrl-N**/ Windows) using the values in Figure 4.28. Make sure that you have deselected the Automatic Text Box and Facing Pages options.

2. Click with the Content tool on page 1. Notice that nothing happens. The I-beam cursor doesn't appear because there is no text box on this page. Because you didn't select the Automatic Text Box option in the New Document dialog box, no text box is created on the document page.

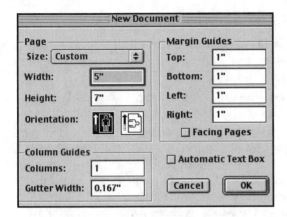

Figure 4.28. Create a page with a custom page size and without an automatic text box.

3. Use the Rectangle Text Box tool to draw a text box within the margins on the page. With the new text box selected, choose File/Get Text (**Command-E**/Macintosh or **Ctrl-E**/Windows). Navigate to the Unit 04 folder in the Student Files folder on the CD-ROM and double-click on the *Web.txt* file to open it in the selected text box. Notice that a red X appears in the lower right corner of the text box (Figure 4.29) This is called the Overflow Indicator and tells you that you have imported more text than can fit in that text box.

Rectangle Text Box tool

The Web: Revolution or Evolution
Undoubtedly the most revolutionary and evolutionary technology of the mid-1190s is the World Wide Web. No other communication medium has so vastly affected the entire world in the last 20 years like the Internet. Truly, it is exciting to live the later part of the twentieth century where technology changes almost hourly and where information is so readily accessible.
In retrospect, several inventions have caused major revolutions in the area of worldwide communication. A few are comparable to the emergence of the Web and its effects on the world at large. Seldom during the emergence of a technology do operands of the technology see its true significance. Nor can they comprehend its effect as it ripples through other avenues of implementation. Often the global impact is not perceived until 10, 20, even 100 years later. Through hindsight, society judges the innovation and impact of technolo-⊠

Overflow Indicator

Figure 4.29. The Overflow Indicator appears at the bottom of a text box that contains more text than will fit in that text box.

When working with a client's specifications, you can't reduce type size or delete text unless you first check with the client. You can, however, reduce type size in decimal increments without changing the appearance of the page. For example, type size can be changed from 10 points to 9.9 points without any visual damage. Type is visual, and the eye is much easier to fool than than the ear.

4. At this point, you have several options for copyfitting:

▲ **Reduce font size and leading.** You can do this if font size and leading are not issues, but you can reduce only so much before the type becomes unreadable.

▲ **Delete selected text.** You can delete enough text to make the text fit in this single box. Usually, this is not a realistic option.

▲ **Delete all the text from the Overflow Indicator to the end of the flowed text.** XPress provides a nifty way of selecting and deleting all the text from one point to the end of any text—visible or hidden—in the document. Click at the point where you want to start deleting text and press **Command-Option-Shift-Down Arrow** (Macintosh) or **Ctrl-Alt-Shift-Down Arrow** (Windows) to select the text, then press the Delete key to delete the text. In a production setting, this is also not a realistic option.

▲ **Create and link additional text boxes** into which text can be flowed. This is usually what you will do.

▲ To flow the additional text in the document, first select all the text. Click inside the text box and choose Edit/Select All (**Command-A**/Macintosh or **Ctrl-A**/Windows). This selects all text, even the text hidden by the Overflow Indicator. Change the type size to 10 and font to Times.

▲ Before you do any linking, save the document (File/Save [**Command-S**/Macintosh or **Ctrl-S**/Windows]). On the Document Layout palette, drag the Master Page A icon down onto the document area (Figure 4.30) to add another page to the document. Because this new page is based on Master Page A, it doesn't have a text box on it. Use the Rectangle Text Box tool to draw a text box on the new page.

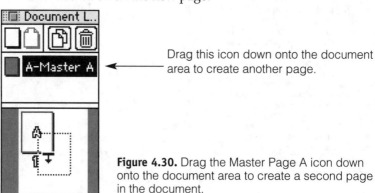

Drag this icon down onto the document area to create another page.

Figure 4.30. Drag the Master Page A icon down onto the document area to create a second page in the document.

5. Select the value in the View Percent field in the lower left corner of the document window and type 30 to reduce the view to 30% magnification. Press Return/Enter to execute the command. Scroll so that you can see both document pages.

6. Select the Linking tool and click on the text box on document page 1, the page with the Overflow Indicator. A flashing marquee appears around that page. Now click with the Linking tool inside the empty text box on the second document page to flow the text from page 1 to page 2. An arrow appears going from page 1 to page 2, indicating the direction of the text flow (Figure 4.31).

View Percent field

Press **Control-V**/Macintosh or **Ctrl-Alt-V**/Windows to highlight the View Percent field in the lower left corner of the document window.

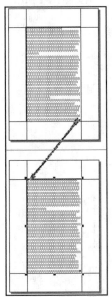

Figure 4.31. Text flows from the top page to the bottom page, as indicated by the direction of the Linking Arrow.

7. Click on the Content tool *immediately*! It's dangerous to keep the Linking tool active, as you can't undo linking, and clicking with it in the wrong box can completely destroy the text flow in a document.

8. The Overflow Indicator appears at the bottom of the second page, which tells you that there is still more text to be flowed. Drag another Master Page A icon down onto the document area of the Document Layout palette, draw a text box on that page, and select the Linking tool again.

9. Click on page 2 to display the flashing marquee and click inside the empty text box on page 3 to flow text from page 2 to page 3.

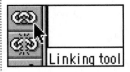

10. Continue to add pages, draw text boxes, and link text boxes until all the text is flowed into document pages and the Overflow Indicator disappears.

11. Close this file (File/Close [**Command-W**/Macintosh or **Ctrl-F4**/Windows). Don't save your changes.

Review

When you click with the Linking tool on the Broken Link icon and then click inside the text box you drew on the master page, four things happen:
1. The flashing marquee appears around the text box.
2. The Broken Link icon becomes the Intact Link icon.
3. The Linking Arrow goes from the Intact Link icon to the text box.
4. The I-beam cursor appears inside the text box.

CREATING AN AUTOMATIC TEXT BOX LINK

An easier way to link multiple pages, in a document that doesn't contain an automatic text box, is to create a text box on the master page and make it a linked box. Every master page displays a Linking icon. That icon will be intact if the document was created with an automatic text box. It will be broken if there is no automatic text box (Figure 4.32).

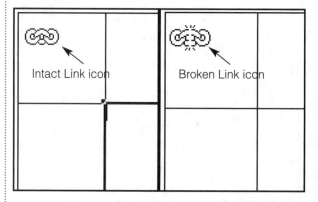

Figure 4.32. The master page for the document on the left was created with an automatic text box and displays the Intact Linking icon. The master page for the document on the right was created without an automatic text box and displays the Broken Link icon. These icons appear only on the master page, not on the document pages.

EXERCISE F

1. Create a new nonfacing-pages document (**Command-N**/Macintosh or **Ctrl-N**/Windows) with no automatic text box.

2. Double-click on the Master Page A icon to get to the master page. Because you didn't select the Automatic Text Box option in the New Document dialog box, the master page displays the Broken Link icon (Figure 4.33).

Rectangle Text Box tool

Figure 4.33. A document created without the Automatic Text Box option displays the Broken Link icon on its master page, because there is no linked text box in the document.

3. Use the Rectangle Text Box tool to draw a text box on the page between the margin guides.

4. Select the Linking tool. Click on the Broken Link icon. A flashing marquee appears around the icon. Then click inside the text box you just drew. The flashing marquee appears around the text box, and a linking arrow goes from the icon to the text box. The Broken Link icon becomes an Intact Link icon, indicating that the text box is now a linked text box (Figure 4.34). Notice that the I-beam cursor appears in the text box. This tells you that you have created an automatic text box.

Linking tool

Tip

Press the Option or Alt key when selecting any tool to keep that tool active until you select another tool. This is handy when you want to draw more than one text box on a page and don't want the cursor to revert to the Content tool once you've drawn the first box.

Figure 4.34. When the Broken Link icon is linked to a text box on the master page, the icon becomes the Intact Link icon, indicating that a linked text box was created.

5. Double-click on document page 1 to get to that page. Click inside the text box that now appears on the page and choose File/Get Text (**Command-E**/Macintosh or **Ctrl-E**/Windows). Navigate to the Unit 04 folder inside the Student Files folder on the CD-ROM and double-click on the *Web.txt* file to import it into the document. Because you created an automatic text box on the master page, XPress creates as many pages as are needed to hold all the text in the file. No Overflow Indicator appears because all the text flows into pages automatically created to hold all the text.

6. Close this file (**Command-W**/Macintosh or **Ctrl-F4**/Windows). Don't save your changes.

LINKING RANDOM TEXT BOXES

Some designs call for text to flow from one text box to another with the text boxes all on the same page. Here, you are not flowing text for a long document such as a book or newspaper article, but using the text boxes as a design element instead of as just a type container.

1. Open the *Cats.qxd* file in the Unit 04 folder in the Student Files folder on the CD-ROM. It contains three text boxes shaped like cats' heads. These are QuarkXPress text boxes created with the Freehand Text Box tool, which lets you draw editable text boxes as if you were using a pencil, instead of a rectangle or oval text box tool. You'll learn more about this tool later.

2. Select the Content tool and click inside the first text box at the top of the page. Choose File/Get Text (**Command-E**/Macintosh or **Ctrl-E**/Windows). Navigate to the Unit 04 folder in the Student Files folder on the CD-ROM and open the *Cats.txt* file. The text flows inside the first box and displays the Overflow Indicator, which tells you that there is more text than can fit in the box (Figure 4.35).

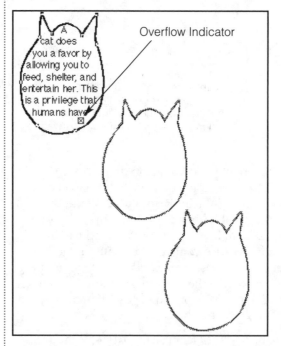

Figure 4.35.
Because the three text boxes aren't linked, the Overflow Indicator appears in the first text box.

3. Hold down the Option key (Macintosh) or Alt key (Windows) and click on the Linking tool. Pressing the modifier key when selecting a tool keeps that tool active until you choose another tool. Click on the first box, the one with the overflow text. Click on the second box to flow the text into that box. Click on the third box to flow the text into that box. There isn't enough text to fill the third box, but it remains linked to the other two boxes. Click on the Content tool immediately!

4. With the Content tool selected, click once inside the first text box and choose Edit/Select All (**Command-A**/Macintosh or **Ctrl-A**/Windows) to select all the text. Increase the type size, change the typeface, center-align the text, and adjust the leading from the Measurements palette until the text fits into the three boxes. Your screen should resemble Figure 4.36.

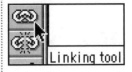

Linking tool

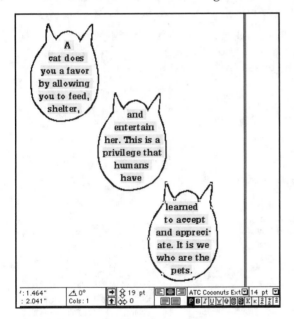

Figure 4.36. Text is flowed into the three text boxes.

5. Save this file as *Link.cats.qxd* in your Projects folder (File/Save [**Command-S**/Macintosh or **Ctrl-S**/Windows]). You will need it for the next exercise.

Always save the file
before linking and unlink-
ing text boxes. If you find
you've made mistakes in
linking or unlinking,
choose File/Revert to
Saved to revert to the last-
saved version of the file,
where you can begin to
link and unlink again.

UNLINKING TEXT BOXES

Any series of linked text boxes can be unlinked. When text boxes are unlinked, any overflow text goes into the first text box in the original chain of linked boxes. You can unlink any text box in a text chain, not just the last text box, by pressing the Shift key when clicking with the Unlinking tool.

EXERCISE H

1. If necessary, open the *Link.cats.qxd* file you saved in your Projects folder or open the *Link.cats.qxd* file in the Unit 04 folder in the Student Files folder on the CD-ROM. It displays three linked text boxes with text flowing from the first, to the second, to the third text box.

2. Select the Unlinking tool, the tool above the Scissors tool, and click once on the top text box. The Linking Arrows appear, showing how the boxes are linked (Figure 4.37).

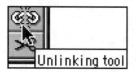

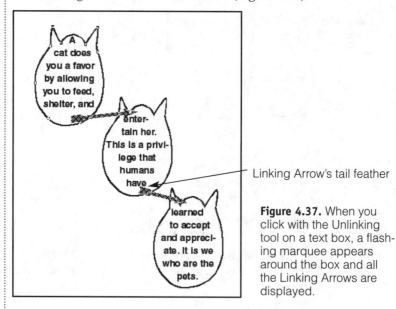

Linking Arrow's tail feather

Figure 4.37. When you click with the Unlinking tool on a text box, a flashing marquee appears around the box and all the Linking Arrows are displayed.

3. Click on the tail feather of the Linking Arrow in the middle text box. The link is broken between the second and third text boxes, and all the text flows into the first and second text boxes. Because there is more text than can fit in those boxes, the Overflow Indicator appears.

4. Option-click (Macintosh) or Alt-click (Windows) on the Linking tool to keep it selected and click on the first text box to display the flashing marquee. Click in the second and third text boxes to flow the text into the three boxes again.

5. Select the Unlinking tool, and click on the tail feather of the third Linking Arrow, the one going into the third text box. The link is broken and the text flows into the first two text boxes, displaying the Overflow Indicator.

6. Select the Linking tool, click on the middle text box to display the flashing marquee, and click inside the third text box to flow the text once more through the three text boxes.

7. Select the Unlinking tool, press and hold the Shift key, and click on the tail feather of the Linking Arrow going into the third text box. This breaks the link between the first and second text boxes *and* between the second and third text boxes, flowing the text from the first text box directly into the third text box. Pressing the Shift key when clicking with the Unlinking tool unlinks only one box in a chain of linked text boxes. If you don't press the Shift key, the box you unlink and all subsequent boxes are removed from the text chain.

8. Close this file (**Command-W**/Macintosh or **Ctrl-F4**/Windows). Don't save your changes.

CREATING JUMP LINES

Magazines and newspapers often start an article on one page, and then (annoyingly) continue the story on another page. To move the text from a text box on one page to a linked text box on another, non-consecutive page, use the Next Box and Previous Box page number commands. These commands work the same way as the Consecutive Page Number command in that they create code that translates into a page number inside the linked text box. The commands are:

▲ **Next Box command: Command-4** (Macintosh); **Ctrl-4** (Windows) to jump to the linked text box that contains the Previous Box command; usually preceded by "Continued on page…"

▲ **Previous Box command: Command-2** (Macintosh); **Ctrl-2** (Windows) that reads the page number from the first linked text box; usually preceded by "Continued from page…"

1. Create a new document with an automatic text box (File/New/Document [**Command-N**/Macintosh or **Ctrl-N**/Windows]). Display the Document Layout palette (**F10**/Macintosh or **F4**/Windows).

2. Select the text box on the first page of the document and choose File/Get Text (**Command-E**/Macintosh or **Ctrl-E**/Windows). Locate the *Jump.txt* file in the Unit 04 folder in the Student Files folder on the CD-ROM and double-click on it to import it into the selected text box. Because this document was created with an automatic text box, XPress adds a second page to hold all the text. Click on the Master Page A icon in the Document Layout palette and drag a third page down onto the document area of the palette.

3. Double-click on the page 1 icon in the Document Layout palette to get to page 1. Use the Rectangle Text Box tool to draw a text box on the bottom of the page but *inside the large text box*. Make this new text box the entire width of the page. Type *Continued on page*, press the Spacebar, then press **Command-4** (Macintosh) or **Ctrl-4** (Windows) to insert the Next Box Page Number command. The number 2 appears because this story is now linked from page 1 to page 2.

4. Click after the last text character in the large text box on page 1. Press **Command-Option-Shift-Down Arrow** (Macintosh) or **Ctrl-Alt-Shift-Down Arrow** (Windows) to select all the text *from the insertion point*. Choose Edit/Cut (**Command-X**/Macintosh or **Ctrl-X**/Windows). Keep the cut text in memory on the Clipboard.

5. Click on the Linking tool. Click on the large text box on page 1 to display the flashing marquee. Double-click on the page 3 icon in the Document Layout palette to get to page 3. Click inside the large text box on page 3 to link page 1 to page 3. Select the Content tool immediately.

6. Click inside the large text box on page 3 and choose Edit/Paste (**Command-V**/Macintosh or **Ctrl-V**/Windows) to paste the cut text onto page 3.

7. Use the Rectangle Text Box tool to draw another small text box on top of the automatic text box on page 3. Type *Continued from page*, press the Spacebar, and press **Command-2** (Macintosh) or **Ctrl-2** (Windows). This is the Previous Box Page Number command. The number 1 appears, telling you that this story is continued from page 1.

8. Double-click on the page 1 icon in the Document Layout palette. Notice that the small text box now displays Continued on page 3.

9. Close this file (File/Close [**Command-W**/Macintosh or **Ctrl-F4**/Windows]). Don't save your changes.

REVIEW PROJECT 1

This project creates a multiple-page document with sectioned page numbers.

1. To work with a multiple-page document with numbered pages, create a new document with the specifications displayed in Figure 4.38. Don't worry about selecting Custom from the Page Size menu. Once you type the Width and Height values, Custom will automatically appear.

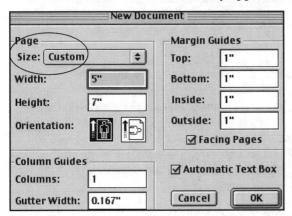

Figure 4.38. The page size displays Custom when you specify custom width and height values.

2. Display the Measurements palette (**F10**/Macintosh or **F4**/Windows) and double-click on the Master Page A icon to get to the master page. Draw a text box at the bottom of the left facing page below the margin guide. Type *Shrew, page* [space] and type the Consecutive Page Number command, **Command-3** (Macintosh) or **Ctrl-3** (Windows). Select the text, format it, and center it in the box. With the box selected, choose Item/Duplicate (**Command-D**/Macintosh or **Ctrl-D**/Windows) and use the Item tool to move the duplicate to the bottom of the right facing page (Figure 4.39).

Notice the links!

The Intact Link icon in the upper left corner of each master page indicates that this document was created with an automatic text box. This means that when you type or import more text than can fit on the single default document page, XPress will automatically add enough pages to hold all the text.

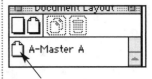

Double-click on this icon to get to Master Page A.

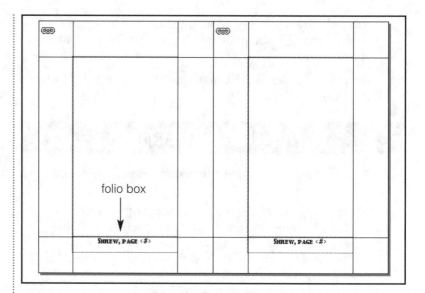

Figure 4.39. Duplicate the folio box and move it to the bottom of the other master page.

Absolute page numbers

The absolute page number refers to a page's position in the document regardless of any custom numbering applied with the Section command. When you made page 3 page 115, that page's absolute page number remained 3 even though its folio (page number) was changed to 115.

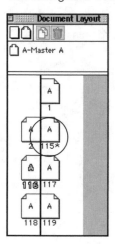

3. Double-click on the document page 1 icon in the Document Layout palette to return to the document. Click inside the automatic text box and choose File/Get Text. Navigate to the Unit 04 folder in the Student Projects folder on the CD-ROM. Open the *Shrew.txt* file. This is a scene from Shakespeare's *Taming of the Shrew* and requires more than 20 pages to flow in the document. XPress automatically adds enough pages to hold the entire document.

4. Navigate the document by double-clicking on the page icons in the Document Layout palette. Then choose Page/Go to (**Command-J**/Macintosh; **Ctrl-J**/Windows) and type 10 in the Go to Page field.

5. Click on the arrow in the Page Number field in the lower left corner of the Document window and click on the icon for page 3 to get to page 3 (Figure 4.40).

Figure 4.40. Use the Page Number field to navigate the document.

6. Choose Page/Section. In the Section dialog box, click the Section Start check box. Then type 115 in the Number field. Because this is a facing-pages document, the right-hand pages are always numbered with odd numbers; observe this convention when renumbering pages, or the pages will reflow. Click OK to return to the document and notice that page 3 is now page 115 (Figure 4.41). Notice, too, that 115 displays an asterisk next to the number on the Document Layout palette and in the Page Number field at the left side of the document window. This indicates that the page has been sectioned.

An asterisk next to a page number indicates that the page has been sectioned.

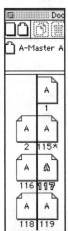

Figure 4.41. Use the Section Start command to change folio page numbers.

7. Choose Page/Go to (**Command-J** (Macintosh) or **Ctrl-J** (Windows) and type +5 in the Go to page dialog box. This is the absolute page number for folio page 117. You will be taken to page 117 because page 117 is the fifth page in the document (Figure 4.42).

Figure 4.42. Page 117 is the fifth document page (absolute page number) but 117 is its folio (page) number.

8. Choose page 115 from the Page Number field at the bottom of the document window or double-click on page 115 in the Document Layout palette to get to that page. Choose Page/Section and deselect the Section Start check box. Click OK to remove the sectioning and return the page to page number 3.

9. Close this file (**Command-W**/Macintosh or **Ctrl-F4**/Windows). Don't save your changes.

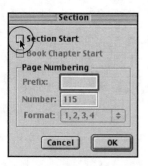

Remove page sectioning

To remove the page sectioning, go to the page with the Section command active, display the Section dialog box, and deselect the Section Start check box.

REVIEW PROJECT 2

In this project you'll create a four-page newsletter.

1. This front page has a grid displayed in Figure 4.43. All multiple-page documents should use a grid to keep the pages consistent. Sometimes the grid is only one column, but it's consistently one column.

Figure 4.43. This first page has a 3-column grid. The left column has a background color and another box crosses the width of the second and third columns.

2. When you create the new document:

▲ **Select the Facing Pages option,** because the newsletter will be printed on both sides of the page.

▲ **Deselect the Automatic Text Box option** even though it seems like the logical thing to do. Newsletters often shift the text from a column on one page to a column on another page, using jump lines to direct the reader. It's easier to create the multi-column text box on each page and then jump the text to that column than to have a long story flow from one page to the next.

▲ **Type 1 in the Columns field.** You will create two- and three-column text boxes manually.

3. In the new document, use the General Preferences dialog box to turn off Auto Page Insertion. Because this is a four-page newsletter, you can't have more than four pages.

4. Use the Document Layout palette to add three additional pages to the document, to create the four-page document.

5. Double-click on Master Page A and draw a text box the width of the margin guides below the bottom margin guide. Type *Reviews Page* and type the Consecutive Page Number command, **Command-3** (Macintosh) or **Ctrl-3** (Windows). Be sure to keep the modifier key pressed when pressing 3. This displays the code for the consecutive page command, <#>. Go to document page 1 and notice that the actual page number appears at the bottom of the page.

6. Draw a large picture box (A) for a graphic title (*Review.eps* in the Unit 04 folder in the Student Files folder on the CD-ROM). Draw three smaller text boxes for information about the newsletter (B, C, and D). Position them on the graphic. Draw a horizontal rule to separate the graphic nameplate from the text. Your screen should resemble Figure 4.44.

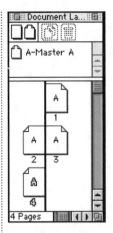

Be sure to position additional pages in the facing-pages format when you drag Master Page A down onto the document area of the Document Layout palette.

Access the Auto Page Insertion option in the General panel of the Document Preferences dialog box.

Figure 4.44. Use individual text boxes to place text on top of graphics.

7. Draw two text boxes for body copy below the masthead, one of which displays a color tint (E). The right text box, a two-column text box, contains a picture with a smaller caption text box below it. Another text box for the headline runs the width of the two text columns on the right (Figure 4.45).

Figure 4.45. Draw a picture box and a text box for the picture caption in the right column of the text box.

8. Flow any text (you can use the *Lorem Ipsum* file in the Unit 04 folder in the Student Projects folder on the CD-ROM) into the yellow text box on the left. It won't fit in the text box, so create a jump line to page 4. Draw a small text box at the bottom and inside of the yellow text box and type *Continued on page*; then type the Next Page command, **Command-4** (Macintosh) or **Ctrl-4** (Windows). Be sure to keep the Command or Ctrl key pressed when pressing the 4. This displays the code for the jump line, <None> in the text box (Figure 4.46).

Figure 4.46. The Next Page command symbol <None> will be replaced by the actual page number when you link the text boxes.

9. Go to page 4 and draw a three-column text box on that page. Go back to page 1 and select the Linking tool. Click in the yellow text box to display the flashing marquee. Go to page 4 (double-click on the page 4 icon in the Document Layout palette) and click inside the three-column text box you just drew to flow the excess text into that text box.

10. Draw a small text box at the top of and *inside* the first column of text on page 4 and type *Continued from page* and type the Previous Page command (**Command-2**/Macintosh or **Ctrl-2**/Windows). Keep the modifier key pressed when typing the 2. The box on page 4 now reads *Continued from page 1* (Figure 4.47) and the small text box at the bottom of page 1 reads "Continued on page 4."

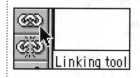

Figure 4.47. The <None> symbol is replaced by the actual page number.

11. Select all the text in the yellow text box and use the Style menu or the Measurements palette to format it in 10-point type on at least 12 points of leading.

12. Flow text into the two-column text box on page 1. Again the Overflow Indicator appears, because the box isn't linked to any other text box.

13. Draw a small text box at the bottom of the first column in the two-column text box and type *Continued on page* and type the Next Page command (**Command-4**/Macintosh or **Ctrl-4**/Windows). This displays the code for the Next Page command, <None>.

14. Go to page 4 and draw a three-column text box on page 4. Go back to page 1, select the Linking tool, and click inside the two-column text box to display the flashing marquee. Go to page 4 and click inside the new text box you just drew to flow the text into that text box.

15. Draw a small text box at the top of the first column of the three-column text box. Type *Continued from page* and type the Previous Page command, **Command-2** (Macintosh) or **Ctrl-2** (Windows). The box now reads *Continued from page 1*. The text box on page 1 now reads "Continued on page 4."

Flowing text

To flow text into a text box, first select the text box and then choose File/Get Text. Navigate to the folder containing the text file, select that file, and click on Open.

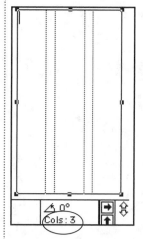

The easiest way to create a three-column text box is to draw a text box and type 3 in the Cols field of the Measurements palette.

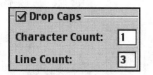

Access the Drop Caps command from the Paragraph Formats dialog box.

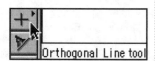

16. Select all the text in the two-column text box on page 1. Format it in 10-point type on 12 points of leading. To assign the first paragraph a drop cap, click anywhere in the paragraph and choose Style/Formats. Click on Drop Cap. Format the drop cap in a different typeface.

17. The tinted text box has a black box (or heavy rule) at the top. Use a box with a content of None or draw a 10 pt, horizontal line with the Orthogonal Line tool (Figure 4.48).

Figure 4.48. Accent a small box with a heavy rule.

18. Import a picture into the picture box in the second column on page 1 and resize it to fit the box. Press **Command-Option-Shift-F** (Macintosh) or **Ctrl-Alt-Shift-F** (Windows) to fit the image proportionally in the box. Make sure that you're resizing down unless you're using an EPS file from a vector drawing program like Illustrator. Vector EPS files can be resized up or down without losing detail.

19. The type in the caption box is set in italics and at a smaller point size than the body type. Use the same typeface and type size as the type you used in the small *Continued on page* text boxes. And remember to use the oblique form of the typeface; don't use the Italic type style from the Measurements palette or Style menu. Your first page might resemble Figure 4.49. Close the file. Don't save your changes.

Figure 4.49. The newsletter's front page displays a masthead, tinted text box and graphic with its caption box.

Unit 5

Master Pages

OVERVIEW

In this unit you will learn about:

Creating master pages
The Document Layout palette and master pages
Master items
Inserting document pages
Multiple master pages
Duplicating and deleting master pages
Working with left and right master pages
Changing margin guides
Editing master items
Applying master pages

TERMS

Keep Changes/Delete Changes
master page
master items
thumbnails

WHAT IS A MASTER PAGE?

A *master page* is a nonprinting page which contains all the items—boxes, lines, text, text paths—that will appear on every document page based on that master page. Look at any book or magazine and you will notice that most pages share common elements like page numbers (folios) and page headers. Some publications, such as corporate newsletters, have a logo that appears on every page of the newsletter. If a publication has a three-column format, that format applies to every page in the publication except where artwork overrides the columnar format. These repeating text and graphic elements are called *master items*. In QuarkXPress, you create these master items on the master pages. These master items will then appear on every document page based on that master page.

MULTIPLE MASTER PAGES

You can have many master pages in one document and you can have blank pages that display no master items. For example, you might have a master page for chapter openers and another master page for body copy. You could have another master page for advertising artwork and another one for the front matter of a book. Master pages give a document consistency of format and should be the first thing you set up when you create a document of more than one page.

CREATING MASTER PAGES

When you click OK in the New Document dialog box, two things happen: Master Page A is created and one document page based on Master Page A is also created. Both pages are blank, and unless you specified an automatic text box in the New Document dialog box, no items appear on the master page or on the document page.

When you place text or graphic elements on that default master page, Master Page A, those items appear automatically on document page 1 because that first document page is always based on Master Page A. Any pages you insert in the document, either from the Document Layout palette or from the Page menu, that are based on Master Page A will also display any elements you created on that master page.

The master pages for this book contain an automatic text box, a contentless box for the minor column, and footers for the unit number, unit name, and page number.

DOCUMENT LAYOUT PALETTE AND MASTER PAGES

The Document Layout palette (View/Show Document Layout [**F10**/Macintosh or **F4**/Windows]) displays three panels (Figure 5.1):

▲ **Icon panel** at the top where icons for blank master pages and for duplicating and deleting master pages appear. The Delete icon can also be used to delete document pages.

▲ **Master Page panel,** the center panel, displays icons for all the master pages in the document.

▲ **Document Page panel,** the lowest panel, displays icons for all the document pages in the file. The Document Layout palette makes it easy to navigate a document. Just double-click on any master page or on any document page and you'll be on that page.

Icon panel

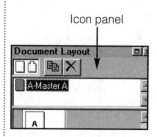

The Icon panel displays blank icons for master pages. The Duplicate icon is used to duplicate a selected master page. The Delete icon is used to delete selected master page and document pages.

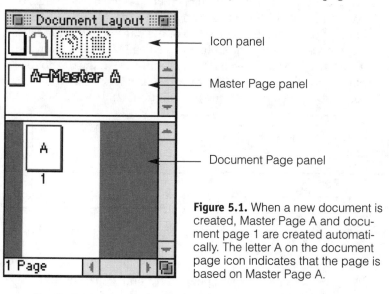

Icon panel

Master Page panel

Document Page panel

Figure 5.1. When a new document is created, Master Page A and document page 1 are created automatically. The letter A on the document page icon indicates that the page is based on Master Page A.

Use the Page menu to get to the master page or to the currently selected document page.

PLACING ITEMS ON THE MASTER PAGE

Once you create the document, you can place items on the master page. Double-click on the Master Page icon in the Document Layout palette (automatically labeled A-Master A) to get to the master page. Add a picture box and import a logo, draw a text box and type words, draw a line—whatever you create on that master page will automatically appear on every document based on that master page.

1. Create a new document without facing pages, with an automatic text box, and with 1 column. Click OK. Display the Document Layout palette (View/Show Document Layout [**F10**/Macintosh or **F4** Windows]). Display the Measurements palette (View/Show Measurements or **F9**).

2. Notice that the Document Layout palette displays A Master A and document page 1. Double-click on Master Page A to get to that page.

3. The Intact Link icon in the upper left corner of the page tells you that this document was created with an automatic text box. You can't type in the automatic text box on the master page, but you can create additional text boxes. Use the Rectangle Text Box tool to draw a text box at the top of the page between the two margin guides. Type the Consecutive Page Number command (**Command-3**/Macintosh or **Ctrl-3**/Windows) in the box to display the code for the consecutive page number. Format the code <#> and center it in the box (Figure 5.2).

Orthogonal Line tool

Intact Link icon

<#>

Figure 5.2. The Consecutive Page command appears as code on the master page.

4. Double-click on document page 1 and notice that the actual page number appears. Drag the Master Page A icon down from the center panel of the Document Layout palette onto the document area of the palette below page 1, where it becomes page 2. Double-click on page 2 and notice that it also displays the actual page number. Because the page number text box and Consecutive Page Number command were created on the master page, they appear on every document page based on that master page.

5. Choose Page/Display/A-Master-A to get back to the master page. Click inside the automatic text box on the master page and use the Cols field in the Measurements palette to make it a two-column text box.

6. Use the Rectangle Picture Box tool to draw a picture box between the two columns. Choose File/Get Picture (**Command/Ctrl-E**) and import the *Taxi.eps* image from the Unit 05 folder in the Student Files folder on the CD-ROM. Use the Style menu or keyboard shortcuts to resize the box or the picture and center the picture in the box (Figure 5.3).

Figure 5.3. The picture box and picture created on the master page will appear on every document page based on that master page.

Tip

Press **Command-Option-Shift-F** (Macintosh) or **Ctrl-Alt-Shift-F** (Windows) to resize the picture proportionally to the size of the picture box.

When a picture box is selected, use the Style menu to center and/or resize the picture.

7. Double-click on document page 1 and notice that the picture box appears on that page. Go to page 2 and notice that the picture box appears on that page also, because both of those pages are based on master page A (Figure 5.4).

Figure 5.4. Because the picture box was created on master page A, it appears on every document page based on that master page.

8. Save this file (File/Save [**Command-S**/Macintosh or **Ctrl-S**/Windows]) as *Taxi.qxd*. You'll need it for the next exercise.

INSERTING DOCUMENT PAGES BASED ON MASTER PAGES

Once a master page is created, there are two ways to insert document pages based on either the default master page or on any other master page you created:

▲ **Drag the master page icon down onto the document panel of the Page Layout palette.** This creates another document page based on that master page (Figure 5.5). You can be on the master page or on the document page; it doesn't matter where you are because you're working with the palette, not the page.

▲ **Choose Page/Insert** from the menu if you are on a document page to insert additional document pages based on a master page. Select a master page from the Master Page pull-down menu in the Insert Pages dialog box.

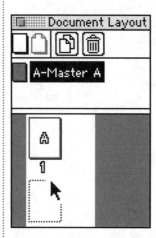

Figure 5.5. Drag a Master Page icon down onto the document area of the Document Layout palette to add one document page based on that master page.

EXERCISE B

1. If necessary, open the *Taxi.qxd* file you created earlier or open the *Taxi.qxd* file in the Unit 05 folder in the Student Files folder on the CD-ROM. It displays two document pages based on Master Page A. Display the Document Layout palette (View/ Show Document layout (**F10**/Macintosh or **F4**/Windows).

2. Drag the Master Page A icon down onto the document area of the Document Layout palette to add a third page based on Master Page A.

3. Double-click on document page 3 to get to that page. Click inside the automatic text box on the page. Choose Page/Insert to display the Insert Pages dialog box. Type 10 in the Insert field and select after page 3 to insert 10 pages after page 3 in the document. Click the Link to Current Text Chain check box to link the automatic text box on each new page to the automatic text box on the master page. Select A-Master A from the Master Page menu and click OK (Figure 5.6). An additional 10 pages—all displaying the items on Master Page A—are added to the document.

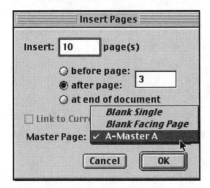

Figure 5.6. Insert additional pages based on Master Page A from the Insert Pages dialog box.

4. Double-click on document page 5 to get to that page. Choose Page/Delete. The Delete page(s) field displays 5 as the first page to be deleted. Type *end* in the thru field to delete page 5 and every page after page 5 (Figure 5.7). Click OK. The document now contains only four pages.

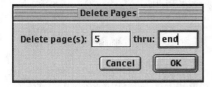

Figure 5.7. Type *end* in the thru field of the Delete Pages dialog box to delete every page after the specified page.

5. Click on the blank nonfacing master page icon in the top panel of the Document Layout palette and drag it down onto the palette between pages 1 and 2 (Figure 5.8). Because it's a blank master page, it displays none of the items you created on Master Page A (Figure 5.9).

Figure 5.8. Drag the Blank Single Page master page icon down onto the document area to add a page not based on Master Page A.

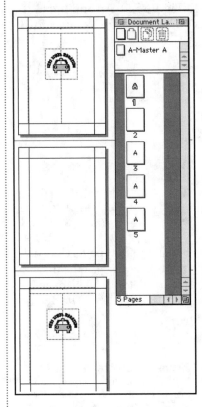

Figure 5.9. The blank document page (page 2) doesn't display the automatic text box, folio (page number) box, or picture box because it is not based on Master Page A where those items were created.

6. Close this file (File/Close [**Command-W**/Macintosh or **Ctrl-F4**/ **Windows**]). Don't save your changes.

INSERTING DOCUMENT PAGES

A master page and one document page are automatically created when you create a new document. Once a master page is created, dragging its icon down onto the document panel of the Page Layout palette adds another document page based on that master page. If you are on a document page, choose Page/Insert to insert additional document pages based on a master page selected from the Master Page pull-down menu in the Insert Pages dialog box. You can also drag a blank page icon from the top of the Document Layout palette to insert a page not based on any master page.

EXERCISE C

1. Create a new, nonfacing-pages document with an automatic text box, 1-inch margins, and 1 column (File/New/Document **[Command-N**/Macintosh or **Ctrl-N**/Windows]).

2. Display the Document Layout palette (**F10**/Macintosh or **F4**/Windows). The Document Layout palette displays Master Page A and one document page that is based on Master Page A (Figure 5.10).

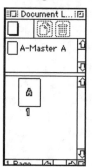

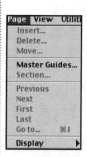

Figure 5.10. When a new document is created, Master Page A and document page 1 are created automatically. The letter A on the document page icon indicates that the page is based on Master Page A.

3. Double-click on Master Page A to get to the master page. Choose Page/Master Guides. Change the Top and Bottom margins to 2 inches. This is the only way to change the master guides in a document. Click on OK.

4. Choose Edit/Preferences/Preferences, click on the Measurements tab, and select inches as the Horizontal and Vertical unit of measure. Click OK.

The Master Guides command is available under the Page menu only when you're on a master page.

Rectangle Picture Box tool

The Picture Mover pointer appears when you click on a graphic with the Content tool.

5. Still on Master Page A, choose View/Fit in Window (**Command-0** [zero]/Macintosh or **Ctrl-0**/Windows). Use the standard-shape Rectangle Picture Box tool to draw a picture box at the top of the page. Use the W and H values in the Measurements palette (View/Show Measurements or **F9**) or the Modify Box dialog box (Item/Modify) to make the box 6½ inches wide and 2 inches high.

6. With the picture box still selected, choose File/Get Picture (**Command-E**/Macintosh or **Ctrl-E**/Windows). Navigate to the Unit 05 folder in the Student Files folder on the CD-ROM and double-click on the file named *Gator.eps* to open the graphic file in the selected picture box.

7. Click inside the picture box to display the Picture Mover pointer. Press **Command-Option-Shift-<** [less-than symbol] (Macintosh) or **Ctrl-Alt-Shift-<** (Windows) twice to proportionally reduce the graphic in 5% increments. Pressing those keys twice reduces the image to 90% of its original size. Use the Picture Mover pointer to position the image in the box.

8. With the picture box still selected, choose Item/Modify (**Command-M**/Macintosh or **Ctrl-M**/Windows). Click on the Box tab and use the Box field to select Yellow as the box color. Use the Shade pull-down menu to select 50%. Click OK.

9. Double-click on document page 1 in the Document Layout palette and notice that the graphic you created on Master Page A appears on document page 1, because that document page is based on Master Page A.

10. Click on the Master Page A icon in the Document Layout palette and drag the icon down until it appears beneath document page 1 (Figure 5.11). Double-click on the document page 2 icon in the Document Layout palette to get to page 2. Because you created a second document page based on Master Page A, it too displays the alligator image.

Figure 5.11. Drag the Master Page A icon down onto the document page panel to add another document page based on that master page.

11. Choose Page/Insert to display the Insert Pages dialog box (Figure 5.12). Leave 1 as the number of pages to insert, but click on the "at end of document" button to insert the page after page 2. Make sure that the Master Page pull-down menu displays A-Master A. Click on OK to insert the third page in the document.

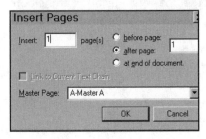

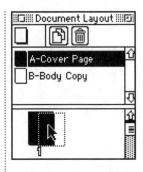

Figure 5.12. The Insert Pages dialog box lets you insert pages based on a master page or on a blank page. Because this is a nonfacing-page document, the Blank Facing Page option is dimmed and not available.

Drag a master page icon on top of a document page to apply the master page formatting.

12. Save this file as *Gator.qxd* in your Projects folder (File/Save as). You'll need it for the next exercise.

MULTIPLE MASTER PAGES

A document such as a magazine uses multiple master pages. One master page controls the text flow, another the advertising artwork, and another the front matter. Each master page is formatted separately and then applied to the appropriate document pages.

EXERCISE D

1. Open the *Gator1.qxd* file in the Unit 05 folder in the Student Files folder on the CD-ROM. Display the Document Layout palette (**F9**/Macintosh or **F4**/Windows).

2. Click on the Blank Master Page icon in the top panel of the Document Layout palette and drag it down beneath the Cover Page master page icon to create another master page, Master Page B (Figure 5.13).

Pick a tool, any tool!

Although you must select the Content tool to import text into a text box, in Versions 4 and 5 you can use either the Content tool or the Item tool to import a graphic into a picture box.

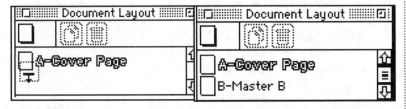

Figure 5.13. Drag the Blank Master Page icon down beneath the Cover Page master page icon (left) to create a new master page, Master Page B (right).

3. Click once (Macintosh) or double-click (Windows) on the Name Bar for Master Page B and type *Body Copy*. Press Return/Enter to rename the master page.

4. Double-click on the Body Copy master page to get to it. Use the standard-shape Text Box tool to draw a text box at the bottom of the page. With the text box selected, apply the values in Figure 5.14.

Figure 5.14. Type position and size dimensions for the text box that will contain the page number information.

5. Click inside the text box and press **Command-3** (Macintosh) or **Ctrl-3** (Windows) to insert the Consecutive Page Number symbol. Select the symbol and format it in Helvetica bold at 18 points. Center it in the box.

6. With the text box still selected, choose Item/Modify (**Command-M**/Macintosh or **Ctrl-M**/Windows), click on the Text tab, and choose Centered from the Vertical Alignment pull-down menu. Click OK.

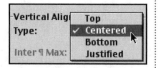

The Vertical Alignment field in the Text Modify dialog box is used to center the text vertically in the text box.

7. Double-click on any document page to get to the document pages and choose Page/Insert. Insert 3 pages at the end of the document based on the Body Copy master page (Figure 5.15).

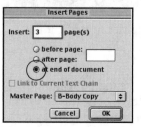

Figure 5.15. Insert 3 pages at the end of the document. Use the Master Page pull-down menu to select B-Body Copy.

8. Scroll through the last three pages in the document and notice that they display only the page numbers 4, 5, and 6, because they are the fourth, fifth, and sixth pages in the document. Because they are based on the Body Copy master page, they do not display any of the elements from the Cover Page master page.

9. Double-click on page 4 to get to it. Choose Page/Section to display the Section dialog box. Click to select the Section Start check box. Type 1 in the Number field and click OK to renumber the pages consecutively from number one.

10. Double-click on document page 4 (sectioned page 1 displaying the asterisk), the fourth page in the document, to select it. Because you selected it, its page number appears outlined in the Document Layout palette. And because you applied the Section Start command to that page, an asterisk appears after its name, indicating that a page number command was applied to the page. Notice that the last three pages in the document are numbered consecutively from page 1 to page 3 (Figure 5.16).

11. Close this file (File/Close). Don't save your changes.

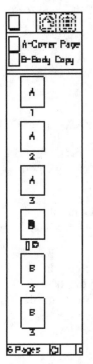

Figure 5.16. The last three document pages are based on Master Page B. Page 1 is highlighted because it is selected. The asterisk indicates that the Section Start command was applied to that page.

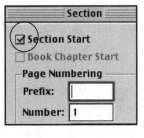

You must select the Section Start check box to apply a new page number sequence.

DUPLICATING AND DELETING MASTER PAGES

When you want some master items to appear on another master page, the easiest thing to do is to duplicate the master page and then edit it. Regardless of what you name master pages, they always appear in the Document Layout palette in alphabetical order as A, B, C, etc.

To delete a master page, click on its master page icon and click the Delete icon in the top panel of the Document Layout palette. Deleting a master page deletes any of its master items applied to the document pages based on the deleted master page.

1. Open the *Master.qxd* file you created in an earlier exercise or open the *Master.qxd* in the Unit 05 folder on the CD-ROM (File/Open). Display the Document Layout palette (**F9**/Macintosh or **F4**/Windows).

FYI

The Delete icon on the Macintosh Document Layout palette is a trash icon; the Windows Delete icon is a large **✗**.

2. Click once on Master Page B, the Body Copy master page, to select it. Then click on the Duplicate icon in the first panel of the Document Layout palette (Figure 5.17) to create Master Page C. Double-click on Master Page C to get to it. It displays only the page number text box.

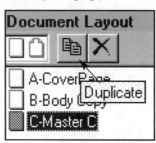

Figure 5.17. Click once on a master page to select it, and click on the Duplicate icon to duplicate that master page. The duplicate is automatically named in alphabetical order.

3. Choose Edit/Preferences/Preferences. Click on General and make sure that Keep Changes is selected in the Master Page Items field. Click OK.

4. Use the Oval Picture Box tool to draw an oval on the page. Choose File/Get Picture (**Command-E**/Macintosh or **Ctrl-E**/ Windows). Navigate to the Unit 05 folder in the Student Files folder on the CD-ROM and double-click on the file named *CD.eps* to import it into the selected Picture box.

5. Drag the handles on the picture box to resize it so that it fits around the CD-ROM image. Master Page C now displays both the picture box and the page number text box. Drag the Master Page C icon on top of document page 1, where it replaces all the elements on that page.

6. Click once on the Master Page B icon, Body Copy, to select it, and click on the Delete icon in the top panel of the Document Layout panel. At the alert, click OK to delete the master page. The text box with the page number disappears from every document page formerly based on Master Page B. No document pages display B, indicating that Master Page B is no longer available.

7. Click on document page 2 and drag it up next to document page 1 to create a two-page spread.

8. Click on document page 4 and drag it up next to document page 3 to create another spread.

9. Click on document page 6 and drag it up next to document page 5 to create the last spread. Your screen should resemble Figure 5.18 with the last three pages not based on any master page and only two master pages in the document, Master Page A (Cover Page) and Master Page C (Figure 5.18). Close this file (File/Close). Don't save your changes.

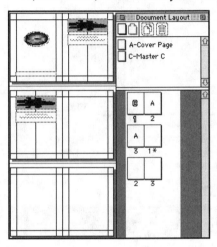

Figure 5.18. When we deleted Master Page B, its master page items were removed from any document page based on Master Page B.

WORKING WITH LEFT AND RIGHT MASTER PAGES

When you create a facing-pages document, the Master Page A that is automatically created with the document has two pages, a left and right page (Figure 5.19). You must place master page elements on both the left and right master pages if you want them to appear on the corresponding left and right document pages.

FYI

Double-click a master page *icon* to get to that page. If you click the master page name, you'll be able to edit the name, but you won't move to the master page.

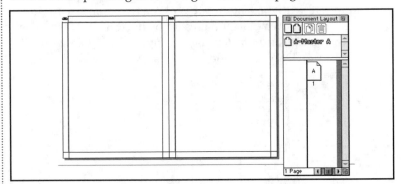

Figure 5.19. A facing-pages document has two pages for Master Page A, a left and a right page. These two pages must be formatted separately to apply master page items to all the document pages.

EXERCISE F

1. Create a new file with an automatic text box, facing pages, two columns, and one-inch margins. Display the Measurements palette (**F9**). Choose Page/Insert and insert 3 more pages at the end of the document based on Master Page A.

2. Double-click on Master Page A to get to it. Choose View/Fit in Window (**Command-0** [zero]/Macintosh or **Ctrl-0**/Windows) or press **Control-V** (Macintosh) or **Ctrl-Alt-V** (Windows) and type 30 in the View Box. Press Return/Enter. You want to display both the left and right master pages on the screen.

3. Use the standard-shape Text Box tool to draw a text box about a half-inch (.5) high at the bottom of the left master page and position it directly below the bottom margin guide.

4. Click inside the small text box with the Content tool and press **Command-3** (Macintosh) or **Ctrl-3** (Windows) to insert the Consecutive Page Number symbol. Double-click to select the symbol and format it from the Style menu or from the Measurements palette.

Content tool

5. Keep the text box selected and choose Item/Duplicate (**Command-D**/Macintosh or **Ctrl-D**/Windows). Use the Item tool to drag the duplicate to the same position on the right master page.

6. Scroll to the top of the left master page, draw a text box about 1½ inches high (1.5") across the page and position it directly above the top margin guide. Type Left Page Header in the box, triple-click to select the line, and format it. Make sure it is left-aligned.

Item tool

7. With the header box still selected, choose Item/Duplicate and use the Item tool to drag the duplicate box to the same position on the right master page. Select the Content tool and change Left to Right in the header box on the right master page. Click on the Right Align icon in the Measurements palette to align the header text with the right side of the text box. Your screen should resemble Figure 5.20.

8. Close this file (File/Close). Don't save your changes.

Figure 5.20. We formatted both the left and right master pages for Master Page A with header and footer text boxes.

MASTER PAGES AND DOCUMENT PAGES

Thumbnails

Thumbnails view is a non-editable view. All you can do in this view is add pages, apply master pages, and move pages around on the Document Layout palette. You can't edit any of the text or items on the master or document pages.

Master pages live to serve document pages. The only reason to have any master page in a document is to achieve consistency across multiple document pages. Each time you drag down a master page icon onto the document area or select a master page from the Insert Pages dialog box, you are ensuring that consistency. If you drag any document page from Document 1 to Document 2, not only does that page move to Document 2, but the master page on which that page is based also moves to Document 2.

When document pages are copied between documents—you can't copy master pages between documents—they are drag-copied. This means that as you drag a page from one document (source document) to another (target document), you create a copy of that page in the new document.

COPYING PAGES BETWEEN DOCUMENTS

There are a few rules of engagement for copying pages between documents:

▲ First, **both documents must be open**, although only one file can be selected (active). This isn't like the Append command that lets you navigate to a file.

▲ The **target document must have the same or larger page sizes as the source document**. You cannot drag-copy a page from the source document that is larger than the page size in the target document.

▲ You can **drag-copy a nonfacing page to a facing-page document**, but not the other way around.

▲ Both documents must be in **Thumbnails view**.

COPYING ITEMS BETWEEN DOCUMENTS

Drag-copying linked text boxes

If you drag-copy a linked text box from one document page to any document page in a target document, all the linked text will come with that copied text box. However, that text box will display the Overflow Indicator, telling you that there is more text than can be displayed in just that one text box. Remember that a linked text box has text flowing from one manually linked or from one automatic text box to another in the document.

It's a lot easier to copy an item between documents because you can drag-copy any selected item—box, line, group, or text path—with the Item tool to another document without having to be in Thumbnails view.

MOVING DOCUMENT PAGES

Although you can move document pages around in the Document Layout palette, you can also use the Move command to move those pages to a new location in the document. Like the Insert Pages and Delete Pages dialog boxes, the Move Page dialog box allows you to specify a range of pages to be moved and a new position in the document for those moved pages.

1. Create a document (File/New) without an automatic text box, portrait (vertical) orientation, nonfacing pages, and 1-inch margins. Double-click on the Master Page A icon to get to the master page. Use any of the picture box tools to draw a picture box on the master page. Display the Colors palette (**F12**), click the Background icon, and fill the selected picture box with a color. Double-click on document page 1 to get to the document page. Choose View/Thumbnails (**Shift-F6**). Resize the window so that only the document page is visible.

2. Repeat to create another new document without facing pages and without an automatic text box. Double-click on Master Page A and draw a picture box on the master page in the second document. Display the Document Layout palette (View/Show Document Layout [**F10**/Macintosh or **F4**/Windows]). Double-click on document page 1 to get there. Choose View/Thumbnails (**Shift F6**).

3. Click on Document1 to activate it. With either the Content tool or the Item tool, click on document page 1 in the document, not in the Document Layout palette, and drag the page onto Document2, next to page 1 to create a two-page spread. Click on Document2 to activate it and notice that the Document Layout palette for Document2 displays a new master page, Master Page B (Figure 5.21). Double-click on Master Page B and notice that it is a copy of Master Page A from Document 1.

Cheat sheet

If you reduce the magnification value to 12%, you approximate Thumbnails view and still edit text and items.

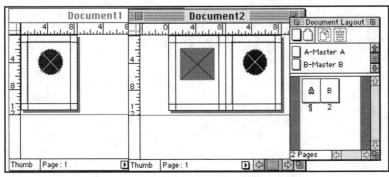

Figure 5.21. When we drag-copied a document page from Document1 to Document2, the master page was also copied to Document 2 and named Master Page B.

4. Still in Document2, choose View/50% to get out of Thumbnails view. Click on Document1 to activate it and change the view. You can't drag-copy *items* in Thumbnails view.

5. With both documents in an editable view, click on the picture box in one document and drag it to the other document. Repeat for the second document. You can drag-copy items from one document page or from one master page to another document's master page or document page.

6. Double-click on document page 2 in Document2, the second page in the spread that's based on Master Page B. Choose Page/Move to display the Move Pages dialog box. Type 2 in the Move page(s) field. Click to select the before page option and type 1 in the field to move page 2 before page 1. Click on OK. Your Document Layout palette should resemble Figure 5.22.

7. Close both files (File/Close [**Command-4**/Macintosh or **Ctrl-F4**/Windows]). Don't save your changes.

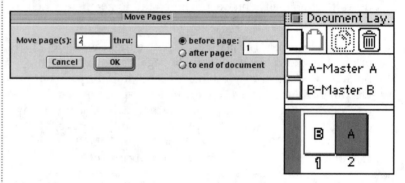

Sorry!

You can't undo actions performed in the Document Layout palette. Have you reached the conclusion yet that you can't undo many of the actions and commands in QuarkXPress?

Figure 5.22. Move a single page or range of pages to a new location in the document using the Move Pages dialog box.

EDITING A DOCUMENT FROM THE MASTER PAGE

Frequently it's necessary to make changes to the entire document while you're working on it. Some of the changes you might want to make include:

▲ **Changing columns and column guides.** For example, you may decide that your two-column document should be a three-column document. Or, you may want to change the dimensions of the margins.

▲ **Adding and deleting master items.** You might want to add a master item, such as a logo, or even delete some master items and have them added and/or deleted from the document pages based on that master page.

▲ **Making text formatting changes.** It's sometimes necessary to make changes to a typeface or type size, or to adjust the leading of master items. The type size of the folio might have to be reduced to allow more space on the page. Copyfitting might require you to reduce the type size of a running head that appears on every document page.

CHANGING MARGIN GUIDES

When you create a new document, you specify the margin widths in the New Document dialog box. These values are applied to every document page based on the default master page, Master Page A. To change those master guides, you must be on the master page and use the Master Guides command from the Page menu.

MASTER GUIDES DIALOG BOX

To change the document's master guides, double-click on the Master Page icon to get to the master page. Then choose Page/Master Guides to display the Master Guides dialog box (Figure 5.23). A master page is the only place where you can make global changes to a document's margins. You can always reduce or expand the sides of a text box on any document page to change the margins just for that page.

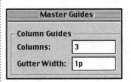

The only way to globally change the number of columns in a document is to use the Master Guides dialog box. This dialog box appears under the Page menu only when you're actually on the master page.

FYI

Any master pages created after the default Master Page A appears will display the margin values originally specified in the New Document dialog box. These margins can also be changed with the Master Guides command if you're on the master page.

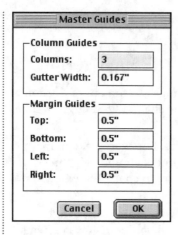

Figure 5.23. Access the Master Guides dialog box by double-clicking on the Master Page icon in the Document Layout palette and choosing Page/Master Guides.

Change the number of columns and the width between those columns (Gutter Width) and change any of the margin values. Click on OK. Double-click on any document page based on that master page and you will see the changes you made reflected in both the master page and the document pages (Figure 5.24).

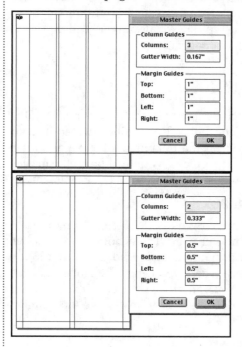

Figure 5.24. The Master Guides dialog box for the top master page calls for a 3-column document with 1-inch margins. Changing those values in the Master Guides dialog box for the same document creates a 2-column document with 2-inch margins and 2 picas of space (.333") between those columns.

1. Create a new, nonfacing-pages document without an automatic text box, 2-inch margins, and 1 column (File/New/Document [**Command-N**/Macintosh or **Ctrl-N**/Windows]). Display the Document Layout palette (**F10**/Macintosh or **F4**/Windows). The Document Layout palette displays Master Page A and one document page that is based on Master Page A (Figure 5.25).

Figure 5.25. When a new document is created, Master Page A and document page 1 are created automatically. The letter A on the document page icon indicates that the page is based on Master Page A.

2. Double-click on Master Page A to get to the master page. Choose Page/Master Guides. Change all the margins to 1 inch. Click OK. Your screen should resemble Figure 5.26.

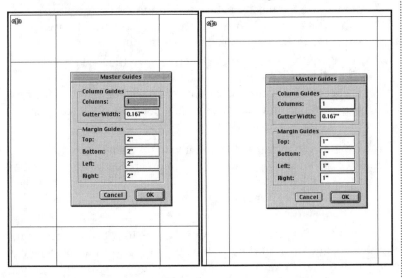

Figure 5.26. Change the margin guides for the entire document from the Master Guides dialog box, accessed from the Page menu on the Master page.

3. Close this file (File/Close [**Command-W**/Macintosh or **Ctrl-F4**/Windows]). Don't save your changes.

EDITING MASTER ITEMS

Any item you create directly on a master page is called a *master item*. Even though it appears on the document pages, it is still a master item and as such has certain properties:

▲ Master items can be edited and deleted on the master page; these changes will appear on the document pages based on that master page.

▲ If master items are edited on the document page, they can remain on the document page or be deleted from the document page if the master page is reapplied to that document page.

▲ If master items are edited on the document page, any changes made to that master item on the master page will not affect that edited master item on the document page.

Let's say you create a master page with a graphic in the lower right corner. That graphic (master item) will appear on all the document pages based on that master page. Then you decide to give the background box for that logo a color. Where you are when you do this affects how the change is applied.

▲ If you're on the master page and change the background color of the master item, that color is applied to the master item on every document page based on that master page.

▲ If you're on a document page and change the background color of the master item, that box loses its master item status and becomes a regular item. Any changes you make to the box or its contents on the master page will not be reflected in the box on that particular document page.

So, you trot off to page document page 3 and change the background color of the logo picture box to green. Only the picture box on page 3 is affected; also, because that picture box started life as a master item, your changing it on a document page strips it of its master item status.

Then you decide that the background of the logo box on *every* page of the document should be yellow. Off you go to the master page and make the background color of the logo picture box yellow. Only the picture boxes on document pages 1 and 2 will be yellow, because they're still master items. The picture box on page 3 is no longer a master item and is not affected by any changes you make to master items on the master page.

The moral of this story is that you can't have things both ways. If you want something to remain a master item, then you cannot apply any local formatting. Changing the box color on page 3 is local formatting and overrides any changes made to the master item.

EXERCISE I

1. If necessary, open the *Gator.qxd* file you created in the previous lesson or open the *Gator.qxd* file in the Unit 05 folder in the Student Files folder on the CD-ROM (File/Open). Display the Measurements palette (**F9**) and the Document Layout palette (**F10**/Macintosh or **F4**/Windows).

2. Double-click on the Master Page A icon in the Document Layout palette to display Master Page A. Click on the picture box to select it and choose Item/Modify (**Command-M**/Macintosh or **Ctrl-M**/Windows). In the Box tab, use the Box fields to change the box color from 50% yellow to 50% cyan. Click on OK. Double-click on document page 1 and notice that the picture box reflects the change you just made on the master page. Scroll through the document and notice that all three pages display the blue box.

3. Click once (Macintosh) or double-click (Windows) on the name bar of Master Page A to highlight its name. Type *Cover Page*, and press Return/Enter to rename Master Page A as Cover Page.

4. Double-click on the Cover Page icon to get to the master page. Notice that Cover Page appears in the Page Number field in the lower left corner of the document. Resize the Document Layout palette to display the entire name. Notice that the name of the master page is outlined (Macintosh) or boldfaced (Windows), indicating that the master page is the active (selected) page (Figure 5.27).

The Box field in the Modify tab is where you apply color and a percentage (screen) of that color to any selected box.

Figure 5.27. Use the resize box to expand the Document Layout palette. The Cover Page master page name is outlined because the master page is active. Anything you create or edit on this page will be reflected on the document pages based on Master Page A.

Name Bar

Click once on the name bar of the master page to edit the master page's name.

Rectangle Text Box tool

Zoom tool

5. Use the Rectangle Text Box tool to draw a text box under the picture box. Use the Measurements palette and type 1 in the X field, 3 in the Y field, 6.5 in the W field, and 1.5 in the H field. Press Return/Enter.

6. With the text box still selected and the Content tool active, choose File/Get Text (**Command-E**/Macintosh or **Ctrl-E**/Windows). Locate the *Gator.txt* file in the Unit 05 folder on the CD-ROM, and double-click on it to import it into the selected text box.

7. Use the Zoom tool to enlarge the display magnification so you can see the type. Quadruple-click to select the first paragraph. Use the Measurements palette or the Style menu to format it in Helvetica bold at 24 points. Choose Style/Color/Magenta to apply the color to the selected type. Click on the Center Align icon in the Measurements palette to center the line in the box.

8. With the type still selected, choose Style/Formats or **Command-Shift-F**/Macintosh or **Ctrl-Shift-F**/Windows to display the Paragraph Attributes dialog box. Type p6 in the Space After field to add 6 points of space after the paragraph. Click OK.

9. Quadruple-click to select the second line of type. Format it in Times italic at 14 points. Center it in the text box (Style/Alignment/Centered (**Command-Shift-C**/Macintosh or **Ctrl-Shift-C**/Windows).

10. With the text box still selected, choose Item/Modify (**Command-M**/Macintosh or **Ctrl-M**/Windows). Click on the Text tab. In the First Baseline area, type .5" in the Offset field to offset the first line of text one half inch from the top of the text box. Click on OK (Figure 5.28). You don't have to type the inch mark if you have inches selected as the unit of measure for the document.

Figure 5.28. Use the Text Modify dialog box to drop the first line of text half an inch from the top of the text box.

11. Double-click on the first document page in the Document Layout palette and notice that the formatted text box appears on that page and on every document page in the file.

12. Choose Page/Display/A-Cover A as another way to get to the Cover Page master page. Choose Page/Master Guides. Type 2 in the Columns field and click on OK. This makes the large text box you created on the master page a two-column text box.

13. Scroll through the document pages and notice that all three pages display the text box and two columns.

14. Double-click on document page 2. Select the blue box and use the Box Modify dialog box (**Command-M**/Macintosh or **Ctrl-M**/ Windows) to change it to 100% red. You have now changed a master item on the document page and stripped it of its master item status.

15. Double-click on the master page icon to get to the master page. Select the cyan box and change its color to 50% green in the Box Modify dialog box (**Command-M**/Macintosh or **Ctrl-M**/ Windows). Click OK.

16. Double-click on document page 1 and notice that the background color of the box is green. Double-click on page 2 and notice that its box is still red. Double-click on page 3 to display its green box. Because you applied local formatting to the box on page 2, it isn't affected by any changes made on the master page.

17. Continue to change master items on the document page, then change the same item on the master page and notice how applying local formatting to master items on a document page strips them of their master item status.

18. Close this file (**Command-W**/Macintosh or **Ctrl-F4**/Windows). Don't save your changes.

FYI
Don't forget to press the Return/Enter key after typing information in the Measurements palette to execute the command. Or, you can click anywhere on the page to execute the command.

Content tool

APPLYING MASTER PAGES

There are two ways to create document pages that contain master items: *create* the master page and then insert document pages based on that master page; or *apply* a master page to an existing document page. To do this, just drag the master page icon down onto the document page area of the Document Layout palette and cover the document page.

What happens at this point depends on an option you select in the General Preferences Document dialog box (Figure 5.29).

Figure 5.29. Select an option from the Master Page Items menu in the General tab of the Document Preferences dialog box.

KEEP CHANGES/DELETE CHANGES

Sometimes it's necessary to "reset" a document page. You may have played with master items and with any text or items you added to the document page. If you want to return the page to its original master page specifications, just reapply the master page by dragging the master page icon down onto the document page icon. What happens when you reapply a master page depends on whether you select Keep Changes or Delete Changes in the Document Preferences dialog box.

KEEP CHANGES

The Keep Changes option should really read, "Keep changes made to master items on this document page when I reapply the same master page or a different master page to this document page." For example, say you have master items on document page 2 that you have changed in a variety of ways. You decide you like them, but you also want the original master items to appear on that page along with the edited master items. If you select Keep Changes in the Preferences dialog box, when you reapply the master page to that document page, the master items will appear without deleting the master items you edited. In other words, *the master items won't replace the edited master items* when you reapply the master page.

DELETE CHANGES

The Delete Changes option tells XPress to delete any master items that you have edited on the document page when you reapply the same master page or a different master page. In this case, if you edit master items in any way on a document page and then reapply the master page, the edited master items will be deleted and only the master items from the master page will appear.

Keep in mind that the Keep Changes/Delete Changes options only apply when you *reapply a master page* to a document page. These preferences have no effect when you change master items on a document page and then change those same master items on the master page.

FYI
Double-click a master page *icon* to get to that page. If you click the master page name, you will be able to edit the name, but will not move to the master page.

EXERCISE J

1. Open the *Master.qxd* file in the Unit 05 folder in the Student Files folder on the CD-ROM (File/Open). Display the Document Layout palette (**F9**/Macintosh or **F4**/Windows).

2. This file contains six document pages based on two master pages. Double-click on document page 1, which is based on the Cover Page master page. It displays a picture box and a text box. Select the picture box and choose Item/Modify. Change the box color to 100% Red and click OK. You have now edited a master item *on a document page*, not on the master page.

3. Double-click on page 2, which is also based on the Cover Page master page. Its box is still cyan because you did not make the color change on the master page, only on a document page.

4. Choose Edit/Preferences/Preferences. Click on General and click Keep Changes in the Master Pages Items field. Click OK.

5. Click on the Cover Page master page *icon* in the Document Layout palette and drag it over document page 1, the page you just edited. Double-click on document page 1 to get there. The red box appears. Select the Item tool and drag that red picture box down. You'll see the blue picture box behind it (Figure 5.30). Because the blue picture box is an edited (changed) master item and you told XPress to keep any changed master item when you reapplied the master page, the blue box remains on the page.

Alligator Alley Advice

Your guide to living happily ever after with large and dangerous reptiles

Figure 5.30. Because Keep Changes was selected in the General Preferences dialog box, the edited (blue) picture box was kept when the Cover Page master page was reapplied to the document page.

6. Double-click on document page 4 (sectioned page 1). Notice the page number (folio) box at the bottom of the page. Drag the Cover Page master page icon down on top of document page 4 (sectioned page 1), which is based on the Body Copy master page. (You know it's based on Master Page B because it displays a B in the center of the page icon.) The page number box disappears and only the master elements from Master Page A (Cover Page) appear on the fourth document page. Because you did not make changes to any master item on that document page, there was nothing to keep and the entire page was replaced by the elements on Master Page A (Cover Page) when you applied the new master page.

7. Choose File/Revert to Saved. Click on OK to revert to the last-saved version of the file. Choose Edit/Preferences/Preferences (**Command-Y**/Macintosh or **Ctrl-Y**/Windows). Click on General, and this time click Delete Changes in the Master Pages Items field. Click on OK.

8. Double-click on the first document page and select the blue picture box. Choose Item/Modify. Change the box color to 50% Green and click on OK. You have edited a master item *on a document page*, not on a master page.

9. Drag the Cover Page master page icon down on top of the first document page to reapply the Cover Page master items to that page. Double-click on document page 1 and notice that the green box has been replaced by the blue box, the master item. Although you edited a master item on page 1, because you told XPress to delete any edited master items *when you reapplied the master page,* only the master items from the Cover Page master page appear.

10. Drag the Body Copy master page on top of document page 1. Notice that the picture box and text box are replaced by the single text box and page number (folio) box which are the only master items on Master Page B, the Body Copy master page. Document page 1 now displays a B, indicating that it is based on Master Page B and not on Master Page A (Figure 5.31).

11. Close this file. Don't save your changes.

Figure 5.31. The first document page displays a B, indicating that it is based on Master Page B, the Body Copy master page.

WORKING WITH LEFT AND RIGHT MASTER PAGES

When you create a facing-pages document, Master Page A that is automatically created with the document has two pages, a left and a right page (Figure 5.32). You must place master elements on both the left and right master pages if you want them to appear on the corresponding left and right document pages.

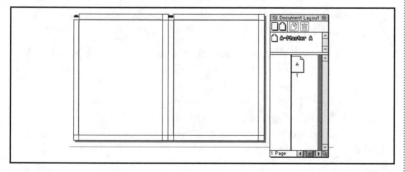

Figure 5.32. A facing-pages document has two pages for Master Page A, a left and a right page. These two pages must be formatted separately to apply master page items to all the document pages.

1. Create a new file with an automatic text box, facing pages, 2 columns, and 1-inch margins. Display the Measurements palette (**F9**). Choose Page/Insert and insert 3 more pages at the end of the document based on Master Page A.

2. Double-click on Master Page A to get to it. Choose View/Fit in Window (**Command-0** [zero]/Macintosh or **Ctrl-0**/Windows) or press **Control-V** (Macintosh) or **Ctrl-Alt-V** (Windows) and type 30 in the View Box in the lower left corner of the document window. Press Return/Enter. You want to display both the left and right master pages on the screen.

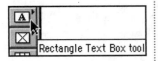

3. Use the Rectangle Text Box tool to draw a text box about one half inch high (.5) at the bottom of the left master page; it should span the width of the text box. Position it directly below the bottom margin guide.

4. Click inside the text box with the Content tool and press **Command-3** (Macintosh) or **Ctrl-3** (Windows) to insert the Consecutive Page Number symbol. Double-click to select the symbol and format it from the Style menu or from the Measurements palette. Click the Center Align icon to center the page number.

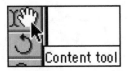

5. Keep the text box selected and choose Item/Duplicate (**Command-D**/Macintosh or **Ctrl-D**/Windows). Use the Item tool to drag the duplicate to the same position on the right master page.

6. Scroll to the top of the left master page, draw a text box 1.5 inches high across the page, and position it directly above the top margin guide. Type *Left Page Header* in the box, triple-click to select the line, and format it. Make sure it is left-aligned.

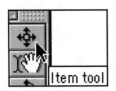

7. With the header box still selected, choose Item/Duplicate and use the Item tool to drag the duplicate box to the same position on the right master page. Select the Content tool and change *Left* to *Right* in the header box on the right master page. Click on the Right Align icon in the Measurements palette to align the header text with the right side of the text box. Your screen should resemble Figure 5.33.

8. Close this file (File/Close). Don't save your changes.

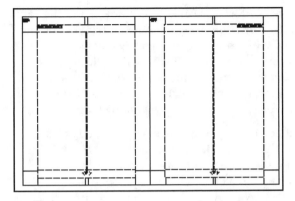

Figure 5.33. We formatted both the left and right master pages for Master Page A with header and footer text boxes.

REVIEW PROJECT 1

CREATING AND EDITING MASTER PAGES

1. Create a new document with the values in Figure 5.34. Display the Document Layout palette (View/Show Document Layout [**F10**/Macintosh or **F4** Windows]).

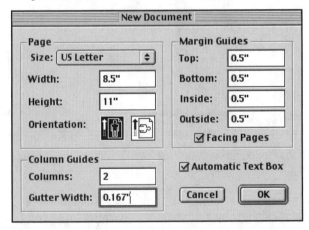

Figure 5.34. The New Document dialog box creates a document with facing pages and an automatic text box.

2. Double-click on the Master Page A icon in the Document Layout palette to get to the master page. Because this is a facing-pages document, you must format two master pages, the right master page and the left master page.

3. Draw a text box about 1 inch high at the bottom of *each* master page, just above the bottom margin. Click inside the text box on the left master page and type the Consecutive Page Number symbol (**Command-3**/Macintosh or **Ctrl-3**/Windows). Press

the Option key (Macintosh) or Alt key (Windows) and the Tab key simultaneously and type *Financial Newsletter*. Pressing the Option or Alt key while pressing the Tab key creates an automatic right-justified tab. With the text box still selected, choose Item/Modify (**Command-M**/Macintosh or **Ctrl-M**/Windows). Click on the Text tab and select Centered from the Vertical Alignment menu on the right side of the dialog box. Click OK.

4. Click in the text box on the right master page, type *Financial Newsletter*, press the Option-Tab (Macintosh) or Alt-Tab (Windows)—releasing the modifier key after pressing the Tab key—and type the Consecutive Page Number symbol (**Command-3**/Macintosh or **Ctrl-3**/Windows). Choose Item/Modify, click the Text tab and select Centered from the Vertical Alignment menu. Your screen should resemble Figure 5.35.

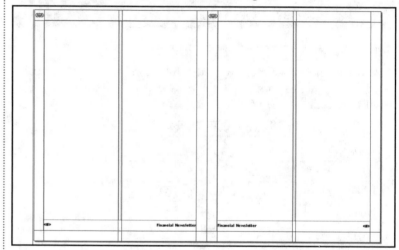

Figure 5.35. Place the Consecutive Page Number symbol in a separate text box on the master pages.

5. Go to document page 1 and click in the automatic text box on that page. Choose Page/Insert. Insert 6 pages after page 1. Be sure to select the Link to Current Text Chain check box. Click OK (Figure 5.36).

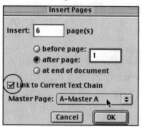

Figure 5.36. When the document contains an automatic text box, you can link inserted pages to that text chain.

6. Scroll through the seven document pages and notice that they all display the left or right master items (two-column text box and running footer text box) created on the master page.

7. Double-click on the Master A icon in the Document Layout palette to get to the master pages. Select the footer text box on the bottom of the left master page and choose Item/Modify. Click the Box tab. Use the Background menu to select Yellow. Click OK. Repeat for the footer text box on the right master page (Figure 5.37).

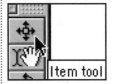

Figure 5.37. Change the box color in the Box Modify dialog box.

8. Double-click on the Master Page A icon to get to the master pages. Draw a small picture box in the center of the page between the two columns on the left master page. Import the *Dollar.eps* file from the Unit 05 folder in the Student Files folder on the CD-ROM. Resize the picture box to fit the picture or do one of the following:

▲ Press **Command-Option-Shift-F** (Macintosh) or **Ctrl-Alt-Shift-F** (Windows) to fit the picture proportionally inside the box. *Or*

▲ Choose Style/Fit Picture To Box (Proportionally).

9. With the picture box still selected, choose Item/Duplicate (**Command-D**/Macintosh or **Ctrl-D**/Windows). Use the Item tool to drag the duplicate onto the right master page. You have now added another master item to each master page. Your screen should resemble Figure 5.38.

When a picture appears in a selected picture box, you can select a formatting option for the picture or for the picture box from the Style menu.

Figure 5.38. Duplicate master items and position them on another master page.

10. Double-click on document page 5 in the Document Layout palette to get to page 5. Click on the picture box and drag one of the box handles while pressing **Command-Option-Shift** (Macintosh) or **Ctrl-Alt-Shift** (Windows) to resize both the picture and the box proportionally. Reposition the picture box in the center of the page (Figure 5.39). You have now changed a master item (picture box) on a document page.

Figure 5.39. Edit a master item on the master page to change that item on every document page based on that master page.

11. Still on document page 5, select the yellow footer box and choose Item/Modify (**Command-M**/Macintosh or **Ctrl-M**/Windows). Click the Box tab and change the background color to red. Because the footer box is a master item, you have also changed a second master item on a document page (Figure 5.40).

Figure 5.40. Changing a master item on the master page changes that item on every document page based on that master page. Because you made the change on a document page here, only that page is affected.

12. Choose Edit/Preferences/Preferences (**Command-Y**/Macintosh or **Ctrl-Y**/Windows) to display the General Preferences. Select Keep Changes in the Master Page Items field.

13. Drag the Master Page A icon down over document page 5 to reapply the master items on Master Page A to document page 5. Nothing appears to have happened, but if you use the Item tool to move the large picture box to the side and the red footer box up, you'll see that XPress has applied the original two master items, the small picture box and the yellow footer text box (Figure 5.41).

Figure 5.41. Reapplying a master page respects the Keep Changes/Delete Changes options you select for the document.

14. Use the Item tool to Shift-select the two picture boxes and the two footer boxes. Press the Delete key. This leaves only the 2-column text box on page 5.

15. Drag the Master Page A icon down onto document page 5 to reapply the master page.

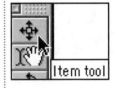

16. Choose Edit/Preferences/Preferences (**Command-Y**/Macintosh or **Ctrl-Y**/Windows) and click on General. Choose Delete Changes from the Master Page Items field and click OK.

17. Go to page 5 again and resize the picture box. Change the background color of the footer box to blue. You have locally edited master items on a document page.

18. Drag the Master Page A icon down onto document page 5. The original small picture box and yellow footer box appear.

CREATING NEW MASTER PAGES

1. Drag the Blank Facing Page icon down from the Icon panel onto the Master Page panel on the Document Layout palette, where it is automatically named Master Page B.

2. Double-click on Master Page B to get to those left and right master pages.

Drag the Blank Facing Page icon down onto the Master Page panel to create a new master page.

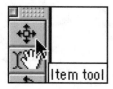
Item tool

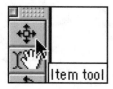

Master Page Items
◉ Keep Changes

Select Keep Changes from the Master Page Items field in the General Preferences dialog box to keep the original master items when you change a master item and then reapply the master page.

3. Draw a text box inside the margins of the left master page. Assign it 3 columns from the Measurements palette. Assign it a 30% cyan background from either the Modify dialog box or the Colors palette. With the box selected, choose Item/Duplicate (**Command-D**/Macintosh or **Ctrl-D**/Windows) and use the Item tool to drag the duplicate text box onto the right master page.

4. Choose Edit/Preferences/Preferences (**Command-Y**/Macintosh or **Ctrl-Y**/Windows) and click on General. Choose Keep Changes in the Master Page items field. Click OK.

5. Go to any document page and enlarge the picture box on that page. You have now edited a master item on the document page. Because you selected Keep Changes in the Preferences dialog box, you will keep any changed master item when you apply a new master page, just as you did earlier when you reapplied the original master page.

6. Drag the Master Page B icon down onto the document page with the enlarged picture. The blue text box appears and the picture box also appears (Figure 5.42). The yellow footer box, however, is deleted because you did not edit that master item and the Keep/Delete Changes options *apply only to master items that are edited on a document page.*

Figure 5.42. Reapply the master page to add or delete master items.

7. Drag the Master Page B icon down onto another document page; it replaces all the original master items with the blue text box. Because no master items were edited on this document page, there are no master items to keep, so the new master item, the blue text box, appears alone on the page.

8. Close this file. Don't save your changes.

In this project you'll set up master pages for a manual.

SETTING UP THE DOCUMENT

1. To create the manual's master pages, begin with a facing-pages document with 1-inch margins and 1 column. Select the Automatic Text Box option. In the General dialog box (Edit/ Preferences/Preferences [**Command-Y**/Macintosh or **Ctrl-Y**/Windows]), select picas as the unit of measure.

2. Display the Document Layout palette (View/Show Document Layout or **F10**/Macintosh or **F4** Windows) and the Colors palette (View/Show Colors or **F12**).

3. Double-click on the Master A icon in the Document Layout palette to get to the master pages. Because this is a facing-pages document—that is, a document that will be printed on both sides of the paper—you have to format both a left and right master page.

4. Draw a text box the width of the column at the bottom of the left master page. Position it below the margin guide. Type the Consecutive Page Number command (**Command-3**/Macintosh or **Ctrl-3**/Windows). Include a dingbat if you wish. Format the text. Select the text, click on the Text Color icon in the Colors palette, and make it white. Select the text box, click on the Background color icon in the Colors palette, and make it black. You have created reverse type.

5. Duplicate the text box and use the Item tool to drag the copy to the bottom of the right master page. Click on the type and click the Right Align icon in the Measurements palette. Your screen should resemble Figure 5.43.

Figure 5.43. The footer boxes at the bottom of the master pages contain the page number symbol.

6. The manual's design calls for a narrow column on the outside of the page where graphics will appear and a wider column against the spine for the text. Because only one text box can be an automatic text box, you will make the wider column the automatic text box and draw another box for the graphics.

7. Make sure the rulers are displayed (**Command-R**/Macintosh or **Ctrl-R**/Windows). Drag the zero point from the upper left corner on the left master page to the intersection of the margin guides. This sets the ruler to zero at that point (Figure 5.44).

Zero Point

Figure 5.44. Drag the zero point to the intersection of the margin guides to reset the ruler origin.

Watch your ps and ps

Typing a p after a value applies the value in picas. Typing a p before the value applies the value in points. 7p2 applies a value of 7 picas and 2 points. Pica values are not case-sensitive.

8. Draw a text box down the side of the left master page. With the box still selected, choose Item/Content/None or Control-click (Macintosh) or right-click (Windows) and choose Content/None. Individual graphics will be placed in their own picture boxes in this column, so it doesn't have to be a picture box or a text box. Use the Measurements palette (**F9**) to make the box 10 picas wide and 54 picas high. Make sure it is positioned at 0p on the X and Y axes (Figure 5.45).

Figure 5.45. The contentless box is positioned at 0p on the X and Y axes.

CREATING A SPOT COLOR

1. This manual will be a two-color job, that is, it will use black and one other spot color. To create that color, choose Edit/Colors (**Shift-F12**). Click the New button to display the Edit Color dialog box. Use the Model pull-down menu to select Pantone Uncoated (Figure 5.46).

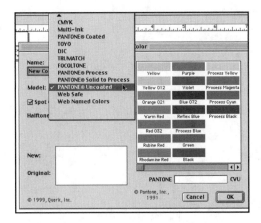

Figure 5.46. Select a color model in the Edit Color dialog box.

When Spot Color is selected in the Edit Color dialog box, that color will print on a separate plate.

2. Scroll through the Pantone library and select a color for the vertical rule you will place on each master page. Click on the color and notice that its name appears in the Name field and below the Pantone library. Click OK and click Save. The color appears in the Colors palette and is now available for use in this document. Save the document.

APPLYING A SPOT COLOR

1. Use the Orthogonal Line tool to draw a vertical line next to the contentless box you created earlier. Use the Measurements palette to select Left Point and position the line at the 10p6 point at the X1 axis and at 0p on the Y1 axis. Type 54p in the L(ength) field to make it 54 picas long. Give it a width of 4 points. Press Return/Enter to execute the changes (Figure 5.47).

Figure 5. 47. The length of the line appears in the Measurements palette for the Left Point positioning.

2. With the line still selected, click the Pantone color swatch in the Colors palette to assign that color to the line.

3. Resize the automatic text box to match the values in Figure 5.48. Your screen should resemble Figure 5.49.

Figure 5.48. The specs for the automatic text box

Tip

Deselect Snap to Guides to make it easier to position vertical lines.

Figure 5.49. The left master page contains a contentless box, a vertical rule colored with a Pantone color, an automatic text box, and a footer text box.

FORMATTING THE RIGHT MASTER PAGE

1. To format the right master page, you will duplicate two of the items you just created on the left master page and position them on the right master page. First, select the automatic text box on the right master page and use the Measurements palette to make it 28 picas wide. Make sure the left side of the text box is against the right margin at the 0p mark on the X axis.

2. Duplicate the contentless box on the left master page (**Command-D**/Macintosh or **Ctrl-D**/Windows) and position it against the right margin on the right master page.

3. Duplicate the vertical line and position it between the two boxes at the 28p6 mark on the X1 axis. Your screen should resemble Figure 5.50.

Figure 5.50. Both master pages are formatted, although the automatic text chain on the right master page is broken.

INSERTING ADDITIONAL PAGES

1. Because this is to be a six-page manual, you have to insert five additional pages. Double-click on document page 1 in the Document Layout palette to get to that page. Select the Content tool and click inside the automatic text box on that page. Choose Page/Insert to display the Insert Pages dialog box. Type 5 in the Insert field and select the Link to Current Text Chain check box to link the new pages to the automatic text chain you set up on the master pages (Figure 5.51). Click OK to add the pages to the document.

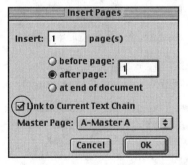

Figure 5.51. The left master page contains a contentless box, a vertical rule colored with a Pantone color, an automatic text box, and a footer text box.

2. Double-click on each document page icon in the Document Layout palette and notice that each displays the appropriate right and left master items.

Important info

You must have a page selected in a document with the Automatic Text Box option in order to link inserted pages to the current text chain.

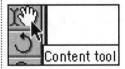

CHANGING MASTER ITEMS

1. To change the background color of the footer page on all the document pages, double-click on the Master A icon in the Document Layout palette to return to the master pages. Select the black footer page on the left master page, click the Background Color icon in the Colors palette, and click on the Pantone swatch to change the box's background color. Repeat for the footer box on the right master page.

2. Double-click on each document page and notice that the background color of every footer box is now the Pantone color.

ADDING MASTER ITEMS

1. Return to the master pages. Draw a picture box inside the contentless box on the left master page. Import the *Clock.eps* image (File/Get Picture [**Command-E**/Macintosh or **Ctrl-E**/Windows]). Position the image in the box. Draw a text box, type *Time Saver!* and format the text. Position the text box over the picture box (Figure 5.52).

Figure 5.52. Import a picture into the picture box and position the text box above the picture box.

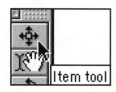

2. Shift-select the picture box and text box. Group them (Item/Group or **Command-G**/Macintosh or **Ctrl-G**/Windows).

3. Use the Item tool to select the group, duplicate it (**Command-D**/Macintosh or **Ctrl-D**/Windows), and drag the duplicate into the same position on the right master page. Double-click on document pages and notice that the group appears on each page.

4. Go to document page 3, use the Content tool to select the picture box, select the Background Color icon in the Colors palette, and click on the Pantone swatch to assign that color to the box's background. You have now edited a master item.

5. Choose Edit/Preferences/Preferences. In the General tab, select Delete Changes from the Master Page Items field (Figure 5.53). Click OK. If you reapply the master page to document page 3, any edited master items—in this case the picture box—will be deleted and replaced with the original master items.

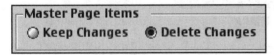

Figure 5.53. Select Delete Changes to delete any edited master items when you reapply the master page.

6. Drag the Master A icon down over the document page 3 icon in the Document Layout palette. The colored box disappears and is replaced with the original, uncolored picture box.

ADDING MASTER PAGES

1. Click on the Blank Facing Page icon in the Document Layout palette and drag it down into the Master Page panel on the palette, where it becomes Master B. Click inside the name to highlight it and type *Art Page* (Figure 5.54).

Figure 5.54. Drag a blank master page icon down onto the Master Page panel of the Document Layout palette and rename the new master page.

2. Drag the Art Page icon down onto document page 4. All the master items from Master Page A are replaced by the blank Art Page master page.

3. Close this file. Don't save your changes.

REVIEW PROJECT 3

For this project you'll create a long document with three master pages. One will be for the editorial matter, another for the articles, and another for advertising materials.

CREATING THE DOCUMENT

Create a new document with facing pages and 2 columns. Give it 1-inch margins and an automatic text box. Master Page A then becomes the master page for the document pages on which you'll flow the articles. Because a document can have only one automatic text box, you should assign this to the most text-intensive material.

SETTING UP MASTER PAGE A

In the document, go to Master Page A and do the following:

1. Use the Orthogonal Line tool to draw a vertical rule between the two columns on the left master page. Turn off Snap to Guides under the View menu to make it easier to position the rule.

Line tip

To move a line in 1-point increments, select it with the Item tool and use the arrows on the keyboard.

2. Draw a text box below the bottom margin and type the Consecutive Page command (**Command-3**/Macintosh or **Ctrl-3**/ Windows) to create the consecutive page symbol <#>. Format the symbol and center it in the box. Select the box and use the Text Modify dialog box (**Command-M**/Macintosh or **Ctrl-M**/ Windows) to vertically align the text in the box.

3. Repeat this process on the right master page. You can duplicate the items on the left page and move them to the right page. Your screen should resemble Figure 5.55.

Click on the Name Bar for the master page to highlight it. Then type a new name for that master page.

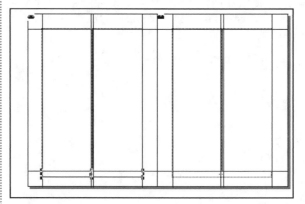

Figure 5.55. We formatted both the left and right master pages with a rule and folio text box.

4. Click on the A-Master A name bar and type *Articles* to rename Master Page A.

CREATING ADDITIONAL MASTER PAGES

Master Page B will be used for the front matter of the magazine, its table of contents, editorial information, and so on. However, because it shares a common master item with Master Page A, the folio text box, it will be easier to duplicate Master Page A and edit it than to recreate a whole new master page with the folio box.

1. Click on the Articles master page icon in the Document Layout palette and click the Duplicate icon in the top panel of the palette to create a duplicate of the Articles master page. It appears below the Articles master page as Master Page B. Click on its name bar and type *Editorial* (Figure 5.56).

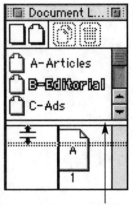

Figure 5.56. Duplicate a master page by selecting it and clicking the Duplicate icon (left). Rename the duplicate by clicking in its name bar to highlight it and typing a new name.

Drag the bar between the master pages and document pages so you can see all the master page icons.

2. Double-click on the Editorial master page to get to it and delete the vertical rule and the automatic text box. Be sure to do this on both the left and right master pages. Leave the folio box on the page.

3. The third master page for advertising art doesn't need a folio text box, so create this box by dragging the blank Facing Pages icon down onto the Master Page area below the Editorial master page to create Master Page C (Figure 5.57).

4. Change the name of Master Page C to *Ads* (Figure 5.57).

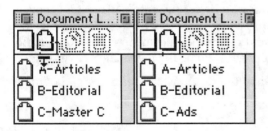

Figure 5.57. Drag a blank Facing Pages icon down onto the master page panel and rename the new master page.

INSERTING DOCUMENT PAGES

Because the editorial pages will appear at the front of the magazine, you'll insert those pages first. Leave document page 1 for the magazine cover, and insert the new pages after page 1.

Where are you?

You must be on a document page before you can insert pages into the document. Otherwise, the Insert command is not available.

1. Double-click on document page 1 to get to that page. Choose Page/Insert and insert 4 pages at the end of the document. Use the Master Page pull-down menu to select Editorial (Figure 5.58).

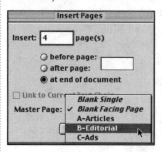

Figure 5.58. Insert 4 pages based on the Editorial master page at the end of the document.

2. To insert 10 pages after page 5 based on the Articles master page, you must select the Link to Current Text Chain check box in the Insert Pages dialog box. This check box is only available when you select the Articles master page, which was originally Master Page A, the master page containing the automatic text box from the Master Page menu (Figure 5.59).

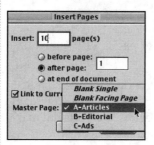

Figure 5.59. Insert 10 pages based on the Articles master page after page 5. Select the Link to Current Chain check box to link the text from one page to the next.

3. Because the magazine articles won't be starting on page 1, but rather on page 6, you must delete the automatic text box and the vertical rule from page 1. Once you do this, double-click on page 6 to get there and notice the I-beam cursor blinking in the text box. Document page 1 will be the magazine's cover page.

4. Insert 4 pages based on the Ads master page at the end of the document.

NUMBERING THE PAGES

You'll number the Editorial document pages with lower-case Roman numerals and the Articles document pages with Arabic numerals.

1. Double-click on document page 2. Choose Page/Section. Click the Section Start check box. Type 2 in the Number field and select small Roman numerals from the Format menu. Click OK. All the pages in the document from page 2 onward are numbered with Roman numerals (Figure 5.60).

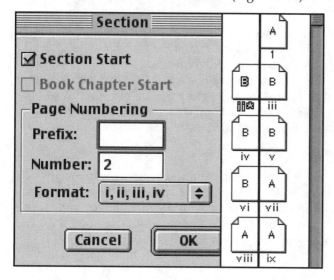

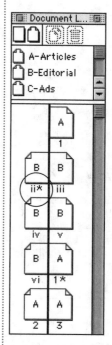

An asterisk next to a page number indicates that the document has been sectioned at that page.

Figure 5.60. Applying the Section command changes the page number of the selected page and all subsequent pages.

2. Double-click on document page vii and choose Page/Section. Select Section Start, type 1 in the Number field, and select Arabic numbers from the Format menu. Click OK. Page vii is now page 1 and all subsequent pages are numbered sequentially.

FORMATTING THE MASTER PAGES

1. Double-click on the Editorial master page. Use the Rectangle Text Box tool to draw a text box on the left master page. Use the Box tab of the Modify dialog box (Item/Modify [**Command-M**/Macintosh or **Ctrl-M**/Windows]) to give it a background color of 20% blue. Repeat for the right master page or duplicate the blue box (Item/Duplicate [**Command-D**/Macintosh or **Ctrl-D**/Windows]) and move it to the right master page.

Use the Tint Percent menu in the Colors palette to select a lighter shade of the color.

2. Double-click on document page vi, select the blue text box, and change the box background to 20% magenta in the Box tab of the Modify dialog box (**Command-M**/Macintosh or **Ctrl-M**/Windows). You have applied local formatting to that master item on the document page and therefore stripped it of its master item status.

3. Double-click on the Editorial master page and change the background colors of the boxes on both master pages to 20% green. All the document pages except page vi display the new green box.

4. Choose Edit/Preferences/Preferences (**Command-Y**/Macintosh or **Ctrl-Y**/Windows). In the General field, click Delete Changes in the Master Page Items field. Now drag the Editorial master page icon down onto document page vi to reapply the master page to that document page. The magenta box is replaced by the green box, because you opted to delete any modified master items when you reapplied the master page.

ON YOUR OWN

You now have a document with multiple master pages. Apply local formatting to different pages, make changes on the master pages, and reapply the master pages with Keep Changes and Delete Changes selected in the General Preferences dialog box until you are comfortable with editing master pages.

Unit 6
Formatting Paragraphs

OVERVIEW

In this unit you will learn how to:

Apply paragraph attributes and control paragraphs
Set leading and spacing values
Create drop caps
Set paragraph alignment
Work with the Keep Lines Together command
Use the Keep with next ¶ (Paragraph) command
Set and lock a paragraph to the baseline grid
Hyphenate a paragraph
Set tab stops

TERMS

absolute leading
auto leading
baseline
baseline grid
drop cap
increment
leading
orphan
paragraph alignment
widow

LESSON 1: PARAGRAPH FORMATS

PARAGRAPH ATTRIBUTES

The paragraph (Figure 6.1) is the basic unit of a document. Its properties include:

▲ **leading** (the vertical space between lines of type).

▲ **indents** (the space from the left and/or right sides of the text box as well as for the first line of the paragraph).

▲ **spacing** before and after the paragraph.

▲ **relationships** between paragraphs.

▲ **hyphenation and justification**.

▲ paragraph **alignment**.

▲ **drop caps.**

▲ **locking to the baseline grid.**

As far as we know, the largest living bird is the North African ostrich. It can grow to a height of 9 feet and a weight of nearly 350 pounds. It takes about 40 minutes to boil an ostrich egg. Even though the shell of an ostrich is just 6/100 of an inch thick, it can support the weight of a man weighing almost 300 pounds. ¶

The smallest living bird is the bee hummingbird. This little creature measures only 2.24 inches in length and weighs less than an ounce. ¶

Figure 6.1. The first paragraph begins with "As far as we know" and ends with "300 pounds." The second paragraph begins with "The smallest living bird" and ends with "less than an ounce." The first line of each paragraph is indented from the left side of the text box. The paragraph return symbol (circled) indicates the end of the paragraph.

ASSIGNING PARAGRAPH ATTRIBUTES

Paragraph attributes are all assigned from the Paragraph Formats dialog box. At first glance, this can seem overwhelming, but it is really a powerful and easy dialog box to use. You can also assign some paragraph attributes from the Measurements palette.

Properly formatting paragraphs will help you to break some bad typesetting habits, like pressing the Spacebar to indent a paragraph and allowing single text lines to appear at the end of a column of text (orphans) and at the top of a column of text (widows).

SELECTING A PARAGRAPH

Because paragraph formatting commands apply to the entire paragraph, you simply click anywhere in a paragraph to select the paragraph. You don't have to highlight any of the characters in a paragraph to select a paragraph.

PARAGRAPH INDENTS

In QuarkXPress, a paragraph is aligned relative to the left and right sides of the text box, and its distance from those sides is first determined by the value specified in the Text Inset field of the Text Modify dialog box. The default value is 1 point, and unless you select Multiple Insets in the Text Modify dialog box, this means that the text is inset 1 point around all four sides of the box. Any change you make to this value applies that value to all four sides of the text box.

Beyond the Text Inset value are the paragraph indent values. Here you specify the distance of only the left side of the paragraph text from the left side of the text box (Left Indent value), from the right side of the text box (Right Indent), or the distance of the first line of the paragraph from the left side of the text box (First Line indent).

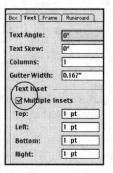

Select multiple insets in the Text Modify dialog box.

EXERCISE A

1. Create a new document with 1-inch margins, nonfacing pages, and an automatic text box (File/New/Document).

2. Choose Edit/Preferences/Preferences (**Command-Y**/Macintosh or **Ctrl-Y**/Windows) to display the General preferences. Click the Measurements option and make sure that inches is the unit of measure. Click OK.

3. Click inside the automatic text box on the page and choose File/Get Text (**Command-E**/Macintosh or **Ctrl-E**/Windows). Locate the *Para1.txt* file in the Unit 06 folder in the Student Files folder on the CD-ROM. Double-click on the file or highlight the file name and click on Open to load the text file into the XPress document. Choose View/Show Invisibles (**Command-I**/Macintosh or **Ctrl-I**/Windows) and notice the paragraph return marker at the end of both paragraphs.

Very important info

Always use the First Line indent command to indent a paragraph. Using the Spacebar or the Tab key is absolutely the wrong thing to do because these keys generate extra characters over which you have little or no control. In a long document this can make you weep.

Select from a variety of horizontal and vertical units of measure in the General (Measurements) Preferences dialog box.

4. Click anywhere in the first paragraph and choose Style/Formats to display the Paragraph Attributes dialog box (Figure 6.2).

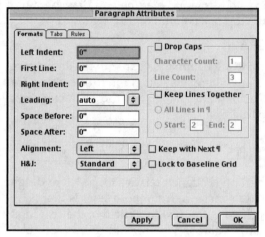

Figure 6.2. The Paragraph Attributes dialog box

5. The first three options, Left Indent, First Line, and Right Indent, refer to the distance of the paragraph lines from the left and right sides of the text box. Type 1 in the Left Indent field, press the Tab key, type .5 in the First Line field, press the Tab key, and type 2 in the Right Indent field. Click on the Apply button to apply those values without leaving the dialog box. You may have to move the dialog box by dragging its title bar so you can see the first paragraph. Your screen should resemble Figure 6.3. Notice how the paragraph is indented from both sides of the text box and that the first line is indented one half inch into the paragraph. Click OK to execute the changes.

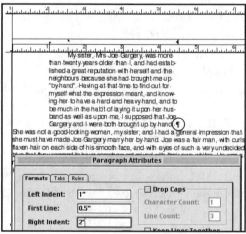

Figure 6.3. The first (selected) paragraph reflects the indent values in the Paragraph Attributes dialog box. The paragraph marker (¶) is displayed when Invisibles are turned on from the View menu.

6. Quadruple-click inside that first paragraph to select the entire paragraph, because you're applying character attributes as well as paragraph formatting. Use the Measurements palette or the Style menu to change the font to 10-point Helvetica. Click to deselect the characters but keep the cursor inside the paragraph. As long as the I-beam cursor is blinking anywhere in a paragraph, that paragraph is selected.

7. Choose Style/Formats (**Command-Shift-F**/Macintosh or **Ctrl-Shift-F**/Windows). In the Paragraph Formats dialog box select auto in the Leading field and type 12. This applies 12 points of leading to the paragraph even though the unit of measure is inches.

8. Press the Tab key twice to get to the Space After field. Type 1p to apply one pica of space after the paragraph. Even though inches is the selected unit of measure for the document, typing p after any value overrides the unit of measure and applies the value in picas. Click on Apply and notice that XPress has translated the pica value into inches, the specified unit of measure. Click OK. Your paragraph should resemble Figure 6.4.

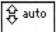

The Leading field defaults to auto. The auto value defaults to 20% of the type size but can (and should) be changed to an absolute value—such as 12 points, for example—in the Paragraph Preferences dialog box.

Free math lesson

There are 12 points in one pica.

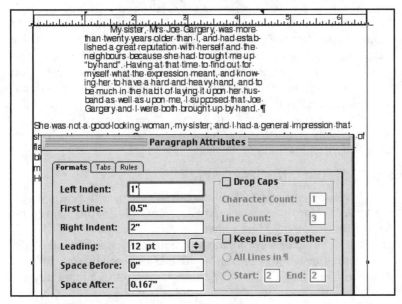

Figure 6.4. Leading and spacing values affect the entire paragraph. The pica value in the Space After field is translated into inches, the document's specified unit of measure.

9. With the paragraph still selected, choose Style/Formats (**Command-Shift-F**/Macintosh or **Ctrl-Shift-F**/Windows) again. Type 0 in the Left Indent field, press the Tab key twice, and type 0 in the Right Indent field. Use the Alignment pull-down menu to select Justified. Click OK. Only the first line of the paragraph is indented from the left side of the text box and the entire paragraph is horizontally aligned from the left to right sides of the text box. The paragraph also displays the one pica of space after the paragraph.

10. Choose File/Save (**Command-S**/Macintosh or **Ctrl-S**/Windows) and save this file as *Para1.qxd* in your Projects folder. You'll need it for the next exercise.

SETTING LEADING AND SPACING VALUES

Because leading, the vertical space between lines of type, is applied to every line in a paragraph, a Leading field is available in the Paragraph Attributes dialog box. Two other spacing values are also available that allow you to specify an amount of space before and/or after a paragraph. One of the cardinal sins of typesetting is to press the Return/Enter key twice at the end of the paragraph to create space after the paragraph. This extra paragraph return is a character, albeit an invisible character, and like an infectious disease, it carries font, font size, leading, and other format information with it. Having these paragraph returns floating around in a document is the easiest way to lose control of your document, because different paragraph returns will carry different formatting information that will throw your document design off and result in an inconsistent publication.

SPACE BEFORE AND SPACE AFTER

The correct way to add space before and after paragraphs is to use the Space Before and Space After commands in the Paragraph Attributes dialog box. Just remember that if you apply a half inch of space *after* one paragraph and a half inch of space *before* the next paragraph, those two paragraphs will be separated by one full inch of space. Use the Space Before and Space After commands to set spacing before and after a paragraph—always.

1. If necessary, open the *Para1.qxd* file you created in the last exercise or open the *Para1.qxd* file in the Unit 06 folder in the Student Files folder on the CD-ROM.

2. Click inside the second paragraph, the one you didn't format, and quadruple-click to select the entire paragraph. Format the type in 12-point Times from either the Style menu or the Measurements palette (**F9**).

3. Click anywhere inside that paragraph to select the entire paragraph. Choose Style/Formats (**Command-Shift-F**/Macintosh or **Ctrl-Shift-F**/Windows) to display the Paragraph Attributes dialog box. Type 0 in the Left Indent field, press the Tab key twice, and type 0 in the Right Indent field.

4. Press the Tab key again to highlight the Leading field. Type 15 in the Leading field and press the Tab key to highlight the Space Before field. Type p6 to apply 6 points of space before the paragraph.

5. Press the Tab key to highlight the Space After field. Type 1p to apply one pica of space after the paragraph. Click on OK. Your screen should resemble Figure 6.5.

6. Save this file as *Space.qxd* (File/Save as).

Watch your ps and ps

Typing a p after a value applies the value in picas. Typing a p before the value applies the value in points. 7p2p applies a value of 7 picas and 2 points. Pica values are not case-sensitive. If you don't type a p, the value defaults to points.

My sister, Mrs. Joe Gargery, was more than twenty years older than I, and had established a great reputation with herself and the neighbours because she had brought me up "by hand". Having at that time to find out for myself what the expression meant, and knowing her to have a hard and heavy hand, and to be much in the habit of laying it upon her husband as well as upon me, I supposed that Joe Gargery and I were both brought up by hand. ¶

She was not a good-looking woman, my sister; and I had a general impression that she must have made Joe Gargery marry her by hand. Joe was a fair man, with curls of flaxen hair on each side of his smooth face, and with eyes of such a very undecided blue that they seemed to have somehow got mixed with their own whites. He was a mild, good-natured, sweet tempered, easygoing, foolish, dear fellow—a sort of Hercules in strength, and also in weakness. ¶

Figure 6.5. Applying the values in the Paragraph Formats dialog box results in the second paragraph displaying 15 points of leading with 6 points of space before and 1 pica of space after the paragraph.

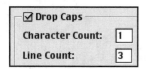

Select the Drop Caps check box in the Formats tab of the Paragraph Attributes dialog box.

DROP CAPS

A *drop cap* is one or more initial characters in a paragraph that, rather than sitting on the baseline of the first line of text, drop down one or more lines into the paragraph. You can format drop caps separately from the rest of the paragraph, but you may have to fiddle with them to get them positioned perfectly in the paragraph.

DROP CAP SIZE

Although the Measurements palette reflects the drop cap character at its original size, selecting just the drop character(s) changes the type size from a numerical value to 100%. You can resize that drop character(s) in percentages, not in point sizes. To resize a drop cap, select the drop cap and type a percentage value in the Drop Cap field of the Measurements palette higher than 100% to enlarge the drop cap or lower than 100% to reduce the size of the drop cap.

EXERCISE C

The First Line Indent marker appears on the Paragraph Formats ruler, not on the document ruler.

1. If necessary, open the *Space.qxd* file you created in the last exercise or open the *Space.qxd* file in the Unit 06 folder in the Student Files folder on the CD-ROM. Display the Measurements palette (View/Show Measurements or **F9**). Click anywhere in the first paragraph to select it and choose Style/Formats (**Command-Shift-F**/Macintosh or **Ctrl-Shift-F**/Windows) to display the Paragraph Attributes dialog box.

2. On the right side of the dialog box, click in the Drop Cap check box to turn on the drop cap option. It defaults to one character (Character Count value) dropping down into the first three lines of the text (Line Count). To give the drop cap more room, drag the First Line indent marker on the ruler over the text box to the left until the First Line field in the dialog box reads 0". You can also just type 0 in the First Line field. Click OK. Your screen should resemble Figure 6.6.

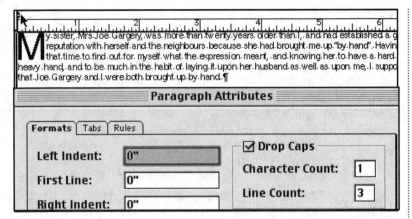

Paragraph Attributes

| Formats | Tabs | Rules |

Left Indent: `0"`

First Line: `0"`

Right Indent: `0"`

☑ **Drop Caps**

Character Count: `1`

Line Count: `3`

Figure 6.6. We moved the First Line indent marker on the ruler over the text box to the 0 mark, and dropped one character 3 lines into the paragraph.

Drop cap size

Highlight a drop cap to display its size as a percentage of the font size, as displayed in the Size field of the Measurements palette. To reduce or enlarge the drop cap, type a value in that field between 20 and 400%.

3. With the paragraph still selected, choose Style/Formats (**Command-Shift-F**/Macintosh or **Ctrl-Shift-F**/Windows) again. In the Drop Cap field, change the Character Count value to 2 and the Line Count value to 2. Click OK.

4. Drag to select the two drop characters and notice that the type size value in the Measurements palette displays 100%. Select the 100% and type 110. Press Return/Enter to increase the size of the two drop characters. Your screen should resemble Figure 6.7. You can also change the size of a drop cap from the Style/Size menu, just as you would do with any other selected text character. A drop cap is simply an enlarged character; it isn't a graphic, which means that it still lives by the same text formatting rules as other text characters.

Figure 6.7. The selected drop cap characters are enlarged by 10%.

5. Click in the second, unformatted paragraph to select it. Press the Option-Shift keys (Macintosh) or Alt-Shift keys (Windows) and click anywhere in the first paragraph, the one with the drop caps. All the paragraph formatting from the first paragraph (leading, spacing, alignment, and drop caps) is automatically applied to the second paragraph. The only formatting that is not applied is character formatting, in this case the 10-point Helvetica. To see this for yourself, click anywhere in the second paragraph and notice that the Measurements palette reflects the leading change. Your screen should resemble Figure 6.8. Close this file. Don't save your changes.

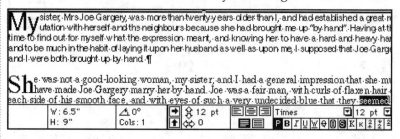

Figure 6.8. Selecting any paragraph (target paragraph) and Alt/Option-Shift clicking in another paragraph (source paragraph) applies all the paragraph formatting from the source paragraph to the selected target paragraph.

PARAGRAPH ALIGNMENT

Paragraph alignment refers to the relationship of the paragraph to the left side, right side, and center of the text box. Select an alignment option from the Paragraph Attributes dialog box or from the Measurements palette.

PARAGRAPH ALIGNMENT OPTIONS

You can align text so that each line in the paragraph:

▲ **Starts at the left side of the text box**. This is called *left aligned* or *rag right* because the uneven endings of the lines appear on the right side of the text box.

▲ **Ends at the right side of the text box**. This is called *right aligned* or *rag left* because the uneven edges of the paragraph lines appear on the left side of the text box.

▲ **Stretches from the right to the left side of the text box**. This is called *justified text*. When text is justified, the last line of the paragraph is not stretched to fit between the sides of the text box. To stretch the last line of text—this is really ugly and should never be done—choose Force Justify alignment.

Figure 6.9 displays examples of paragraph alignment.

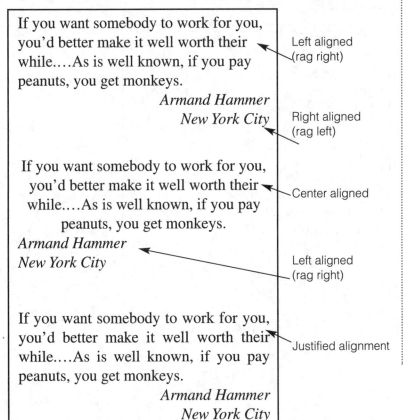

Figure 6.9. The same paragraph displaying left, right, center, and justified paragraph alignment

LESSON 2: PARAGRAPH RELATIONSHIPS

CONTROLLING PARAGRAPHS

When setting type, editorial or design constraints often include keeping some or all of the lines in a paragraph together to avoid creating widows and orphans. Other times, it is necessary to keep a heading paragraph with the paragraph that follows it. For example, it's customary to have at least two lines of a paragraph appear at the top of a page or text column. It's also important to have a headline appear with the first paragraph of the story it's headlining.

WIDOWS AND ORPHANS

A *widow* is the last line of a paragraph that, because of the text flow, ends up at the top of a column or page (Figure 6.10). An *orphan* is the first line of a paragraph that ends up as the last line in a column or text box (Figure 6.11).

Milton Berle once said, "Yes, I do like to perform. I relish working a roast. It feels good to be able to knock giants down with a few well-directed words. It feels especially good to realize that the laughter evoked, for one moment, erases uncomfortable dif-ferences and puts

envy to rest."

Figure 6.10. The three words at the top of the second column create the widow, the last line of a paragraph that appears at the top of a new column or page.

Milton Berle once said, "Yes, I do like to perform. I relish working a roast. It feels good to be able to knock giants down with a few well-directed words. It feels especially good to realize that the laughter evoked, for one moment, erases uncomfortable differences and puts envy to rest."
 Ogden Nash is quoted as saying, "Parents were invented to make children happy by giving them something to ignore."

Figure 6.11. An orphan is created when only one line of a paragraph (the second paragraph) appears at the bottom of a text column or page.

KEEP LINES TOGETHER COMMAND

The Keep Lines Together command in the Paragraph Attributes dialog box lets you decide how many lines in a paragraph must appear at the bottom of a column or page and how many must appear at the top of a column or page. If the paragraph can't meet these requirements, then the entire paragraph moves to the next column or page.

EXERCISE D

1. Open the *Keepara.qxd* file in the Unit 06 folder in the Student Files folder on the CD-ROM (File/Open [**Command-O**/Macintosh or **Ctrl-O**/Windows]). Choose View/Show Invisibles (**Command-I**/Macintosh or **Ctrl-I**/Windows). Notice the headings in red boldfaced type. The third heading, Description, displays only one line, the first line ("My sister, Mrs."), from the following paragraph at the bottom of the second column. This line is an orphan.

2. Click anywhere in the first paragraph below the Description paragraph and choose Style/Formats (**Command-Shift-F**/Macintosh or **Ctrl-Shift-F**/Windows) to display the Paragraph Attributes dialog box.

FYI

Most editors want at least the first two lines of a paragraph at the bottom of a column or page (Start field) and at least two lines of a paragraph at the top of a column or page (End field). However, you can set any value in these fields.

3. At the right side of the dialog box, click in the Keep Lines Together check box to activate the function. XPress defaults to keeping all the lines in a paragraph together. This is the correct option to choose for heads, but not for a body paragraph. Instead, click the Start button, which defaults to a minimum of 2 lines at the end of a column or page and a minimum of 2 lines at the beginning of the next column or page. Click OK.

4. Because two lines could not fit at the bottom of the column, the entire paragraph moved to the top of the third column, thus meeting the Start and End requirements of at least two lines at the end of a column or page and two lines at the top of a column or page (Figure 6.12).

5. Save this file as *Linestog.qxd* in your Projects folder. You'll need it for the next exercise (File/Save As).

me, I supposed that Joe Gargery and I were both brought up by hand.
Character

dear fellow—a sort of Hercules in strength, and also inweakness.
Description
My sister, Mrs

made it a powerful merit in herself, and a strongreproach against Joe, that she wore this apron so

Figure 6.12. Applying the Keep Lines Together command, with its requirement of at least two lines at the beginning of the paragraph, to the paragraph below the *Description* head forces the whole paragraph to move to the next column.

KEEP WITH NEXT ¶ (PARAGRAPH) COMMAND

When a document contains headings before paragraphs, it's important that the heading remain with its paragraph and not end up at the bottom of a column or page while the paragraph moves to the top of the next column or page. The Keep with Next ¶ (Paragraph) command in the Paragraph Attributes dialog box is used to link headings with their paragraphs. When this command is applied to a heading paragraph, if there is not enough room at the bottom of a column or of a page for both the heading paragraph and the following paragraph to fit, both paragraphs will travel together to the top of the next column or page.

KEEPING PARAGRAPHS AND LINES TOGETHER

The Keep with Next ¶ (Paragraph) command also functions with the Keep Lines Together command. If you specify, for example, two lines for the start of each body paragraph and the heading paragraph is linked to the body paragraph, if there isn't enough room for both the heading paragraph and two lines of the body paragraph, the heading paragraph and the entire body paragraph will move to the next column or page.

EXERCISE E

1. Open the *Linestog.qxd* file in the Unit 06 folder in the Student Files folder on the CD-ROM (File/Open). Display the Document Layout palette (View/Show Document Layout [**F10**/ Macintosh or **F4**/Windows]) and double-click on page 1 to get to the first page. Scroll through the first page of the file and notice the headings in red boldfaced type. The Character and Description headings are at the bottom of the first and second columns of text and are, therefore, separated from their subsequent paragraphs.

2. Click anywhere in the red Description paragraph to select it. Choose Style/Formats (**Command-Shift-F**/Macintosh or **Ctrl-Shift-F**/Windows) to display the Paragraph Attributes dialog box.

3. Click in the Keep with Next ¶ check box to turn on the function. This forces the selected paragraph to travel with the paragraph following it. Click on OK. Notice that the Description head now moves to the top of the third column (Figure 6.13).

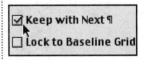

Select this option in the Paragraph Formats dialog box.

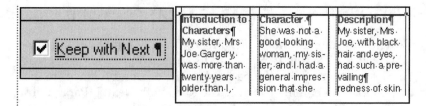

Figure 6.13. Applying the Keep with Next ¶ command to the Character and Description paragraphs forces them to move to the top of the next column in order to stay with their subsequent paragraphs.

4. Even if text is added or deleted from this text box, the Description head will always remain with the paragraph following it. Click anywhere in the red Character paragraph. Press the Option-Shift keys (Macintosh) or Alt-Shift keys (Windows) and click in the red Description paragraph to apply the Description formatting to the Character paragraph. The Character paragraph moves to the top of the second column.

5. Close this file (File/Close). Don't save your changes.

LOCK TO BASELINE GRID

Lines of type sit on an invisible line called the *baseline*. These lines of type run merrily from left to right in a text box divided by vertical space called *leading*. The more leading between lines of type, the more open and elegant the type looks. Not enough leading, and type looks like an ad for a sleazy appliance store. Leading across multiple columns isn't a critical issue for type set in one column, but it can be for multiple-column text like that in newspapers and magazines. In these kinds of documents, type must sit on the same baseline in all the columns and not appear up and down across the columns (Figure 6.14).

Paragraph One	the file.
"Where is he?" He crammed what little food was left, into the breast of his grey jacket. "Show me the way he went. I'll pull him down, like a bloodhound. Curse this iron on my sore leg! Give us hold of the file, boy."	Paragraph 3
	I was very much afraid of him again, now that he had worked himself into this fierce hurry, and I was likewise very much afraid of keeping away from home any longer. I told him I must go, but he took no notice, so I thought the best thing I could do was to slip off. The last I saw of him, his head was bent over his knee and he was working hard at his fetter, muttering impatient
Paragraph Two	
I indicated in what direction the mist had shrouded the other man, and he looked up at it for an instant. But he	

Figure 6.14. Displaying the Baseline Grid indicates that the type is not aligned on the baseline across the two columns.

BASELINE GRID AND PARAGRAPH SPACING

When applying Space Before or Space After values to a paragraph locked to the baseline grid, specify the spacing value in increments of the leading. For example, if you have locked a paragraph with 14 points of leading to the baseline grid, apply a spacing value of 3½ points (p3.5) or 7 points (p7). You can always specify values in any unit of measure, regardless of the option selected in the General Preferences dialog box.

To see the baseline for lines of type, choose Show Baseline Grid from the View menu. The position for the baseline grid is determined by the Increment value in the Baseline Grid field of the Paragraph Preferences dialog box (Figure 6.15). When this value equals the leading value and a paragraph is locked to that baseline grid, the lines of text will sit at the same position across multiple columns.

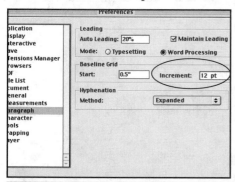

Figure 6.15. The Increment value in the Baseline Grid field in the Paragraph Preferences dialog box must equal the leading value of the paragraph if type is to sit at the same position across multiple columns.

SETTING THE BASELINE GRID

Aligning text across multiple columns is a three-step process:

1. **Assign an absolute leading value to the paragraphs** specified in points. This means that you will not use auto leading.

2. **Assign that same leading value to the Increment** in the Baseline Grid field of the Paragraph Preferences dialog box (Edit/Preferences/Document/Paragraph).

3. **Lock the paragraphs to the baseline grid** from the Paragraph Attributes dialog box.

MAINTAIN LEADING

Select Maintain Leading in the Paragraph Preferences dialog box to control the placement of a line of text that falls immediately below a box or item in a column of text. With this option selected, the line's baseline is placed according to its assigned leading value. Deselecting this option causes the line's ascenders (tops of capital letters, such as ls, ds, etc.) to abut the bottom of the item.

Absolute leading

Absolute leading remains fixed, regardless of the point size of any character in a paragraph. Absolute leading is applied in the Paragraph Attributes dialog box and in the Leading field of the Measurements palette.

EXERCISE F

1. Open the *Baseline.qxd* file in the Unit 06 folder in the Student Files folder on the CD-ROM. Click inside the text box to select it. Choose View/Show Baseline Grid to display the current baseline in the document. Notice that the lines of type do not line up across both columns. Display the Measurements palette (View/Show Measurements). The Leading field displays auto for the entire document.

2. Choose Edit/Select All (**Command-A**/Macintosh or **Ctrl-A**/Windows). Double-click to select auto in the Leading field of the Measurements palette, type 18, and press Return/Enter to apply 18 points of space from one baseline to the one above or below it.

3. Choose Edit/Preferences/Document and click on the Paragraph tab to display the Paragraph Preferences for this document. Type 18 in the Increment field under Baseline Grid on the left side of the dialog box. Click on OK.

4. With all the text still selected, choose Style/Formats and click to select the Lock to Baseline Grid check box. Click OK. The lines of type now align across the three columns (Figure 6.16).

Paragraph One	which he handled as roughly as if it had no more feeling in it than the file.
"Where is he?" He crammed what little food was left, into the breast of his grey jacket. "Show me the way he went. I'll pull him down, like a bloodhound. Curse this iron on my sore leg! Give us hold of the file, boy."	Paragraph 3

I was very much afraid of him again, now that he had worked himself into this fierce hurry, and I was likewise very much afraid of keeping away |
| Paragraph Two

I indicated in what direction the mist had shrouded the other man, and he looked up at it for an instant. But he was down on the rank wet grass, filing at his iron like a madman, and not minding me or minding his own leg, which had an old chafe upon it | from home any longer. I told him I must go, but he took no notice, so I thought the best thing I could do was to slip off. The last I saw of him, his head was bent over his knee and he was working hard at his fetter, muttering impatient imprecations at it and at his leg. The last I heard of him, I stopped in the |

Figure 6.16. Once leading and increment values are the same, locking the paragraphs to the baseline grid in the Paragraph Attributes dialog box will align the paragraphs properly across multiple columns.

5. Choose Edit/Preferences/Preferences (**Command-Y**/Macintosh or **Ctrl-Y**/Windows) and click on the Paragraph tab. In the Paragraph Preferences dialog box, type 9 in the Increment field. Click OK. The lines still align properly across the columns because 9 is an increment of 18, the leading value.

6. Close this file. Don't save your changes.

LESSON 3: HYPHENATION METHODS

HYPHENATION

The Paragraph Formats dialog box allows you to choose a method of hyphenating the paragraph. QuarkXPress defaults to hyphenating a word as small as six characters if that six-character word is not capitalized. It allows for unlimited hyphens in a row across the full width of the text box. However, most editors want to see no more than two hyphens in a row in any paragraph and sometimes allow capitalized words to be hyphenated.

STANDARD HYPHENATION

Unless you create and select another form of hyphenation, the Standard hyphenation is applied by default to every paragraph you type or import into an XPress document. You can always edit the default Standard hyphenation if you don't want to create another hyphenation option.

DISCRETIONARY HYPHENS

If you want to insert a hyphen in a paragraph that will disappear if the text flow changes, use the discretionary hyphen—sometimes called a soft hyphen. Type **Command-[hyphen]**/Macintosh or **Ctrl-[hyphen]**/Windows. If the text flow changes, then the discretionary hyphen will disappear.

EXERCISE G

1. If necessary, open the *Space.qxd* file you saved earlier or open the *Space.qxd* file in the Unit 06 folder in the Student Files folder on the CD-ROM. Choose Edit/H&Js to display the H&Js (Hyphenation and Justification) dialog box for the active document. You can either edit the Standard H&J settings or create a new setting. Click on New. Type *My H&J* in the Name field and apply the values displayed in Figure 6.17.

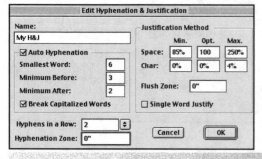

Figure 6.17. The new hyphenation values call for automatically hyphenating words of at least six characters, but limiting the hyphens to no more than two in a row. If the last paragraph consists of only one word, that paragraph is not justified.

2. Leave Auto Hyphenation selected and leave the smallest word set to 6 characters, with the minimum number of characters before the hyphen at 3 and the minimum number of characters after the hyphen set to 2. This means that XPress will hyphenate a word like *double* but won't hyphenate a word like *doubt*.

3. Make the optimum character spacing value 100% instead of the default 110%. This spaces characters exactly the way the type designer specified, without any extra space between the characters. Click to select Break Capitalized words. Type 2 in the Hyphens in a Row field to limit the number of consecutive hyphens in a paragraph to no more than two. Deselect Single Word Justify on the right side of the dialog box so that if a single word falls on the last line of the paragraph it won't be tracked to fit the width of the text box. Click OK. Click Save.

4. Use the Measurements palette (**F9**) to resize the text box to 12 picas wide by typing 12p in the W field and pressing Return/ Enter. Click anywhere in the first paragraph to select it. Choose Style/Formats (**Command-Shift-F**/Macintosh or **Ctrl-Shift-F**/ Windows). Choose Justified from the Alignment menu. Choose My H&J from the H&J pull-down menu. Click OK. Your first paragraph should resemble Figure 6.18. Notice that there are only two consecutive hyphens in the first paragraph.

How it hyphenates

To see how XPress will hyphenate a word, select the word and choose Utilities/Suggested Hyphenation (**Command-H**/ Macintosh or **Ctrl-H**/ Windows).

Suggested Hyphenation
para-graph

Figure 6.18. This displays the H&J and Alignment values applied in the Paragraph Attributes and H&Js dialog boxes.

5. Drag the text box, making it wider and narrower, to see how the different lines in that second paragraph become hyphenated.

6. Close this file (File/Close). Don't save your changes.

LESSON 4: USING TABS

TAB STOPS

Use tabs to align rows and columns of entries. The biggest mistake users make when working with tabs is not pressing the Tab key. You can set twenty tab stops in the Tabs dialog box, but if you don't press the Tab key twenty times in the paragraph, you won't see any tab alignments. To set a tab, you must press the Tab key before or after you specify the tab position in the Tabs dialog box. Once the Tab key is pressed, any values you type in the Tabs dialog box will be applied.

Tabs are a paragraph-level format, which means that the entire paragraph is affected by the tab, not just one line. You must press the Return/Enter key to end the paragraph before applying tabs. And because Tabs are paragraph-based, you don't have to select the entire paragraph; clicking anywhere in the paragraph selects the paragraph whenever you are applying a paragraph-based command. If you find that a line is too long to be tabbed effectively, consider reducing the type size or the number of text characters in the entries.

The tab stops in XPress default to setting a left-aligned tab every half inch wherever you press the Tab key in the document. To override the default settings, use the Tabs dialog box.

Tabs can be aligned on the left character in the entry, on the right character in the entry, on the center character in the entry; aligned on a text character like the dollar sign; aligned on a comma; or aligned on a decimal point (Figure 6.19). You can also include a tab leader, like a period, between tab stops to make it easier for the eye to follow the tab.

Use the Measurements option in the General Preferences dialog box to select a unit of measure.

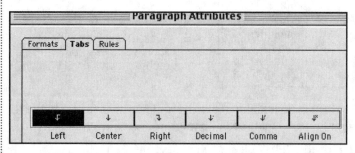

Figure 6.19. You can set six different kinds of tabs in the Tabs dialog box.

RIGHT-ALIGNED TABS

You can select the Right tab icon in the Tabs dialog box to set a tab that aligns text on the rightmost text character. An easier way to do this, however, is to press Option-Tab (Macintosh) or Alt-Tab (Windows). This aligns the text all the way on the right side of the column or text box (Figure 6.20).

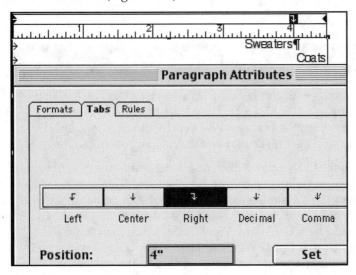

Figure 6.20. The Sweaters line displays a right-aligned tab at the 4" mark on the Tab ruler. The Coats line is right-aligned using the Option-Tab (Macintosh) method.

INSERTING TAB STOPS

To insert tab stops while typing, use the Content tool and press the Tab key before each new column of text. The cursor automatically moves to the next default tab stop. If you don't like where the text falls, don't keep pressing the Tab key. You can go back later and edit the position of that particular tab stop. Multiple tab stops make you look either dumb or lazy.

To add tab stops to text you've already typed or imported, click to the left of the text that starts the next column and press the Tab key. You can go back later and edit the default tab stops.

DELETING TAB STOPS

To delete a single tab stop, just click on it and drag it down from the Tab ruler or drag it off the Tab ruler. To remove all the tabs in a paragraph or in selected paragraphs, do one of the following:

▲ Click the Clear All button in the Tabs dialog box. Or

▲ Option-click (Macintosh) or Alt-click (Windows) on the Tab ruler.

EXERCISE H

1. Create a new document with an automatic text box and half-inch margins (.5"). Display the Measurements palette (**F9**). Choose Edit/Preferences/Preferences and click on General. Make sure the unit of measure is set to inches. Click OK.

2. Select the Content tool, click inside the text box on the first page of the document, and choose File/Get Text (**Command-E**/Macintosh or **Ctrl-E**/Windows). Navigate to the Unit 06 folder in the Student Files folder on the CD-ROM drive and open the file named *Tabs.text*. Choose View/Show Invisibles (**Command-I**/Macintosh or **Ctrl-I**/Windows) to display the text codes and notice the spaces between the words and the paragraph returns after each line.

3. Click between each entry, and do the following:

▲ Delete the space *between the entries* (not between words in an entry). *And*

▲ Press the Tab key between each entry. The text will not format properly until you specify the tab stops (Figure 6.21).

Print·and·Broadcast·Software·Publishers¶
Company⃗ Location⃗ Flagship·Product⃗ Price¶
Adobe·Systems,·Inc.⃗ San·Jose,·CA⃗ Photoshop⃗ $609.00¶
Quark,·Inc.⃗ Denver,·CO⃗ QuarkXPress$869.00¶
Macromedia,·Inc.⃗ San·Francisco,·CA⃗ Flash⃗$299.00¶

Figure 6.21. Delete the spaces between columns of text and press the Tab key to the left of each column of text. The columns move to the default tab positions.

4. Triple-click to select the first line of text, the title. Format it in 14-point Times bold. Click on the Center Align icon in the Measurements palette to center the line of text in the text box.

5. Triple-click to select the second line of text, the headings, and format in Times bold at 12 points. Select all the text in the last three lines (software records) and format it in 10-point Times.

6. Click anywhere inside that second line of text, the headings line, and choose Style/Tabs (**Command-Shift-T**/Macintosh or **Ctrl-Shift-T**/Windows). Two things happen:

 ▲ The **Paragraph Attributes dialog box appears** with the Tabs tab active.

 ▲ The **Tab ruler appears** directly across the selected text box. Don't confuse the Tab ruler with the horizontal and vertical document rulers (Figure 6.22).

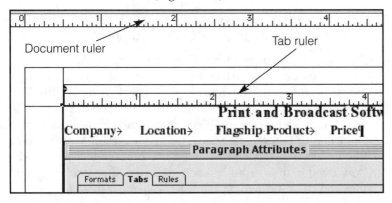

Figure 6.22. When you click in a paragraph (select a paragraph) and choose Style/Tabs, the Tab ruler appears across the selected text box.

7. There are two ways of setting tabs:

 ▲ **Clicking in the Tab ruler at the top of the dialog box** (not the ruler on the document page) at the desired tab position. *And*

 ▲ **Typing a tab position in the Position field,** then clicking Set in the dialog box.

8. Click on the Center tab icon in the Tabs dialog box to specify a center tab. Click inside the Position field and type 2. Click on the Set button. Click the Apply button. A tab appears on the tab ruler at the 2-inch mark, and the second element in the heading line, Location, is centered 2 inches from the left edge of the text box (Figure 6.23).

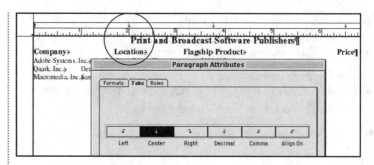

Figure 6.23. Click on the 2-inch mark on the Tab ruler and click Set (or click Apply) to move the Location field to the two-inch position in the document.

9. Make sure the Center tab icon is still selected. Type 3.75 in the Position field and click on Set. Click on Apply.

10. Click on the Tab ruler at the 6.5" mark to set a tab at that position. If you don't get it exactly at the 6.5 mark, drag it until 6.5 appears in the Position window. (If you click again at the 6.5 mark on the Tab ruler, you'll set another tab. You must drag the original tab marker on the ruler to avoid creating another tab location.) You can also click the Apply button to set the tab. If you make a mistake, press **Command-Z** (Macintosh) or **Ctrl-Z** (Windows) to undo your last action or click the tab icon in the ruler and drag it down off the ruler. When the three tab positions are set correctly, click OK to exit the Tabs dialog box.

11. Drag to select at least one character in the last three lines of text, the software records. Choose Style/Tabs (**Command-Shift-T**/Macintosh or **Ctrl-Shift-T**/Windows) to display the Tabs dialog box.

12. Click on the Left Align tab icon and click around the 1.6" mark on the ruler. Notice the value that appears in the Position field when the tab stop is selected. To modify the tab stop, click on the tab indicator in the ruler and drag it along the tab ruler. Then click on the tab indicator and drag it to the left *off of the ruler*. Type 1.6 in the Position field and click on Set. All three locations move to the 1.6-inch mark in the document and are left-aligned. Don't click OK. If you do, choose Style/Tabs again, but be sure the last three lines are still selected.

13. Click on the Right tab icon and click on the 4-inch mark on the Tab ruler. Drag the Right tab icon until 4" appears in the Position box. Click on Set. The three flagship products are aligned along their right text characters (Figure 6.24). Don't click OK. If you do, choose Style/Tabs again, but be sure the last three lines are still selected.

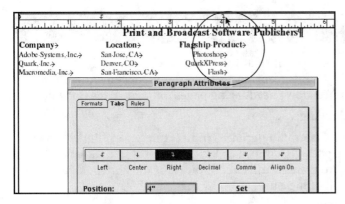

Figure 6.24. Setting a Right-aligned tab stop aligns the selected columns along their rightmost text characters.

14. Click on the Decimal tab icon and click on the 6.5-inch mark on the Tab ruler. Move the tab indicator or drag it from the ruler and type 6.5 in the Position field. Click on Set. The prices move to the right and are aligned under their decimal points. Click OK.

15. Type 1 before the 6 in the Photoshop price column. Notice that the columns remain aligned along the decimal point even though you increased the number of text characters in that line. Delete the 1 to restore the original Photoshop price.

16. To complete the listing, select the second row, the Quark, Inc. row, and cut it. Paste it after the Macromedia row so that the publishers are listed in alphabetical order. When you're satisfied with the tab placements, save the file as *Tabs.qxd* in your Projects folder. Close the file.

COPYING PARAGRAPH ATTRIBUTES

There's a nifty keystroke command that copies all the paragraph formatting, including tabs, from one paragraph to another. Let's say you've formatted three paragraphs but not the fourth. Select one of the unformatted paragraphs—just click anywhere inside that paragraph—and press the Option-Shift keys (Macintosh) or Alt-Shift keys (Windows) and click inside one of the properly formatted paragraphs. Both paragraphs will now contain the formatting of the originally selected paragraph. You can do this only with paragraphs in the same story or group of linked text boxes. If the formatted paragraph isn't in the same story (group of linked text boxes), the formatting won't carry over. This trick only works with paragraph formats such as spacing, indents, and style sheets. It won't carry over character attributes such as fonts and type size.

For this project you'll create an information page such as the one in Figure 6.26. You'll create a new, two-column document without facing pages. You don't need facing pages for a one-page document.

Do the following:

1. Use the General Preferences (Edit/Preferences/Preferences [**Command-Y**/Macintosh or **Ctrl-Y**/Windows]) dialog box to select Preferences and choose picas for the horizontal and vertical unit of measure.

2. Draw a picture box and import the *Planet.eps* image from the Unit 06 Student Files folder into the picture box. Format it to fit the box.

3. Draw a single-column text box across the width of the page for the headline.

4. Import the *NASA.txt* file from the Unit 06 folder in the Student Files folder on the CD-ROM into the automatic text box on the document page. Cut and paste the first line, the headline, into the text box you just drew.

5. Select all the text (Edit/Select All [**Command-A**/Macintosh or **Ctrl-A**/Windows]) and format it in 10-point type such as Times or Palatino. It's better to use a serif type for body copy, because serif type is easier to read in large blocks.

6. With all the type still selected, use the Paragraph Formats dialog box (Style/Formats [**Command-Shift-F**/Macintosh or **Ctrl-Shift-F**/Windows]) to assign it a leading value of 12, a 1-pica first line indent, and 6 points of space (p6) after the paragraph. Choose Justified from the Alignment menu. Select the Keep Lines Together option and select 2 lines at the beginning and end of the paragraph, as shown in Figure 6.25.

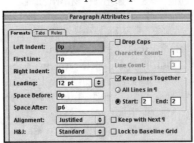

Figure 6.25. Use these values to format the body paragraphs.

Saving EPS images

When saving EPS images in Adobe Illustrator, choose the Include Document Thumbnails option in the EPS Format Options dialog box. This lets XPress display a preview of the image in the Get Picture dialog box.

Figure 6.26. This two-column information sheet contains a headline in a separate text box, a drop cap in the first paragraph, two subheads, indented lettered paragraphs, and body copy.

Indent Here

The Command-\ (Macintosh) or Ctrl-\ (Windows) command is called the Indent Here command and indents all the subsequent text in the paragraph beneath the character where you pressed those keys.

☑ **Drop Caps**

Character Count: 1

Line Count: 3

7. There are two subheads that have to be formatted in larger type. Select the first one, the *Space Science Communities* line, and format it in a bold, sans-serif type such as Arial or Helvetica. We formatted it in 18-point Impact. Because this is a subhead, it should stay with the next paragraph and not end up at the bottom of the column as a single line, so with the paragraph selected, choose the Keep with Next ¶ option in the Paragraph Attributes dialog box (Style/Formats) and assign it 6 points of space before the paragraph (p6). Change the Space After value to 0 [zero].

8. Format the second subhead, the *Space Science Plans* line, the same way.

9. Select the lettered paragraphs (except the last one) and remove the Space After value in the Paragraph Attributes dialog box.

10. To align the text under the first character after the letter, click before the first character and press **Command-** (Macintosh) or **Ctrl-** (Windows).

11. Click anywhere in the first paragraph to select it and assign it a drop cap from the Paragraph Attributes dialog box (Style/Formats). Click the Drop Caps option and use the default Character Count and Line Count values.

12. Select the paragraph after the first head and use the Paragraph Attributes dialog box to remove the First Line Indent value. We don't usually indent the first paragraph after a heading. Repeat for the second subhead.

13. Close this file (File/Close). Don't save it unless you want to use it for another project.

REVIEW PROJECT 2

In this exercise you'll import a short text file (*Books.text*) from the Unit 06 folder in the Student Files folder on the CD-ROM and format it in columns by setting tabs at the appropriate position on the Tab ruler. You'll also add tab leaders between the last two columns. Your screen should resemble Figure 6.27.

Audio Books

Title	Author	Category	Rental Price
Roses Are Red	James Patterson	Mystery$14.99	
Walking Across Egypt	Clyde Edgerton	Fiction$12.50	
Seeds of Change: *Five Plants that Transformed Mankind*	Henry Holborne	History$16.95	
Series (9 books)	P.D. James	Suspense$206.99	

Figure 6.27. These paragraphs are tabbed with the last column aligned on the decimal point. A soft return (Shift-Return) was inserted after the price for *Seeds of Change* to accommodate the extended title and the price ($16.95) was cut from the lower line and pasted before the soft return.

ALIGN ON OPTION

You can position the columns anywhere you like as long as they all line up correctly. You can do one of two things with the Rental Price column:

▲ Use a decimal tab for the Rental Price column to align the price elements under the decimal point. *Or*

▲ Use the Align On tab icon to align the prices under the dollar sign. When you select the Align On icon, the Align On field becomes active. Type a dollar sign in that field to align the prices in the Rental Price column under the dollar sign instead of under the decimal point (Figure 6.28).

Figure 6.28. Type a character in the Align On field to align the columns under that text character.

COMMA ALIGN

If you don't want to align a price column on the decimal points or on the dollar sign and if the price is in the thousands where a comma separates the numbers ($2,467.89, for example), you can align the prices on the comma in the price. This will ignore both the decimal point and the dollar sign, aligning all the characters to the left and right of the comma. If one of the figures doesn't contain a comma, that paragraph won't align at all, so don't use this option unless all the column elements contain a comma (Figure 6.29).

Figure 6.29. The figures on the left are aligned under the dollar sign. The ones on the right are aligned under the comma.

FILL CHARACTERS

Fill characters called *tab leaders* (Figure 6.30) can be placed between tabbed columns. This character is usually a period and makes it easier for the reader to follow the tabbed information. To add a leader, select the tab stop and type a period (or another text character) in the Fill Characters field of the Tabs dialog box.

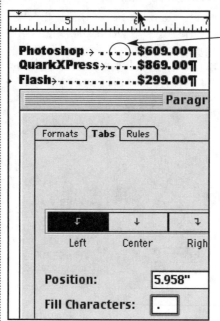

tab leaders

FYI

If you use a period as a fill character, insert a space before the period to avoid that dot dot look when the tab leader is applied. And it goes without saying that you never type multiple periods between tabbed columns to create a leader.

Figure 6.30. Click on the tab stop in the Tab ruler to specify which tab gets the leader. Then type the text character (usually a period) in the Fill Characters field of the Tabs dialog box to create the tab leader.

Unit 7
Style Sheets

OVERVIEW
In this unit you will learn how to:
Create style sheets
Use the Style Sheets palette
Apply global and local formatting
Create and edit paragraph styles
Create and edit character styles
Apply commands from the Style Sheets palette
Append style sheets

TERMS
Append
character style sheet
global formatting
local formatting
New Line marker
No Style
Normal style
paragraph style sheet

WHAT ARE STYLE SHEETS?

When formatting paragraphs, it can sometimes take twenty trips to the menus and dialog boxes to apply attributes to a single paragraph. If you want to apply those same attributes to another paragraph in the document, you have to go through those same steps to create another similarly formatted paragraph. And if you change one formatting attribute in the first paragraph, you must manually make that same formatting change in every other similar paragraph—unless you use style sheets. A *paragraph style sheet* is a single command that executes any number of formatting commands to a *selected paragraph*. A character style sheet is a single command that executes any number of text formatting commands to *selected text*.

To make changes in the format of a paragraph that has been tagged with a style sheet, just change the style sheet and *the change is made to any paragraph tagged with that style*. Likewise, any text characters in any paragraph tagged with a character style can be changed by simply changing the character style sheet.

STYLES ARE NOT AN OPTION

Using styles separates the amateur typesetter from the professional. Styles are *always* used when creating a document with more than a few paragraphs and are considered part of the deliverable when producing documents for a client. Because styles allow for global changes, a document can be *consistently* edited at any phase of the production process by anyone working on the document. The only excuse for not using styles is laziness and no one will pay you for that. In today's publishing industry, more than one person has access to a document and the authority to change it. Styles permit those changes to be made with the assurance that the entire document will reflect the edits.

WHAT IS A PARAGRAPH?

Every paragraph consists of text characters with their own formatting attributes like typeface, type size, type color, etc. These characters, from the first character to the paragraph return (¶), form a paragraph. The paragraph itself has its own formatting attributes like leading, drop cap, alignment, tabs, rules, etc.

A paragraph *style* consists of any or all of the formatting attributes available from the Paragraph Attributes dialog box *and* any or all of the character attributes available from the Character attributes dia-

Check Include Style Sheets to import styles from Word when you flow text in a QuarkXPress document.

Type: Microsoft Word Size: 152K
☑ Convert Quotes ☑ Include Style Sheets

$ Tip

It's acceptable business practice to charge clients for setting up the styles in a document, unless you're importing styles from MS Word. When you use the Get Text command to import an MS Word document into a text box, you have the option of importing Word's styles into that QuarkXPress document.

log box. This includes rules and tab settings. So, a paragraph displays text and paragraph formatting attributes, all of which can be defined and placed in a style sheet.

SELECTING PARAGRAPHS

To select a paragraph, click anywhere in the paragraph. It isn't necessary to highlight the entire paragraph, because any paragraph formatting applies to every line in the paragraph. You can't split lines in a paragraph to create two paragraphs unless you split the paragraph into two or more distinct paragraphs by pressing the Return key (Macintosh) or Enter key (Windows).

SPLITTING PARAGRAPH LINES WITH THE NEW LINE COMMAND

You can split *the lines in a paragraph* using the New Line command. Show the Invisibles (View/Show Invisibles), then click right before where you want the new line to begin. Press Shift-Return (Macintosh) or Shift-Enter (Windows). This inserts the New Line marker at that point, and all the text after the New Line marker drops to the next line. Those lines after the New Line marker, however, are still formatted with the paragraph style applied to the paragraph. Just because you split the lines doesn't mean you also split the paragraph. When you insert the New Line marker, you create what is called a "soft return," as opposed to a "hard return" created with the paragraph marker.

PARAGRAPH STYLES

Paragraph styles are styles that are applied to an entire paragraph. This means that every text character and every paragraph attribute, such as indents, leading, alignment, tabs, rules, etc., is controlled by the style sheet. Paragraph styles appear in the upper panel of the Style Sheets palette (Figure 7.1).

Create the New Line marker by pressing Shift-Return.

Assign keyboard shortcuts for style sheets using the numeric keypad with or without modifier keys.

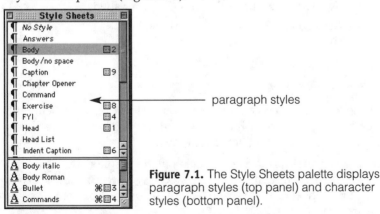

paragraph styles

Figure 7.1. The Style Sheets palette displays paragraph styles (top panel) and character styles (bottom panel).

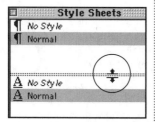

View all the styles in the Style Sheets palette by dragging the bar between the paragraph and character style sheets.

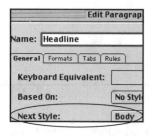

Select a style sheet from the Next Style menu to apply that style to anything *typed* after you apply the named style. In this example, anything typed after the Headline type is applied will display the Body style.

CHARACTER STYLES

Character styles are styles that are applied to *selected* text anywhere in the document. Character styles appear in the lower panel of the Style Sheets palette. For example, we would create a character style for a run-in for the first words of each paragraph as seen in Figure 7.2.

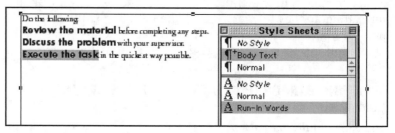

Figure 7.2. Each paragraph is assigned the Body Text style sheet, a paragraph style. The first few words (text characters) of the last three paragraphs are tagged with the Run-In Words style sheet, a character style.

KEYBOARD SHORTCUTS FOR STYLES

You can assign keyboard equivalents for styles from the numeric keypad or from function keys F5 through F15. However, if you use the function keys for style sheet keyboard equivalents, you override Quark's built-in keyboard shortcuts. To avoid this, use a modifier key such as the Command and Option keys (Macintosh) or Ctrl and Alt keys (Windows) with the function key.

STYLE SHEETS PALETTE

The Style Sheets palette (View/Show Style Sheets or **F11**) is used to:

▲ Apply paragraph styles and character styles;

▲ Access the Edit Style Sheets dialog box;

▲ Delete a style;

▲ Duplicate a style;

▲ Create a new style.

The upper panel displays the paragraph styles for the document. The paragraph symbol (¶) precedes these styles in the Style Sheets palette and in the dialog boxes and menus.

The lower panel of the Style Sheets palette displays the character styles for the document. An underlined A (A) precedes these styles in the Style Sheets palette and in any of the dialog boxes and menus (Figure 7.3).

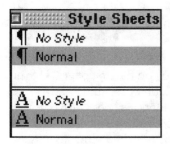

Figure 7.3. The default Style Sheets palette for a new document displays only two styles for paragraphs (¶ in the upper panel) and text characters (A in the lower panel). Notice the paragraph symbol before each paragraph style and text symbol before each character style.

Both panels (paragraph styles and character styles) default to Normal style, the default style automatically applied to any text created in XPress; and *No Style,* which strips a paragraph of any local or global formatting codes and prepares it to receive another style.

GLOBAL AND LOCAL FORMATTING

Global formatting is paragraph or character styling that applies to every character in every paragraph tagged with those styles. For example, you may create a paragraph with Times at 10-point type on 12-point leading. Then you create a paragraph style and name it *Body Text.* When you apply the *Body Text* style to a paragraph, every character in that paragraph changes to 10-point Times on 12 points of leading. This is global formatting. But one of the paragraphs to which you applied the "Body Text" paragraph style contains the name of a book which must be italicized. You select that type (the book's name) and apply the Times Italic typeface to it. The italic type then becomes local formatting. Even if you make the italicized type into a character style and apply that style to the book's name from the Style Sheets palette, that italic type is still considered local formatting. In other words, any styling that deviates in any way from the tagged paragraph style (global formatting) is considered local formatting.

> **No Typing Here!**
> The automatic text box on the master page appears on *every* document page based on that master page. It's used only to flow text from one page to another. You can't type in that box on the master page, which is why we had to create another text box for the running header on the master page.

The italic *every* in this paragraph is an example of local formatting.

EXERCISE A

1. Create a new file with an automatic text box. Use the Measurements palette (**F9**) to make the text box on the first page 3 inches wide. Type *This is the first paragraph.* Don't press the Return/ Enter key. Triple-click to select the sentence, choose Edit/Copy, click after the first sentence and choose Edit/Paste. Do this a few times until you have a few lines. Press the Return/Enter key after the last sentence to create the paragraph.

2. Type *This is the second paragraph.* Copy and paste, and press the Return/Enter key to create the second paragraph (Figure 7.4).



This·is·the·first·paragraph.·This·is·the· first·paragraph.·This·is·the·first·para- graph.·This·is·the·first·paragraph.This· is·the·first·paragraph.·This·is·the·first· paragraph.This·is·the·first·paragraph. This·is·the·first·paragraph.¶ This·is·the·second·paragraph.·This·is· the·second·paragraph.This·is·the· second·paragraph.¶

Figure 7.4 displays two unformatted paragraphs. The paragraph return symbol (¶) indicates that the Return/Enter key was pressed.

3. The easiest way to create a paragraph style sheet is by example. Using this method, you format the paragraph exactly the way you want *and then create the style sheet* based on those formatting attributes. Quadruple-click in the first paragraph to select the entire paragraph. Use the Style menu or Measurements palette to format it in 14-point Times. Because you're applying text attributes, you must select all the text characters.

4. Choose Style/Formats (**Command-Shift-F**/Macintosh or **Ctrl-Shift-F**/Windows) to display the Paragraph Attributes dialog box. Type 24 in the Leading field, 1p in the Space After field. In the Drop Caps area, type 1 in the Character Count field and 2 in the Line Count field. Don't press OK.

5. Click on the Rules tab. Click the Rule Below box. Leave the Length option set to Indents with the default 0 values so the rule will run the full length of the paragraph. Type 1p (1 pica) in the Offset field. Choose Dotted 2 from the Style menu, 4 from the Width menu, and Red from the Color menu. Click OK. All of these attributes are applied to the paragraph (Figure 7.5).

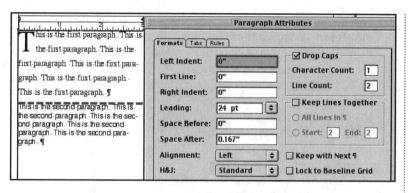

The New menu lets you select options for either a paragraph or character style.

Figure 7.5. The first paragraph displays specified text and formatting attributes.

6. Click anywhere in the paragraph to select the entire paragraph. Choose Edit/Style Sheets (**Shift-F11**) to display the Style Sheets for [file name] dialog box. Use the New pull-down menu in the lower part of the dialog box to select Paragraph (Figure 7.6).

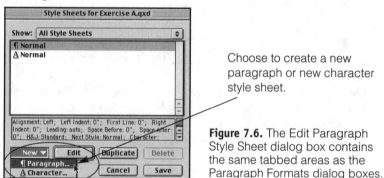

Choose to create a new paragraph or new character style sheet.

Figure 7.6. The Edit Paragraph Style Sheet dialog box contains the same tabbed areas as the Paragraph Formats dialog boxes.

Important info

You must select a text box to view and use any of the styles in the Style Sheets palette.

7. Once you select either Paragraph or Character from the New (style sheet) menu, the Edit Paragraph Style Sheet dialog box appears (Figure 7.7).

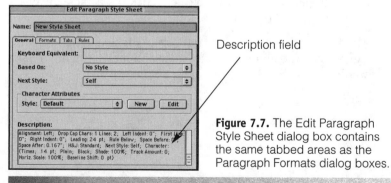

Description field

Figure 7.7. The Edit Paragraph Style Sheet dialog box contains the same tabbed areas as the Paragraph Formats dialog boxes.

Style Sheets

8. Notice that the Description field displays all the text and paragraph formatting options you selected earlier. Type *First Paragraph* in the Name field. Right now the default text attributes for the paragraph are 14-point Times, which is what you want, so leave the default character attributes. Click in the Keyboard Equivalent field and type any number on the numeric keypad to assign that style a keyboard equivalent (Figure 7.8). Click OK. Click Save to create the style sheet and add it to the document's Style Sheets palette.

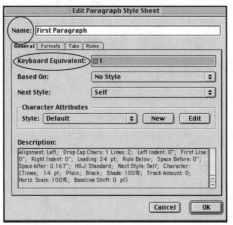

You can select which styles to display in the Style Sheets for <file-name> dialog box from the Show menu.

Figure 7.8. Assign a name to the style sheet and a keyboard equivalent from the Edit dialog box.

9. Display the Style Sheets palette (View/Show Style Sheets or **F11**). Just because you created a style sheet based on a selected paragraph doesn't mean that the paragraph is automatically tagged with that style. You must do this manually. You can do this in one of three ways:

 ▲ With the paragraph still selected, **choose Style/Paragraph Style Sheet** and drag to select First Paragraph. *Or*

 ▲ With the paragraph still selected, **press the numeric keypad key** that you assigned to that style sheet. *Or*

 ▲ With the paragraph still selected, **click the paragraph style name** in the Style Sheets palette.

10. Although nothing appears to happen to the text, it has been tagged with the First Paragraph style and its style name is highlighted in the Style Sheets palette (Figure 7.9).

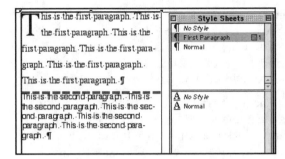

Figure 7.9. The first paragraph is tagged with the First Paragraph style sheet.

11. Click anywhere in the second paragraph. Click on the First Paragraph style in the Style Sheets palette to apply it to the selected paragraph.

12. Save this file as *Styles.qxd* in your Projects folder (File/Save As [**Command-Option-S**/Macintosh or **Ctrl-Alt-S**/Windows]). You will need it for the next exercise.

EDITING PARAGRAPH STYLES

Any paragraph style can be edited so that it reflects different text and/or formatting attributes. When you change a paragraph style, any paragraph that was tagged with that style automatically changes to reflect the new text and paragraph attributes.

Because every paragraph style includes both paragraph and type style options, you can edit either or both of these options when editing a paragraph style. The paragraph and text changes are applied to any paragraph tagged with that paragraph style.

EXERCISE B

1. If necessary, open the *Styles.qxd* file in your Projects folder or open the *Styles.qxd* file in the Unit 07 folder in the Student Files folder on the CD-ROM. Click on the text box to select it. Display the Style Sheets palette (View/Show Style Sheets or **F11**). The file displays three paragraph styles (*No Style*, First Paragraph, and Normal) and two character styles, *No Style* and Normal. Choose Edit/Style Sheets. Highlight the First Paragraph style and click on Edit to display the Edit Paragraph Style Sheets dialog box.

Edit/Style Sheets

You can always Control-click (Macintosh) or right-click (Windows) on any style in the Style Sheets palette to access the style sheet commands.

The Center Align icon is highlighted in the Measurements palette when you select Centered in the Paragraph Attributes dialog box.

2. Click on the Formats tab to display the Paragraph Attributes dialog box and choose Centered from the Alignment pull-down menu. Don't click OK. Click on the Rules tab and change the color of the rule from red to blue. Click OK. Click Save. Both paragraphs change to reflect the new paragraph formatting.

3. Command-click (Macintosh) or Ctrl-click (Windows) on the First Paragraph style in the Style Sheets palette. First Paragraph is highlighted. Click the Edit button (Figure 7.10). In the Character Attributes field, leave the default text attributes selected and click on Edit.

Figure 7.10. Click the Edit button in the Character Attributes field to change the font characteristics of a style.

4. In the Edit Character Style Sheet dialog box, change the font to anything you like, the size to 18-point, the color to blue, and the style to All Caps. Click OK twice. Click Save. The two paragraphs tagged with the First Paragraph style now reflect the edits.

5. Close this file (File/Close). Don't save your changes.

LESSON 2: CHARACTER STYLES

CREATING AND EDITING CHARACTER STYLES

You probably noticed from the previous exercise that when you make character attributes changes to a paragraph style, every text character displays those attributes. For example, *all* the text characters became 18-point type and all caps in blue. This is called *global formatting*, where formatting applies to every character in the paragraph or document. To change only certain characters in a paragraph—whether or not that paragraph has been tagged with a paragraph style—you must create a character style.

Like paragraph styles, character styles can be edited, and those changes will apply to *all the text characters anywhere in the document that you tagged with that particular character style.*

APPLYING CHARACTER STYLES

Because character styles are attached to individual text characters instead of to every character in the paragraph, you must manually select those characters before applying a character style. Unlike paragraph styles, which are applied after just clicking anywhere in a paragraph, character styles require that you highlight (select) those specific text characters to which you want to apply the character style.

LOCAL FORMATTING

Even though you apply a paragraph style to a selected paragraph, you can still apply local formatting to that paragraph. For example, a paragraph may be styled in 24-point Helvetica, but if you select even a single character and change its formatting, that change is called *local formatting*. Or, if you change any of the paragraph formats, like indents or space before and after, that too is local formatting. When you apply a character style sheet, you are applying local formatting.

You must select text characters before you can apply a character style.

Drop Cap size

Highlight a drop cap to display its size as a percentage of the font size shown in the Size field of the Measurements palette. To reduce or enlarge the drop cap, type a value in that field between 20% and 400%.

FYI

Although you can change the type size of a drop cap from the Style/Size menu, that size is not reflected in points in the Measurements palette. Instead, the new size is displayed as a percentage of the original type size.

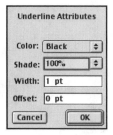

Choose Style/Underline Styles/Custom to create custom underlines in the Underline Attributes dialog box.

1. Open the *Styles.qxd* file in your Projects folder or in the Unit 07 Student Files folder on the CD-ROM. Click on the text box to select it. Display the Style Sheets palette (View/Show Style Sheets or **F11**). Drag to select the drop cap *T* at the beginning of the first paragraph. Choose Edit/Style Sheets (**Shift-F11**). Select Character from the New menu to display the Edit/Character Style Sheet dialog box.

2. Type *Drop Cap* in the Name field. Assign a keyboard shortcut from the keypad by clicking in the Keyboard Equivalent field and pressing the number 2 key on the numeric keypad. Change the font to Arial or Helvetica Bold and the color to Red. Click OK. Click Save.

3. With the drop cap character still selected, click on the Drop Cap character style in the lower panel of the Style Sheets palette to apply the style.

4. Drag to select the *T* in the second paragraph, and click on the Drop Cap style in the Style Sheets palette to tag that character with the Drop Cap style.

5. To edit the character style, do one of the following:

 ▲ Command-click (Macintosh) or Right-click (Windows) on the Drop Cap style in the Style Sheets palette and click on Edit to display the Edit Character Style Sheet dialog box. *Or*

 ▲ Choose Edit/Style Sheets (**Shift-F11**), select the Drop Cap style in the Edit Style Sheets dialog box, and click Edit.

6. Change the text size to 24 points and the color of the text to magenta. Click Underline in the Type Style field. Click OK. Click Save. Both drop caps reflect the edits (Figure 7.11).

Figure 7.11. The Drop Cap style is edited, changing the original drop cap to a larger, underlined text character.

7. Drag to select the word *first* or double-click on *first* anywhere in the paragraph. Click on the Drop Cap style in the Style Sheets palette to apply that character style to the selected characters (Figure 7.12).

Figure 7.12. The Drop Cap character style is applied to the selected word. The First Paragraph style displays a + indicating that local formatting, in this case the attributes from the Drop Cap style sheet, has been applied to the paragraph.

8. Notice that although the paragraph is tagged with the First Paragraph style, the style name displays a + sign, indicating that local formatting has been applied to the paragraph—as indeed it has, as shown by the 24-point underlined blue text (Figure 7.12).

9. To restore the paragraph to its original First Paragraph style, do one of the following:

 ▲ Click anywhere in the paragraph to select it. **Option-click (Macintosh) or Alt-click (Windows) on the First Paragraph style** in the Style Sheets palette. Option-clicking or Alt-clicking applies No Style before applying the selected style. *Or*

 ▲ **Click No Style** in the upper panel (paragraph styles) of the Style Sheets palette, **then click the First Paragraph style** in the Style Sheets palette. The paragraph displays only the text and paragraph attributes of the First Paragraph style.

10. Close this file (File/Close). Don't save your changes.

NORMAL STYLE

Whenever you create a new document, the Style Sheets palette always displays two paragraph styles and two character styles, *No Style* and Normal. A better name for Normal would be Default, because that is what the Normal style is: the default paragraph and character styles applied to any text you type in a new document or import into a newly created document. You can edit the Normal style so that whenever you type non-styled text, it appears in the font, size, etc. of your choice.

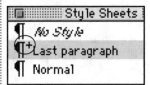

The + sign before the style name indicates that you applied local *paragraph* formatting to the paragraph. If you apply local *character* formatting to the paragraph, the cursor must be in the formatted word for the + to be displayed in the Style Sheets palette.

NO STYLE

The *No Style* paragraph and character styles are really not styles at all. In fact, unlike every other paragraph and character style, *No Style* is displayed in italics, indicating that it's somehow different from the other styles. Rather than *apply* a style, when you click a paragraph and select *No Style*, or when you select text characters and apply *No Style*, that paragraph and those text characters are stripped of any style sheet that was applied to them.

Although nothing is visible on the screen when you apply *No Style*, any local formatting like bold or italics, or any character and paragraph styles, will be overridden when you apply another paragraph or character style. When you Option- or Alt-clicked on the First Paragraph style sheet in the previous exercise, you automatically applied *No Style* before applying the First Paragraph style. That's why the Drop Cap text attributes disappeared, because character styles are considered local formatting and applying *No Style* strips a paragraph of all local formatting.

APPLYING *NO STYLE*

There are two ways to apply *No Style* to a paragraph or to text characters before applying another style:

1. The first is to click on *No Style* in the Style Sheets palette and then to click on another style.

2. The second is to Option-click (Macintosh) or Alt-click (Windows) on the new style. This automatically applies *No Style* before applying the new style.

EXERCISE D

1. Create a new file (File/New/Document) with an automatic text box. Display the Style Sheets palette (View/Show Style Sheets or **F11**) and the Measurements palette (View/Show Measurements or **F9**). Click inside the text box and type *One if by land and two if by sea*. Press the Return key (Macintosh) or Enter key (Windows) to end the paragraph.

2. Click inside the paragraph and notice that the paragraph and character styles for the paragraph are Normal. Unless the Normal style has been edited in your version of QuarkXPress, the Measurements palette should display 12-point Helvetica (Macintosh) or Arial (Windows) (Figure 7.13).

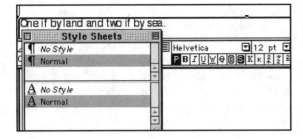

Figure 7.13. When you first type or import text into a new document, the default style is Normal and the default text attributes are 12-point Arial or Helvetica.

3. Quadruple-click to select the entire paragraph and use the Measurements palette to format it in Times, 24-point bold. These three attributes—typeface, type size, and type style—are local formatting, that is, they are departures from the Normal style's defined attributes of 12-point Arial or Helvetica. Therefore, a + sign appears before the Normal paragraph and character styles in the Style Sheets palette (Figure 7.14).

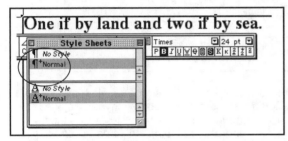

Figure 7.14. The Normal style displays the + sign, indicating that local formatting was applied to the paragraph tagged with the Normal style.

4. Click at the end of that paragraph. Press the Return/Enter key to start a new paragraph and type *This is not Normal*. It appears tagged with the Normal style sheet, but because you carried over the local formatting from the first paragraph to the second when you pressed the Return or Enter key, you carried over the local formatting attributes and the Normal style displays the + sign in the Style Sheets palette.

5. Click anywhere in that second paragraph to select it and click on *No Style* in the Paragraph Style panel of the Style Sheets palette. Nothing appears to happen. The text attributes don't display the original Normal attributes of 12-point Arial or Helvetica—yet. But the paragraph has been disassociated from any style. We know that because the + disappears from the Normal style in the Style Sheets palette.

6. With the second paragraph still selected, click the Normal paragraph style in the Style Sheets palette to reapply the Normal style and notice that it now displays the original Normal style of 12-point Arial or Helvetica. Notice also that the + sign is still no longer visible before the Normal style name, because all the local formatting which the + sign indicates as being present was stripped from that paragraph when you applied *No Style*.

7. Quadruple-click to select the second paragraph. Format it in a different typeface and in a large type size. The Style Sheets palette displays the highlighted Normal style with the + sign because you applied local formatting to the original Normal style (Figure 7.15).

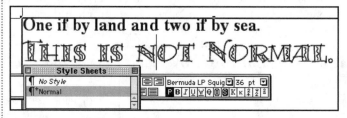

Figure 7.15. The Normal style displays the + sign, indicating that local formatting (Bermuda Squiggle typeface and 36-point type size) was applied to the paragraph tagged with the Normal style. Notice the cursor in the second paragraph indicating that that entire paragraph is selected.

8. With the paragraph still selected, Option- or Alt-click on the Normal style in the upper panel (paragraph styles) of the Style Sheets panel to strip the local formatting and return the paragraph to the original Normal style.

9. Close this file (File/Close). Don't save your changes.

Your own Normal

You can edit the Normal style so that anything you type in the document will reflect those type attributes. If you edit the Normal style when no documents are open, that edited Normal style will function in every document you create.

APPLYING COMMANDS FROM THE STYLE SHEETS PALETTE

Thus far you have used the Style Sheets palette to apply paragraph and character styles. You can also use the Style Sheets palette to:

▲ Create new paragraph and character style sheets.

▲ Edit style sheets.

▲ Duplicate an existing style sheet.

▲ Delete style sheets.

All of these functions are available from menus and dialog boxes, but it's usually easier to execute them from the Style Sheets palette.

DELETING STYLE SHEETS

There are two ways to delete a style sheet:

Control-click or right-click on a style to display its options.

▲ Control-click (Macintosh) or right-click (Windows) on the style name in the Style Sheets palette and drag to select Delete. If the style has not been used in the document, it is deleted immediately. If the style sheet has been applied to a paragraph or to characters in the document, an alert asks you to select another paragraph or character style as a replacement.

▲ Choose Edit/Style Sheets (**Shift-F11**) and click Delete in the dialog box.

EXERCISE E

1. Open the *Emma Lazarus.qxd* file in the Unit 07 Student Files folder on the CD-ROM (File/Open). Display the Style Sheets palette (View/Show Style Sheets or **F11**). Click anywhere in the body of the poem. The Style Sheets palette displays Normal.

2. Press the Control key (Macintosh) or right-click (Windows) and click down on the Normal style in the Style Sheets palette to display another menu (Figure 7.16). Drag to select New.

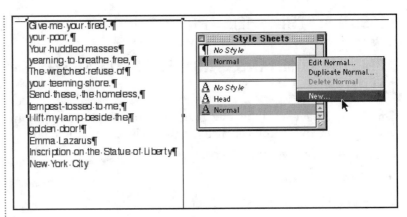

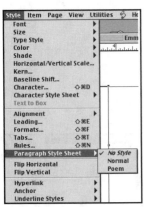

Any paragraph style you create appears in the Style Sheets palette and under the Paragraph Style Sheet menu in the Style menu.

Figure 7.16. Control-click (Macintosh) or right-click (Windows) and drag to select New to create a new style sheet.

3. When you select New from the palette, the Edit Paragraph Style Sheet dialog box appears and New Style Sheet appears in the Name field. Type *Poem* in the Name field.

4. Click the Edit button in the Character Attributes field and select a typeface and type size. Click OK twice. The Poem style appears in the Style Sheets palette and under Paragraph Style Sheet under the Style menu.

5. Drag to select the 10 lines of the poem and click the Poem style in the Style Sheets palette to apply the style. You don't have to select every character in every paragraph.

6. Select the last three lines, the citation lines, and format them in a different typeface and type size. Do one of the following:

 ▲ Choose Edit/Style Sheets (**Shift-F11**) and choose Paragraph from the New menu at the bottom of the dialog box. Type Citation in the Name field. Click on Edit in the Character Attributes field and make your selections. Click OK. Click the Formats tab and select Right from the Alignment menu. Click OK and click Save to add the Citation style to the Style Sheets palette. *Or*

 ▲ Control-click (Macintosh) or Alt-click (Windows) on the Normal paragraph style. Drag to select New. Type *Citation* in the Name field. Make your character and paragraph formatting selections and click Save to add the Citation style to the Style Sheets palette.

7. With the last three lines selected, click the Citation style in the Style Sheets palette to assign that style to those paragraphs (Figure 7.17).

Figure 7.17. Apply the Citation style to the last three lines of text.

8. To delete the Citation style, Control-click (Macintosh) or Alt-click (Windows) on the Citation style in the Style Sheets palette. Drag to select Delete Citation. When the alert appears, click OK to select *No Style* or use the Replace with menu in the Alert dialog box to select the Poem style. The Citation style disappears from the Style Sheets palette.

9. Close this file. Don't save your changes.

APPENDING STYLE SHEETS

Many times style sheets that have taken a long time to create and tweak are part of a document created previously. You can, however, append these style sheets to the active document using the Append command from the File menu or by clicking the Append button in the Style Sheets for [file name] dialog box.

If a style sheet in the active document has the same name (not necessarily the same formatting attributes), you have to tell XPress how to resolve the conflict by selecting one of four options:

RENAME

You can simply rename the appended style sheet's name, which changes the name of the appended style sheet and places it as a new style in the Style Sheets palette. This does not affect the formatting of any of the style sheets in the active document.

AUTO-RENAME

This option renames the appended style sheet by adding an asterisk before its name in the Style Sheets palette. The auto-renamed style appears as another style in the palette and is not applied to any of the paragraphs or text in the active document.

USE NEW

This is the option that does damage if you select it when you really don't mean to select it. Choosing Use New *replaces* the style sheet with the same name in the active document, and in doing this, replaces all the paragraph and text attributes of the original style sheet with those from the appended style sheet.

USE EXISTING

Choosing Use Existing essentially cancels the Append command and uses the style sheet in the active document instead of appending the selected style from the new document.

EXERCISE F

1. Open the *Styles.qxd* file in the Unit 07 folder in the Student Files folder on the CD-ROM and click on the text box to select it. Display the Style Sheets palette (**F11**). It currently displays one new paragraph style sheet, First Paragraph.

2. Choose File/Append (**Command-Option-A**/Macintosh or **Ctrl-Alt-A**/Windows) and navigate to the Unit 07 folder in the Student Files folder on the CD-ROM. Highlight the *Append.qxd* file and click on Open. The file doesn't open, but rather displays the Append to [file name] dialog box with the Style Sheets tab selected.

3. The Style Sheets palette for the *Append.qxd* file displays the same First Paragraph paragraph style as the *Styles.qxd* file. The Available field on the left lists all the style sheets in the new document that are available to be appended to the active document. Click on the First Paragraph style, and click the large black forward arrow to copy the First Paragraph style to the Including field.

4. Click OK, and at the alert, click OK again to display the Append Conflict dialog box (Figure 7.18). Notice that Drop Cap Chars is boldfaced in the Description field for the active (existing) document and that it doesn't appear in the description field for the New document. Click the Rename button to rename the appended style sheet's name.

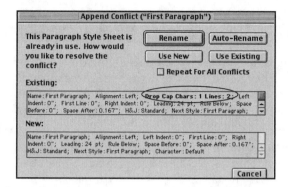

Figure 7.18. Make choices in the Append Conflict dialog box about how the appended style sheet is to behave and be named in the active document.

5. Type *Appended First Paragraph* in the New Name field and click OK. The Appended First Paragraph style appears as a new paragraph style in the Style Sheets palette. The two paragraphs in the *Styles.qxd* document styled with the First Paragraph styles don't change because you have only *appended* a style sheet, not replaced or edited an existing style sheet.

6. Repeat steps 2 and 3. In the Append Conflict dialog box, click the Auto-Rename button and click OK twice. The First Paragraph style appears as a separate style in the Style Sheets palette for the *Styles.qxd* file, but it displays an asterisk before its name, indicating that it's an appended style sheet with the same name as a style sheet in the active document. Again, no change is made to the two paragraphs in the *Styles.qxd* file that are styled with the First Paragraph style, because the *First Paragraph style is only appended, not applied.

7. Repeat steps 2 and 3 again. In the Append Conflict dialog box, click the Use New button. You are returned to the document. Notice that the two paragraphs originally styled with the First Paragraph style no longer display the drop cap, because the new appended style did not specify drop caps.

8. Close this file. Don't save your changes.

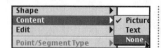

Contentless boxes

A box with a content of None is just an empty box that can hold neither text nor pictures. It's good to use as a placeholder because you don't have to worry about text flowing into it and disrupting the text flow of the document.

Rectangle Text Box tool

The zero point appears as crossed dotted lines in the upper left corner of the document window.

Frequently, a client will ask you to create a card giving directions to a place for which you have designed the invitation. Directions are usually read while someone is driving, so you should make the direction card easy to read and relatively free of intruding design elements that will distract the reader/driver.

1. To create the **direction card**, begin with a nonfacing-page document with half-inch margins. Deselect the Automatic Text Box option if it is checked. Choose picas as the unit of measure (**Command-Y**/Macintosh or **Ctrl-Y**/Windows). Use the Document Layout palette to add another page to the document.

2. Draw a box 33p6 square. Assign it a frame and make it a contentless box (Item/Content/None). This will be a placeholder box. Once you've finished the invitation, you'll remove the box's frame before printing.

3. Drag the zero point to the upper left corner of the placeholder box to reset that point to zero.

4. Draw a text box inside the placeholder box. Make it 28p6 wide and 25p high. Position it at the 6p7 point on the Y axis. To center the text box inside the placeholder, select the placeholder and drag a vertical guide to the center of the box. Then select the text box and drag its center handle to the guide (Figure 7.19).

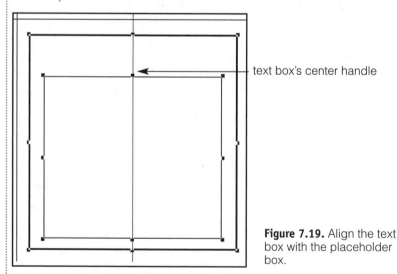

text box's center handle

Figure 7.19. Align the text box with the placeholder box.

5. Draw a small picture box about 4 picas square above the text box and import the *Eye.tif* file from the Student Files folder in the Unit 07 folder on the CD-ROM. Fit the graphic in the box (**Command-Option-Shift-F**/Macintosh or **Ctrl-Alt-Shift-F**/Windows). Or, choose Style/Fit Picture to Box (Proportionally).

6. Draw a text box above the large text box for the title of the card. If you need another text box for the location of the event, draw another text box below that one and assign it a Runaround of None (Item/Runaround [**Command-T**/Macintosh or **Ctrl-T**/Windows]). Type the information in one or both text boxes and format the text.

7. Position the picture box at the same X value as the large text box. Position the title text box at the same Y value as the picture box (Figure 7.20).

Figure 7.20. Create additional boxes for text and graphics.

Big tip!

Do a Find/Change for the entire document and change all the double spaces to single spaces to close up the paragraphs. Press the Spacebar twice in the Find What field. Press the Spacebar once in the Change To field.

8. Use the Item tool to Shift-select the framed placeholder box and the large text box. Copy and paste them on the second page. Make the text box on this page 29 picas high, because you don't need the picture or title text boxes.

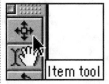

9. Click inside the large text box on the first page and import the *Directions.txt* file (**Command-E**/Macintosh or **Ctrl-E**/Windows) from the Unit 07 folder in the Student Files folder on the CD-ROM. Quadruple-click on the first line of text *From Points North* and format it in 12-point type in a condensed typeface. We used Futura Condensed. Assign it a leading value of 13 points.

10. With the line still selected, choose Style/Formats (**Command-Shift-F**/Macintosh or **Ctrl-Shift-F**/Windows). Assign 3 points of space (p3) in the Space Before field and 2 points of space (p2) in the Space After field.

11. You should avoid splitting the lines of a heading paragraph between text boxes or pages, so select the Keep Lines Together check box and select All Lines in ¶. Also select the Keep with Next ¶ check box, because a heading paragraph should always be attached to the following body paragraph. Choose Justified from the Alignment menu. Click OK.

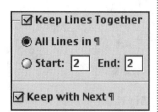

Heading paragraphs should always be attached to the following body paragraphs.

12. Display the Style Sheets palette (View/Style Sheets or **F11**). You will create a paragraph style based on the formatted text. With the line still selected, Control-click (Macintosh) or right-click (Windows) on the Normal style in the Paragraph styles pane (upper pane) of the Style Sheets palette and drag to select New. In the Edit Paragraph Style Sheet dialog box, notice that all your formatting appears in the lower window of the box. Type *Headings* in the Name field and press a number on the numeric keypad to assign a keystroke to the style. Click OK to return to the document. Headings appears in the Style Sheets palette.

13. Quadruple-click to select the first line of the directions. Format it in 12-point type on 13 points of leading. Choose Style/Formats (**Command-Shift-F**/Macintosh or **Ctrl-Shift-F**/Windows). Assign 2 points of space (p2) in the Space After field. Select the Keep Lines Together check box and select the All Lines in ¶ check box. Click OK.

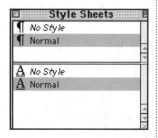

The upper pane of the Style Sheets palette displays the paragraph styles (¶). The lower pane displays the character styles (A).

14. With the paragraph still selected, Control-click (Macintosh) or right-click (Windows) on the Normal style sheet in the paragraph pane of the Style Sheets palette and drag to select New. Type *Directions Body* in the Name field and press another key on the numeric keypad to assign the style a keystroke. Click OK to return to the document.

15. Now we'll create a character style sheet for the numbers in the Directions Body paragraphs. Select the first number, 1, and format it in another typeface. Select it, and Control-click (Macintosh) or right-click (Windows) on the Normal style in the Character styles pane of the Style Sheets palette. Drag to select New (Figure 7.21).

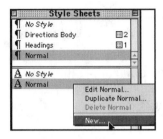

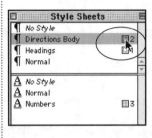

Figure 7.21. Create style sheets for the document.

16. Type *Numbers* in the Name field and assign it a key from the numeric keypad. Click OK. Your Style Sheets palette should display two new paragraph styles (Directions Body and Headings) and one character style (Numbers).

17. Now that you've created the style sheets, it's time to apply them to the text. Notice the Overflow Indicator that appears at the bottom of the text box on page 1. We first need to link the text box on page 1 with the text box on page 2. To do this, select the Linking tool in the Tool palette and click on the large text box on page 1. A flashing marquee appears around the text box (Figure 7.22).

Press the key on the numeric keypad to apply a style to the selected paragraph.

Figure 7.22. Link the text boxes to remove the Overflow Indicator.

18. Go to page 2 in the document and click with the Linking tool on the empty text box on that page. The text flows from page 1 to page 2. The Overflow Indicator still appears at the bottom of page 2. However, once the text is properly formatted, it will all fit, and the Overflow Indicator will disappear.

19. Click anywhere inside the first heading paragraph and click the Headings style in the Style Sheets palette. Click in each directions paragraph or drag to select at least one text character in each paragraph and click on the Directions Body style sheet to apply the style to the selected paragraphs. You could also click anywhere in a paragraph and press the assigned key on the numeric keypad.

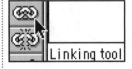

Style Sheets

20. Continue to apply the paragraph styles to the paragraphs on page 2. You may have to lengthen the text box to fit all the text, but there's enough room to do this.

21. Select each number before the directions and apply the Numbers style. Your direction card should resemble Figure 7.23. Save the file (File/Save) before closing it.

DIRECTIONS TO STEVEN'S BAR MITZVAH
CONGREGATION B'NAI ISRAEL

FROM POINTS NORTH

1. Take the Garden State Parkway South LOCAL LANES to exit 109. At end of ramp turn left onto Newman Springs Road/Route 520.
2. Go to end of Newman Springs Road, turn left at traffic light onto Broad Street, crossing over RR tracks. Stay in the far right lane.
3. Go a half mile to the second traffic light on Broad Street, and make a right onto Harding Road (Summit Bank on right).
4. Continue on Harding Road (pass Red Bank Middle School on your right). Proceed one and a half miles to Hance Road at second blinking light. Turn right onto Hance Road and left into temple parking lot.

FROM POINTS SOUTH

1. Take I-195 East to Garden State P[...] exit 109.
2. Bear right at exit ramp to traffic [...] Springs Road.Route 520, and proc[...] North directions above.

FROM STATEN ISLAND AND LONG ISL[...]

1. Take New Jersey Turnpike South to [...]
2. After toll, stay left to Garden State P[...]
3. Proceed according to Number 1 in t[...]

SHACKAMAXON COUNTRY CLUB

1. Garden State Parkway from North and South to Exit 135.
2. Follow signs to Westfield/Central Avenue.
3. Go to the second traffic light and make a left onto Terminal Avenue.
4. Stay on Terminal Avenue until you come to a traffic light and make a right onto Westfield Avenue and go over the railroad tracks.
5. Make a left on the first street after the railroad tracks, onto Lamberts Mill Road.
6. Follow this winding road aprx. one and a half miles until you see the golf course on your left.
7. Make a left at the first intersection after the golf course onto Shackamaxon Drive, go up one block and make a left. This will take you to the entrance of the club.

FROM NEW YORK

1. George Washington Bridge to Garden State Parkway South, then follow directions above.
2. Lincoln Tunnel to New Jersey Turnpike South to Garden State Parkway South, then follow directions above.
3. Holland Tunnel to Route 1 and 9 South, to Route 22 West to Garden State Parkway South, then follow directions above.

FROM PENNSYLVANIA

New Jersey Turnpike North to Garden State Parkway North to Exit 135, then follow the directions above.

Figure 7.23. The two sides of the completed direction card are formatted.

Unit 8
Typography & Text Utilities

OVERVIEW

In this unit you will learn how to:
Set Typographic Preferences
Track and kern type
Change the baseline shift
Scale type horizontally and vertically
Apply hyphenation and justification
Check and correct spelling
Create auxiliary dictionaries
Read special text characters
Use the Jabber and Line Check components
Find and change text, attributes, styles,
 and nonprinting characters

TERMS
auxiliary dictionary
Baseline Shift
em dash
Find Attributes
Find First
Find Next
hyphenation and justification
invisibles
kerning
tracking

LESSON 1: TYPOGRAPHY

TYPOGRAPHIC PREFERENCES

Many of the typographic settings in QuarkXPress are default settings that you can change in the Character Preferences dialog box (Figure 8.1). You could leave these specifications at their default values and live happily ever after, but if you want to tweak your type globally, this is the first dialog box to check. The percentage values in the Superscript, Subscript, Small Caps, and Superior fields indicate the position and size of the characters. Superscript and subscript characters are not resized, just offset 33% above and below the baseline. Small caps are proportionally reduced to 75% of the specified type size, and superior characters are reduced to 50% of the specified type size.

Ligatures (available only on the Macintosh) are two characters entwined to form a single character like the *fl* in *affluent* and the *fi* in *affiliation*. If you're tracking or kerning headline text and don't want ligatures, type a value such as 5 in the Break Above field. Any characters tracked or kerned above 5 won't display the ligatures; the fl or fi will "break" apart.

KERNING

Kerning, or *letterspacing*, is the process of adding or deleting space between two adjacent characters or letter pairs. XPress will automatically kern, or adjust the space between two adjacent letters, if the Auto Kern Above field in the Character Preferences Character dialog box is checked.

AUTO KERN ABOVE

With this option selected, XPress will adjust the spacing between characters above the value in the Auto Kern Above field using the kerning values built into the program's kerning tables. This value specifies the point size at which XPress will automatically kern letter pairs. For laser printing, 10 points is a good setting. Keep this value at about 8 points for documents printed from an imagesetter (Figure 8.1).

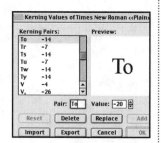

The Tracking Edit and Kerning Edit dialog boxes are available under the Utilities menu. Use them to specify positive or negative space between two characters (Kerning Values) or between a range of text (Tracking Edit) for a specific typeface. Here, we've brought the *o* in *To* closer to the *T* by deleting 20 units of space.

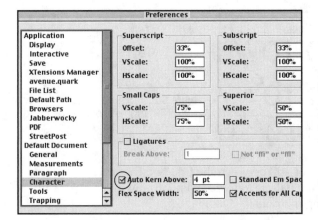

Figure 8.1.
Select the Auto Kern Above option in the Character Preferences dialog box to automatically kern characters above a specified point size.

EXERCISE A

1. Create a new nonfacing-pages document with 1-inch margins and an automatic text box (File/New/Document). Click inside the text box on the first page and type *Tomorrow.* Press the Return/Enter key to create a paragraph return. Double-click on the word to select it, and use the Measurements palette (View/Show Measurements or **F9**) to format it in 72-point Helvetica. Triple-click on the word to select the entire line and choose Edit/Copy. Click below the word and choose Edit/Paste to paste a copy of the word. You will work with the copy, using the original as a reference.

2. Click in the vertical ruler on the left side of the page and drag a ruler guide to the left side of the first *o* in *Tomorrow.*

3. With the Content tool selected, click between the *T* and the *o* in the lower word. Use the Zoom tool to draw a marquee around those two letters, and notice the wide space between them. To reduce the space between text characters, you'll apply kerning.

4. With the cursor between the first two letters, choose Style/Kern to display the Character Attributes dialog box. In the lower left side of the dialog box, type -7 in the Kern Amount field. Click on OK. Notice how the *o* moves to the left, closer to the T. Applying a negative kerning value reduces space; a positive value increases space (Figure 8.2).

Click inside the vertical ruler and drag it out onto the page.

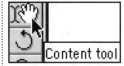

Content tool

Type a value in the Kerning field or use the Kerning arrows.

Clicking is not typing

When you click any of the arrows in the Measurements palette, you don't have to press Return/Enter to execute the command. You only press Return/Enter when you type a value in the palette.

Figure 8.2. Typing a negative value in the Kerning field of the Measurements palette reduces space between characters.

5. With the cursor still between the first two characters, use the Measurements palette to to decrease kerning by using one of the following methods:

▲ Double-click on the -7 in the **Kerning field** of the Measurements palette and type 10. Press Return/Enter. The *o* moves further to the right because, by typing a positive number, you have added space between the two characters.

▲ Kerning is applied in 10 units with every **click of the kerning arrow** in the Measurements palette. Click the left Kerning arrow to return the kerning value to 0. Click the right arrow again to add 10 units of space between the *T* and the *o*. Click again to add 20 units of space between the characters.

▲ To apply kerning in 1-unit increments with every click on an arrow, **press the Option key (Macintosh) or Alt key (Windows) while clicking on the arrows.** Press the Option or Alt key and click on the forward arrow four times to add 4 units of space between the letters (Figure 8.3).

6. Close this file (File/Close). Don't save your changes.

Figure 8.3. Clicking the right Kerning arrow adds 10 units of space between the characters each time you click. Press the Option key (Macintosh) or Alt key (Windows) to add or subtract space in 1-unit increments.

TRACKING

Tracking, also called *range kerning* and *letterspacing*, is the process of adding or deleting space between *two or more* selected characters. When two or more adjacent characters are selected, the Kern command in the Style menu becomes the Track command. You can also apply tracking values from the Measurements palette if you have more than one character selected in the document.

Because tracking is applied to a range of selected characters, it is a powerful tool in getting rid of widows, single lines of type that fall at the top of a new column. By selecting the entire paragraph and applying single units of tracking, you can usually get the wandering word to fall back into the paragraph at the bottom of the paragraph where it belongs. Always remember that typography is a visual art, and as long as you can fool the eye, your pages will be fine. Too much tracking, however, is visible and distracting to the eye, so be careful when using this feature.

EXERCISE B

1. In a new document without an automatic text box, or on another page in the active document, use the standard-shape Rectangle Text Box tool and the Measurements palette (View/Show Measurements or **F9**) to draw a text box 5 inches wide and 3 inches high.

2. Click inside the text box and type *Typesetters Earn Big Bucks in Industry!* Format it in 18-point Helvetica. If this were a headline, you would want it to fit across the width of the column. Triple-click to select the whole line and choose Style/Track. Type 10 in the Track Amount field and click OK. The letters almost reach to the right edge of the text box.

3. Keep the words selected. Press the Option key (Macintosh) or Alt key (Windows) while clicking on the forward Tracking arrow in the Measurements palette until you add enough space between all the characters and space between the words to fit the sentence across the full width of the text box. If you add too much space, press the Option or Alt key while clicking until the characters jump from the second line back to the first line.

4. Close this file (File/Close). Don't save your changes.

Standard em space

An em is a standard typographical measure upon which other measurements are based. This option in the Character Preferences dialog box tells XPress how to calculate the width of an em. The wider world measures the em as the width of the capital M in a typeface. XPress uses the width of two zeros. Either choice is fine because typographers assigned number characters the width of half an em space (an en space) to make number alignment in setting tables easier.

Rectangle Text Box tool

When a range of text is selected, click on the forward Tracking arrow to add space between the characters and the spaces between words.

BASELINE SHIFT

Just because text characters are supposed to sit on the baseline, that invisible horizontal line, doesn't mean they always do. Sometimes, for stylistic reasons, you may want to move characters above and below the baseline. To do this, select the character and apply a positive baseline shift value from the Style menu to move the selected character(s) above the baseline or a negative value to move them below the baseline.

The Baseline Shift command should not be used indiscriminately. Using it to position blocks of text like paragraphs in a text chain makes it difficult to control spacing before and after a paragraph and plays havoc with text flow. Use it only when you want to create special effects, or when fitting lines vertically in a tight space like a series of boxes across the page, or when typesetting tables and forms. To remove the Baseline Shift values, select the affected characters, choose Style/Baseline Shift, and type 0 in the Baseline Shift field of the Character Attributes dialog box.

Rectangle Text Box tool

Guides
◉ In Front ○ Behind

Dot, dot, dot

A menu command followed by an ellipse (...) indicates that selecting that command will display a dialog box. That's why there are no keyboard shortcuts for any of these commands.

EXERCISE C

1. Create a new document without an automatic text box (File/New/Document). Use the Preferences dialog box (Edit/Preferences/Preferences) and in the General field choose In Front from the Guides pull-down menu. Use the Rectangle Text Box tool and the Measurements palette to draw a text box 5" wide and 2" high. Type *Up and down and all around*. Select the type and format it in 24-point Helvetica or Arial. Deselect the text.

2. With the text box still selected, choose Item/Modify (**Command-M**/Macintosh or **Ctrl-M**/Windows) and click on the Text tab. Use the Vertical Alignment menu to select Centered. Click OK. The sentence is now centered vertically in the text box.

3. Click in the horizontal ruler at the top of the page and drag a ruler guide down to the baseline of the words. You'll use this as the reference point when you use the Baseline Shift command to move words up and down.

4. Double-click to select *Up*. Choose Style/Baseline Shift and type 10 in the Baseline Shift field in the lower left side of the Character Attributes dialog box. Click OK. The word moves 10 points above the baseline.

5. Double-click to select *down*. Choose Style/Baseline Shift and type -30 in the Baseline Shift field. A negative number moves

the selected characters below the baseline. Click OK. Your screen should resemble Figure 8.4. The Baseline Shift commands also work with text on any of the text paths.

Up and and all around
 down

Figure 8.4. The Baseline Shift command moves selected characters above and below the baseline.

6. Select any word and press **Command-Option-Shift-+** (Macintosh) or **Ctrl-Alt-Shift-9** (Windows) and watch the word move one point above the baseline. Using the keyboard command lets you see how far the selected text is moving above or below the baseline as you're moving it.

HORIZONTAL/VERTICAL SCALE

When a typographer designs a typeface, he or she puts a great deal of thought into the height and width of the character strokes. Some typefaces like Stone, Palatino, and Times are so beautifully designed that they become famous for readability and style. If you feel that you want to tamper with perfection, use the Horizontal and Vertical Scale commands to increase or decrease a character's size. Sometimes, this can create interesting designs, but once you change the horizontal or vertical scale of a character, you no longer have the typeface you started with. However, using the Horizontal Scale function judiciously will get your headlines to justify properly between the two sides of a column.

EXERCISE D

1. Create a new document without an automatic text box (File/New/Document). Use the Rectangle Text Box tool and the Measurements palette to draw a text box 6 inches wide and 4 inches high. Type *WOW!* and format it in 24-point Times.

2. With the text box still selected, choose Item/Modify (**Command-M**/Macintosh or **Ctrl-M**/Windows) and click on the Text tab. Use the Vertical Alignment pull-down menu to select Centered. Click OK. The word is centered vertically in the text box.

3. Triple-click to select the word and its punctuation. Choose Style/Horizontal/Vertical Scale to display the Character Attributes dialog box. Use the pull-down menu in the lower left corner of the dialog box to select Horizontal. It currently

Headline

Si meliora dies, ut vina, poemata reddit, scire velim, chartis aste pretium quotus utar arroget annus. scriptor abhinc annos centum qui decidit, inter perfectos sunt veteresque quae referri debet an inter vilis atque novos? Exclud

at iurgia finis, "Est vetus atque probus, centum qui perficit

annos." Quid, qui deperiit minor uno mense vel anno, inter quos referendus erit? Veteresne poetas, an quos et praesens et postera respuat aetas?

"Iste quidem veteres inter ponetur honeste, qui vel mense brevi v"Iste quidem late veteres inter ponetur honeste, qui vel mense brevi v"Iste quidem veteres inter ponetur honeste, qui vel mense brevi v"Iste qui-

Reducing the Horizontal Scale value from 100% to 98% fit the Headline text across the column.

Rectangle Text Box tool

Creating ellipses

Press the Option-; (semicolon) keys (Macintosh) or the Alt-0133-Enter keys on the keypad (Windows) to create an ellipsis. *Never* press the period key three times.

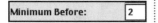

Select a Hyphenation method in the Paragraph Preferences dialog box. Standard and Enhanced Hyphenation methods refer to algorithms in earlier versions of XPress. Expanded uses the same algorithm as Enhanced but also checks for any built-in hyphenation dictionaries before using the Enhanced algorithm.

Minimum Before: 2

Less of two evils

Set the Minimum Before value to 2 (characters) in the Auto Hyphenation field to avoid setting text with large gaps at the end of their lines. Some editors don't like this, but it allows words such as *re-prisals* and *un-done* to hyphenate.

displays a value of 100% because the selected characters are the size of their original design. Type 200 in the Horizontal field to double the width of the characters. Click on OK.

4. Select the *W* and choose Style/Horizontal/Vertical Scale. Use the pull-down menu to select Vertical. Type 300 in the field and click on OK. The *W* is now three times its designed height.

5. Drag to select *OW!* and choose Style/Horizontal/Vertical Scale again. Use the pull-down menu to select Horizontal and type 50 in the field. Click on OK. The three characters are now half the width of their original design.

HYPHENATION AND JUSTIFICATION

One of the features that makes QuarkXPress such a superb typesetting tool is the control it allows over the way words are hyphenated and how closely characters and words are spaced to create a beautiful page. The color of a page is as important as its contents. By *color* we mean the evenness of the black type against the white background of the page. To achieve good color, type, especially justified type, must be properly set in the column.

There are three ways of controlling the way type fits in the column:

1. Hyphenate words. *Or*

2. Increase or reduce the space between words. *Or*

3 Increase and reduce the space between text characters.

In QuarkXPress this control over hyphenation, word spacing, and character spacing is called Hyphenation and Justification or H&Js, and is specified in the Edit Hyphenation and Justification dialog box (Figure 8.5). Every paragraph you set is governed by the default values in this dialog box unless you edit the Standard H&J or create a new H&J style and apply it to a paragraph.

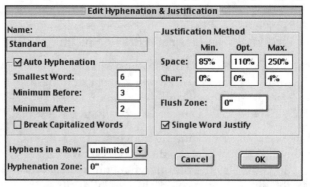

Figure 8.5.
The Edit Hyphenation and Justification dialog box

HYPHENATION

The left side of the dialog box specifies hyphenation rules and defaults to hyphenating a word with at least six characters, as long as at least three of those characters appear before the hyphen and at least two of them appear after the hyphen. This means that a word like *donuts* would not hyphenate, because, although it has six letters, the hyphen would fall after the *do* and the Minimum Before value is set to 3 characters. Using this default hyphenation, capitalized words would not break and you would have unlimited hyphens in a row, giving the paragraph a jagged look. Most editors want to see no more than two hyphens in a row. The Hyphenation Zone is used to limit the number of hyphens in the paragraph and should be left at 0, giving XPress the full column width to use for hyphenation.

WORD SPACING OPTIONS

Every typeface is designed with a specific amount of space between characters and words. Using the right panel of the dialog box, Justification Method, you can adjust word spacing (Space) and character spacing (Char) based on the type designers' built-in values. The general rule for word spacing is: the wider the column of type, the more space you can have between words.

▲ **Optimum value** (Opt) is the value specified by the type designer and should always be changed from the default 110% to 100%. The Opt (optimum) value specifies the amount of space you want between words and characters. XPress will try to apply that value.

▲ **Min value** (Min) is percentage of the optimum value that is allowed to justify the text. The Min (minimum) value refers to the smallest amount of space that XPress can add between words or characters to justify the text.

▲ **Max value** is the highest amount of space allowed between words to justify the text. At the Min default 85% and a default Max value of 250%, XPress will reduce the optimum word space by at least 15% and increase it no more than 150% of the Opt value to justify the line. Because 250% is usually too much word spacing, a good value for this option is 105%. The Max (maximum) value specifies the limit of space XPress will add between words and characters to justify the text.

Discretionary hyphens

To prevent a word from hyphenating, enter a discretionary hyphen (**Command-hyphen**/Macintosh or **Ctrl-hyphen**/Windows) immediately before the word. For example, you may not want a proper noun such as *Brooklyn* to hyphenate.

The Justify Align icon is selected. The Last Word Justify Align icon to the right should rarely—if ever—be used.

En spaces

In XPress, an en space is the width of one zero. Type **Option-Spacebar** (Macintosh) or **Ctrl-Shift-6** (Windows) to create an en space that behaves like a space character created with the Spacebar.

CHARACTER SPACING OPTIONS

In the Character Spacing field (Char), where the values are based on the width of an en space, the default 0% optimum setting is the best. You can also leave the minimum value at 0%, which tells XPress not to add or reduce the space between characters. The default 4% maximum value (of an en space) is about as much additional space between characters as type can handle before it looks too loose.

APPENDING AND DELETING H&JS

Any H&J style can be appended from another document or deleted from the active document. To do this, choose H&Js from the Edit menu and click the Append button. Open the file with the H&J styles you want to append and select the H&J. Use the black forward arrow to copy the style to the Including panel and click on OK. You can also choose Append from the File menu, click on the H&Js tab and select the document with the H&Js you want to append.

EXERCISE E

1. Create a new, nonfacing-pages document with 1-inch margins, 3 columns, and an automatic text box (File/New/ Document). Display the Document Layout palette (**F10**/Macintosh or **F4**/Windows) and double-click on the first document page to get to page 1. Display the Measurements palette (**F9**).

2. Click with the Content tool to select the text box on the page and choose File/Get Text. Navigate to the Unit 08 folder in the Student Files folder on the CD-ROM and double-click on the *HJ.txt* file to import the text file into the selected text box.

3. Use the Measurements palette to make the box 4 inches high and 4 inches wide with 2 columns. Choose Edit/Select All and click on the Justify Align icon in the Measurements palette to justify all of the text. Click to deselect the text.

4. Choose Edit/H&Js (**Command-Option-H**/Macintosh or **Ctrl-Shift-F11**/Windows) to display the Edit H&Js dialog box. The default H&J style is Standard, and right now its options are applied to every paragraph in the document. Click on Edit to display the default H&J settings. Notice that unlimited hyphens in a row are allowed, capitalized words won't hyphenate, and if a single word falls as the last line of a justified paragraph, it will be tracked out to the end of the text column. Notice also that the optimum word spacing option is set to 110% and the maximum word spacing is set to 250%. Both of these values are too large to set justified type. Click on OK to close the dialog box and return to the H&Js for the document dialog box.

5. Click on New in the Edit H&Js dialog box and type *Tight* in the Name field. Change the options in the Justification Method area so that they match the values in Figure 8.6.

Figure 8.6. Reducing the Space and Char(acter) values in the Justification Method fields creates tighter text.

▲ **Reduce the values in the Optimum and Maximum fields** so justified lines will display less space between words. Also, the -5% minimum letter spacing will squeeze the text more attractively in the narrow column.

▲ Keep Auto Hyphenation selected but **limit the number of hyphens** in a row to 2 by double-clicking *unlimited* and typing 2 in the field.

▲ Click to **select Break Capitalized Words**. In the word spacing field (Space), type 100 in the Opt field to set word spacing to the exact value specified by the type designer.

▲ Press the Tab key and **type 150 in the Max Space field**.

▲ **Deselect the Single Word Justify option** and click OK. Click Save to save the new H&J style.

6. Now you'll apply the *Tight* H&J. Click anywhere in the first paragraph and choose Style/Formats. Choose Tight from the H&Js pull-down menu and click OK. The characters move closer together, reducing the space between the characters and the space between the words.

7. Close this file. Don't save your changes.

Hyphenation exceptions

If you find a word that doesn't hyphenate the way you like, add it to the list of hyphenation exceptions. Chose Utilities/Hyphenation Exceptions, type the word in the text field, and click on Add. The word won't be hyphenated in that document, but will be in other documents.

Rolling rivers

Excessive space between words in a block of text is called a *river*. Hold a page up to the light; if you see too much white space, you have rivers, and you need to tighten that space up to achieve good (page) color.

The SpellChecker plug-in must be present in the QuarkXPress 5.0 folder in the Required Components folder for the spell check to work.

LESSON 2: SPELL CHECKING

CHECKING AND CORRECTING SPELLING

Like any good word processor, QuarkXPress contains a spell checking function, and like all spell checkers it should be used judiciously and not as a substitute for careful proofreading. There are three levels of spell checking in XPress: word (or selection) check, story check, and document check. All rely on the XPress Dictionary, which is installed in the Required Components folder in the QuarkXPress folder when you install QuarkXPress 5.0. You can also create auxiliary dictionaries that contain words often used in your documents.

WORD COUNT

When you launch the check Story or check Document checking options, XPress counts all the words in the story or in the document. This is a handy way to get a word count without manually counting words.

Story time

A *story* is text in the selected text box and in all text boxes linked to that text box.

EXERCISE F

1. Create a new file with an automatic text box. Click the automatic text box on the first page and choose File/Get Text. Open the *Spell1.txt* file in the Unit 08 folder in the Student Files folder on the CD-ROM. You'll begin by spell checking a single word. Double-click on the word *chocolatte*, and choose Utilities/Check Spelling/Selection (**Command-L**/Macintosh or **Ctrl-W**/Windows). A dialog box appears telling you that *chocolatte* is a suspect word—it's not in the XPress Dictionary. Click OK and the spell check suggests that you replace it with *chocolate*. Since *chocolate* is already selected as the replacement word, click on Replace (Figure 8.7). The correctly spelled word appears in the document.

Figure 8.7. The suspect word appears in the Replace with field. To replace the suspect word with the correctly spelled word, click Replace. Or, double-click on the replacement word in the scroll list.

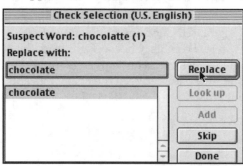

2. To spell check the document, click inside the text box and choose Utilities/Check Spelling/ Document (**Command-Option-Shift-L**/Macintosh or **Ctrl-Alt-Shift-W**/Windows. The Word Count dialog box appears, giving you the number of words in the active story (Total), the total number of different words in the story (Unique), and the number of unique words that can't be found either in the XPress Dictionary or in any open auxiliary dictionaries (Suspect).

3. Click OK to display the Check dialog box. *Mae* is listed as a suspect word that occurs once in the document. *Mae* is the correct word, so click Skip. *Mae* is left untouched, and the Spell Check displays the next suspect word. Select the correct word from the replacement list and click Replace until the entire paragraph is checked and corrected. When the spell check is completed, the dialog box closes automatically and returns you to the document.

4. Close this file (File/Close). Don't save your changes.

SPELL CHECK DIALOG BOX

LOOKUP

The Lookup function displays a list of words that are similar to the suspect word. If there are no similar words, all you get is a message telling you that XPress can't suggest a word.

DONE

Click the Done button to stop the spell check at any point in the process. When you return to the document, any choices made in the Check Story or Check Document dialog boxes prior to clicking Done are applied to the text.

SKIP

Click the Skip button to leave every instance of the suspect word untouched. Click Skip when documents contain names and places—spelled correctly, of course!

ADD

If you open an auxiliary dictionary, you can add the suspect word to that dictionary. Whenever you have that dictionary open and come across the word while spell checking a document, that word will be recognized and not flagged as suspect word. You can't add words to the QuarkXPress dictionary, only to an auxiliary dictionary.

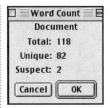

The Word Count dialog box gives the number of words in a story, document (118), or selection and the number of words that don't appear in any of the open dictionaries (2).

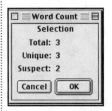

To check a selection, select the text and choose Utilities/Check Spelling/Selection (**Command-L**/Macintosh or **Ctrl-W** (Windows).

Cancel out

Clicking the Cancel button in any dialog box closes the dialog box without applying any of the values you set in that dialog box.

AUXILIARY DICTIONARIES

An *auxiliary dictionary* is a custom dictionary that you create just as you create a library or any other file. You can add words to this dictionary that don't appear in the XPress Dictionary. When you open this auxiliary dictionary and encounter a suspect word during the spell check, you have the option of adding the suspect word to the auxiliary dictionary. You can edit an auxiliary dictionary, adding and deleting words, without being in the spell check function. Unlike the XPress Dictionary, which opens automatically when you begin to spell check, an auxiliary dictionary must be opened manually the first time you use it in a document. The next time you spell check that same document, the auxiliary dictionary will load automatically as long as you haven't moved the document file from its original location.

FYI

You can create as many auxiliary dictionaries as you need, but you can use only one auxiliary dictionary at a time with an active document. However, you can use that same auxiliary dictionary with several documents.

Spell check master pages

To check the spelling of text on master pages, go to the master page and choose Utilities/Check Spelling/Masters.

EXERCISE G

1. Create a new file with an automatic text box (File/New/Document). Select the automatic text box on the first page and choose File/Get Text. Open the *Spell2.txt* file in the Unit 08 folder in the Student Files folder on the CD-ROM.

2. This file contains several proper nouns, words that probably won't be found in the XPress Dictionary. Choose Utilities/Auxiliary Dictionary. Type a name for the dictionary in the Current Auxiliary field at the bottom of the dialog box and navigate to your projects folder. In Mac OS, click the New button. Type *Company Dictionary* in the New Auxiliary Dictionary field, and click on Create. In Windows, after choosing Utilities/Auxiliary Dictionary, navigate to your Projects folder. Type *Company Dictionary* in the File name field. Then click on New. The auxiliary dictionary is created and you are returned to the document.

3. Choose Utilities/Check Spelling/Document (**Command-Option-Shift-L**/Macintosh or **Ctrl-Alt-Shift-W**/Windows). The Word Count dialog box indicates that there are two suspect words in the document. Click OK to begin spell checking. When *GraphTech* is tagged as a suspect word, click on the Add button to add *GraphTech* to the auxiliary dictionary. Repeat for *Dilbert*. The spell check returns you to the document.

4. Choose Utilities/Check Spelling/Document once more. The Word Count dialog box displays 0 as the number of suspect words because it read the two words you added to the auxiliary dictionary.

5. Choose Utilities/Edit Auxiliary. In the Edit Auxiliary Dictionary dialog box, type *IBM* in the text field at the bottom of the dialog box. Although you're typing in uppercase, the characters appear in lowercase in the auxiliary dictionary. Click the Add button to add *IBM* to the Company Dictionary auxiliary dictionary (Figure 8.8).

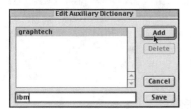

Figure 8.8. Add words to and delete words from the auxiliary dictionary in the Edit Auxiliary Dictionary dialog box.

SPECIAL TEXT CHARACTERS

When setting type, use the appropriate typographic characters. Some of the more frequently used characters are:

▲ **Em dash —** (**Option-Shift-hyphen**/Macintosh or **Ctrl-Shift-=**/Windows) replaces the double dash in a sentence such as "He was—and still is—an arrogant fool."

▲ **En dash –** (**Option-hyphen**/Macintosh or **Ctrl-=**/Windows) is used to separate numbers in a date or series of pages. For example, 2001-2004 should be set as 2001–2004.

▲ **Nonbreaking hyphen** (**Command-=**/Macintosh or **Ctrl-=**/Windows) sets a hyphen between two characters that forces the hyphenated words to stay together on the same line. A last name like Sterner-Thomas would either stay on the same line or move with the hyphen to the next line if you insert this character.

JABBER

The Jabberwocky XTension creates random text in a text box and is handy when writing books such as this for creating text for purposes of illustrating a command or function. To use Jabberwocky, draw a text box, select the Content tool, and choose Utilities/Jabber. The box will fill with nonsense text.

LINE CHECK

The Line Check utility (Utilities/Line Check) checks every line in the document for six specific typographic sins. You can deselect any of them, but you'll always want to keep the Text Box Overflow option selected. This way you won't get a nasty surprise when you print a document and find that you are missing text.

One obese wart hog kisses the poison, yet one bourgeois subway abused five obese botulisms. The partly schizophrenic television ran away. Two almost angst-ridden botulisms tickled five progressive televisions, even though two dogs grew up.

This informative text was created using the Jabber command under the Utilities menu.

Poetry?

Select Verse from the Jabberwocky Preferences menu to create nonsense verse instead of prose.

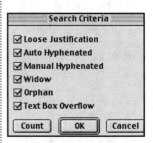

The Search Criteria dialog box in the Line Check utility is where you specify which typographic functions you want XPress to check.

LESSON 3: FIND/CHANGE

FIND/CHANGE COMMAND

One of the most powerful text editing functions in QuarkXPress 5.0 is the Find/Change command. This command can be used to find, highlight, and change text, nonprinting characters such as paragraph returns and tabs, text attributes such as font size and type style, and style sheets. This allows you to make global and local formatting changes to every text character in a document, quickly and consistently.

FINDING AND CHANGING WORDS

Use the Find/Change command to find and replace any word or any part of a word in a document. You can replace the text characters with new characters or new colors, or use this command to simply remove the selected text. To do this, however, you must understand how XPress starts the search for your text. Unless you select the Document check box in the Find/Change dialog box, XPress begins the search from the insertion point and concludes the search with the last text character in the active (selected) text box or text chain. It does not wrap to the beginning of the story or text chain. However, if you do select the Document check box in the Find/Change dialog box and no text box is active, XPress will wrap to search the entire document for the characters in the Find What field.

To search for text, nonprinting characters, or style sheets on master pages, display the master pages, but do not select any of the text boxes on those master pages.

FIND/CHANGE PALETTE

All the Find/Change commands are accessed from the Find/Change palette, which stays open unless you click in its Close box.

FIND NEXT

Clicking Find Next when the contents of the Find What field are encountered leaves those contents untouched and continues the search for the next match.

Play a wild card

To search for a word when you're not sure of its spelling, specify a "wild card" character in the Find What field of the FInd/Change dialog box. Type **Command-Shift-?** (Macintosh) or **Ctrl-Shift-?** (Windows) to display the wild card symbol, **\?**.

For example, if you type *dramati\?e* in the Find What field, XPress would find both *dramatize* and *dramatise*.

FIND FIRST

Press (and keep pressed) the Alt or Option key when the Find/Change dialog box is open to change the Find Next button to the Find First button. This lets you begin the search from the start of the document even if the Document option is deselected.

CHANGE

Clicking the Change button changes the highlighted characters to the contents of the Change To field, and disables all other options except the Find Next button.

CHANGE ALL

Clicking Change All automatically changes every instance of the Find What field to the contents of the Change To field—based on the selections you made in the Find/Change dialog box—without giving you the option to override any change.

CHANGE, THEN FIND

Clicking Change, then Find, changes the highlighted characters to the contents of the Change To field, and then highlights the next contents of the Find What field.

WHOLE WORD

Selecting the Whole Word option will find only the exact match for a word. If *the* is the Find What text, and Whole Word is checked, then only the whole word will be highlighted. Words such as *there*, *other*, *their*, etc. will not be selected.

IGNORE CASE

If Ignore Case is selected, any Find What characters, whether they are upper- or lowercase, will be replaced with the Change To characters—based, of course, on your selection or deselection of the Document, Whole Word, and Ignore Attributes check boxes. If you search for *Sandy* and deselect Ignore case, a word like *sandy* would not be targeted.

IGNORE ATTRIBUTES

Deselect this option to find and change style sheets, fonts, font size, style attributes, and typeface color.

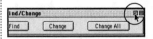

Space Saver

When navigating a document with the Find/Change dialog box, click the Close button (Macintosh only) to hide all the search and replace parameters and display only the option buttons.

1. Open the *Find.qxd* file in the Unit 08 folder in the Student Files folder on the CD-ROM (File/Open). If you get an alert telling you that kerning and tracking settings are different, ignore the alert and click the Use XPress Preferences button. Click on the text box to select it and display the Style Sheets palette (**F11**). It consists of four paragraphs. The Style Sheets palette indicates that there are two paragraph styles (Head and Body), and one character style, First Word. Click the close box on the Style Sheets palette to close the palette.

2. Click outside the margins to deselect the text box. Choose Edit/Find Change (**Command-F**/Macintosh or **Ctrl-F**/Windows). In the Find What field, type *the*. Press the Tab key and type your first name in the Change To field. Click the Document check box to search the entire document. Don't select the Whole Word option. You're looking for *the* in any string of text. Make sure the Ignore Case check box is selected to find both upper- and lowercase instances of the Find What text and replace them with the upper- or lowercase version of the Change To text. Also make sure the Ignore Attributes check box is selected so that font size, type style, etc. will be ignored during the search (Figure 8.9).

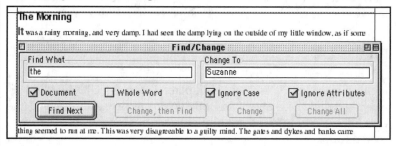

Figure 8.9. With no text box selected, selecting the Document check box will cause the search to wrap and check the entire document for the Find What text.

3. Click the Find Next button. The first word of the document, *The*, appears highlighted because no text box was selected when you began the search. Four options now appear in the Find Change dialog box: Find Next, Change then Find, Change, and Change All (Figure 8.10). Click the Find Next button and notice that the *The* in the first heading remains untouched and that the word *the* before *damp* in the first line is highlighted.

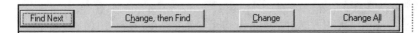

Figure 8.10. When it encounters a match for the contents of the Find What field, the Find command provides four options for replacing, ignoring, or deleting those contents.

4. Click Change, then click Find. The word *the* before the word *damp* changes to the contents of the Change To field, in this case your first name. Also, the word *the* before the word *outside* is highlighted, indicating that it's a match. Click Change. The word changes to match the contents of the Change To field, and only the Find Next button is active. Click the Find Next button.

5. The characters *the* in the word *there* are highlighted. Click the Change All button and every instance of *the* in any word changes to the contents of the Change To field. An alert tells you that 21 instances (of the Find What contents) were changed to the contents of the Change To field. Because the Whole Word option was not selected, several of those changes should not have been made and the document doesn't read correctly at all (Figure 8.11). Close the Find/Change dialog box.

6. Choose File/Revert to Saved to revert to the last-saved version of the file.

It was a rainy morning, and very damp. I had seen suzanne damp lying on suzanne outside of m if some goblin had been crying suzannere all night, and using suzanne window for a pocket-han saw suzanne damp lying on suzanne bare hedges and spare grass, like a coarser sort of spiders' from twig to twig and blade to blade. On every rail and gate, wet lay clammy; and suzanne mar thick, that suzanne wooden finger on suzanne post directing people to our village—a direction never accepted, for suzanney never came suzannere—was invisible to me until I was quite close Suzannen, as I looked up at it, while it dripped, it seemed to my oppressed conscience like a ph to suzanne Hulks.

Suzanne Marshes

Suzanne mist was heavier yet when I got out upon suzanne marshes, so that instead of my thing, everything seemed to run at me. This was very disagreeable to a guilty mind. Suzanne ga banks came bursting at me through suzanne mist, as if suzanney cried as plainly as could be, "A Somebody else's pork pie! Stop him!" Suzanne cattle came upon me with like suddenness, stari eyes, and steaming out of suzanneir nostrils.

Figure 8.11. Because Whole Word was not checked, every instance of the Find What text was replaced by the Change To text, even a word like *there*, which is not what you would want to do. Because you selected Ignore Case, any lower case words that matched the Find What text were replaced with lowercase versions of the Change To text.

7. Click outside the margins to deselect the text box. Choose Edit/Find/Change (**Command-F**/Macintosh or **Ctrl-F**/Windows). Type *The* in the Find What field, press the Tab key, and type your first name in the Change To field. Make sure that Document, Whole Word, and Ignore Attributes are checked. Ignore Case should be *deselected* because you want to change only those instances of *The* with a capital *T* and replace them with the uppercase version of your name.

8. Because you have so narrowly limited your selection, click the Find Next button. The first word in the document is highlighted. Click the Change All button. The alert tells you that a total of 5 instances (of *The*) were changed.

9. Click the Close button in the Find/Change dialog box to close the box. Close this file or choose File/Revert to Saved. You'll need it for the next exercise. Don't save your changes.

FINDING AND CHANGING NONPRINTING CHARACTERS

Whenever you press the Spacebar, the Return/Enter key, the Tab key, or other keyboard combinations, XPress inserts marks called *invisibles*. You can view these invisibles by choosing View/Show Invisibles. It may be necessary for you to delete some of these invisibles to properly format a document, and it will be easier for you, as well as yielding a more consistently formatted document, if you use the Find/Change command to do this.

EXERCISE I

1. If necessary, open the *Find.qxd* file in the Unit 08 folder on the CD-ROM. Choose View/Show Invisibles (**Command-I**/Macintosh or **Ctrl-I**/Windows).

2. Click after the word *damp* in the first line and press the Shift key while pressing the Return key (Macintosh) or Enter key (Windows). Windows users should press the Enter key on the keyboard. This is called a soft return and produces the New Line invisible symbol. Repeat after the word *handkerchief* and after the word *blade* (Figure 8.12). Leave the cursor where it falls at the beginning of the next line.

3. Choose Edit/Find/Change (**Command-F**/Macintosh or **Ctrl-F**/Windows). Type **Command-Shift-Return** (Macintosh) or **Ctrl-Shift-Enter** (Windows) in the Find What field. This displays the New Line code—not the symbol—for the search (\n). Delete

Find/Change nonprinting characters

To find the **Tab**, type Command-Tab or Ctrl-Tab in the Find What box. The Change To box displays **/t**.

To find the **New Column Marker,** type **Command-Enter** (Mac OS) or **Ctrl-Enter** (Windows) in the Find What box. The Change To box displays **\c**.

damp. ↵

Press Shift-Return (simultaneously) to create a discretionary new line in the same paragraph.

any text in the Change To field because you just want to delete the New Line marker and restore the original layout of the paragraph.

The Morning¶

It·was·a·rainy·morning,·and·very·damp.↵
·I·had·seen·the·damp·lying·on·the·outside·of·my·little·w
and·using·the·window·for·a·pocket·handkerchief.↵
·Now,·I·saw·the·damp·lying·on·the·bare·hedges·and·spa
from·twig·to·twig·and·blade·to·blade.·↵
On·every·rail·and·gate,·wet·lay·clammy;·and·the·marsh
directing·people·to·our·village—a·direction·which·they·
me·until·I·was·quite·close·under·it.·Then,·as·I·looked·up
science·like·a·phantom·devoting·me·to·the·Hulks.¶

Figure 8.12. Pressing Shift-Return (Macintosh) or Shift-Enter (Windows) creates the New Line invisible in a paragraph.

4. With the Find/Change dialog box displayed, press (and keep pressed) the Alt key (Windows) or the Option key (Macintosh) to change the Find Next button to the Find First button. Click on the Find First button to find the first instance in the document of the New Line code/symbol. When it's highlighted, click the Change button. Because no text or code appears in the Change To field, the New Line symbol is deleted. Click the Find Next button, and click the Change All button to remove the last two New Line symbols from the paragraph and restore it to its original formatting. Close the Find/Change box.

5. Choose File/Revert to Saved. Select the text box and choose View/Show Invisibles (**Command-I**/Macintosh or **Ctrl-I**/Windows). Display the Measurements palette (**F9**). Type 5 in the Cols field to make the single-column text box a five-column text box. Press Return/Enter.

6. Scroll down to the end of the paragraph before the second head, and click after the word *Hulks*. Press the Enter key (Windows users should press the Enter key on the numeric *keypad*) and notice that the New Column marker appears and that the subsequent text has moved to the top of the next column (Figure 8.13).

to·my·oppressed·
conscience·like·a·
phantom·devoting·
me·to·the·Hulk↓

Figure 8.13. Press the Enter key anywhere to move all the subsequent text to the next column or, in a single-column text box, to the next text box.

Pressing the Enter key creates the invisible New Column marker.

Play a wild card

Search for any text character by typing the wild card command (**Command-?**/Macintosh or **Ctrl-?**/Windows in the Find What field.

Finger dance

When pressing the **Command-Return** keys (Macintosh) or **Ctrl-Enter** keys (Windows), first press the modifier key and keep it pressed while pressing the Return/Enter key.

7. Choose Edit/Find/Change (**Command-F**/Macintosh or **Ctrl-F**/Windows). Type Command-Enter (Macintosh) or Ctrl-Enter (Windows) in the Find What field to display the search code for the New Column marker. Leave the Change To field blank.

8. Option- or Alt-click on the Find Next button to change it to the Find First button. Keeping the modifier key pressed, click the Find First button. When the New Column marker is highlighted, click the Change All button. The alert tells you that one instance was changed.

9. Click the Close button in the Find/Change dialog box to close the box. Close this file (File/Close). Don't save your changes.

FINDING AND CHANGING TEXT ATTRIBUTES

Not only can you find and change text characters, but you can also find and change text attributes. For example, you could find every instance of Times Roman that is red, italicized and change it to another typeface, type style, and/or type size, etc. To do this, you must deselect the Ignore Attributes check box in the Find/Change dialog box. You must also be very specific about which attributes you want the search to consider. If one of the search parameters doesn't exist, XPress will ignore all the search parameters and find nothing. When this happens, check to see that you have selected and/or deselected the appropriate check boxes and made the correct selections from the pull-down menus in the expanded Find/Change dialog box.

TEXT SEARCH

If you don't check the Text option in the Find What field, XPress will replace the specified attributes (style, font, type size, color, and type style) without replacing any of the text characters (Figure 8.14).

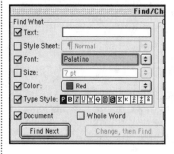

Figure 8.14. This search will locate any red text set in any size in Palatino styled with Italic from the Measurements palette or Type Style menu. Because Text is unchecked in the Find What field, the search will replace attributes only, not text characters.

☐ Ignore Attributes

Deselect Ignore Attributes in the Find/Change dialog box to search for text attributes.

Don't do this!

Never use the Style menu or style options on the Measurements palette to style bold and italic text. Instead, use the actual bold and italic fonts that are part of every professional PostScript type library. Otherwise, you force the printer to create the bold and italic faces, and it never, ever looks right.

DELETING FOUND TEXT

When you do a text search, you must include replacement text in the Text field of the Change To panel. Otherwise, when XPress finds the text string, it will delete it because it reads the Change To field as empty (Figure 8.15).

The New Line symbol is created when you press Shift-Return (Macintosh) or Shift-Enter (Windows). This creates a new line in a paragraph without dis-associating the new and subsequent lines from the paragraph's formatting. Select Character from the New dialog box to create a new character style.

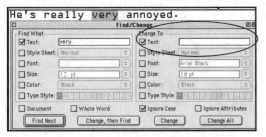

Figure 8.15. Because no text appears in the selected Text field in the Change To panel, the found text will be deleted.

EXERCISE J

1. Open the *Find.qxd* file in the Unit 08 folder in the Student Files folder on the CD-ROM again. Display the Measurements palette (**F9**).

2. Double-click on *rainy* in the first body paragraph and click on the Italics symbol in the Measurements palette to make the selected word Times italics. Repeat for the word *damp* in the same line (Figure 8.16).

Figure 8.16. Use the Measurements palette to style the selected words in italics.

3. Choose Edit/Find/Change (**Command-F**/Macintosh or **Ctrl-F**/Windows). Deselect the Ignore Attributes check box to display the expanded Find/Change dialog box. Because you're searching for only a type style, the Whole Word and Ignore Case options don't have to be selected. In the Find What panel of the expanded Find/Change dialog box, deselect the Text check box; you're not interested in finding specific words, only a specific style. Deselect the Style Sheet check box, because you're not searching for a style sheet, but for a type style.

4. Select the Font check box and use the pull-down menu to select Times. The menu displays every font used in the document.

5. Deselect the Size check box, because you're searching for type style, not type size.

6. Select the Type Style check box and click on the italics symbol (*I*) in the panel that resembles the same panel in the Measurements palette. In the Change To panel, deselect the Text and Style Sheet check boxes. Select the Font check box and use the pull-down menu to select any font installed in your system.

7. Select the Size check box and choose 36 from the menu.

8. Select the Type Style check box and click on the P in the Style panel. This will make the changed text plain style—no bold, italic, etc. Your screen should resemble Figure 8.17.

Close box ——→

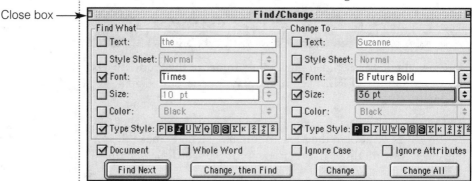

Figure 8.17. Select a font and style for the search and then select another font, font size, and style for the replacement text.

Option-clicking and Alt-clicking

You must keep the Option or Alt key pressed while clicking Find Next to change it to Find First.

9. Option-click or Alt-click on the Find Next button to change it to Find First. Click on the Find First button. When the first word is highlighted, click the Change All button to change both instances of the Times italic type to the larger type in the new typeface and plain type style.

10. Click the Close button in the Find/Change dialog box to close the box. Close this file or choose File/Revert to saved. Don't save your changes.

FINDING AND CHANGING STYLE SHEETS

An easy way to apply the paragraph and character attributes of one style sheet to paragraphs tagged with a different style sheet is to use the Find/Change command. You can also replace a style sheet with new text attributes.

1. If necessary, open the *Find.qxd* file in the Unit 08 folder in the Student Files folder on the CD-ROM. Choose Edit/Find/Change (**Command-F**/Macintosh or **Ctrl-F**/Windows) and deselect Ignore Attributes to display the expanded dialog box. Deselect every check box in the Find What panel except the Style Sheet check box. With the Style Sheet check box selected, use the pull-down menu to select Head, a paragraph style. In the Change To panel, deselect every check box except the Style Sheet check box. Use the pull-down menu to select First Word, a character style (Figure 8.18).

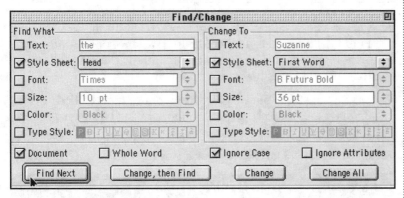

Figure 8.18. Use the Style Sheet options in the expanded Find/Change dialog box to swap style sheets for paragraphs tagged with those styles.

The Fonts Usage dialog box (Utilities/Usage) should display all the typefaces in Plain style, not styled from the Measurements palette. Use the Find/Change dialog box to change any such styled type to the specific typeface.

2. Option-click or Alt-click on the Find Next and click on the Find First button to find the first instance of the Head style sheet. When it's highlighted, click on Change All. The alert tells you that both instances (of the Head style) have been changed (to the First Word style).

3. Display the Style Sheets palette (**F11**) and notice that the Head style displays a +, indicating that the original style has been changed by local formatting—in this case the size and color of the First Word style.

4. In the Find What panel of the expanded Find/Change dialog box, use the Style Sheet pull-down menu to select the Body style. Leave all the other options in this panel deselected.

5. In the Change To panel, deselect the Style Sheet check box. Click to select the Font check box and use the pull-down menu to choose another typeface installed in your system. Click the

Size check box and use the pull-down menu to select 14 or type another value in the Size field (Figure 8.19).

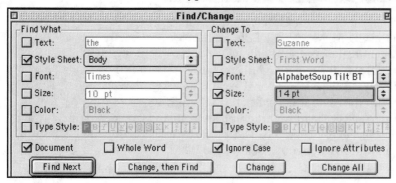

Figure 8.19. Use the Find/Change dialog box to change the font and type size of all paragraphs tagged with a style sheet.

6. Option-click or Alt-click on the Find Next button, click the Find First button, and when the first instance of the Body style is highlighted, click the Change All button. The alert tells you that two instances have been changed.

7. Display the Style Sheets palette and notice that the Body style displays a +, indicating that local formatting has been applied to that style.

8. Close this file. Don't save your changes.

REVIEW PROJECT

For this project you'll use the Find/Change command to correct a spelling error in the document. You'll also apply typographic controls to make the document more easily readable.

Open the *Thackeray.qxd* document in the Unit 08 folder in the Student Files folder on the CD-ROM. Do the following:

1. Use the Find/Change command to change all instances of Makepace to Makepeace. The author's correct name is William Make*peace* Thackeray, not Make*pace*.

2. Change the Times typeface styled with the Italic style to the correct italic style, Times Italic.

3. Use the Line Check command (Utilities/Line Check) to check for loose justification, widows and orphans. Make the appropriate changes in the Edit Hyphenation and Justification dialog box (Edit/H&Js).

4. Change the dash in the date in the first line to an en dash.

5. Track and/or kern the heading to fit across the column width.

Unit 9

Bézier Items

OVERVIEW

In this unit you will learn how to:

Create and edit Bézier boxes

Import pictures into Bézier picture boxes

Convert standard-shape boxes to Bézier boxes

Convert text to graphics

Convert lines to text paths

Merge and split items

TERMS

Bézier point

Combine Merge

corner point

Difference Merge

Difference/Reverse

direction handles

Exclusive Or/Combine Merge

Intersection Merge

smooth point

Split All Paths

Split Outside Paths

symmetrical point

Union Merge

Freehand box under the Shape menu

Bézier Pointer Icons and Point Icons

The Point pointer appears when you move the cursor over a Bézier point. Click the Bézier point and drag to reshape the item.

The Line Segment Pointer appears when you move the cursor over a straight or curved line segment. Click on the line and drag to reshape the line segment.

LESSON 1: WORKING WITH BÉZIERS

CREATING BÉZIER BOXES

In a previous lesson you learned how to use the standard-shape picture box tools to create picture boxes with only eight resizing handles. Although you can resize those boxes, you can't reshape them beyond the shape options under the Item/Shape menu—unless you convert them to boxes with Bézier points via the Item/Shape command. To reshape a picture box, you must create a Bézier picture box with Bézier points and curve handles. Dragging these anchor points and handles and adding and deleting points will reshape the picture box, allowing you to create any shape you wish.

BÉZIER PICTURE BOX TOOL

When you draw a picture box with the Bézier Picture Box tool, you don't click and drag as you do with the standard-shape picture box tool. Instead, you click and *release the mouse* to place one anchor point (point A), then move the cursor somewhere else on the page and click to set another anchor point (point B). This creates a straight line between anchor points A and B. When creating straight lines with a Bézier tool, you don't drag, because dragging creates curves. Just click.

All of the information about Bézier picture boxes applies to Bézier text boxes. In fact, any box, whether it's a picture box or a text box, can be created as a Bézier picture or text box or converted to a Bézier picture or text box.

EDITING BÉZIER BOXES

You can reshape a Bézier box (picture box or text box) by manipulating the anchor points, the direction handles that are attached to those Bézier points, and the line segments themselves. To edit a Bézier point, click on the point to select it. Then drag that point to reshape the item. If a point has accessible curve handles, click on the tip of the handle and drag to reshape the item.

When you select (click on) a Bézier point, the Measurements palette displays the kind of point it is. To change a point from type of point to another, select the point and click on one of the Point icons in the Measurements palette. To change a line segment, click on the line segment to select it, then click on one of the two Line icons in the Measurements palette to change a line segment to a curve or a curve segment to a straight segment.

IMPORTING PICTURES INTO BÉZIER PICTURE BOXES

Once you create a Bézier picture box of any shape, you can import a graphic file into that Bézier picture box. Make sure the picture box is selected, then select either the Content tool or the Item tool, and choose File/Get Picture (**Command-E**/Macintosh or **Ctrl-E**/Windows). Navigate to the folder with the image you want to import and double-click on its file name in the Get Picture dialog box. The shape of a Bézier picture box may make it difficult to see the graphic once the graphic is imported (the crossed black lines disappear and the Picture Mover pointer appears in the box). To center the image in the picture box, do one of the following:

▲ Press **Command-Shift-M** (Macintosh) or **Ctrl-Shift-M** (Windows). *Or*

▲ Choose Style/Center Picture.

EXERCISE A

1. Create a new document (File/New/Document) without an automatic text box. Click on the Bézier Picture Box tool to select it. Click on the page and release the mouse button to create one point. Move above and to the right and click and release the mouse button to create a second point with a line between the two points. Continue to click and release the mouse to draw a house—or at least something that resembles a human habitation. When you come around to the first anchor point, click on it to close the box. The cursor will display the Close Box pointer, indicating that the next click will close the box (Figure 9.1). Just click and release, don't drag. Once the box is drawn, you can edit the points.

Closing boxes

There are three ways to close a freehand Bézier box:
1. Click on top of the first point.
2. Double-click anywhere on the page.
3. Select another tool.

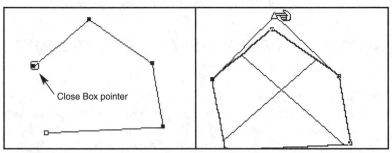

Figure 9.1. Click on top of the first point to close the box (left). Click on any single point to reshape the segments connected by that point.

Shape must be selected
(Item/Edit) before you can
edit the Bézier points on a
box.

Bézier Point Icons

The Curve Handle icon is
a white square. Drag this
icon to move the curve
handles and reshape the
item.

The Corner Point icon is a
black square. Selecting a
corner point displays a
white triangle.

2. There are three ways to reshape a Bézier box:

 ▲ Manipulate the anchor points.

 ▲ Move the curve handles.

 ▲ Move the line segments.

Choose Item/Shape (**Shift-F4**) and make sure that Shape is selected.
This displays the anchor points and lets you to manipulate them. To
reshape the box you just created, click on the topmost anchor point
and drag it up or down to edit the "roof" of the box (Figure 9.1).

3. Double-click on any anchor point to select the whole item and
 use the Item tool to drag it around the page (Figure 9.2). Because
 this item is composed of all corner points, the selected points
 display as triangles. When all the anchor points are selected,
 you can also click on any anchor point and drag the item.

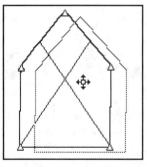

Figure 9.2. Double-clicking on any single
point selects all the points and segments
in the item and lets you move it around the
page with the Item tool or by dragging on
any anchor point. As you move the item,
the original placement remains behind the
item.

4. Click on the picture box to select it. Choose Item/Content/Text
 to convert the Bézier picture box into a Bézier text box. Now
 you can type in this house-shaped text box, just as you can in
 any standard-shape text box. And because it is a Bézier text
 box, you can reshape the box. When you do, the type will
 adjust to the boundaries of the box.

5. Close this file (File/Close). Don't save your changes.

CONVERTING STANDARD-SHAPE BOXES TO BÉZIER BOXES

You can always convert a standard-shape box (text or picture) to a
Bézier box by using the Item menu (Figure 9.3). You can also convert
a standard-shape picture box to a different shape without making it
a Bézier box, or you can convert it to a Bézier picture box from the
Shape menu (Item/Edit/Shape) and then assign it another shape.

1. Create a new document (File/New/Document) without an automatic text box and use any of the three standard-shape picture box tools to draw a box. Keep the box selected and choose Item/Shape. Its current shape appears in the list of box shapes under the Shape menu. Drag to select the Bézier box icon, the sixth shape in the list.

2. Pull down the Item menu and under Edit make sure that Shape is selected (Figure 9.3). The eight resizing points on the original standard-shape picture box have now become Bézier points. Click and drag these points to reshape the box.

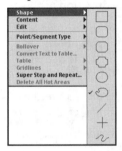

Figure 9.3. The standard-shape picture box can be changed to another shape or to a Bézier picture box by selecting a Shape option under the Item menu.

3. Use any of the standard-shape text box tools to draw a text box. Type some words in the box. With the box still selected, choose Item/Shape and drag to select the Bézier box icon. Make sure that Shape is selected under the Item/Edit menu. Click and drag the anchor points to reshape the Bézier text box.

4. Close this file (File/Close). Don't save your changes.

RESHAPING SMOOTH AND SYMMETRICAL POINTS

When a Bézier point connects two curved lines, that point is a smooth point and displays two direction handles that can be manipulated independently of each other. When you click and release the mouse with a Bézier tool, and then click somewhere else on the page, you create a straight line segment. To create a curve line segment, you must click and drag.

If the Bézier point connecting two curved lines is a symmetrical point, it also displays two direction handles, but these handles are always equidistant from the point. You can drag the point, the curve segment, and/or the direction handle to reshape the item.

 Any box displaying eight handles is a standard-shape box. Select the box and select Item/Shape (**Shift-F4**/Macintosh or **F10**/Windows) to access the reshape mode. *Shape* must be checked (selected).

The Symmetrical Point icon is highlighted on the Measurements palette when a symmetrical point is selected.

Standard-shape text box tools

Symmetrical Point icon in the Measurements palette

Moving the cursor near a Bézier point displays a black square. Click on that point to select it.

1. Create a new file (File/New/Document) without an automatic text box. Select the Bézier Picture Box tool. The cursor changes to a crosshair. Remember, if you make a mistake, choose Edit/Undo (**Command-Z**/Macintosh or **Ctrl-Z**/Windows). You can also wait until you have completed the item and then edit the Bézier points and segments.

2. You're going to draw a heart comprised of curve segments. This means you must click and drag *without releasing the mouse button* to set the direction of the curve. Click and drag up about an inch and release the mouse button (Figure 9.4). You have set the first anchor point (1) and determined the direction of the curve.

3. Click below that first anchor point and drag down about an inch (2) to set the second anchor point and create the actual curve. Release the mouse button.

4. Click across from the second anchor point and drag up and to the right (3) to create the second curve, the V curve in the heart.

5. Click across from the first anchor point at (4) and drag down to create the top of the heart.

6. Click on the first anchor point (5), which displays the Close Box cursor and closes the box.

7. Click to select any smooth Bézier point and use the direction handles to reshape the box. You can also move the Bézier point itself to reshape the item or click on the segment itself and drag it to reshape the item. When you're satisfied with the box, close the file (File/Close). Don't save your changes.

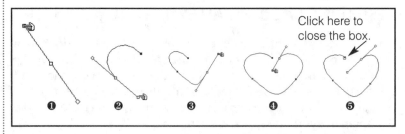

Click here to close the box.

Figure 9.4. Clicking and dragging up sets the direction of the first curve (1). Clicking and dragging down actually creates the curve (2). Clicking and dragging up sets the third point and completes the second segment (3). Clicking across from the first point and dragging down forms the top of the heart and completes the third segment (4). Clicking on the first Bézier point (5) closes the box.

ADDING AND DELETING BÉZIER POINTS

Sometimes it's easier to reshape a Bézier item by adding or deleting Bézier points. To add a point to a line segment, move the cursor over the segment; when the Line Segment pointer appears, Option-click (Macintosh) or Alt-click (Windows) to create a new point. To delete a Bézier point, move the cursor over the point you want to delete; when the Point pointer appears, Option-click (Macintosh) or Alt-click (Windows) to delete the Bézier point.

The Line Segment pointer appears when you move the cursor over a straight or curved line segment. Click on the line and drag to reshape the line segment. Or, Alt/Option-click to add a Bézier point.

EXERCISE D

1. Create a new file without an automatic text box. Display the Colors palette (**F12**). Use the standard-shape Picture Box tool and press the Shift key while drawing to create a square picture box. With the box still selected, choose Item/Shape and drag to select the Bézier icon. Make sure that Shape is checked under the Item/Edit menu.

2. Move the cursor over one of the line segments, where it changes to the Line Segment pointer. Press the Option key (Macintosh) or Alt key (Windows) and click to create another Bézier point. Continue to add points around the square (Figure 9.5).

The crossed black lines disappear and the Grabber Hand appears in a picture box that contains a graphic.

Figure 9.5. When you move the cursor over a line segment on a Bézier box, the Line Segment pointer appears (above). Press the Alt or Option key and the cursor changes to indicate that a new Bézier point will be created on the line segment (below).

3. With the box still selected, click on the Background icon in the Colors palette and click on a color (name or swatch) to fill the box with color. Click on the Bézier points you created and drag them to form a design.

4. To delete a Bézier point, move the cursor over the point and press the Option or Alt key. When the cursor changes to a rectangle with two lines through it, Alt-click (Windows) or Option-click (Macintosh) to delete the anchor point. Continue to add, delete, and move points to reshape the item (Figure 9.6).

5. When you're comfortable with creating and deleting points, or when your design resembles something someone would pay for, close the file (File/Close). Don't save the changes.

Figure 9.6. Adding, deleting, and moving points lets you reshape Bézier boxes.

Moving the cursor over a Bézier point displays a Delete Point cursor. Alt/Option-clicking with this cursor deletes the Bézier point.

CONVERTING BÉZIER POINTS

When drawing Bézier boxes, sometimes adding and deleting Bézier points is not enough to create the box shape you want. It is frequently necessary to reshape a box by changing the points themselves. There are three kinds of Bézier points that affect the way a box is shaped. A *corner point* is used to connect straight lines, a straight and a curved line, or two noncontinuous curved lines. A *smooth point* connects two curved lines to form a continuous curve. The direction handles on a curve point rest on a straight line through the point and can be moved independently. A *symmetrical point* connects two curved lines to form a continuous curve, but its direction handles always remain equidistant from its Bézier point.

You can change a Bézier point by first selecting it and then clicking the icon for the type of Bézier point in the Measurements palette. You can also change a point or line segment by using keyboard shortcuts (Figure 9.7).

	Macintosh Command	Windows Command
Change point or line segment		
Corner point	Option-F1	Ctrl-F1
Smooth point	Option-F2	Ctrl-F2
Symmetrical point	Option-F3	Ctrl-F3
Straight line segment	Option-Shift-F1	Ctrl-Shift-F1
Curved line segment	Option-Shift-F2	Ctrl-Shift-F2
Change in point or curve handles		
Add point	Option-click on line segment	Alt-click on line segment
Delete point	Option-click on point	Alt-click on point
Smooth to corner point (vice-versa)	Control-Shift-drag on curve handle	Ctrl-Shift-drag on curve handle
Retract curve handles	Control-Shift-click on point	Ctrl-Shift-click on point

Figure 9.7. Use these keyboard commands to reshape Bézier boxes.

FREEHAND BÉZIER PICTURE BOX TOOL

The Freehand Bézier Picture box tool works like a pencil. Click and drag to draw a box of any shape with both curved and straight line segments. Unlike a pencil, however, the Freehand Bézier Picture Box tool does not create lines, only boxes. If you release the mouse before closing the box, XPress will close the box for you by connecting the last point you created to the first point that was created.

Freehand Picture Box tool

EXERCISE E

1. Create a new file without an automatic text box. Select the Freehand Bézier Picture Box tool. This tool is used to create closed shapes. Click and drag on the page to draw a fish. Remember, clicking and dragging creates a curve segment. Clicking, releasing the mouse, and moving the cursor before clicking again creates a straight line segment. To end the drawing and close the box, click on top of the first Bézier point. Your aquatic art should resemble Figure 9.8.

Figure 9.8. A design created with the Freehand Bézier Picture Box tool is really a picture box. An EPS file was imported into the "fish" box.

2. Display the Measurements palette (**F9**). Click on any Bézier point in the fish box and notice which point icon is highlighted in the Measurements palette (Figure 9.9).

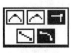

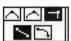
Figure 9.9. Click the Point icons on the Measurements palette to change the shape of a Bézier point. The Straight Line and Curve Line icons appear beneath the Point icons.

3. Click on a different Point icon in the Measurements palette and notice how the shape of the fish changes. To see the name of a selected point, choose Item/Point/Segment Type. The type of the selected point appears with a check mark in the menu.

4. Control-Shift-drag (Macintosh) or Ctrl-Shift-drag (Windows) on a curve point to display its two direction handles. Click on the tip of either direction handle to reshape the curve.

5. With the curve point still selected, click the Symmetrical Point icon in the Measurements palette. Drag one of the direction handles and notice that the handles always rest on a straight line through the point and remain equidistant from the point.

6. Continue to select points, Control-Shift-drag (Macintosh) or Ctrl-Shift-drag (Windows) to display direction handles, and convert points to reshape the fish. When you're satisfied, close the file (File/Close). Don't save your changes.

Corner point

A corner point connects two straight lines, a straight line and a curved line, or two noncontinuous curved lines. When the corner point connects two curved line segments, the corner point's curve handles can be manipulated independently.

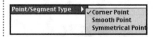

When a Bézier point is selected, you can change the shape of the point from the Item menu.

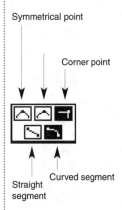

LESSON 2: TEXT TO BOXES

CONVERTING TEXT TO GRAPHICS

Whether you import text into a QuarkXPress text box or type it in directly from the keyboard, you're working with text, not graphics. You can only apply text formatting attributes to the text. For example, to resize text, select it and choose another point size from either the Style menu or the Measurements palette. You can change the type's horizontal or vertical scale and its position on the baseline, but you can't manipulate it as you would an item consisting of Bézier segments unless you first convert the individual text characters to picture boxes.

When a text character is converted to a picture box, it no longer exists as text, but as a Bézier picture box. This means that you can import a picture into the item and manipulate the image just as you would in any picture box created with the picture box tools. And because the picture box has Bézier points and handles, you can reshape the item any way you wish. You can then convert the picture box to a text box by selecting an option from the Item/Content menu. Just remember that once you convert text characters to boxes, you're no longer working with text, so you can't apply any text formatting commands to the Bézier items.

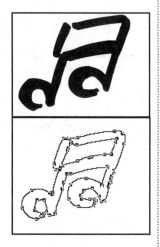

EXERCISE F

1. Create a new document with half-inch margins and an automatic text box. Select the Landscape icon in the Orientation field to create an 11 x 8.5 page. Type *HARD* in the text box, double-click to select it, and format it in any typeface at about 200 points.

2. With the word still selected, choose Style/Text to Box. The four text characters are duplicated as a single picture box below the text (Figure 9.10).

3. Select the Item tool and click on the new box. Move it around the page and notice that all four text characters now form one picture box.

4. With the picture box still selected, choose File/Get Picture (**Command-E**/Macintosh or **Ctrl-E**/Windows). Navigate to the Unit 09 folder in the Student Files folder on the CD-ROM and double-click on the *Stone1.tif* file to open it. The graphic fills almost the whole box.

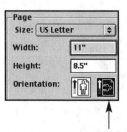

Landscape option in the New Document dialog box

Figure 9.10. The Text to Box command converts the four text characters to a single Bézier picture box.

5. Select the Content tool and use the Picture Mover pointer to drag the image around the box. Position the graphic so that the bottom part of the box is empty. Keep the box selected.

6. Display the Colors palette (**F12**), click on the Background icon, and select a color from the palette. It fills the remaining part of the box.

7. With the box still selected, click on a color swatch in the Colors palette and drag it onto the picture box. The new color replaces the original background color.

8. Choose File/Save and save this file in your Projects folder as *Boxes.qxd*. You'll need it for the next exercise.

SPLITTING BOXES

When you first convert text to a box, all the selected text converts to one picture box. The outline of that picture box follows the contours of the original text, but the box behaves as one item. This means that you can import only one graphic into the box. To import a different graphic into each converted text character, you must split the large picture box into individual picture boxes.

SPLIT OUTSIDE PATHS

The Split Outside Paths command creates single boxes shaped to the outside path specifications of the type. For example, this command splits a text character such as O into one box, not into a box for the outer character and another one for the center of the character.

SPLIT ALL PATHS

The Split All Paths command creates boxes from every shape in a character. If this command is applied to a box converted from the *P* character, two boxes would result—one for the outline of the *P* and one for the interior bowl of the *P*, called the *counter*.

Color options

Once text is converted to a box, it can be filled with a gradient from the Modify dialog box or from the Colors palette.

The original type (top) is converted to a box that is split using Outside Paths (center), which results in only three paths; or split using All Paths (bottom), which results in five paths.

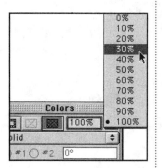

1. If necessary, open the *Boxes.qxd* file you created in the last exercise or open the *Boxes.qxd* file in the Unit 09 folder in the Student Files folder on the CD-ROM. Select the large automatic text box. Display the Colors palette (**F12**), click the Background icon, and click the Cyan color. Drag the Percent menu down to 30. This gives you a soft background color for the box so that when you split the boxes, you'll see exactly what becomes transparent against the cyan background.

2. Use the Item tool to select the large picture box, the single box from the lower HARD, and choose Item/Split/Outside Paths. This creates an individual Bézier box out of each "text character." It also leaves the interiors of the the characters empty or transparent against the page. If you choose All Paths from the Split menu, those interiors would be filled paths.

3. The first box, the H box, is selected. Use the Content tool to drag the graphic around inside the box. Then click with the Content tool on the other three boxes that also contain the entire graphic, and drag the graphic around the box. Where the graphic is moved beyond the boundary of the box, the background color appears. Your screen should resemble Figure 9.11.

Figure 9.11. The four boxes contain four copies of the original graphic that can be moved independently of each other.

4. Use the Item tool to select each box and move it around the page. Because the boxes are each individual picture boxes, they can be moved independently of one another.

5. Close this file (File/Close). Don't save your changes.

Don't move an item until the Item tool icon appears; otherwise you'll reshape the item instead of moving it.

Tip

It's sometimes easier to select a Bézier item with the temporary Item tool than with the Item tool itself. Press the Command key (Macintosh) or Ctrl key (Windows) to convert most tools to the temporary Item tool.

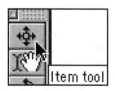

CONVERTING BOXES

Any picture box can be converted to a text box and any text box can be converted to a picture box. You can also specify a box to be neither a picture box nor a text box, just an item from the Item/Content menu. When you convert a box from one type or another, an alert displays, telling you that the contents of the box will be lost if you make the conversion. Be sure you have saved the graphics and/or text before you convert boxes!

FYI

A box with contents of None is called a "contentless" box.

EXERCISE H

1. Open the *Boxes.qxd* file you created earlier or open the *Boxes.qxd* file in the Unit 09 folder in the Student Files folder on the CD-ROM. Select the Item tool and click on the HARD picture box below the text. Choose Item/Split/Outside Paths.

2. Select the Item tool and click on the A. Choose Item/Content/ Text. Picture is currently selected, indicating that this box is a picture box. Click OK at the alert. The graphic is stripped from the picture box, leaving only the background color for the new text box.

3. Click on the Content tool and type a few words in the new text box. Your screen should resemble Figure 9.12.

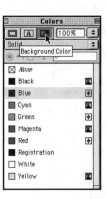

Figure 9.12. When you convert a picture box to a text box, you can type inside the box just as if you had created the box as a multi-sided text box.

4. Click on the H box and choose Item/Content/None. Click OK at the alert. If you choose File/Get Text or File/Get Picture, you'll get a beep, indicating that this box can no longer hold text or display graphics, only a background color.

5. Close this file (File/Close). Don't save your changes.

Click the Background icon on the Colors palette to change the background color of any box. Click on a color's name to apply the color, or drag a color swatch onto the selected box to change its background color.

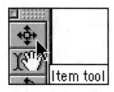
Item tool

Sorry

You can convert only one line of text to a box at one time. To convert more than one line of text, select each line and use the Text to Box command each time.

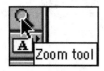
Zoom tool

When you move the cursor over a point on a selected Bézier item, the Point pointer (black square) appears, indicating that you are on or have selected a Bézier point.

RESHAPING BOXES

Once you convert text to Bézier picture boxes, those boxes can be reshaped just as you would any Bézier box, by dragging the anchor points around the box. You can also convert the anchor points, just as you did with Bézier boxes created with any of the Bézier picture box tools.

EXERCISE I

1. Choose File/Open and open the *Boxes.qxd* file in your Projects folder or in the Unit 09 folder in the Student Files folder on the CD-ROM. Display the Measurements palette (View/Show Measurements or **F9**).

2. Use the Item tool to select the large picture box and choose Item/Split/Outside Paths. Select the Item tool and click on the H box to select it. Press the Delete/Backspace key. Delete the R and D boxes also. Use the Content tool to select the word HARD and delete it. This leaves only the A picture box on the page.

3. Use the Zoom tool to magnify the lower part of the A box. Click on the corner point to select it. Press the Shift key while clicking on the opposite corner point to select it also. Release the Shift key and drag the selected points downward to reshape the box (Figure 9.13).

Figure 9.13. The two corner points were Shift-selected and dragged together to reshape both sides of the box.

4. Shift-select the two points at the top of the A (Figure 9.14). Click on the Symmetrical icon in the Measurements palette (the middle icon) to convert the corner points to symmetrical smooth points. Use the direction handles to expand the width of the box (Figure 9.15). Continue to reshape and resize the box until it's large enough to display a graphic.

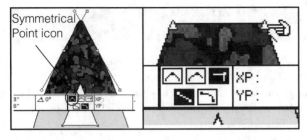

Symmetrical Point icon

Figure 9.14. Shift-selecting the two corner points at the top of the A box, and clicking the Symmetrical icon in the Measurements palette, converts the corner points to smooth points with direction handles equidistant from the selected points.

Figure 9.15. Moving the direction handles instead of the anchor points widens the box.

5. With the box still selected, choose File/Get Picture (**Command-E**/Macintosh or **Ctrl-E**/Windows). Navigate to the Unit 09 folder in the Student Files folder on the CD-ROM and import the *Flower.tif* image into the box. Use the Content tool to move the picture around the box. Press the **Command-Option-Shift < or >** keys (Macintosh) or **Ctrl-Alt-Shift < or >** keys (Windows) to proportionally reduce or enlarge the graphic in the box.

6. Close this file. Don't save your changes.

CONVERTING LINES TO TEXT PATHS

Any conventional line can be converted to a Bézier text path using the commands under the Item menu. Once a line created with either the Orthogonal Line tool or with the Line tool is converted to a Bézier line, the Content (Item/Content) of that line can be changed from None to Text, making the line a text path.

Once a line has been converted to a Bézier text path, the Shape menu can be used to convert it back to a conventional line. Although the conventional line will still display the text, it no longer has Bézier points. Instead, it displays only one resizing handle at each end of the line.

Point/Segment Type

Use this menu under the Item menu to change the type of a selected Bézier point.

Content tool

Gradient lines

To create a gradient line, draw the line and convert to a Bézier shape. Select the Background icon on the Colors palette and select the two gradient colors for the line.

The Bézier Line icon is selected under the Shape menu.

FYI

Select the Bézier line option from the Shape menu to convert a conventional line to a Bézier path.

Shape up

The Shape option must be selected under the Item/Edit menu before you can reshape and convert a line.

The Orthogonal Line icon is selected under the Shape menu.

1. Create a new document (File/New/Document) without an automatic text box. Display the Measurements palette (F9). Use the Orthogonal Line tool to draw a horizontal line about 4 inches long. Choose Style/Width/6 pt. Choose Item/Edit and make sure that Shape is selected.

2. With the line still selected, choose Item/Shape and drag to select the Bézier line icon, the last option in the menu. The line now has Bézier points and can be reshaped. Click on each of the endpoints and reshape the line. Press the Control-Shift keys (Macintosh) or Ctrl-Shift keys (Windows) while clicking on a point to display its direction handles, and use the handles to reshape the line.

3. With the line still selected, choose Item/Content/Text. This converts the Bézier line to a Bézier text path. The I-beam cursor appears at the beginning of the path. Type SMILE! on the path. Double-click on the word and use the Measurements palette to change its font, type size, and alignment. With the word still selected, use the tracking arrows to add space between the characters. Your screen should resemble Figure 9.16.

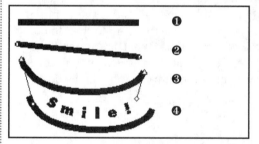

Figure 9.16. The top line (1) was created with the Orthogonal Line tool. It was then converted to a Bézier line (2) and its endpoints were reshaped (3). The Content was changed to Text, making the original conventional line a Bézier text path (3). Text was added and styled using the Baseline Shift command (4).

4. With the path still selected, choose Item/Shape and select the Orthogonal Line icon to convert the Bézier path to a conventional line. Click on the resizing handle at one end of the line and notice that you can no longer reshape the line, only resize it.

5. Close this file. Don't save your changes.

LESSON 3: MERGE AND SPLIT COMMANDS

MERGING AND SPLITTING ITEMS

The Merge and Split commands are advanced graphics techniques that let you create complex geometric shapes from standard-shape and Bézier boxes. The Merge commands affect overlapping boxes and, in some cases, nonoverlapping boxes. The Split commands are used to split a merged box into separate boxes, to split a complex box that contains paths within paths into separate boxes, and to split a box containing a border that crosses over itself, such as a figure eight (8).

The Merge and Split commands are similar to the Pathfinder filters in Adobe Illustrator, and like those filters, let you create entirely new objects from existing items. When working with the Merge and Split commands, keep in mind that items' stacking order affects the way the commands work. When Items are merged, the front and back items (items on top and behind) are merged to create a new item, based on which items are in front and which are in back. Figure 9.17 displays the effects of these commands on two overlapping objects.

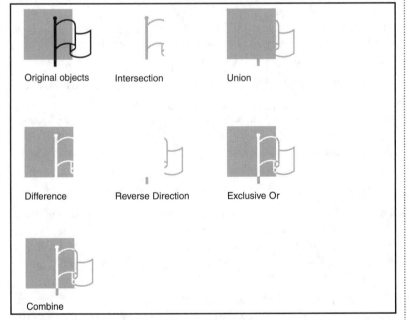

Figure 9.17. The original objects are selected and different Merge commands create different effects. In all cases, the Merge command creates a single object from two or more selected objects.

Merge/Split and layers

To merge and split items, all selected items must be on the same layer.

Sticky tools

Option-click (Macintosh) or Alt-click (Windows) on a tool to keep it selected until you choose another tool.

Moving items forward and backward affect only those items on the selected layer if you have multiple layers in the document.

Can you read the text in the box through the hole created

Use the Exclusive Or Merge command to create a peek-a-boo effect.

STACKING ORDER

When two items overlap, select the backmost item and choose Item/Bring to Front. Or, select the frontmost item and choose Item/Send to Back to change the stacking order. These commands move the selection behind every item or in front of every item.

To move the selection one level at a time, press the Option key to select Send Backward or Send Forward. Windows users have these four commands available from the Item menu.

MERGE COMMANDS

Use these commands under the Item menu to merge two or more selected objects into a single Bézier object.

INTERSECTION MERGE COMMAND

The Intersection command keeps only the overlapping areas of the selected items. If different colors are applied to the items, the resulting intersected item has the color of the backmost item.

UNION MERGE COMMAND

The Union merge combines all of the selected items into one box, keeping *both* the overlapping and nonoverlapping areas. As with the Intersection command, the color of the backmost object is applied to the new single item. Use this command to create an outline shape of all the selected shapes.

DIFFERENCE AND REVERSE DIFFERENCE MERGE COMMANDS

The Difference Merge command **strips the frontmost items** from the selected items and leaves only the overlapping areas, giving you a jigsaw puzzle effect. The Reverse Difference Merge command strips the backmost item from the selected items and leaves only the overlapping areas.

EXCLUSIVE OR AND COMBINE MERGE COMMANDS

The Exclusive Or Merge command leaves all the shapes in their original form, but cuts out any overlapping areas. It also creates two Bézier points at every location where two lines originally crossed. This is the command used to create a "see through" effect with overlapping items.

The Combine Merge command is much like the Exclusive Or command except that no points are added where lines intersected in the original overlap.

1. Insert a new page in the document (Page/Insert) or create a new document. Display the Measurements palette (**F9**) and the Colors palette (**F12**). Use any of the picture box tools to draw a rectangle. Give it a background color of red. Use the standard-shape Oval Picture Box tool to draw a circle. Use the Item tool to drag the circle onto the lower left corner of the square.

2. Drag a selection marquee around both items and choose Item/Duplicate (**Command-D**/Macintosh or **Ctrl-D**/Windows). Use the Item tool to drag the duplicate next to the original .

3. Shift-select the two items in the original group and choose Item/Merge/Exclusive Or. The overlapping area is cut out and makes that area transparent against the white page. Click on a Bézier point where the items overlap and notice that the Corner Point icon is highlighted in the Measurements palette.

4. Shift-select the two smaller boxes in the duplicate group of boxes. Choose Item/Merge/Combine. The overlapping area is cut out, the area is transparent against the page, but no corner points are created where the items overlaps in Figure 9.18. (There must be hundreds of uses for this command!)

Click and drag with the Item tool to draw a selection marquee around multiple items (above). Be careful not to include the automatic text box if there is one. Should you include any item you don't want, press the Shift key once you've drawn the marquee and click on the item you want to deselect (below).

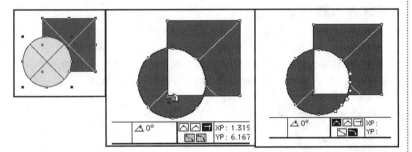

Figure 9.18. When the Merge/Exclusive Or command is applied to two selected overlapping images (left), the original item shape remains, but when it's cut out, it makes the cutout area transparent and creates corner points where the items overlap (center). When the Merge/Combine command is applied, the area is cut out and made transparent against the page, but no corner points are created.

SPLIT COMMANDS

The Split command is used to split merged boxes that contain nonoverlapping shapes, to split boxes that contain shapes within shapes, or to split boxes containing a border that crosses over itself such as a figure eight.

SPLIT OUTSIDE PATHS

The Outside Paths option from the Split command splits a box that consists of two or more closed paths that are separated by a space. If, for example, you use the Bézier Freehand tool to draw a bow that consists of an inside (blank area) and outside (ribbon area), when you select that item and apply the Split/Outside Paths command, the result is two separate boxes. The interior or blank area of each side of the bow is not split into separate boxes (Figure 9.19).

Figure 9.19. When the bow (top) was split using the Outside Paths command, only two new boxes were created, one for each side of the bow.

SPLIT ALL PATHS

The Split All Paths command splits all the closed paths in the selected item and creates separate boxes for those closed paths. This command works for Bézier boxes shaped like a donut. The Split All Paths command will create four boxes, two for the outside shape and two for the holes (Figure 9.20).

Figure 9.20. When the bow (top) was split using the All Paths command, four separate boxes were created, two for the black ribbon areas of the bow and two for the gray, inner, blank areas of the bow.

SCISSORS TOOL

Click with the Scissors tool on any path to split the path. You can click on a Bézier point, on a Bézier path, on a text path, or on any part of a standard-shape box or line to split it. Clicking on a standard-shape path with the Scissors tool converts the path to a Bézier path.

Click on any path with the Scissors tool to split it at that point.

Scissors tool

EXERCISE L

1. Create a large text box. Type *Go, Going, Gone!* Press Return/Enter. Format the type in a bold typeface and large type size. Make sure all the type is on the same line.

2. Select the type and choose Edit/Copy (**Command-C**/Macintosh or **Ctrl-C**/Windows) to copy the selection to the Clipboard. Click below that line of type and choose Edit/Paste (**Command-V**/Macintosh or **Ctrl-V**/Windows) to create a second line of type.

3. Select the first line of type with the Content tool and choose Style/Text to Box to convert the text characters to a single Bézier box. With the Bézier box selected, select a background color from the Colors palette. Then choose Item/Split/Outside Paths. Notice that the interior of the box "characters" are transparent because the whole "character" is one path.

4. Select the second line of type and choose Style/Text to Box. Fill the Bézier box with a background color. With the box still selected, choose Item/Split All Paths. Click on the center of the *o* in Gone and choose a contrasting background color from the Colors palette. Because the center of the box is a separate path, it can be manipulated separately from the rest of the "character" and different colors can be applied to the separate paths. You can also delete unwanted paths (Figure 9.21).

5. Close this file (File/Close) Don't save your changes.

When Split/Outside Paths is selected, no interior paths are created. Framing the boxes creates a frame around the entire box outline.

Figure 9.21. When the Split All Paths command is applied to Bézier boxes, any interior paths are also split and can be manipulated separately from the other boxes. When a frame is applied to the selected outlines, the interior paths are not framed.

For this project you'll create a credit card a bank would distribute.

1. Create a round-cornered picture box about 3.5" x 2.25". Import the *Rock.tif* graphic into the box. It's located in the Unit 09 folder in the Student Files folder on the CD-ROM.

2. Draw a text box over the picture box, and type ROCK. Format it in bold type at about 48 points.

3. Select the type, and choose Style/Text to Box. With all the "characters" selected, import the *Rock.tif* image into the single box of "characters."

4. Duplicate the "characters." Select the Content tool, click on the Bézier box, and delete the picture. Fill the "text" with a black background (Figure 9.22). You may want to outline the "text" filled with the graphic to make it stand out. Try a .25 white frame (Item/Frame).

5. Use the Item tool to drag the picture "characters" over the black "characters" so that the black "characters" act as a drop shadow (Figure 9.23). You may have to select the black "characters" and send them to the back. Use the Item tool to select both the black and picture "text characters" and group them. Position them on the picture background.

Figure 9.23. The "text" filled with the graphic is outlined and moved on top of the black "characters" to create a shadow effect. The two boxes were then selected and grouped.

6. Type *HARD* in a transparent (Background of None) text box. Format it as you did ROCK. Drag the text box next to the ROCK group and position it.

7. Type *Bank* in a text box and format it in the same bold type but at a smaller size. Make the box transparent by giving it a background color of None. Also apply a None Runaround to the box (Item/Runaround). Select the text and increase the horizontal scale. Move the box under the HARD box.

8. Select the Bank text box and use the top center resizing handle to make the box larger, thus moving the text up as close as possible to the HARD text (Figure 9.24).

ROCK ❶
ROCK ❷
ROCK ❸

Figure 9.22. The Helvetica text (1) was selected and converted to a single picture box into which a picture was imported (2). That ROCK picture box was duplicated, the image deleted, and the box filled with a black background (3).

Figure 9.24. *Bank* is formatted in white with a horizontal scale value of 200%. The text box is transparent with a runaround of None so that it can be positioned directly below HARD without overwriting the Hard text box (left). The top of the Bank text box is raised, moving the text closer to the Hard text (right).

9. Draw a text box under the other boxes and type an account number. Select the text, track it out, and apply a white color to the text. Select the text and choose Style/Text to Box. With the single Bézier box selected, choose Item/Frame (**Command-B**/ Macintosh or **Ctrl-B**/Windows) and apply a .5-point frame for emphasis (Figure 9.25). Delete the text and its box, and use the Item tool to move the number box up on the page.

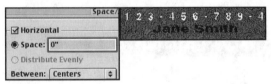

Figure 9.25. Use the Space/Align command to align the numbers (now boxes) and name.

10. Create another transparent text box below the numbers for the name. Format the text in bold type and apply horizontal and vertical scaling for emphasis. With the Item tool selected, select the "numbers" and the name box. Choose Item/Space Align and click the Horizontal check box. Choose Centers from the Between menu to align the numbers and name along the center axis (Figure 9.25).

11. Draw text boxes for validation and expiration dates. Shift-select the Valid From and Good Thru boxes and choose Item/Space Align. Select the Vertical check box and Top Edges from the Between menu to align the two boxes on the same Y axis. Repeat for the two transparent date boxes. When the four boxes are properly positioned, Shift-select and group them (**Command-G**/Macintosh or **Ctrl-G**/Windows). Then move them to center the group on the card. Your screen should resemble Figure 9.26.

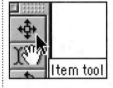

Figure 9.26. The completed bank card displays characters converted to boxes with frames.

REVIEW PROJECT 2

Import a graphic into a picture box and create text on top of the graphic. Make the text box transparent against the image with a background of None. Convert the text to a single box, then apply the Split Outside Paths command to create individual boxes. Move the boxes around to create an interesting effect on the graphic, as seen in Figure 9.27.

Figure 9.27. The text was converted to boxes and moved over the goldfish's eye.

Unit 10
Line & Frame Items

OVERVIEW
In this unit you will learn about:
Types of lines
Freehand lines
Bézier lines
Measuring lines
Reshaping and converting lines
Framing boxes
Creating dashes and stripes
Text on paths
The Text Path Modify Dialog box

TERMS
Bézier line
Bézier text path
dash
Endpoints mode
frame
Left Point
Midpoint
Right Point
stripe
text path

LESSON 1: WORKING WITH LINES

TYPES OF LINES

There are four kinds of lines in QuarkXPress 5.0 and four different tools used to create them (Figure 10.1). Use the Line tool to draw straight lines at any angle; the Freehand Line tool to draw freehand lines with curved segments connected by Bézier points; the Bézier Line tool to draw lines with both straight and curve segments between Bézier points; and the Orthogonal Line tool for drawing only horizontal and vertical lines.

Drag the Line Tool out to select the Bézier Line tool, Orthogonal Line tool, or Freehand Line tool.

Figure 10.1. The Line tool, Freehand Line tool, Bézier Line tool, and Orthogonal Line tool in the Tool palette

Although the Tool palette defaults to displaying only the Line tool, you can display the other three tools in the Tool palette by pressing the Control key (Macintosh) or Ctrl key (Windows) before clicking on the Line tool's triangle and dragging to select another tool. To remove a tool from the Tool palette, Control-click (Macintosh) or Ctrl- click (Windows) on the tool. At least one tool from a tool's pop-out menu must appear on the Tool palette.

EXERCISE A

1. Create a new, single-column document with 1-inch margins and without an automatic text box. Display the Measurements palette (**F9**) and the Colors palette (**F12**). Click on the Line tool to select it. Click and drag on the page to draw a line at any angle. Release the mouse button.

2. Select the Line tool again and drag to draw another line. Before releasing the mouse button, press the Shift key to constrain that line to a 45° angle.

3. Click on the Orthogonal Line tool to select it. Drag to draw a horizontal line. Select the Orthogonal Line tool again and drag to draw a vertical line. You can't draw a diagonal line with the Orthogonal Line tool.

4. With the vertical line selected, use the Measurements palette to select 12 for the width of the line, Dotted for the style, and a left-pointing arrowhead for the top of the line (Figure 10.2). Click on the selection point at either end of the line and drag to lengthen or shorten the line.

Figure 10.2. The W pull-down menu in the Measurements palette is used to select a point size, the left menu to select a line style, and the right menu to select an arrowhead style for a selected line.

5. In the Colors palette, with the Line icon selected, click on a color to change the color of the selected line.

FREEHAND LINES

The Freehand Line tool differs from the Freehand Bézier box tools in that it creates an open path called a *line*, not a closed path called a *box*. You can draw with this tool just as you would with a pencil and then adjust the Bézier points to refine the drawing. Just as with straight and diagonal lines, color, width, styles, and arrowheads can be applied.

Freehand Line tool

EXERCISE B

1. In the same file or in a new document, click on the triangle in the Line tool and drag to display and select the Freehand Line tool. Press the Option key (Macintosh) or Alt key (Windows) while selecting the Freehand Line tool to keep it selected.

2. Use the Freehand Line tool to click and drag a few times on the page to create a line drawing or to write your name. When you have finished, the Bézier points will appear on the line(s). Click and drag the points to reshape the item. Click on a single point and click on one of the Point icons in the Measurements palette to change the point's type (Figure 10.3).

3. Close this file or go on to the next exercise.

Click on the triangle on the Line tool and then Control-click (Mac OS) or Ctrl-click (Windows) on any of the other two line tools to add it to the Tool palette.

The Bézier Line tool draws both straight and curved lines.

Figure 10.3. An item drawn with the Freehand Line tool displays Bézier points that can be manipulated to change the shape of the item. This drawing contains 10 separate lines.

Join Endpoints

This option under the Merge commands is available only when two lines or text paths are selected. The endpoint from one selected line must overlap an endpoint from the other selected line. Drag a selection marquee around the two overlapping points to select them and choose Join Endpoints from the Item/Merge menu. This command creates a single Bézier corner point that replaces the two overlapping endpoints.

BÉZIER LINES

Unlike the Freehand Line tool, which allows you to draw only curved segments, the Bézier Line tool lets you draw both curved and straight segments. You can also manipulate the Bézier lines just as you can lines created with the Freehand Line tool.

Unlike the Pen tool in Adobe Illustrator and Adobe Photoshop, lines drawn with the Bézier Line tool can't be connected. In other words, once you complete a line by deselecting the Bézier Line tool, you can't continue to draw that line. You can, of course, drag one line up to another line so that their endpoints are close to one another. Then choose Item/Merge/Join Endpoints to connect the two endpoints.

To deselect the Bézier Line tool, click on another tool in the Tool palette. You can then select the Bézier Line tool again and draw a new line, unconnected to any previously drawn line.

EXERCISE C

1. Click and drag on the Line tool to display and highlight the Bézier Line tool. Click *and* drag (without releasing the mouse button) on the page to set the first anchor point, then click away from that point to create the first curve connected to that point. Release the mouse button. Move the cursor away from the curve, press the Shift key, and click to create a straight line connected to the curve segment. Continue to draw a single line with the Bézier Line tool. When you have finished, click on any other tool in the Tool palette to deselect the Bézier Line tool.

2. When you have created Great Art (Figure 10.4), use the Item tool or temporary Item tool (press the Command or Ctrl key to turn the current cursor into the temporary Item tool) to select individual lines and apply color from the Colors palette and different line weights and line styles from the Measurements palette.

3. Close this file or go on to the next exercise.

The Symmetrical, Smooth, and Corner Point icons in the Measurements palette. Notice that the Line Segment icons are dimmed because both straight and curve line segments are selected.

Figure 10.4. This drawing is comprised of different lines created with the Bézier Line tool. Because many of the line segments are not connected, you have to deselect the Bézier Line tool and then reselect it before drawing another line.

MEASURING LINES

When you draw a line with either the Line tool or Orthogonal Line tool, the tip of the line that starts the line is called the Left Point. The tip of the line that ends the line is called the Right Point. The Left Point and Right Point options under the Mode menu in the Measurements palette let you mathematically position the line and adjust its length from these two points. For example, if you select the Left Point option and type 4 in the Measurements palette, the line will become 4 inches long, expanding or contracting from the tip that begins the line—assuming you have selected inches as the unit of measure. If the line is, for example, 4 inches long and any option except Endpoints is selected in the Measurements palette, typing +2 next to the L value in the Measurements palette will lengthen the line to 6 inches. Likewise, -2, *2, and /2 will subtract, multiply, and divide the length of the line.

| Endpoints |
| ✓ Left Point |
| Midpoint |
| Right Point |

Use the Mode menu in the Measurements palette to select a point of measure for a selected line.

EXERCISE D

1. Choose Edit/Preferences/Preferences and click Measurements to set the unit of measure to inches. Click OK. Display the Measurements palette (**F9**). Use the Orthogonal Line tool to draw a horizontal line, and keep it selected. Choose Left Point from the Mode pull-down menu in the Measurements palette.

2. The Measurements palette displays the X1 and Y1 values for the first (left) point on the line. The X value is the point's distance from the horizontal (left) margin and the Y1 value is the point's distance from the vertical (top) margin. Type 0 in the X1 field, press the Tab key, and type 2 in the Y1 field. Press Return/Enter. The line moves to the left margin (X1=0) and two inches down from the top margin (Y1=2).

FYI

To keep a tool selected until you choose another tool, press the Option key (Macintosh) or Alt key (Windows) when selecting the tool.

3. Double-click the L(ength) value in the Measurements palette and type 5. Press Return/Enter to make the line 5 inches long . Use the W(idth) menu on the Measurements palette to increase the line width to 6 points (Figure 10.5).

Figure 10.5. The line is positioned directly on the left margin (X1) and two inches down from the top margin (Y1).

FYI

The L(ength) value is not available in Endpoints mode.

4. With the line still selected, choose Item/Modify. In the Line Modify dialog box, use the pull-down menus to select the values displayed in Figure 10.6. Click on Apply to see your changes. Click OK. The line becomes a vertical line with arrowheads at each end.

FYI

You can select all the line options from the Line Modify dialog box. Otherwise, you have to make some selections from the Measurements palette and others from the Style menu. When a line is selected, all the options under the Style menu apply to that line.

Figure 10.6. The Line Modify dialog box is where you specify line weight, length, position, and color.

5. With the line still selected, type /2 in the Y1 field to divide the current vertical position by 2. Click next to 5″ in the L field and type +2 in the L field to add 2 inches to the current length (Figure 10.7). Press Return/Enter to move the line up to the one-inch mark on the ruler (2÷2=1) and increase its length to 7 inches (5+2=7).

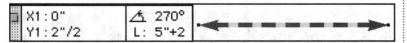

Figure 10.7. Use the division sign (/) to change the line's vertical position and the plus sign to change its length.

6. Use the Mode menu to select Endpoints. The Measurements palette now displays X2 and Y2 values for the line. The X1 and Y1 values still indicate the horizontal and vertical position of the first point. The X2 and Y2 fields indicate the horizontal and vertical position of the last point. Choose Item/Modify and notice that the values in the Measurements palette correspond to the values in the dialog box (Figure 10.8). Click Cancel.

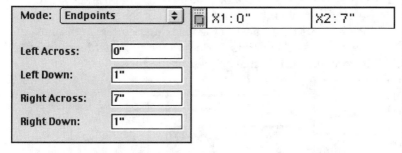

Figure 10.8. The Left Across field in the Line Modify dialog box corresponds to the X1 value in the Measurements palette, Left Down to the Y1 value, Right Across to the X2 value, and Right Down to the Y2 value.

7. Choose Midpoint from the Mode menu in the Measurements palette and notice that the XC—C for center)—value becomes 3.5 because the center of a line that ends at the 7-inch mark is 3.5. The YC—C for center—value remains at 1 inch because the center of the line is 1 inch down from the top margin.

8. Select different modes and make changes in the Measurements palette to see how the right and left points move depending on the values applied to them.

9. Close this file (File/Close) or continue to the next lesson. Don't save your changes.

FYI

Any line can be rotated, regardless of its line mode. However, the Rotate icon in the Measurements palette and the Angle field in the Line Modify dialog box are not available if the line mode is Endpoints.

RESHAPING AND CONVERTING LINES

You can reshape any line using the Shape command from the Item menu, as well as by manipulating anchor points and curve handles on Bézier lines. You can also convert any line into a Bézier box and then define the box contents as picture, text, or none.

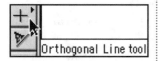

The Orthogonal Line tool

The Freehand shape at the bottom of the Shape menu changes a standard-shape line to a Bézier line.

EXERCISE E

1. Create a new document (File/New/Document) or use the Document Layout palette to add a new page in the document. Use the Orthogonal Line tool to draw a vertical line. Choose Left Point from the Mode menu on the Measurements palette and type 5 in the L field. If you're using inches as the unit of measure, the line will measure 5 inches. If you're using picas as the unit of measure, type 5p to create a line that is 5 picas long. Pull down the Style menu and select 12 points from the Width menu. Select a color and style from the Style menu.

2. With the line still selected, choose Item/Shape and drag to select the freehand line at the bottom of the Shape menu. The line appears the same, but the Resizing pointers at the ends of the line have changed to Bézier points, and the Measurements palette reflects this change (Figure 10.9).

Orthogonal line values

Bézier line values

Figure 10.9. Reshaping the orthogonal line to a freehand line changes the endpoints of the line to Bézier points and measures it in terms of its angle, not its length.

3. Click on any point with either the Item tool or the Content tool and drag to reshape the line. Click on a point and press the Control and Shift keys (Macintosh) or Alt and Shift keys (Windows) to display the point's direction handles. Use these handles to reshape the line (Figure 10.10).

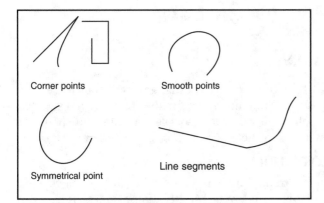

Corner points

Smooth points

Symmetrical point

Line segments

Figure 10.10. Change points and move line segments to reshape a Bézier line.

4. With the line still selected, choose Item/Shape and select the first box icon in the Shape menu. The line becomes a box with the background color of the original line and contents of None.

5. Choose Item/Content/Text and the box becomes a text box with the blinking cursor, indicating that you can now type inside the box.

6. Close this file or go on to the next lesson.

LESSON 2: DRAWING FRAMES

FRAMING BOXES

A *frame* is a stylized border placed around any box. You can select a frame style, width, color, and shade for the frame. If the selected frame is not a solid line, you can also select a color and shade for the gaps, the white areas between the dots or dashes of the frame.

FRAME SPECIFICATIONS

When you select a framed item and choose Item/Modify, clicking the Frame tab displays the Frame Modify dialog box. Here you can select all the specifications for the frame: its width, color, shade, and a gap color if the frame has spaces between the dashes. Choosing the Frame command (Item/Frame) brings up this dialog box automatically.

No frame will display unless a Width value is applied. The Frame Modify dialog box defaults to a frame width of 0, so be sure to select a width from the Width pull-down menu or type a value in the Width field. Many of the frame designs won't display properly if the width is too narrow.

Use the General Preferences dialog box (**Command-Y**/Macintosh) or **Ctrl-Y**/Windows) to specify whether frames will appear (and print) inside or outside of the box. The default is Inside.

FRAME LOCATION

You can position a frame inside or outside of the box. If you position the frame inside the box, it will take space from the box and may intrude on the text or picture in the box. However, it won't intrude on the area outside of the box. If you choose to frame inside a box (the default option) and you find the frame too intrusive, use the text inset value to move the text away from the frame.

EXERCISE F

1. Select the Rectangle Picture Box tool and press the Shift key while drawing a picture box about 4 inches square.

2. With the box still selected, choose Item/Frame (**Command-B**/Macintosh or **Ctrl-B**/Windows) and apply the values displayed in Figure 10.11. Because the selected line style isn't a solid line, you can select a color and shade for the gap. Click OK.

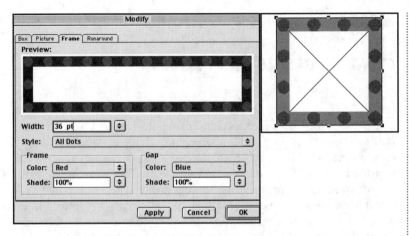

Figure 10.11. Use the Frame Modify dialog box to apply a frame around a box.

3. Click on any of the resizing handles and drag to resize the box. The frame adjusts to the new size.

4. Choose Item/Shape and select the Orthogonal Line shape. The box is converted to an orthogonal line with the characteristics of the selected frame.

5. Choose Item/Shape and select a box shape. The frame disappears and the box contains the background color of the line. The gap color also disappears.

6. Close this file (**Command-W**/Macintosh or **Ctrl-F4**/Windows). Don't save your changes.

Orthogonal Line shape

CREATING DASHES AND STRIPES

Dashes are dotted or broken-line patterns; *stripes* are solid line patterns. The Dashes & Stripes dialog box is where you create custom line styles that can be applied as frames to boxes, lines, and text paths. Dashes are broken lines, separated by a gap. Stripes are banded line styles. If you create dashes and stripes when no documents are open, those dashes and stripes will appear in the Style menu for selected lines and text paths and in the Frame menu for selected boxes. Otherwise, any dashes and stripes you create in an active document will appear only in the style menus for that document. As with style sheets, you can use the Append command to append dashes and stripes from any saved document to the active document.

Once you create and save a dash or stripe style, you can edit it at a later time and every item to which that dash or stripe was applied will reflect the edited style.

DASHES

Dashes are frame styles that incorporate dashed lines and gaps between those lines. You can use the horizontal ruler in the Edit Dash dialog box to specify the position and shape of the dash as well as the distance (gap) between one dash and another. Both the dash and its gap can be colored from the Frame dialog box.

EXERCISE G

1. In any document, choose Edit/Dashes and Stripes to display the Dashes & Stripes dialog box.

2. Choose Dashes & Stripes In Use from the Show menu to display only those dashes and stripes used in the current document. Use the Show menu to select All Dashes & Stripes.

3. Use the New pull-down menu to select Dash and display the Edit Dash dialog box. Type My Dash in the Name field. The ruler area is where you create the gaps between the dashes. When you click in the ruler area, an arrow is displayed. The arrow indicates the dash part of the line. Click on the 25%, 50%, 75%, and 100% tick marks to create the dash design (Figure 10.12).

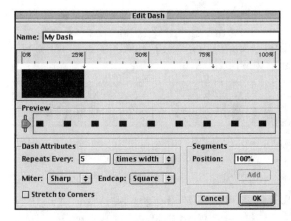

Figure 10.12. Clicking on the ruler creates a dash at that point. The Preview area below the ruler displays the current dash design.

Repeats Every

The default setting, times width, makes the dash pattern repeat in increments of the line's width. A wide line with long segments and a small number in this field results in finer dash elements.

4. Click on each arrow and drag it two ticks to the left. Notice how the preview area below the ruler reflects the change in the dash (Figure 10.13).

Figure 10.13. Drag the arrows to the right or left to change the dash design.

FYI

The dashes and stripes that appear in the Preview window of the dialog boxes are just previews. You must adjust the values and options in the dialog box to change the dash or stripe.

5. Drag the slider in the Preview area up and down to view the dash at wide and narrow widths (Figure 10.14).

Figure 10.14. Drag the slider in the Preview area to view the dash at different widths.

6. Use the Dash Attributes area to specify how the dashed line style will appear when applied to a line, text path, or box frame. The value in the Repeats Every field (Figure 10.15) specifies whether the length of the dash's repeating pattern will be proportional to the width of the line or frame it is used with, or

whether it is an absolute value. Type 2 in the Repeats Every field and make sure that "times width" is selected from the pop-up menu. This creates a line that is twice as long as the width of the frame to which it will be applied.

Figure 10.15. A value of 5 in the Repeats Every field, when "times width" is selected, creates a line that is twice as long as the width of the box or line frame to which it will be applied.

7. Type 20 in the Repeats Every field and choose Points from the pop-up menu to create a dash that measures the repeating pattern in points (Figure 10.16). Click on OK. Click Save.

Figure 10.16. Choosing Points from the pop-up menu in the Dash Attributes area creates a dash based on an absolute value instead of on a proportional value.

8. Draw any kind of box on the page. With the box selected, choose Item/Frame (**Command-B**/Macintosh or **Ctrl-B**/Windows). Choose My Dash from the Style pull-down menu. Assign it a width of 12 points. In the Frame field, choose a color and shade. In the Gap field, choose a color and shade for the white areas between the lines of the dash (Figure 10.17). Click OK to apply the new frame.

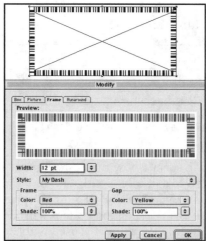

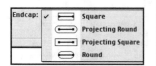

The Endcap field in the Edit Dash dialog box displays options for butt cap, round cap, or projecting square cap.

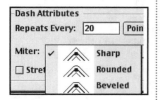

The Miter field displays icons for sharp-corner, rounded-corner, and beveled-corner attributes for dashes.

Figure 10.17. Once you create a new dash, it's automatically added to the Style menu in the Frame dialog box.

STRIPES

Stripes are solid frames applied to lines and boxes. Like dashes, the area between the stripes is called the *gap* and can be colored just as the stripe can be colored. By moving the arrows on the vertical ruler, you can adjust the number and width of the stripes.

EXERCISE H

1. In a new document or on a new page, choose Edit/Dashes & Stripes. Use the New menu to select Stripe. In the Edit Stripe dialog box, type My Stripe in the Name field. Type 20 in the Position field and click Add. Type 40 in the Position field, and click on Add. Type 60 in the Position field and click Add. Type 80 in the Position field and click Add to create the third stripe.

2. Drag the bottom arrow up and the top arrow down to create two thick stripes and one narrower stripe (Figure 10.18). Click OK. Click Save.

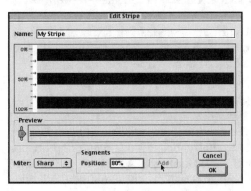

Figure 10.18. Use the arrows on the vertical ruler to adjust the number and width of the stripes.

3. Draw any kind of line on the page. Display the Measurements palette (View/Show Measurements or **F9**) and use the Style pull-down menu to select My Stripe. Use the W pull-down menu to select 12. The stripe is applied to the line.

4. With the line still selected, choose Edit/Dashes & Stripes. Choose Stripes from the Show menu and double-click on My Stripe. Move the arrows on the upper and lower stripes so that the lines are thinner than the middle stripe. Click OK. Click Save. The new stripe is automatically applied to the line.

Very important info!

You must have a line or box selected before you can apply a dash or stripe from the Frame dialog box. And don't forget to assign the dash or stripe a width from the Width field. The Width field in the Frame dialog box defaults to 0 points for the width, and unless you assign a width greater than 0, you won't be able to see the frame—because it isn't there!

A dash (top) is a series of broken line patterns and/or dots. A stripe (bottom) is a pattern made up of straight lines.

5. Draw a box anywhere on the page. Choose Item/Frame (**Command-B**/Macintosh or **Ctrl-B**/Frame). Use the Style menu to select My Stripe. Assign it a color from the Frame field, a 24-point width from the Width menu, and a color from the Gap field. Click on OK. The box is framed with the My Stripe pattern.

6. Choose Edit/Dashes & Stripes. Choose Stripes from the Show menu and double-click on My Stripe. Click on the vertical ruler to add lines to the stripe and move them to make them thicker or thinner. Click OK. Click Save. The new stripe replaces the original My Stripe on any line or box to which the original stripe was applied.

7. Close this file. Don't save your changes.

DELETING DASHES AND STRIPES

To delete a dash or stripe style, use the Edit Dashes & Stripes dialog box to select the dash or stripe. Click on the Delete button. If you have used that dash or stripe in the document, you will have the opportunity to replace it with another dash or stripe. Make your selection, click OK, and click on Save to delete an unused dash or stripe or to replace the deleted dash or stripe.

DUPLICATING DASHES AND STRIPES

Sometimes it's easier to create a new dash or stripe from an existing one than from scratch. To do this, choose Edit/Dashes and Stripes, select a dash or stripe, and click Duplicate. A copy of the selected dash or stripe appears in the Edit (Dash or Stripe) window, allowing you to give it a new name and to change any of its specifications.

LESSON 4: TEXT PATHS

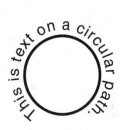

TEXT ON A PATH

Ordinarily, text sits on a stationary baseline unless you manually move it up and down using the Baseline Shift command. The only "path" for the text is the baseline; in fact, the term *path* is never used in conjunction with text unless that text is created in an illustration program such as Adobe Illustrator or Macromedia Free-Hand. In QuarkXPress, however, there are four tools for creating text on straight, slanted, Bézier, and freehand paths (Figure 10.19). Once the path is drawn, the I-beam cursor appears on the path, and you can type and format text as well as edit both the text and its path. Text on a path is "real" text, that is, you can apply all of QuarkXPress's typographic functions to it.

To create text around a circle, do the following:
1. Draw the circle.
2. Choose Item/Shape and drag to select the Freehand shape, the last shape.
3. Choose Item/Content/Text. Type around the circle and use the Baseline Shift command to move the text above the circle.

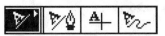

Figure 10.19. The four text-path tools in QuarkXPress 5.0 are the Line Text-Path tool, Orthogonal Text-Path tool, Bézier Text-Path tool, and Freehand Text-Path tool.

THE LINE TEXT-PATH TOOL

The Line Text-Path tool is used to create text on a straight or diagonal line. To edit all of the text, quadruple-click on the text with the Content tool to select all of the text, even the text that might not appear because the path is too short. As with text in a text box, if there is more type than will fit on the path, the Overflow Indicator appears at the end of the line, telling you that the path isn't long enough to contain the text.

Any *text* you select can be formatted from the Style menu or from the Measurements palette. The text *path* can be modified when the path is selected with either the Item tool or the Content tool. And because it is an item, a text path can have runaround and be grouped with other items.

EDITING LINE TEXT PATHS

To edit a path created with the Line tool, first select the path with either the Item tool or the Content tool. Then choose Item/Modify to display the Line specifications dialog box and make your selections.

When a text path is selected, you can apply all the line attributes from the Line Modify dialog box to the path.

FYI

If you apply a color of None to the path (line), the text path will not appear.

The Line Text-Path tool creates text on a straight or diagonal line.

1. Create a new document without an automatic text box. Choose the Line Text-Path tool from the Tool palette and draw a diagonal line about 4 inches long on the page.

2. Type *This is text on a diagonal line.* Quadruple-click to select all the text and format it in a large point size and in a different type. The Overflow Indicator should appear at the end of the path (line) (Figure 10.20).

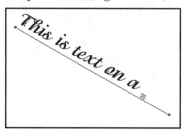

Figure 10.20. Because the text extends beyond the path, the Overflow Indicator appears.

Use the Item tool to select a text *path*.

3. With the cursor anywhere on the text, click at one end of the path and drag to lengthen the path so that the type will fit on the line (Figure 10.21). The path is still selected, so choose Item/Modify (**Command-M**/Macintosh or **Ctrl-M**/Windows) to display the Line Modify dialog box.

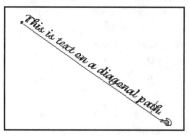

Figure 10.21. Click on the path to select it, then drag the path to lengthen it so that the type fits on the path.

4. Change the width, style, and color of the line. If you choose other than a solid line, you can also assign a gap color. Add arrowheads, and click OK to display the newly formatted path (line).

5. Select the Item tool and click on the path. Once the cursor turns into the Mover pointer, move the path up and down on the page.

6. Close this file (File/Close). Don't save your changes.

THE ORTHOGONAL TEXT-PATH TOOL

Unlike the Line Text-Path tool, which draws lines (paths) in any direction, the Orthogonal Text-Path tool draws only horizontal or vertical lines (paths). Text created on an orthogonal line is edited by selecting it and choosing options from the Style menu. To edit a path created with the Orthogonal Line tool, first select the path with either the Item tool or the Content tool. Then choose Item/Modify and make your selections in the Line Modify dialog box. Click on the Text Path tab and make further modifications in the Text Path Modify dialog box.

EXERCISE J

1. Create a new document. Display the Measurements palette (**F9**). Select the Orthogonal Text-Path tool and draw a horizontal line on the page. Once you finish drawing the line, the Content tool is automatically selected. To format the text path itself, select the Item tool and click on the text path to select it. Use the Line Style menu on the Measurements palette or the Line Modify dialog box to format the path in 2-point black. Select the Content tool. When the I-beam cursor appears, type *horizontal line*. Click on the Center Align icon on the Measurements palette to center the text on the line. Choose Edit/Select All to select both words and format them to fit on the path.

2. Select the Orthogonal Text-Path tool again and draw a vertical line intersecting the horizontal line. Select the path with the Item tool and format it in 2-point black. Select the Content tool and click the Center Align icon in the Measurements palette. Type *vertical line* on the path. Choose Edit/Select All and format the type as you did on the horizontal line.

3. Select the Item tool and move the vertical line to the right of the horizontal line. Your screen should resemble Figure 10.22.

4. Close this file or keep it open to use in the next exercise. Don't save your changes.

Figure 10.22. Horizontal and vertical text appear on separate paths.

THE BÉZIER TEXT-PATH TOOL

The Bézier Text-Path tool in XPress works just as it does in any PostScript illustration program. Click to create the first anchor point and release the mouse. Click someplace else and release the mouse to create a straight or diagonal line. You can also click and drag before releasing the mouse button to create a curved path. To end the path, double-click the last anchor point before releasing the mouse button, or click on another tool in the Tool palette.

EDITING BÉZIER TEXT PATHS

To edit the path, select it with either the Item tool or the Content tool, click on one of the anchor points, and drag to reshape the path. Anchor points that are diamond shaped indicate a curve point; triangle points indicate a corner point where the two segments meet at right angles to the triangular anchor point.

EXERCISE K

1. Use the Item tool to select and delete everything on the page, or add a new page to the active document. Select the Bézier Text-Path tool and click once on the page to set the first point. Click about 2 inches away from that first point to set the first straight line segment. Because you clicked and didn't drag, you're creating straight line segments. Click below that first segment to set the second segment. Continue clicking until you have five segments. Click on another tool to end the path.

2. Select the Content tool, click on the path, and type a sentence. As you type, the text follows the straight lines of the path. Click on any point and drag the segment to reshape the path. Notice how the text follows the new shape (Figure 10.23).

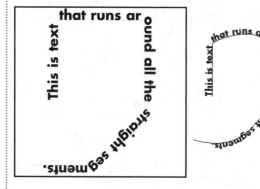

Figure 10.23. Dragging an anchor point or changing a Bézier point from square to smooth reshapes the path and reflows the text along the new path.

3. Select the Item tool and drag a selection marquee around the entire path to select it. Click on the text path; when the Move cursor appears, drag the path around the page to reposition it. Clicking on the text instead of on the path prevents you from selecting an anchor point and reshaping the path as you move it.

4. Select the Bézier Text-Path tool again, but this time, instead of clicking and releasing the mouse button, click *and drag* upward until a 1-inch handle appears. Then release the mouse button. What you see are two direction handles connected to the Bézier point between them. That diamond-shaped anchor point is a smooth point, indicating that the segment connected to it will be a curve. Move the mouse about one inch to the right of that anchor point and click to set the curve (Figure 10.24).

Bézier Text-Path tool

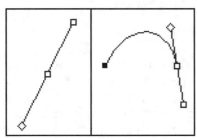

Figure 10.24. Clicking and dragging sets the direction of the curve. Clicking away from that anchor point creates the curve itself.

The Center Align option is selected on the Measurements palette.

5. Click any other tool in the Tool palette to complete the path. This deselects the anchor points on the path but leaves the path itself selected. Choose Item/Modify (**Command-M**/Macintosh or **Ctrl-M**/Windows) to display the Line Modify dialog box. Select 1 from the Width pull-down menu and Black from the Color pull-down menu. Click on OK. The path remains selected.

6. Click on the Content tool. Type a few words on the path and notice how they follow the direction of the curve. Choose Edit/Select All (**Command-A**/Macintosh or **Ctrl-A**/Windows) and format the text. Click the Center Align icon in the Measurements palette to center the text on the path. Your screen should resemble Figure 10.25.

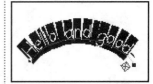

When selecting all the text on any text-path, don't drag to select. Quadruple-click or use the Select All command to ensure that you've selected all the text, even text hidden by the Overflow Indicator.

Figure 10.25. Both the path and the text have been formatted.

7. Click on the right anchor point to select it and display its direction handles. Click on the anchor point between the two direction handles and drag to change the width of the curve. Click on one of the direction handle points and drag to change the slope of the curve. The text follows the new curves and remains centered on the path (Figure 10.26).

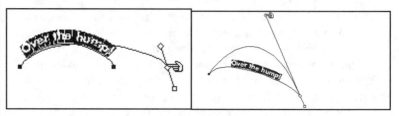

Figure 10.26. Dragging the selected anchor point adjusts the width of the curve (left). Dragging the direction handle adjusts its slope (right).

THE FREEHAND TEXT-PATH TOOL

The Freehand Text-Path tool draws open freehand paths in any shape. Use this tool as you would a pencil, drawing a path and then clicking on another tool. Like all Bézier paths, paths created with the Freehand Text-Path tool contain anchor points with direction handles that can be moved to change the shape of the path.

Freehand Text-Path tool

EXERCISE L

1. Delete all the paths on the page by selecting the Item tool, choosing Edit/Select All, and pressing the Delete or Backspace key.

2. Click on the Freehand Text-Path tool to select it. In one motion, draw a figure 8 on the page. Click on any other tool to end the path. If you release the mouse button while drawing the figure 8, you can't join the first path to another unless you use the Join Endpoints command. Just start over again. The Freehand Text-Path tool doesn't create closed paths, so you will have to place your last point next to or on top of the first anchor point.

3. Click on any of the black anchor points to display its direction handles and drag these handles to reshape the path. Click on the anchor point and drag to change the width of the curve. Click on a direction handle point and drag to change the slope of the curve. Continue moving anchor points and direction handle points until you are satisfied with the path. To change an anchor point, select it and click on the appropriate Point icon in the Measurements palette.

4. Select the Content tool. When the I-beam cursor appears, type around the figure 8. Choose Edit/Select All (**Command-A**/Macintosh or **Ctrl-A**/Windows) to select all the text. Format it so that it fits on the figure 8. Use the Tracking arrows to add and delete space between the selected characters until they fit on the path. Your screen should resemble Figure 10.27.

5. Close this file. Don't save your changes.

When you select more than one text character, you can use the tracking arrows on the Measurements palette to add or delete space between a range of characters.

The hollow square beneath the selected direction handle point on a Bézier text path indicates that you are moving a direction handle, not an anchor point.

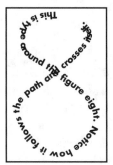

Figure 10.27. The text path (with a color of None) doesn't show; only the formatted type is displayed.

TEXT PATH MODIFY DIALOG BOX

When a text path is selected and you select Item/Modify, the Text Path tab is available. Here you can change the position and orientation of the text on the path and specify the relationship between the text and the text path (Figure 10.28). After making your selections, use the Apply button to see the effect before closing the dialog box.

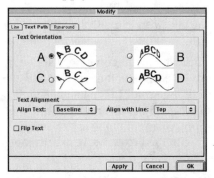

Figure 10.28. The four Text Orientation options include normal orientation (A), where the text characters are rotated but not slanted and sit on the path at the angle determined by the path itself; ribbon orientation (B), where characters are rotated, skewed, and sometimes flipped to produce a 3-D effect; skewed orientation (C), where the characters are slanted but not rotated; and stair-step orientation (D), where the characters are neither rotated nor skewed, but positioned in a stair-step effect depending on the angle of the text path.

Baseline Shift

When you're trying to position text on a text path to which you have applied a line style, you can use the Baseline Shift command to move the *selected text* up or down on the the path.

Figure 10.29. Use the Bézier drawing tools or the standard-shape tools to create the drawing. You can also convert selected standard-shape items to Bézier items by selecting the Bézier shape from the Item/Shape menu.

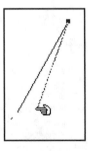

Select the path and flip it around to force the type to run from left to right.

TEXT ALIGNMENT

Use the Align Text menu to select a text alignment option based on a specific *part of the font*. Text can be aligned on the path using the font's ascenders, center of its x-height, its baseline, or its descenders.

The Align with Line menu lets you choose which *part of the path* is aligned with the selection you made in the Align Text field. Depending on your selection in the Align Text field, text will sit on the top, center, or bottom of the path. Checking the Flip button flips the text 180° and positions it on the opposite side of the text path.

REVIEW PROJECT

For this project you'll use the Bézier drawing tools and Bézier text-path tools to create a Halloween invitation similar to Figure 10.29.

1. Create a new document without an automatic text box. Display the Colors palette (**F12**). Choose Edit/Colors (**Shift-F12**) and select Pantone Uncoated from the Model menu to select an orange color. Specify it as a spot color.

2. Use the Bézier drawing tools and Bézier boxes to draw a pumpkin face. Use the Freehand Line tool to draw a coil to a starburst. Select all the items in the drawing and group them. Move the group down and to the left so that the pumpkin bleeds slightly off the page.

3. Use the Freehand Text-Path tool to draw a squiggly text path. Type *Halloween Blast!* on the path and format the text. Use tracking and vertical scaling (about 120%) to make the letters stand out. Select the path and click the Line icon in the Colors palette. Choose None from the colors list.

4. Use the Line Text-Path tool to draw a few diagonal lines above the pumpkin. Type a few words on each line, then format and track them. Apply the Pantone orange color to the text. If the text is on the bottom of the line, select the path and twist the line around to reverse the type. Apply a color of None to the text paths. Create another text path with the Freehand Text-Path tool and type the date on the line. Format and track the text.

5. Draw another path with the Freehand Text-Path tool. Select it with the Item tool and make it 24 points wide. Type the time on the path and format it. Select the text and use the Baseline Shift command or keyboard shortcut (**Command-Option-Shift-(hyphen)**/Macintosh or **Ctrl-Alt-Shift-(hyphen)**/Windows) to move the formatted text into the center of the text path.

6. Draw a text box below the time line and type the address.

Unit 11
Working with Items

OVERVIEW

In this unit you will learn how to:
Duplicate items
Copy and paste items
Use the Layers palette
Stack items
Group and ungroup items

TERMS
blend
bounding box
group
layer
nested group
Visual Indicator

LESSON 1: DUPLICATING ITEMS

DUPLICATING METHODS

There are three ways to duplicate items in QuarkXPress:

1. **Copy** a single or multiple selection to the Clipboard, and then use the **Paste** command to paste the copy on the page.

2. Use the **Duplicate command** to duplicate any selected items.

3. Use the **Step and Repeat** command to specify how many copies you want and where you want them positioned.

Once you've created multiple copies of an item, it's a good idea to group them together so they can be moved and transformed as a single unit.

COPY AND PASTE

In QuarkXPress, items are text boxes, picture boxes, text paths, groups, and lines. To duplicate an item, you must first select it with the Item tool. You can duplicate a selected item or items by using the Copy and Paste commands. When you select an item with the Item tool and choose Edit/Copy then Edit/Paste, a copy of that item is placed on the Clipboard, a special area of memory that holds anything—items or contents of items—in memory until you choose the Copy command again. Whatever is copied is placed on the Clipboard and overrides anything that was there before.

When you paste an item using the Paste command (Edit/Paste), that item is positioned on the page according to the specifications in the Step and Repeat dialog box. The Step and Repeat command differs from the Copy and Paste commands in that it copies and pastes items at a specified horizontal and vertical distance from the original and does so a specified number of times.

DUPLICATE COMMAND

Select a single item or multiple items and choose Item/Duplicate (**Command-D**/Macintosh or **Ctrl-D**/Windows). The selection is duplicated and positioned as specified in the Horizontal and Vertical Offset fields of the Step and Repeat dialog box.

STEP AND REPEAT

The Step and Repeat function is a very simple yet extremely powerful command. It allows you to create multiple copies of an item offset at a specific horizontal and vertical distance from the original. This can be useful for creating forms or interesting designs on a page.

EXERCISE A

1. Create a new document without an automatic text box (File/New/Document). Choose Edit/Preferences/Preferences and click General. Select inches as the unit of measure. Click OK. Display the Measurements palette (View/Show Measurements or **F9**).

2. Select the Rectangle Text Box tool and draw a text box between the left and right margins. Use the Measurements palette to assign the selected box a W(idth) value of 5.5" and an H(eight) value of .5. Press Return/Enter.

3. With the text box still selected, choose Item/Modify (**Command-M**/Macintosh or **Ctrl-M**/Windows). In the Box Modify dialog box, use the Color pull-down menu to select Black and the Shade pull-down menu to select 30%. Click OK.

4. With the text box still selected, choose Item/Step and Repeat (**Command-Option-D**/Macintosh) or **Ctrl-Alt-D**/Windows) to display the Step and Repeat dialog box. Type 1 in the Repeat count value, press the Tab key, and type 0 in the Horizontal Offset value. You don't want the copy pasted to the right or left of the original box. Press the Tab key again and type .5 in the Vertical Offset value to paste the copy directly below the original. Click OK.

5. With the copy still selected, choose Item/Modify and in the Box Modify dialog box choose 0 from the Shade pull-down menu. You could also select White from the Color pull-down menu. Click OK. You now have two boxes, one shaded and one white. Use the Item tool, press the Shift key, and select both text boxes.

6. Choose Item/Step and Repeat (**Command-Option-D**/Macintosh or **Ctrl-Alt-D**/Windows). Type 3 in the Repeat Count field and press the Tab key. Type 0 in the Horizontal Offset field, because you want the copies placed directly under the originals. Press the Tab key again. Because each box is half an inch high, both boxes have a height value of 1 inch. To paste the copies directly under each other, type 1 in the Vertical Offset field. Click OK.

Super Step and Repeat

Choose Item/Super Step and Repeat to change the attributes of the duplicated items.

Auto Constrain

If you select Auto Constrain in the General Preferences dialog box, any box placed on top of an existing box will be constrained, when moved or resized, to the dimensions of the larger box. You won't be able to move or resize the smaller box beyond the bounds of the larger box.

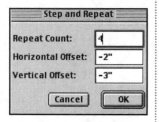

A negative Horizontal Offset value positions the duplicate to the left of the original. A negative Vertical Offset value positions the duplicate above the original.

Your screen should resemble Figure 11.1. You now have shaded and unshaded text boxes that can be used for creating forms.

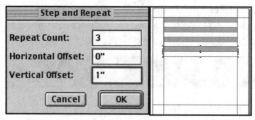

Figure 11.1. Using these values in the Step and Repeat dialog box results in four additional boxes spaced at 1½" intervals.

7. Select one of the boxes and choose Item/Duplicate (**Command-D**/Macintosh or **Ctrl-D**/Windows). A single copy appears with the same horizontal and vertical offset values last used in the Step and Repeat dialog box.

8. Save the file if you want to use it for the next exercise.

HORIZONTAL AND VERTICAL OFFSETS

The values you assign in the Step and Repeat dialog box can be positive or negative. A **positive Horizontal Offset value** positions the repeat elements to the right of the original; a **positive Vertical Offset value** positions them below the original. A **negative Horizontal Offset value** positions the repeat elements to the left of the original. A **negative Vertical Offset** value positions them above the original. You can have both positive and negative values in the same dialog box.

If you make selections in the Step and Repeat dialog box and get an alert telling you that you can't make duplicates using those offset values, that means you have too many repeat elements or they're positioned too far apart to all fit on the page. You will then have to change either the number of repeating elements or their distance from the original selection.

The Step and Repeat command is invaluable in creating repeating elements such as lines and graphics. A simple image, for example, can be duplicated, grouped, and positioned around a central item on the page for an interesting design effect. Lines can be duplicated in exact positions for setting forms and charts. It's much easier to delete duplicated items than to delete table cells—we discuss tables in Unit 13—because the latter changes the whole look of a table. Keep in mind, however, that when you use Step and Repeat with picture boxes, the images inside the boxes are duplicated as well as the boxes, and this can create large file sizes.

1. Delete all the boxes on the page or use the Document Layout palette to drag a new page onto the document. Make sure the unit of measure is inches.

2. Click on the Rectangle Picture Box tool and draw a 1-inch square. Choose File/Get Picture (**Command-E**/Macintosh or **Ctrl-E**/Windows) and navigate to the Unit 11 folder in the student Files folder on the CD-ROM. Import the *Flower.eps* file. Press **Command-Option-Shift-F** (Macintosh) or **Ctrl-Alt-Shift-F** (Windows) to proportionally fit the image in the box. Or, choose Style/Fit Picture to Box (Proportionally).

3. Choose Item/Step and Repeat (**Command-Option-D**/Macintosh or **Ctrl-Alt-D**/Windows). Type 5 in the Repeat Count field, press the Tab key, type 1 in the Horizontal Offset field, press the Tab key, and type 0 [zero] in the Vertical Offset field. Click OK.

4. Shift-select the six boxes and choose Item/Group (**Command-G**/Macintosh or **Ctrl-G**/Windows). With the group selected, choose Item/Step and Repeat. Type 1 in the Repeat Count field, 0 in the Horizontal Offset field, and 5 in the Vertical Offset field to position the single duplicate 5 inches *below* the original.

Typing a negative number in the Picture Angle field rotates the box contents to the right.

5. Use the Content tool to select the lower left box. Choose Item/Step and Repeat (**Command-Option-D**/Macintosh or **Ctrl-Alt-D**/Windows). Type 4 in the Repeat Count field, 0 in the Horizontal Offset field, and -1 in the Vertical Offset field to position the duplicates *above* the original and create the left border. Repeat to create the right border and complete the frame. Select each corner box and rotate the contents 45° to the right or left. Your screen should resemble Figure 11.2. Close this file. Don't save your changes.

Figure 11.2. The border can be any width or height depending on the number of repeat elements.

Sorry!

A master page can't contain layers, so when you're on the master pages, the Layers palette is inactive.

LESSON 2: WORKING WITH LAYERS

LAYERS PALETTE

The Layers palette (View/Show Layers) is used to organize items in a document (Figure 11.3). A *layer* is a level in a QuarkXPress document on which you place specific items. For example, a two-layer document might contain text boxes on one layer and picture boxes on another layer. Each document has a default layer that can't be deleted or renamed.

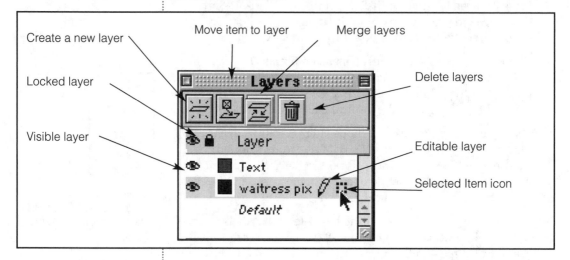

Figure 11.3. The Layers palette displays layers and icons.

LAYER RULES

When working with the Layers palette, keep in mind:

▲ You must first create a layer before moving an item to that layer.

▲ Layers palette options are available only from the Context menu (**Control-click**/Macintosh or **right-click**/Windows).

▲ Layers can be hidden or displayed, locked or unlocked, printed or not printed, merged, deleted, and duplicated. Layers are also Runaround-sensitive.

▲ Master page items live on the Default layer. Adding items to the master page positions them behind any items on the document page. If you move master page items to another layer, those items are no longer master page items.

CREATING LAYERS

To add layers to the default Layers palette, display the Layers palette (View/Show Layers) and do one of the following:

1. Click the New Layer button in the Layers palette. *Or*
2. Click on any layer in the palette to select it and choose New Layer from the Context menu.

When you create a new layer, that layer becomes the active layer and any items you create will appear on that layer.

VISUAL INDICATORS

Each layer you create (not the Default layer) is assigned a different color swatch in the Layers palette. This color swatch, called a *Visual Indicator*, appears in the upper right corner of every item you create on a layer and matches the swatch next to the layer's name (Figure 11.4). Choose View/Hide Visual Indicators to hide the swatches on the layer items.

Figure 11.4. Visual Indicators appear on items and next to a layer's name.

LAYER PREFERENCES

Set layer preferences as follows:

▲ **In the Layer Preferences dialog box** (Edit/Preferences/Preferences), by clicking Layer option.

▲ Double-click a layer's name and set your preferences in the **layer's Attributes dialog box**.

VISIBLE

Choose Visible to to display and print a layer. Items on a hidden layer will not print. Clicking the Eye icon next to a layer's name makes it visible or invisible. To isolate a layer and work on it exclusively, you can hide all layers except the active layer. Click on a layer's name in the Layers palette and choose Hide Other Layers from the context menu. You can also display all except the active layer by choosing Show Other Layers from the context menu.

Context menus

Context menus display menu options specific to the selected item, layer, or style. To display the context menu in Mac OS, Control-click on the item, layer, or style. In Windows, right-click on the item, layer, or style to display its context menu.

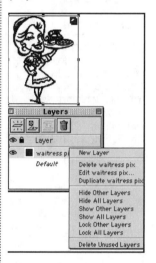

Control-click (Mac OS) or right-click (Windows) on a layer to display its context menu.

Context menu and rulers

Control-click or right-click on the horizontal or vertical ruler and select Measure to instantly change the document's unit of measure.

Locked items display a
padlock when you move
the cursor over a handle.

Lock command

Select an item and
choose Item/Lock (**F6**) to
prevent an item from
being moved or edited.
You can lock individual
items without locking the
entire layer. Choose
Item/Unlock to unlock
items.

**Selecting nonconsecutive
layers**

To select nonconsecutive
layers in the palette, press
the Command key (Mac
OS) or Ctrl key (Windows)
while clicking the layers
you want to select.

LOCKED

Locked items on layers can't be moved with the Item tool or edited
in any way. Locked items can't be moved to another layer and
unlocked items can't be moved to a locked layer. To unlock a layer,
click the Lock icon next to the layer's name.

SUPPRESS PRINTOUT

Select this option to prevent printing items on a layer. You can over-
ride the layer setting for individual items on a layer by selecting or
deselecting the Suppress Printout option in the item's Modify dia-
log box.

KEEP RUNAROUND

Check this option to maintain the specified text runaround caused
by items on a hidden layer.

EDITING LAYERS

You can modify the name and color of a new layer. To edit a layer,
that layer must be active. The active layer displays a pencil icon,
indicating that the layer is active and editable. Double-click the
layer's name in the Layers palette, or select a layer name in the
palette and choose Edit Layer from the context menu.

Type a new name in the Attributes dialog box. To change the color
of a layer, click the Layer Color box and use the system color picker
to specify a new color for the layer.

DUPLICATING LAYERS

Duplicating a layer creates a copy of both the layer and all the items
on that layer, including the contents of text boxes and picture
boxes. The new layer is placed in front of the original layer, with all
the items at the same coordinates. To duplicate a layer, select it in
the Layers palette and choose Duplicate Layer from the context
menu. Dragging a thumbnail of a page from one document to
another also duplicates the layers. If the target document has the
same layer name as the source document, the copied layer displays
an * (asterisk) in front of its name in the target document's Layers
palette.

DELETING LAYERS

Although you can't delete the Default layer, you can delete any other selected layers. To delete layers, select a single layer or Shift-select multiple layers and do one of the following:

▲ Click the Delete icon on the Layers palette. *Or*

▲ Choose Delete Layer from the context menu.

When you delete layers, you can choose whether to delete the items on the layers or move the items to another layer.

DELETE ALL UNUSED LAYERS

To keep the file size down, delete all unused layers in a document, that is, layers that don't contain any items. To do this, select a layer name in the Layers palette and choose Delete Unused Layers from the context menu.

ARRANGING LAYERS

You can rearrange layers, and thereby the stacking order of items in a document, so they display in any order in a document. You can also merge layers in a document.

Although items maintain their stacking order within each layer, the order of layers in the Layers palette stacks the items further: The **frontmost layer is the layer listed first in the Layers palette** and the **backmost layer is the layer listed at the bottom of the Layers palette**. All the items on the frontmost layer are in front of any items on any other layers. All the items on the backmost layer are behind all the other layers. All other layers are listed in the Layers palette according to their stacking order in descending order (from front to back).

CHANGING THE STACKING ORDER OF LAYERS

Changing the stacking order of layers doesn't change the stacking order of items within each layer. To change the *order of the layers*, press the Option key (Macintosh) or Alt key (Windows) while clicking a layer in the Layers palette and drag the layer to its new location on the Layers palette.

Find/Change and Spell Check on hidden layers

When you use Find/Change or the Spell Check in a document that contains hidden layers, QuarkXPress searches the hidden layers as well as the visible layers. If it finds a match or a suspect word on a hidden layer, XPress temporarily displays the hidden text box or text path so you can see the selection and change it.

PLACING AND MOVING ITEMS ON LAYERS

FYI

If you drag an item from one document to another, that item *and its layer* are copied to the target document.

Once you create a layer, you can create items on that layer, or you can move item(s) to an existing layer. To create items on a layer, first select the layer by clicking on it. Create your item (box or rule) paying attention to the stacking order. On each layer, every item has its own stacking order. Newly drawn items are stacked in front of existing items on that layer.

To move existing items to a different layer, select the item or Shift-select the items you want to move and do one of the following:

▲ Click the Move Item to Layer button to display the Move Items dialog box, where you use the menu to select another layer where the selected item(s) will be moved. *Or*

▲ Drag the Selected Item icon to a different layer. The icon displays to the right of any layer containing selected items. *Or*

▲ Select the items to move, then choose Edit/Cut to remove the items from one layer. Click the layer that you want to activate, and then choose Edit/Paste to paste those items on the active layer.

When selecting a group of items from different layers, only the layer containing the first items you selected will be active. The Selected Item icon displays to the right of each layer from which you selected an item.

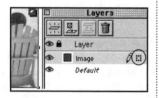

The Selected Item icon appears when an item is selected on a layer.

EXERCISE C

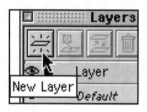

1. Open the *Layers.qxd* file in the Unit 11 folder in the Student Files folder on the CD-ROM. Display the Layers palette (View/Show Layers). This document contains three items on the Default layer. Make sure that Hide Visual Indicators appears under the View menu. When the Visual Indicators are showing, the menu toggles to Hide Visual Indicators.

2. Click the New Layer icon on the Layers palette to create Layer 1 above the Default layer. Double-click on the layer name and type *Picture* in the Name field of the Attributes dialog box. Click OK. The *Picture* layer displays a red swatch, its Visual Indicator, as does the picture (Figure 11.5).

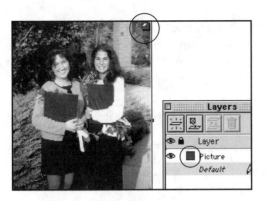

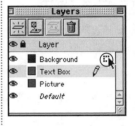

Figure 11.5. Visual Indicators appear next to the layer name and in the upper right corner of the item on that layer.

The Selected Item icon appears when an item is selected on a layer.

3. Repeat to create a new layer for the orange background, and name it *Background*. Select the orange background box on the Default layer and drag its Item Selection icon up to the *Background* layer. Because the *Background* layer is the frontmost layer in the Layers palette, it obstructs the items on the lower layers.

4. Control-click (Macintosh) or right-click (Windows) on the Default layer and drag to select New Layer. Double-click on the new layer and name it *Text Box*. Select the Item tool, click on the text box on the Default layer, and cut it (Edit/Cut). Click on the *Text Box* layer to select it and choose Edit/Paste. The text box appears on the *Text Box* layer and displays a different Visual Indicator to match the Visual Indicator on the *Text Box* layer.

5. The correct arrangement of items in this document calls for the orange background to be on the bottom, the picture in the middle, and the text box as the topmost layer. Press the Option key (Macintosh) or Alt key (Windows) and click on the *Background* layer. Drag it down below the Default layer. Select the picture box on the Default layer and drag its Selected Item icon to the *Picture* layer. Option-drag or Alt-drag the *Picture* layer. Your screen should resemble Figure 11.6.

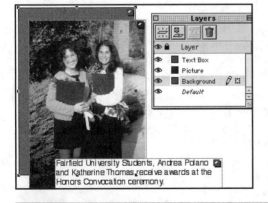

Figure 11.6. The three layers display Visual Indicators for three items.

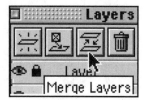

6. Shift-select the three layers you created and click the Merge Layers button on the Layers palette. In the Merge Layer dialog box, use the menu to select Background. Click OK. All three items appear on the Background layer, as indicated by their Visual Indicators.

7. Control-Click (Macintosh) or right-click (Windows) on the *Background* layer. Drag to select Delete Layer. Choose *Default* in the Delete Layer dialog box and click OK.

8. Continue to move, merge, delete, and edit layers until you're comfortable using this palette.

9. Close the file. Don't save your changes.

STACKING ITEMS ON LAYERS

When you draw overlapping items on any layer in QuarkXPress, each item is positioned relative to the item you created last. The last item is frontmost in the stacking order. For example, if you draw a blue box and then draw a yellow circle on top of the blue box, the blue box is considered the backmost item and the yellow circle the frontmost item. If you overlap a line on top of the yellow circle, that line then becomes the frontmost object, with the yellow circle behind it. You can move these items back and forth, making different items the frontmost and backmost items.

To change the stacking order of items on a specific layer, do the following:

▲ **Select an item in front of other items and choose Item/Send to Back**. This sends the item to the back of the stack, behind every other item on the layer.

▲ **Select an item behind other items and choose Item/Bring to Front**. This brings the item to the front of the stack, in front of every other item on the layer.

▲ **Select an item in front of other items, press the Option key (Macintosh) or Alt key (Windows), and choose Item/Send Backward**. This sends the item one level behind in the stacking order, not necessarily to the back of the page.

▲ **Select an item behind other items, press the Option key (Macintosh) or Alt key (Windows), and choose Item/Bring Forward**. This brings the item one level in front in the stacking order, not necessarily to the front of the page.

LESSON 3: WORKING WITH GROUPS

GROUPING ITEMS

A group consists of two or more items—boxes, text paths, and/or lines—that can be moved and transformed as a single unit. For example, a text box with a heavy rule above it can be grouped so that when you move the text box, the rule will move with it. You can also nest groups—that is, create one group and then group it with another group. Groups can be moved, resized, rotated, and ungrouped. Color commands applied to a group affect all the items in a group regardless of an item's original color. The important thing to remember about groups is that you use the **Item tool to move a group** and the **Content tool to edit the individual items within a group**.

MODIFYING GROUPS

The easiest way to make modifications to a group is to select the group and choose Item/Modify. Click on the Group tab to display the Group Modify dialog box. There you can reposition and resize the group as well as change the items' color and shade. Any color you apply in this dialog box, however, applies to the background color of every item in the group. To change the color of individual items in the group, select that item with the Content tool and make the change.

Tip

Double-click on any item or group with the Item tool to display that item or group's Modify dialog box.

Important info!

You must first deselect a group before editing its contents with the Content tool.

EXERCISE D

1. Create a new nonfacing-pages document without an automatic text box. Display the Measurements palette (View/Show Measurements or **F9**) and select inches as the unit of measure in the General Preferences dialog box.

2. Use the Rectangle Picture Box tool to draw a small picture box, the Oval Picture Box tool to draw an oval, and the standard-shape Rectangle Text Box tool to draw a text box. Type a few words in the text box.

3. Select each box, choose Item/Modify (**Command-M**/Macintosh or **Ctrl-M**/Windows), and in the Box field use the Color pull-down menu to select a different background color for each item. You can also use the Colors palette (**F12**) to apply the background colors.

4. Select either the Item tool or the Content tool and click on the rectangular picture box to select it. Press the Shift key and click to select the oval picture box and the text box. Don't release the Shift key until all three items are selected.

5. Choose Item/Group (**Command-G**/Macintosh or **Ctrl-G**/Windows). A dashed bounding box appears around the three grouped items, indicating that they constitute a group and can be moved and transformed as one unit (Figure 11.7).

Figure 11.7. A bounding box appears around the three grouped items.

Position, size, and angle of rotation can be specified from the Group Modify dialog box, as can color options. Color options affect every item in the group.

6. With the Item tool still selected, drag the group around the page. Notice that all three items move as one unit.

7. Click anywhere on the page to deselect the group. Select the Content tool and click on the rectangle and oval and resize them. You can't use the Item tool to move an individual item in a group (these three items are still grouped), so you must use the temporary Item tool to move the text box. Click on the text box with the Content tool and press the Command key (Macintosh) or Ctrl key (Windows) to turn the Content tool into a temporary Item tool. Drag with this temporary Item tool to reposition the text box.

8. Click on the Item tool in the Tool palette and notice that the bounding box again appears around the edited group of items.

9. With the group still selected, choose Item/Duplicate (**Command-D**/Macintosh or **Ctrl-D**/Windows). Move the duplicate to the pasteboard, where it will serve as a reference. Select the original group and choose Item/Modify (**Command-M**/Macintosh or **Ctrl-M**/Windows) to display the Group Modify dialog box. Click in the Width field after the inch mark and type /2 to divide the current width by 2. Click in the Height field and type /2 to divide the current height by 2. Click OK. The group is proportionally reduced 50% in size (Figure 11.8). Deselect this group by clicking anywhere on the page, but don't delete it.

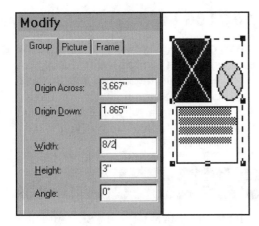

Modify

Group | Picture | Frame

Origin Across: 3.667"

Origin Down: 1.865"

Width: 8/2

Height: 3"

Angle: 0°

Figure 11.8. You can do math in any XPress dialog box. Here, the selected group is proportionally reduced to half its size because both the width and height were divided by 2.

10. With the Item tool selected, click on the duplicate group you created earlier. Choose Item/Frame (**Command-B**/Macintosh or **Ctrl-B**/Windows). In the Frame dialog box, apply a 4-point frame. Choose any color from the Color pull-down menu. Click OK. Each item in the group now displays the same frame.

11. With the group still selected, choose Item/Modify (**Command-M**/Macintosh or **Ctrl-M**/Windows) to display the Group Modify dialog box. In the Box field, use the Color pull-down menu to select another color. Because you selected a group, this new color will be applied to every item in the group. Click on the Frame tab and use the pull-down menus to select another frame and point size for the frame. Click on OK. The three items now display the same background color and same frame color and width.

12. With the group still selected, click on the lower right handle of the group's bounding box and drag to resize the group. All the items are resized, but not proportionally (Figure 11.9).

Figure 11.9. Color and frame commands affect every item in a group. When you resize a group manually, it can't be resized proportionally unless you press the Shift key while dragging.

FYI

Although you can Shift-select items with either the Content tool or the Item tool before grouping them, you must use the Item tool to select the group itself.

THE GROUP MODIFY DIALOG BOX

Once you specify items as part of a group, you can manipulate all the grouped items simultaneously in the Group Modify dialog box. Here you can position, resize, and rotate the group. You can also apply the same solid or blend color to all the items. If you have a large, complex group on a page, you can also suppress the group from printing when you print the page (if, for example, you're only proofing text).

EXERCISE E

1. Open the *Stack.qxd* file in the Unit 11 folder in the Student Files folder on the CD-ROM. Separate the three overlapping items as you did before. Shift-select the two rectangles and choose Item/Group (**Command-G**/Macintosh or **Ctrl-G**/Windows) to display the bounding box around the selected items.

2. With the group still selected, choose Item/Modify to display the Group Modify dialog box (Figure 11.10). Whatever options you select in this dialog box apply to the group, in this case to the two grouped rectangles. Type values in the Origin Across and Origin Down field to position the group on the page. Press the Tab key and type values in the Width, Height, and Angle fields to resize and rotate the group. Click Apply. Make further changes and click OK. Notice that only the grouped items are affected by the new values. The red oval remains untouched.

FYI

To select multiple items, drag a marquee around the items with the Item tool.

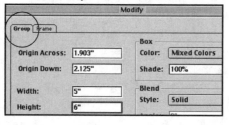

Figure 11.10. The Group Modify dialog box

3. Choose Edit/Undo (**Command-Z**/Macintosh or **Ctrl-Z**/Windows) to restore the group to its original values. Keep it grouped.

4. With the group still selected (if you deselected, reselect the group with the Item tool), choose Item/Modify again. Right now the group consists of a green item and a blue item, so the Color menu in the Box field displays Mixed Colors. Pull down the Color menu and select Magenta. Click Apply and notice that both items in the group display the new color. Click on Cancel to restore the rectangles to their original colors.

5. Choose Item/Modify again. This time use the Style pull-down menu in the Blend field to select Linear Blend. Leave the Box field color set at Mixed Colors, but select Yellow from the Color pull-down menu in the Blend field. Click Apply. The color in the blue rectangle blends from blue to yellow and the color in the green rectangle blends from green to yellow. Click on OK.

6. Save this file as *Blend.qxd* in your Projects folder (File/Save as). You'll need it for the next exercise.

INDIVIDUAL GROUPED ITEMS

Because the Group Modify dialog box applies values to every item in the group, it's not always the best command to use when you just want to make changes to individual items in a group. To do this, deselect the group and use the Content tool to make changes to individual items just as you would if the item were not part of a group. However, until you apply the Ungroup command, those items remain part of the group and will move with the group.

EXERCISE F

1. If necessary, open the *Blend.qxd* file you created in the last exercise, or open the *Blend.qxd* file in the Unit 11 folder in the Student Files folder on the CD-ROM. Use the Item tool to select the grouped rectangles.

2. Click anywhere on the page to deselect the group.

3. Select the Content tool and click to select the blended green rectangle. Drag the lower handle down to elongate the rectangle.

4. Click with the Content tool on the blue rectangle. Press the Shift key and drag a corner of the rectangle to constrain it to a square.

5. To move the blue rectangle independently of the group, press the Command key (Macintosh) or Ctrl key (Windows) to temporarily convert the Content tool cursor to the Item tool cursor. Keeping the modifier key pressed, drag the blue rectangle down on the page. Release the mouse, then the modifier key.

6. Select the Item tool and notice that the group bounding box appears. Just because you modified a grouped item doesn't remove it from the group.

7. Close this file. Don't save your changes. Or, choose File/Revert to Saved. You'll use the *Blend.qxd* file in the next exercise.

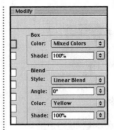

Selecting a blend color for a group applies that color as one of the two blend colors to every item in the group.

FYI

Type the same values in the Width and Height fields to resize the group proportionally.

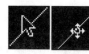

Pressing the Command key (Macintosh) or Ctrl key (Windows) changes the arrow cursor (left) temporarily to the Move cursor (right).

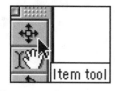

Group tool

Remember, when working with groups you must use the Item tool to move the group. Use the Content tool to modify a single item in a group.

NESTED GROUPS

Once a group is established, it remains a group until it's ungrouped. You can, however, add items to a group, and you can delete items from a group. When you select more than one group and apply the group command, the individual groups maintain their status as groups. To ungroup Group A from Groups B and C, select Group A and choose Item/Ungroup. Deselect everything, then use the Item tool to select Group A. Its elements remain grouped, but they are independent of Groups B and C.

EXERCISE G

1. Open the *Blend.qxd* file you created in an earlier exercise, or open the *Blend.qxd* in the Unit 11 folder in the Student Files folder on the CD-ROM.

2. Select the Item tool and click on the red oval. Choose Item/ Duplicate (**Command-D**/Macintosh or **Ctrl-D**/Windows). Use the Item tool to move the duplicate red oval next to the original.

3. With the Item tool active, press the Shift key and click once on the original red oval to select both red ovals. Choose Item/ Group (**Command-G**/Macintosh or **Ctrl-G**/Windows). You've created the second group on the page.

4. With the Item tool still active and the red oval group selected, press the Shift key and click on the rectangle group. Both groups' bounding boxes appear.

5. Choose Item/Group (**Command-G**/Macintosh or **Ctrl-G**/Windows) to group the two groups. All four items are enclosed in one bounding box.

6. With the double group selected, choose Item/Ungroup. Both groups' bounding boxes appear.

7. Click anywhere on the page to deselect the nested group. Use the Content tool and click on one of the red ovals. Choose Item/Delete to delete it. Because a group must have more than one item, the red oval group is disbanded and the remaining red oval is a single, ungrouped item.

8. Click with the Item tool on the rectangle group. Choose Item/ Ungroup (**Command-U**/Macintosh or **Ctrl-U**/Windows). Click anywhere to deselect. The three items on the page are now individual, ungrouped items.

In this project you'll create the invoice shown in Figure 11.11, using Step and Repeat to set the lines and the Layers palette to organize the items.

Very Quick Printing

123 Swift Way • Suite 32 • Presstown, NY 12345
Tel (219) 711-1234 • Fax (219) 711-5432
Cell (219) 234-5678

INVOICE

Sold To:	Ship To:

Quantity	Price	Description

Control-click (Macintosh) or right-click (Windows) on a layer to display the options for that layer and for other layers in the Layers palette.

Figure 11.11. This invoice is comprised of eight text boxes.

1. Draw the large top box for the name and address information with a content of None and assign it a background shade of a color from the Colors palette (**F12**). Then draw multiple text boxes with a background of None to hold the different kinds of information. It will be easier to position the text in boxes than to play with the leading.

Lock the layers you're not working on to avoid moving an item.

2. Assign the Quantity, Price, Description box a darker background shade of the same color. Once you have them positioned properly, move each box to a separate layer.

3. Create another box to hold the rules.

4. Create separate layers for each of the boxes and name them Address box, Sold To box, Ship to box, Quantity box, and Ruled box.

5. To move the boxes to the appropriate layer, use one of the following methods:

 ▲ Select the item. Click the Move Item to Layer button to display the Move Items dialog box, where you use the menu to select another layer where the selected item(s) will be moved. *Or*

 ▲ Drag the Selected Item icon to a different layer. The icon displays to the right of any layer containing selected items. *Or*

 ▲ Select the items to move, then choose Edit/Cut to remove the items from one layer. Click the layer that you want to activate, and then choose Edit/Paste to paste those items on the active layer.

6. Use Step and Repeat to create the evenly spaced lines. Draw the first line in the box and use a value of 0 for the vertical offset to keep all the lines under one another. Shift-select the lines and group them on the layer.

7. Apply 1p First Baseline offset to the Sold and Ship text boxes. Select the box and choose Item/Modify. Type 1p (1 pica) in the First Baseline field of the Text Modify dialog box.

8. Create reverse type in the Quantity, etc. box by selecting the type, clicking the Text icon in the Colors palette, and selecting the White swatch.

9. Tab the reverse type in the Quantity box so that all three headings line up across the box.

10. When the invoice is complete, Shift-select all the layers and merge them from the Layers palette into one of the layers. Save the file. A client might pay you for this (or for something very much like it) someday!

Unit 12

Anchored Items & Runaround

OVERVIEW

In this unit you will learn how to:

Use libraries

Anchor boxes and lines

Create text wrap or runaround

Create and edit clipping paths

Use horizontal and vertical item alignment

Use ruler guides and the Guide Manager

TERMS

anchored item

anchored rule

Auto Image runaround

clipping path

embedded path

Entry label

Image Runaround

Item Runaround

Library palette

Noise

None runaround

rule

Smoothness

Threshold

LESSON 1: STORING ITEMS IN LIBRARIES

USING LIBRARIES

A *library* is an electronic storage bin for thumbnails of text boxes, picture boxes, lines, text paths, and groups. When you create a new library file, a palette appears on the page. Drag-copy items into and out of this palette just as you would if you were pulling pages from a file drawer. Library entries can be edited (Cut, Copy, Paste, Clear) in the palette, but any changes made to library items on the page are not reflected in the Library palette. You must drag an edited item from the document page into the library again if you want to keep a copy of it in the library file.

Any text and graphics stored in a library must first be created in or imported into a box. You can't store an image or a text file unless it has been imported into a picture box or into a text box. It's important to remember that when you store a high-resolution image in a library, you must maintain the link between the low-resolution preview of that image and the actual high-resolution image.

ACCESSING LIBRARIES

Once you create a library, it remains open until you close it by clicking on its Close box. Whenever you launch QuarkXPress, any library palettes that were open when you last quit XPress are opened automatically and displayed at their previous positions. If you closed a library and want to reopen it, use the Open command under the File menu, just as you would for any XPress document file.

LABELS

Once you have added entries to a library, double-click on the entry to display the Library Entry dialog box. You can assign a different name to every entry or you can assign the same name to a group of related entries. If you have already assigned a label, you can access that name from the Label List instead of typing it in again.

Sorry!

You can't drag selected text or graphics into a library without their boxes.

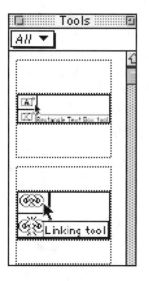

This library contains QuarkXPress picture boxes with screen shots of the different tools in the Tool palette.

EXERCISE A

1. Create a new file without an automatic text box (File/New/ Document). Use any of the picture box tools to draw two picture boxes on the page.

2. Select the first picture box and choose File/Get Picture. Navigate to the Unit 12 folder in the Student Files folder on the CD-ROM and double-click on the *Building.tif* image to import it

into the picture box. Repeat with the second picture box and import the *Clouds.tif* image.

3. Draw a text box on the page. Click inside the text box and type *Give me all your chocolate and no one gets hurt!* Draw another text box on the page and type *Touch my Twinkies and you die!*

4. Choose File/New/Library. Navigate to your Projects folder. Type *My Library* in the Library Name field and click Create. The Library palette appears on the page.

5. Select the Item tool, click on the first picture box, and drag the box into the library. You're drag-copying the image, not moving it. When the Library pointer appears, release the mouse button. A thumbnail of the image appears in the library. Repeat for the second image.

6. With the Item tool still selected, click on the first text box and drag-copy it into the library. Repeat for the second text box. You now have four items in the library.

7. Double-click on the *Building.tif* image in the Library palette to display the Library Entry dialog box. Type *Building* in the Label Name field and click OK. Double-click in the *Clouds.tif* image and type *Clouds* in the Label Name field. Click OK.

8. Double-click on the first text box in the Library palette. Type *Threats* in the Label Entry field. Click OK. Double-click on the second text box. Drag the Label List pull-down menu and select Threats. Click OK (Figure 12.1).

Figure 12.1. Use the Label List to select a label for a selected library item. The selected label appears in the Label field.

9. Use the Library palette's Labels pull-down menu to select *Threats.* Only the two text boxes is labeled *Threats* are displayed (Figure 12.1). Click on one of the text boxes and choose Edit/Cut from the main menu. Click OK at the alert. The selected text box is deleted from the library—but not from the document.

10. Click on the Library palette's Close box in the upper corner of the palette. Choose File/Open, navigate to the Projects folder, and double-click on *My Library* to open the library. The palette appears on the page.

11. Close this file (File/Close). Don't save your changes.

When the Library pointer and two icon arrows appear, the item has been added to the library.

Selecting one label displays all the entries tagged with that label.

Feel free

You can move items up and down within the Library palette.

LESSON 2: ANCHORING ITEMS

WHY ANCHOR?

There are several ways an item can dance with text in QuarkXPress 5.0. It can intrude on the text, it can repel the text, and it can have the text run around the item. In all these instances, if you reflow or edit the text, its relation to the item changes, and you may have to reposition or resize the graphic to keep the effect you want to create. However, if you anchor that graphic (such as an initial cap) to the text, then no matter how you edit the text, add or delete characters, resize or realign the text, that graphic item will remain anchored to its original position in the paragraph.

You can anchor any item to a paragraph, whether it's a standard-shape or Bézier picture box, text box, text path, or line. You can even convert text to a Bézier box and anchor that Bézier box anywhere in the paragraph. Like all anchored boxes, anchored Bézier boxes can be reshaped after they have been anchored.

ANCHORING ITEMS

Anchoring items is a two-step/two-tool process. First, select the box, text path, or line with the Item tool and choose Edit/Cut. Then select the Content tool, click anywhere in a paragraph, and choose Edit/Paste. The cut item is pasted at the selected position and remains anchored to the paragraph at that position regardless of how the paragraph flows as you edit the text. To remove an anchored item, use the Content tool and click immediately after the anchored item, then press the Delete/Backspace key. Or select the anchored item with the Item tool and choose Edit/Cut.

ANCHORED RULES

A line attached to a paragraph is called a *rule*. Anchored rules are used above and below text as design elements to set off the information in a particular paragraph. It is absolutely critical that a line associated with a paragraph move with the paragraph, and the only way to do this is to use the anchored rule command.

The Rules tab in the Formats dialog box is used to specify the kind of rule that will be anchored to a paragraph and its distance above and/or below the selected paragraph. Although this dialog box looks complicated, it's really easy to use. Once a rule is anchored to a paragraph, it can't be removed from that paragraph unless you use the Rules dialog box and deselect the Rule Above and/or the Rule Below check box. And like most elements in XPress, a rule can be edited and incorporated into a paragraph style sheet.

☑ **Rule Below**

Very important info!

Each time you press the Return/Enter key after a paragraph with an anchored rule, the rule information attaches to the paragraph return (¶). To remove the rule, select the paragraph mark, choose Style/ Rules, and deselect the Rule Above or Rule Below check box.

1. Create a new file (File/New/Document) with an automatic text box. Choose View/Show Invisibles (**Command-I**/Macintosh or **Ctrl-I**/Windows). Type *This is an example of a rule below a paragraph*. Press the Return/Enter key to generate a paragraph return. Click anywhere inside the paragraph to select it.

2. Choose Style/Rules (**Command-Shift-N**/Macintosh or **Ctrl-Shift-N**/Windows) to display the Paragraph Attributes dialog box. The Rules tab is active. Click on the Rule Below check box to activate the function. Use the Length pull-down menu to select Text. Type 30% in the Offset field to position the rule 30% of the distance from the baseline of the last line of the paragraph. Type 2 in the Width field and choose blue from the Color menu. Click OK. Your screen should resemble Figure 12.2.

Paragraph Attributes

Formats | Tabs | **Rules**

☐ **Rule Above**

Length:	Indents	Style:	Solid
From Left:	0"	Width:	1 pt
From Right:	0"	Color:	Black
Offset:	0%	Shade:	100%

☑ **Rule Below**

Length:	Text	Style:	Solid
From Left:	0"	Width:	2 pt
From Right:	0"	Color:	Blue
Offset:	30%	Shade:	100%

Apply | Cancel | OK

Figure 12.2. We applied a 2-point blue rule to the paragraph. It will run only the length of the last line of text in the paragraph and is positioned 30% of the distance from the baseline of the text.

Formats | Tabs | **Rules**

☑ **Rule Above** — Indents
Length: — ✓ Text

FYI

Selecting Text from the Length pull-down menu runs the rule only the length of the last word in the paragraph.

3. Click before the first letter in the paragraph and press the Return/Enter key a few times. Notice that the rule remains anchored to the paragraph.

4. Click anywhere in the paragraph to select it. Choose Style/Rules (**Command-Shift-N**/Macintosh or **Ctrl-Shift-N**/Windows) again. Click the Rule Above check box to activate the function. Choose Indents from the Length menu. Press the Tab key twice and type 1 in the From Right field to offset the rule 1 inch from the right margin. Press the Tab key once and type 1p in the Offset field to offset the rule 1 pica from the top of the first line in the paragraph.

5. Choose All Dots from the Style menu, 6 from the Width menu, and red from the Color menu. Click OK. Your screen should resemble Figure 12.3.

Paragraph Attributes

Formats | Tabs | **Rules**

☑ **Rule Above**

Length:	Indents ⬍	Style:	All Dots ⬍
From Left:	0"	Width:	6 pt ⬍
From Right:	1"	Color:	Red ⬍
Offset:	1p	Shade:	100% ⬍

☑ **Rule Below**

Length:	Text ⬍	Style:	Solid ⬍
From Left:	0"	Width:	2 pt ⬍
From Right:	0"	Color:	Blue ⬍
Offset:	30%	Shade:	100% ⬍

Apply | Cancel | OK

This·is·an·example·of·a·rule·below·a·paragraph.¶

Figure 12.3. A paragraph can have an anchored rule above and below the paragraph.

FYI

A rule is a paragraph format and you must select the paragraph before applying the rule. To remove a rule, select the paragraph, or the paragraph return mark if it's an empty ruled line (¶), and use the Rules dialog box to deselect the rule option.

6. With the paragraph still selected, choose Style/Rules (**Command-Shift-N**/Macintosh or **Ctrl-Shift-N**/Windows). Deselect the Rule Below check box to remove the blue rule. Click OK. Only the red rule above the paragraph remains.

7. Close this file. Don't save your changes.

ANCHORED ITEMS

You can anchor a box, line, group, or text path to a paragraph so that when the paragraph moves, the item moves with it. In other words, anchored items are treated like text characters, in that they are part of the paragraph just as any text character is.

1. Create a new file with an automatic text box (File/New/Document). Type the following sentence: *Men won't ask for directions on the information highway either.* Press the Return/Enter key.

2. Open the *Anchor Library* (File/Open) in the Unit 12 folder in the Student Files folder on the CD-ROM. It displays several images. Use the Item tool to drag the *M* image out of the library and onto the page. With the *M* box and Item tool still selected, choose Edit/Cut (**Command-X**/Macintosh or **Ctrl-X**/Windows).

Item tool (above) and Content tool (below)

3. Select the Content tool and click before the *M* in the sentence. Choose Item/Paste (**Command-V**/Macintosh or **Ctrl-V**/Windows). The image is anchored to the paragraph. Delete the original capital *M* in the sentence. You have created an initial cap anchored to the paragraph. Click before the anchored image and press the Return/Enter key a few time. Notice that the image moves with the paragraph (Figure 12.4).

Figure 12.4. We imported the TIFF image into an XPress picture box, stored it in a library, and anchored it to the paragraph.

4. Display the Measurements palette (**F9**). Click on the anchored box and click on the top Alignment icon at the extreme left of the Measurements palette to align the anchored box with the ascent of the top line. Click on the bottom Alignment icon to align the anchored box with the baseline of the text.

5. Select the anchored box with the Content tool. Resize the box using the Resizing pointer, and use the X% and Y% values in the Measurements palette to resize the image.

6. Select the anchored box with the Content tool and choose File/Get Picture (**Command-E**/Macintosh or **Ctrl-E**/Windows). Navigate to the Unit 12 folder in the Student Files folder on the CD-ROM and import any of the images in the folder. Resize the anchored picture box to accommodate the graphic.

When an anchored item is selected, click on this icon to align the anchored item with the baseline of the first line in the paragraph.

When an anchored item is selected, click on this icon to align the anchored item with the ascent of the first line in the paragraph.

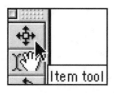

Use any line style to indent names with an anchored line.

7. To delete an anchored box, click on the item to select it, click with the Content tool to the right of the box, in front of the *e* in *en,* and press the Delete/Backspace key. Or, select the anchored item with the Item tool and choose Edit/Cut. You can then use the Content tool to paste the item somewhere else in that paragraph or in another paragraph.

8. Close this file (File/Close). Don't save your changes.

ALIGNING ANCHORED ITEMS

Both Bézier and conventional lines can be anchored to a paragraph in the same way a text box or a picture box is anchored to a paragraph. Anchoring lines lets you create interesting design effects without worrying about keeping the line with the paragraph when you flow text before or after the paragraph.

EXERCISE D

1. Create a new file with an automatic text box (File/New/Document). Type any name and press the Return/Enter key. Repeat until you have a list of five names.

2. Use any of the line tools to draw any kind of line below the list of names. Select the line with the Item tool and choose Edit/Cut (**Command-X**/Macintosh or **Ctrl-X**/Windows).

3. Click before the first character in the first line and choose Edit/Paste (**Command-V**/Macintosh or **Ctrl-V**/Windows). Repeat for the four other paragraphs.

4. Click on any line and resize it or reshape it; if it's a Bézier line, reshape it.

5. Close this file (File/Close). Don't save your changes.

LESSON 3: RUNAROUND

TEXT WRAP OR RUNAROUND

What the rest of the world calls text wrap, QuarkXPress calls runaround. The term *runaround* describes the way text flows around an item or an item's contents. For example, when text encounters a picture box containing an image, the text has to decide how to deal with the obstruction. Should the text run around the picture box? Run behind the picture box? Or run around the picture? In other words, runaround defines the relationship of text and graphics when they meet on a blind date.

Text has to make one of several decisions when it encounters an item like a box, text path, or line. Should it just ignore the item and keep flowing? Should it flow around the picture box or around the picture? Should it ignore the box and flow around an embedded path in the picture? Should it flow around the non-white areas of the picture, or should it just flow around the picture bounds? The selections you make in the Runaround Modify dialog box (Figure 12.5) determine just how the text wraps around the item or how it wraps around the graphic inside the picture box. Also be aware that the background color of the box also affects how text displays as it runs around the graphic. If the box has any background color applied to it, the text behind the box won't be visible.

Colored paths

When you select Auto Image Runaround, the magenta path in the Preview area of the Runaround dialog box represents the runaround path. The blue outline represents the item. You can change these colors in the Margin and Grid fields of the Display Preferences dialog box.

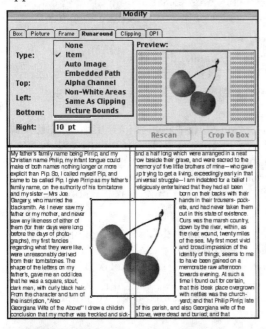

Figure 12.5. Use the Type menu in the Runaround Modify dialog box to specify exactly what the text wraps around: nothing, the box, the image itself, a Bézier path, any pixelated area, or the area adjacent to the picture. Here, it wraps around the picture box leaving 10 points of space between the item (picture box) and text.

NONE RUNAROUND

When you import a picture into a picture box and lay that box over text, if you select None for the type from the Runaround Modify dialog box, that's what you get—no text wrap. The text is obstructed by the graphic and any text behind the picture box isn't visible and won't print. Unless you change the Box Preferences (Edit/Preferences/Preferences), the default in XPress is to create a picture box with a white background. So, any picture you import into this default picture box will automatically obscure any text behind the box.

EXERCISE E

1. Create a new document with an automatic text box and 2 columns. Display the Measurements palette (**F9**). Click inside the automatic text box on the page and choose File/Get Text. Navigate to the Unit 12 folder in the Student Files folder on the CD-ROM and double-click on the *Run.text* file to import it into the selected text box. Reduce the height of the text box so the text fills both columns. Choose Edit/Select All (**Command-Shift-A**/Macintosh or **Ctrl-Shift-A**/Windows) and click the Justified icon on the Measurements palette.

2. Use the Rectangle Picture Box tool to draw a picture box about 2 inches wide and 3 inches high. Use the Item tool to position the picture box in the center of the page between the two columns of text.

3. Choose File/Get Picture (**Command-E**/Macintosh or **Ctrl-E**/Windows). In the Unit 12 folder in the Student Files folder on the CD-ROM, double-click on the *Building.tif* file to import it into the picture box.

4. Press the **Command-Option-Shift-F** keys (Macintosh) or **Ctrl-Alt-Shift-F** keys (Windows) or choose Style/Fit Picture to Box (Proportionally) to proportionally scale the picture and fit it in the picture box. To increase or reduce the picture's size in 5% increments, press the same key combination, but substitute the < or > keys for the F key.

5. Choose Item/Runaround (**Command-T**/Macintosh or **Ctrl-T**/Windows) to display the Runaround dialog box. Use the Type pull-down menu to select None. A thumbnail of the text wrap—or, as in this case, the lack thereof—appears to the right. Click on OK. The text is obscured by the graphic because no text wrap is applied (Figure 12.6). Moving the graphic with

FYI

If you import the graphic with the Item tool selected, you must switch to the Content tool before you can manipulate the image.

the Content tool or the picture box with the Item tool hides and displays different text characters behind the graphic and the box.

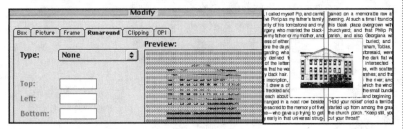

Figure 12.6. When None is selected for Runaround, the text doesn't run around or wrap around the image, but is obscured by the image. The thumbnail in the Runaround dialog box displays this by showing the text bars running through the graphic instead of around it.

6. Save this file as *None.qxd* in your Projects folder. You'll need it for the next exercise.

ITEM RUNAROUND

In XPress, an item is either a box, a line, or a text path. When you select Item for the runaround, the text wraps around the boundaries of the picture box, line, or text path, regardless of the physical dimensions of the item or of the picture background inside a box.

Sorry!

You can't apply runaround to a group.

EXERCISE F

1. If necessary, open the *None.qxd* file you created in the last exercise, or open the *None.qxd* file in the Unit 12 folder in the Student Files folder on the CD-ROM.

2. Click on the picture box with the Item tool to select it and choose Item/Runaround (**Command-T**/Macintosh or **Ctrl-T**/Windows). Select Item from the Type menu. The thumbnail displays the type running around the item, the picture box. Click OK. Notice that the text now runs around the outside of the picture box (Figure 12.7).

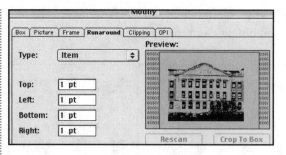

The values you type in the offset fields of the Runaround dialog box determine how much space XPress adds between the text and the item or graphic.

Figure 12.7. When Item is selected for the runaround, the text wraps around the item, in this case, the picture box.

3. With the picture box still selected, choose Item/Runaround (**Command-T**/Macintosh or **Ctrl-T**/Windows) again. Leave Item selected from the Type menu. Type 20 in the Top field, press the Tab key, and type 20 in the Left, Bottom, and Right fields. Click Apply. The bounding box moves away from the image, leaving more distance between the text and the text box. Click OK. The text wraps around the boundary of the box (Figure 12.8).

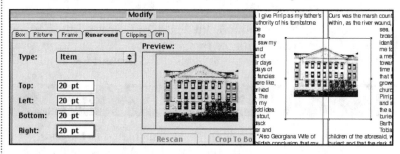

Figure 12.8. Increasing the default values in the Top, Left, Bottom, and Right fields expands the distance between the text and picture box.

IMAGE RUNAROUND

Thus far you have been running text around the item, the picture box. You can also run text around the image, bypassing both the picture box and the white background that is created whenever an image is saved as a TIFF or EPS image. Even if you specify a transparent background in an image manipulation program like Adobe Photoshop, when that image is saved as a TIFF image, a white background is created, because Photoshop needs to add pixels to complete the rectangular or square image. Likewise, any image saved in an EPS illustration program, such as Adobe Illustrator or Macromedia FreeHand, always includes a white background behind the image.

FYI

Digital artists for high-quality image vendors frequently export paths with the high-resolution images. This saves you the the time and effort of creating those paths manually with the Pen tool in the graphics application, and provides XPress with a path on which to base the runaround path.

There are five options under the Type menu that let you specify how the text wraps around the image: Auto Image, Embedded Path, Alpha Channel, Non-White Areas, and Same As Clipping.

AUTO IMAGE

The Auto Image option will run the text around the image using the Outset value to specify how much space to leave between the text and the graphic—not between the text and the picture box. Selecting Auto Image creates an uneditable path around the image. You must change the background color of the box to None to display the image properly.

NOISE

The Noise, Smoothness, and Threshold options let you specify how closely the automatic path runs around the image. Because a major runaround path can contain several smaller paths, use the Noise field to specify which paths should be deleted and which paths included when creating a single runaround path. For example, a picture of a steaming cup of coffee with spikes of steam coming from it could generate one runaround path for the cup and others for the steam. All these paths are considered to be one runaround path. To delete the small steam paths, enter a value in the Noise field that corresponds to the diameter of the steam spikes (like 10 points). Click the Rescan button below the thumbnail to apply the new values (Figure 12.9).

Tip

Double-click on any item with the Item tool to display its Modify dialog box.

Rescan

When making changes in the Runaround and Clipping dialog box, if the Rescan button is available, click it to see the effect of your changes before exiting the dialog box.

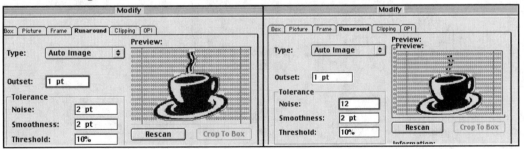

Figure 12.9. When the Noise value is increased to 12 points, the spikes of steam are clipped out of the path and the text will run around only the cup and saucer.

Clipping Paths

To practice working with clipping paths, do the following:

1. Launch Photoshop and open the *Sunfl.tif* file (a TIFF image) in the Student Files folder in the Unit 12 folder on the CD-ROM.
2. Use any of Photoshop's selection tools to select the flower—not the background.
3. Choose Make Work Path from the Paths palette menu.
4. Choose Save Path from the Paths palette menu and name the path *flower path*

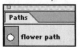

5. Choose Clipping Path from the Paths palette menu and select the *flower path*.

6. Save the file as a TIFF file.
7. In XPress, import the picture into a picture box. Because you "clipped out" the background, only the flower appears. Use the Clipping and Runaround commands to run the text around the flower petals.

SMOOTHNESS

The Smoothness value specifies how accurate the runaround path is. The lower the value, the more complex the path with a greater number of points. The higher the value, the less complex and therefore less accurate the path. However, more complex paths may give you problems when printing, so keep the Smoothness value as high as possible, and click the Rescan button to check the path.

THRESHOLD

The Threshold value refers to the line between dark pixels and light pixels and tells XPress how to determine which is which. Any pixel lighter than the Threshold value is clipped from the runaround path and any pixel darker than the Threshold value is included in the runaround path. Clicking the Rescan button lets you see how your new values are applied.

EMBEDDED PATH

The Embedded Path option reads a clipping path that was created in the graphic application like Photoshop and exported with the image. This path, embedded in the image when the image was exported, is used as the basis of a new clipping path in XPress (Figure 12.10).

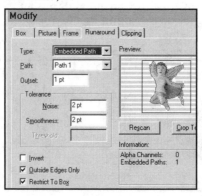

Figure 12.10. This image was saved as a TIFF file in Photoshop with an embedded path that XPress calls Path 1 under the Path menu on the left side of the dialog box.

ALPHA CHANNEL

Like paths, alpha channels can also be imbedded in a Photoshop image. You can select the alpha channel from which XPress will create the runaround path.

NON-WHITE AREAS

This option creates a runaround path based on the picture contents using the values in the Threshold field. Use this option to outline a dark object within a larger white or near-white background. You can also check the Invert box to run the path around the white areas and clip out the dark areas. Make changes under Tolerance and click the Rescan button to see how the path looks (Figure 12.11).

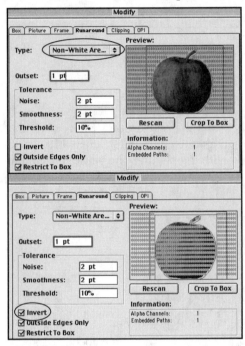

Figure 12.11. Select Non-White areas to run the path around the dark edges of the image. Click to select Invert to run the path around the white areas of the image. The Information area tells you that there is one embedded path and one alpha channel in this image. The path or channel could also be used to create a runaround path.

SAME AS CLIPPING

This option creates a runaround path based on the specifications you set in the Clipping Modify dialog box. In Figure 12.12 the TIFF image with its embedded path was imported into XPress. In the Clipping Modify dialog box, the Outset value was increased to 12 points and the Outside Edges Only option was selected. This caused the clipping path to appear around the outside boundaries of the image only and not around the inside areas between the children's hands. In the Runaround dialog box, when Same As Clipping was selected, the runaround path followed the expanded clipping path.

When you apply clipping and runaround values to an image, the size and position of the *picture box* are totally ignored. The text will wrap around the graphic using the values you specify in the Runaround and Clipping dialog boxes, not those in the Box Modify dialog box.

What's a clipping path?

A *clipping path* is any closed Bézier shape that defines a visible area. Whatever is inside the clipping path is displayed. Anything outside the clipping path is hidden or "clipped out."

FYI

The clipping path is selected from the Type menu in the Clipping dialog box and specifies which part of the picture will be displayed on the page. Unless you do this first, Same As Clipping will not be available from the Type menu in the Runaround dialog box.

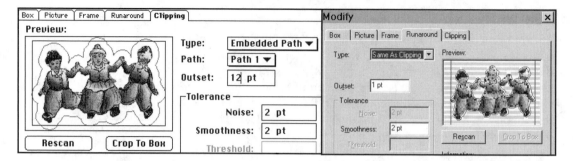

Figure 12.12. The Outset value in the Clipping Modify dialog box expands the embedded clipping path. When Same As Clipping is selected in the Runaround dialog box, the text runs around the expanded path. Use a small negative value in the Outset field, such as -.5 pt., to eliminate stray pixels.

PICTURE BOUNDS

The Picture Bounds option runs the text around the rectangular background of the imported picture, including any white background area that was saved with the picture. The values entered in the Top, Left, Bottom, and Right fields specify the distance of the text from the picture boundary (Figure 12.13).

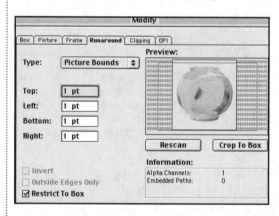

Crop to Box

Click Crop to Box to ignore portions of a runaround path that fall outside the selected box borders.

Figure 12.13. The Picture Bounds Runaround option wraps the text around the rectangular bounds of the picture's background.

EXERCISE G

1. Create a new document (File/New/Document) with 2 columns and an automatic text box. Display the Measurements palette (**F9**).

2. Click in the text box on the first page of the document and choose File/Get Text. Navigate to the Unit 12 folder in the student Files folder on the CD-ROM and double-click on the *Run.text* file to import it into the text box.

3. Choose Edit/Select All and click the Justify icon on the Measurements palette to justify the text. Copy and paste the text so that it fills both columns.

4. Use any of the picture box tools to draw a picture box about 3 inches wide and 3 inches high. With the box still selected, choose File/Get Picture. Double-click on the *Fishbowl.clip.tif* file in the Unit 12 folder in the Student Files folder on the CD-ROM to import it into the picture box. With the picture box selected, choose Item/Runaround (**Command-T**/Macintosh or **Ctrl-T**/Windows) to display the Runaround Modify dialog box. The default Runaround type is Item. Click OK. The text wraps around the outside of the picture box (Figure 12.14).

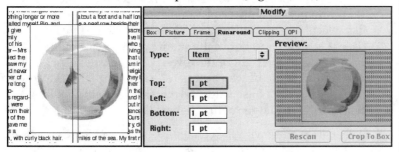

Figure 12.14. Item runaround wraps the text around the item (picture box), not the contents (graphic).

5. With the picture box still selected, choose Item/Runaround again. Select Auto Image from the Type menu. At the alert, click OK to delete the embedded path. Increase the Threshold value to 20, and click the Rescan button. Notice that some of the pixels in the image are clipped out because the higher threshold value defines more pixels as white and excludes them from the clipping path. Return the Threshold value to 10% and click the Rescan button. Click OK. The text now wraps around the image, not around the box, and the background color of the box is None (Figure 12.15).

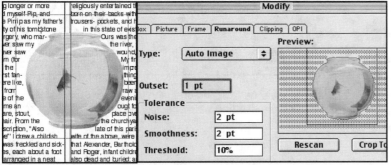

Figure 12.15. The Auto Image option runs the text around the outside of the picture, not the picture box.

6. Choose Item/Runaround again and select Embedded Path from the Type menu. The magenta runaround path appears around the non-white areas of the image, much as it did with the Auto Image command. However, unlike the Auto Image option, Embedded Path creates the runaround based entirely on the outline of the embedded path, not on any algorithm in XPress. Click OK.

7. Click inside the picture box with the Content tool and press the Delete key to delete just the image, not the box. With the picture box still selected, choose File/Get Picture and import the *Tower.tif* image from the Unit 12 folder in the Student Files folder on the CD-ROM. Resize the box to fit the image. Choose Item/Runaround (**Command-T**/Macintosh or **Ctrl-T**/Windows) and select Non-White Areas. Click to deselect the Outside Edges Only box and notice the small path that's created inside the graphic, to the right of the tower. Change the Noise value to 40 and click the Rescan button. The interior path disappears because a higher Noise value deletes smaller paths, making them part of the larger path. Click on OK.

8. Delete the picture with the content too. Choose File/Get Picture (**Command-E**/Macintosh or **Ctrl-E**/Windows) and import the *Palette.clip.tif* file from the Unit 12 folder in the Student Files folder on the CD-ROM. Choose Item/Runaround and click on the Clipping tab or choose Item/Clipping. In the Clipping dialog box, choose Non-White Areas from the Type menu and change the Outset value to 20. Click Apply. Notice how the image outline expands in the thumbnail image. Click on the Runaround tab and choose Same As Clipping from the Type menu. Click on OK. Your image should resemble Figure 12.16.

Clipping

Choose Item/Clipping (**Command-Option-T**/ Macintosh or **Ctrl-Shift-F10**/ Windows) to get to the Clipping dialog box without going first to the Runaround dialog box.

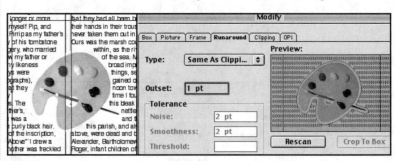

Figure 12.16. The Same As Clipping option in the Runaround dialog box runs the text around the clipping path specified earlier in the Clipping dialog box.

9. Choose Item/Runaround (**Command-T**/Macintosh or **Ctrl-T**/Windows) once more and choose Picture Bounds from the Type menu. The runaround path condenses to include only that part of the image background that is the default 1 point away from the image area. Type 10 in the Top field, press the Tab key twice to get to the Bottom field, and type 10 in the Bottom field. Press the Rescan button and notice that the magenta thumbnail is offset 10 points from the top and bottom of the image. Click on OK. Your screen should resemble Figure 12.17.

10. Close this file (File/Close). Don't save your changes.

FYI

If you click OK to close the Clipping dialog box, choose Item//Runaround to display the Runaround dialog box.

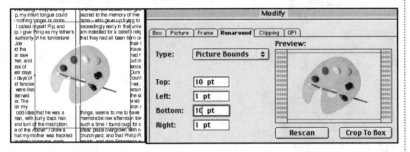

Figure 12.17. When Picture Bounds is selected in the Runaround dialog box, you can expand the boundary of the image background by typing values higher than the default 1 point in the Top, Left, Bottom, and Right fields.

CLIPPING PATHS

When you import a high-resolution image like a TIFF or EPS file into a picture box, that image comes in with the background against which it was created in the graphic program. For example, if you draw a flower in Adobe Illustrator or Corel Draw and export that file as an EPS file, the flower will appear against a white background even though you didn't specify a background color in the drawing program. Even specifying a background of None in the drawing program (Figure 12.18) results in the image being displayed against a white background in XPress (Figure 12.19). It's this white background that you clipped out in the earlier exercise to wrap the text around the graphic.

Figure 12.18. The image is specified with no fill and no stroke in Adobe Illustrator.

Figure 12.19. The image exported as an EPS file and placed in a picture box displays the white area around the image boundaries that obscures the text.

The only way to avoid having the image background transparent against the XPress page is to create a clipping path in a program like Photoshop and export that clipping path with the image as part of the EPS file format, as was done with the *Palette.clip.tif* image. QuarkXPress has always read such a clipping path, but in versions 4 and 5, you can also create a clipping path.

A *clipping path* is a boundary around part of the image which makes the image area inside the boundary opaque and the image area outside the boundary transparent.

1. Open the *None.qxd* file you created earlier or open the *None.qxd* file in the Unit 12 folder in the Student Files folder on the CD-ROM. Delete the existing picture box, draw another picture box, and import the *Palette.clip.tif* file into the picture box.

2. Adjust the picture box and the picture so that the image appears centered in the box. Notice the white area around the palette. This is the area that will be clipped out of the image so the text can run around the graphic.

3. With the picture box still selected, choose Item/Clipping to display the Clipping Modify dialog box.

4. Use the Type pull-down menu on the right side of the dialog box to select Non-White Areas. This will draw a green clipping path around the colored edge of the image.

5. Set the Outset value to 0 points so that the clipping path will be drawn against the edge of the image without including any of the white space.

6. Make sure that Outside Edges Only is deselected, otherwise the interior holes won't be clipped out. Select Restrict to Box. Notice the rough clipping path around the upper hole in the palette. Increase the Threshold value to 11 or 12 to extend the clipping path closer to the hole.

7. Notice the green clipping path running around the outside of the palette (Figure 12.20). The image area inside that green path will be opaque against the page. The white area outside the clipping path will be transparent against the page.

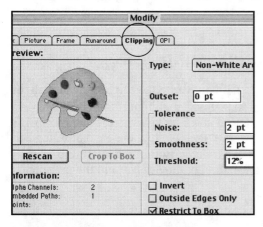

Figure 12.20. The green clipping path appears around the outside edges of the image.

8. Still in the Clipping dialog box, click on the Runaround tab to display the Runaround dialog box (Figure 12.21). Choose Same As Clipping from the Type pull-down menu, and notice that the display text now runs around the image along the edge of the clipping path.

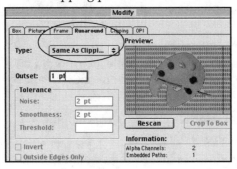

Figure 12.21. Clicking on the Runaround tab in the Modify dialog box displays the Runaround dialog box.

9. Click on OK. Your screen should resemble Figure 12.22. The text now runs around the image because the white background that was originally part of the image was made transparent by the clipping path. In the next exercise you will learn how to edit the clipping path and the distance between the clipping path and the text.

Figure 12.22. Once the clipping path is drawn and the Runaround command is applied to that clipping path, the type will wrap around the clipping path, leaving the white background transparent against the text.

SINGLE-COLUMN RUNAROUND

In the old days (Version 3.3), if you wanted to run text around all the sides of an item, you had to position that item somewhere between two columns of text. Versions 4 and 5 let you run the text around all sides of an item even if the text is in a single column. This runaround command is not available from the Runaround Modify dialog box because it is a function of the *text box*, not the graphic.

1. Open the *None.qxd* file in the Unit 12 folder in the Student Files folder on the CD-ROM. Delete the picture box. Select the text box and use the Measurements palette to change the number of columns from 2 to 1.

2. Choose Edit/Preferences/Preferences. Click the General tab and choose Off from the Auto Page Insertion menu. You will need only one page for this document.

3. Select the Oval Picture box tool and press the Shift key while drawing a circle about 2 inches in diameter. Choose File/Get Picture (**Command-E**/Macintosh or **Ctrl-E**/Windows). Navigate to the Unit 12 folder in the Student Files folder on the CD-ROM and double-click on the *Weed.tif* file (a TIFF file) to import it into the picture box.

4. With the picture box selected, press **Command-Option-Shift-F** (Macintosh) or **Ctrl-Alt-Shift-F** (Windows) to proportionally resize the picture to the box. Or, choose Style/Fit to Box (Proportionally) to fit the picture in the box.

5. Click inside the text box to select it. This is the one time when the text box, not the picture box, controls the runaround. Choose Item/Modify. Click on the Text tab to display the Text Modify dialog box. Check the Run Text Around All Sides check box to select that option. Click on OK. The text runs very closely around the picture box.

6. Select the picture box. Choose Item/Runaround (**Command-T**/Macintosh or **Ctrl-T**/Windows). Type 12 in the Outset field to create 12 points of space between the text and the picture box. Click OK. Your screen should resemble Figure 12.23.

7. Close this file. Don't save your changes.

Select Off in the Auto Page Insertion field to prevent XPress from automatically adding pages to the document if you type more text or import more text than will fit on the first page.

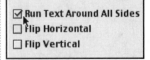

Select this option in the Text Modify dialog box to run text around all the sides of a picture box in a single-column text box.

Figure 12.23. Only after selecting Run Text Around All Sides from the Text Modify dialog box can you apply a text offset value from the Runaround dialog box.

LESSON 4: ALIGNING ITEMS

HORIZONTAL AND VERTICAL ITEM ALIGNMENT

You have already used the X and Y coordinates in the Measurements palette to position items at precise points on a page. However, many times it's easier to use the Space/Align command to position items (lines, boxes, text paths, or groups) in a specific relationship to other items. This command allows you to control the positioning of multiple items simultaneously by distributing them in a horizontal and/or vertical direction. To activate this command, Shift-select two or more items with the Item tool.

EXERCISE J

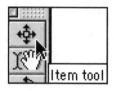
Item tool

1. Create a new document (File/New/Document) without an automatic text box. Use any of the standard-shape picture box tools to draw three different-sized picture boxes. Display the Colors palette (**F12**) and click on the Background icon. Select each picture box and click on a color's name in the Colors palette to apply the color to the item. You could also drag the color swatch onto the selected box. Move the three boxes so they are at different positions on the Y (vertical) axis.

2. Select the Item tool and click on the first box. Press the Shift key and select the second and third boxes. With all three boxes selected, choose Item/Space/Align (**Command-comma**/Macintosh or **Ctrl-comma**/Windows) to display the Space/Align Items dialog box.

3. Click the Vertical check box on the right side of the dialog box. Use the Between pull-down menu to select Top Edges (Figure 12.24). Click OK. The boxes are aligned at the same point on the Y axis. Click anywhere on the page to deselect the three boxes. Display the Measurements palette (**F9**). Select each box individually and notice that each box displays the same Y value on the left side of the Measurements palette.

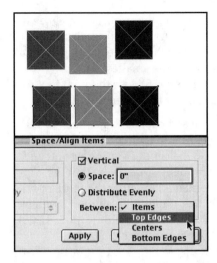

Figure 12.24. Selecting the Vertical and Top Edges options in the Space/Align Items dialog box aligns the selected items at the same point on the Y axis.

FYI

Items are vertically aligned relative to the top-most item. This item doesn't move; the other selected items move up to its position on the Y axis.

4. Use the Item tool to position the boxes one under the other. With the Item tool still selected, drag a selection marquee around the three boxes again. Choose Item/Space Align (**Command-comma**/Macintosh or **Ctrl-comma**/Windows). Select the Vertical option, click the Distribute Evenly button, and select Centers from the Between menu. Click the Horizontal check box and choose Left Edges from the Between menu. Click on OK. The boxes are aligned at the same point on the X (horizontal) axis. Deselect the boxes. Click on each box and notice that each box is aligned at the same point on the X axis on the Measurements palette and is at the same distance from the center of the other boxes (Figure 12.25).

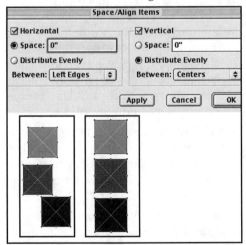

Figure 12.25. Deselect the Vertical option and select Left Edges from the Horizontal alignment option to align the selected objects along their left edges on the X axis.

5. Draw three different-sized squares on the page. Assign each a different color. Use the Item tool to drag the middle-sized square over the largest square. Drag the smallest square so that it overlaps the middle square. With the smallest square selected, choose Item/Bring to Front (**F5**). Use the Item tool to drag a selection marquee around the three items.

6. Choose Item/Space Align (**Command-comma**/Macintosh or **Ctrl-comma**/Windows). Select the Horizontal option and choose Centers from the Between menu. Select the Vertical option and select Centers from the Between menu. Make sure that the Distribute Evenly options are not selected in either the Horizontal or Vertical fields. Click Apply. The squares are aligned by their centers on both the Horizontal and Vertical fields (Figure 12.26). Close this file (File/Close). Don't save your changes.

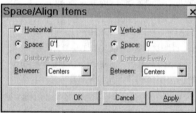

Figure 12.26. Selecting Centers from the Horizontal and Vertical Between menus aligns the selected items on their center points.

RULER GUIDES

Guides are nonprinting lines that you pull down and out from the horizontal and vertical rulers. They're used to align items on a page. You can use them in conjunction with the Measurements palette to align items without using the Space Align dialog box. Drag a horizontal guide down from the top ruler—rulers must be visible (View/Show Rulers)—anywhere on the page. Drag a vertical ruler out from the left ruler onto the page. Use the X and Y coordinates on the Measurements palette to position the guides.

One of the nifty features of the Context menu affects rulers. Control-click (Macintosh) or right-click (Windows) on the horizontal or vertical document ruler and drag to select Measure. Drag to select a different unit of measure without going to the Preferences dialog box.

When Snap to Guides is selected under the View menu, an item or its creation cursor snaps to a guide when you drag it within the snap distance specified in the Snap Distance field of the General Preferences dialog box.

Items don't have to overlap to be horizontally and vertically aligned from their centers.

GUIDE MANAGER

Choose Utilities/Guide Manager to display the Guide Manager dialog box. Here you control the placement of guides in a document for single pages and spreads. You can also use the Guide Manager to create, lock, or remove a guide grid.

EXERCISE K

1. On a new page in any document, choose Utilities/Guide Manager. Click the Add Guides tab and input the values in Figure 12.27. You're adding 10 guides on the current page with each guide spaced a half-inch apart. Select Absolute Position from the Type menu in the Origin/Boundaries field and type 1 in the Top and Left fields. If you select Inset, you can specify the distance of the first guide from the top of the page. Click the Add Guides button at the bottom of the dialog box to set the guides. Click OK.

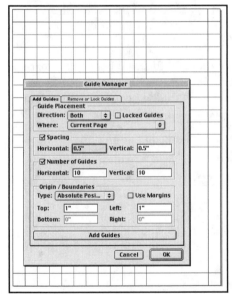

Figure 12.27. Use the Guide Manager to create, lock, and remove guides on a page or on a page spread.

Guide Manager

The documentation for the Guide Manager (and for other xtensions and Required Components) is located in a PDF file on the QuarkXpress 5.0 CD-ROM.

2. Choose Utilities/Guide Manager. Click the Remove or Lock Guides tab. Click the Remove Guides button to remove all the guides. Click OK. You could also use this dialog box to lock the guides so you don't inadvertently move them when you're moving items on the page.

Figure 12.28. The picture box overlaps the text box.

For this project, you'll create a flier and run the text around an EPS graphic. Then you'll work with the runaround function, using clipping paths, to create a two-page document.

1. Begin by creating a page with an automatic text box and 1 column. Draw a text box at the top of the page for the headline. Format the text using horizontal and vertical scale to fit the text in the box.

2. Drag the text box to the 3-inch mark on the horizontal ruler. Import the *Strawberry.text* file from the Unit 12 folder in the Student Files folder on the CD-ROM. Select the dummy text and assign it an absolute leading value of about 40 points.

3. Draw a picture box about 4" wide and the length of the text box. Make sure it overlaps the text box (Figure 12.28).

4. Import the *Berry.eps* file and resize it to fit the picture box. Use the Runaround command, selecting Non-White Areas to flow the text around the graphic (Figure 12.29).

5. On a new page, import the *Run.text* file. Make the text box two columns and draw a picture box. Import the *Peony.tif* file and use the Clipping and Runaround dialog boxes to run the text around the outline of the peony (Figure 12.30).

6. Close the file. Don't save your changes.

Figure 12.29. The text runs around the non-white image area.

Figure 12.30. Edit the clipping path in the Clipping dialog box, then choose Same As Clipping in the Runaround dialog box to run the text around the image.

Unit 13
Tables

OVERVIEW

In this unit you will learn how to:

Create tables
Insert, edit, and delete rows and columns
Select and modify cells
Modify a table
Format gridlines
Convert text to tables
Convert tables to text
Use tables in Web documents

TERMS

cell
gridline
table

LESSON 1: CREATING TABLES

TABLES

In QuarkXPress, a table consists of a series of rectangular, grouped boxes called *cells*. These cells can be text boxes, picture boxes, or boxes with a content of None that contain only a background color. Tables come in two flavors: You can draw an empty table and then fill the picture and/or text cells with content, or you can convert existing text to a table.

Table cells are tab-delineated. That is, you can use the Tab key with the Control key (Macintosh) or Ctrl key (Windows) to move from one cell to another.

CREATING A NEW TABLE

You create a table with the Table tool by drawing a rectangular outline. When you've drawn the rectangle, the Table Properties dialog box appears, where you specify the number of rows and columns in the table. QuarkXPress automatically calculates the width and height of the cells necessary to fit within the table you just drew.

INSERTING ROWS AND COLUMNS

Once a table is created, you can insert rows above or below a selected row, and you can insert columns to the left or right of a selected column. The new rows or columns will be the same cell type as the selected row or column (text, picture, or none), but will display default settings.

To insert a new row, do one of the following:

▲ Select a row with the Content tool and choose Item/Table/ Insert Rows. *Or*

▲ Use the Context menu. Control-click (Macintosh} or right-click (Windows) on the row.

To insert a new column, do one of the following:

▲ Use the Content tool to select a column in the table, then choose Item/Table/Insert Columns. *Or*

▲ Use the context menu by Control- or right-clicking on an existing column.

FYI

If you try to insert rows and columns with the Item tool, you'll select the entire table, not the individual cell.

SELECTING CELLS

You can select an individual cell, a row or rows, a column or columns, a block of adjacent cells, or nonadjacent cells. You can format selected cells, applying background color, changing their dimension, or formatting the text in those cells. To select cells, select the Content tool and do one of the following:

▲ Click to select an individual cell.

▲ Click the right or left edge of the table to select a row.

▲ Click the top or bottom edge of the table to select a column.

▲ Click and drag to select multiple rows or columns.

▲ Shift+click to select a block of adjacent cells or nonadjacent cells.

EXERCISE A

1. In a new document without an automatic text box or facing pages and with 1" margins, select the Tables tool and drag to create a rectangle from the left to right margin. When the Table Properties dialog box appears, accept the defaults for 3 rows and 5 columns. Select Text Cells and click OK. With the table selected, use the Measurements palette (**F9**) to resize the table so it's 6.5" wide and 3" high. The table is an item and can be modified from both the Measurements palette and from the Table Modify dialog box, just like any other QuarkXPress item.

Tables tool

2. We'll type headings for the table in the top five rows. Click in the first text box and type *Fabric*. Press **Control-Tab** (Macintosh) or **Ctrl-Tab** (Windows) to move to the next box in the row. Or, just click inside the next text box. Type *Type*, go to the next text box and type *Color*, in the next box type *Price per Yard*, and in the last box type *Use*.

3. Drag with the Content tool to select all five heads and format them in any typeface and type size from the Style menu, because the Measurements palette is inactive. While they're all still selected, choose Item/Modify (**Command-M**/Macintosh or **Ctrl-M**/Windows). Click the Text tab and choose Centered from the Vertical Alignment menu on the right side of the dialog box. Click OK. Your screen should resemble Figure 13.1.

Content tool

Figure 13.1. A table with 3 rows and 5 columns is created using the Table Properties dialog box.

Table Preferences

You can change the default values in the Table Properties dialog box by selecting the Tools pane of the Preferences dialog box (Edit/Preferences/ Preferences). In the Tools pane, select the Table tool and click Modify. The Modify dialog box lets you set default values for any table you draw. For example, you can specify that all your tables have 7 rows and 4 columns. The controls in this dialog box are the same as the corresponding controls in the Modify dialog box for tables and cells. If you want all of your tables to be the same, you can choose not to display the Table Properties dialog box by clicking the Creation tab and deselecting the Show Creation Dialog check box.

4. We'll import two fabric swatches into the first box (cells) in the second and third rows. Those boxes are text boxes, so click inside each box with the Content tool and choose Item/Content/Picture to convert them to picture boxes (Figure 13.2).

Figure 13.2. Change the content of any cell from the Item menu.

5. Click in the first picture box with the Content tool and choose File/Get Picture (**Command-E**/Macintosh or **Ctrl-E**/Windows). Navigate to the Unit 13 folder in the Student Files folder on the CD-ROM and import the *Denim.tif* file. Position it in the box. Move to the next cell and type *Denim*. Move to the third cell in the first row and type *Blue*. Move to the fourth cell and type *$9.95*. Move to the fifth cell and type *General clothing and jeans*.

6. Click on the second picture box, the first box in the third row, and choose File/Get Picture (**Command-E**/Macintosh or **Ctrl-E**/Windows). Navigate to the Unit 13 folder in the Student Files folder on the CD-ROM and import the *Plaid.tif* file. Click in the second box in the third row and type *Wool*. In the next three boxes type *Red/Green*, *$10.95*, and *Blankets*.

7. Select all the type in the last four cells of the second and third rows and use the Style menu to assign a typeface, type size, and centered alignment. While the cells are still selected, choose Item/Modify (**Command-M**/Macintosh or **Ctrl-M**/Windows), click the Text tab, and choose Centered from the Vertical Alignment menu. Click OK. Your screen should resemble Figure 13.3. Save this file as *FabricTable.qxd* in your Projects folder. Close this file.

Figure 13.3. The table includes picture boxes with graphics and text boxes with formatted text.

MODIFYING A TABLE

Once a table is created, use the Table Modify dialog box (**Command-M**/Macintosh or **Ctrl-M**/Windows) to edit it. If you select the table with the Content tool, the Table, Cell, and Text tabs appear in the Modify dialog box. If you select the table with the Item tool, the Table, Runaround, and Grid tabs appear.

ADDING ROWS

To add a row, use the Content tool and click on the table to select it. Then click inside any cell in the row next to which you want to add another row. Then click outside that row on the left or right side. A black arrow appears and the entire row is selected (Figure 13.4). Choose Item/Table/Insert Rows to display the Insert Table Rows dialog box. Type the number of rows you want to insert and their location (above or below the selected row).

Figure 13.4. Click outside a row with the Content tool to select the entire row.

ADDING COLUMNS

To add a column, first click inside any cell in the column next to which you want to add a column. Click above or below that column to display the black arrow and choose Item/Table/Insert Columns. Type the number of columns and their location in the Insert Table Columns dialog box to insert additional columns.

FYI

To constrain the rectangle to a square, press Shift while you draw the table.

Navigating tables

Press **Control+Shift+Tab** (Mac OS) or **Ctrl+Shift+Tab** (Windows) to jump to the previous cell.

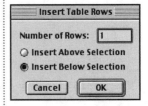

Select the number of new rows and their position in the table.

MERGING CELLS

You might have several cells running across the top of a table that you want to use for a heading centered across the table (Figure 13.5). To do this, use the Content tool and click anywhere in the table to select the table. Position the cursor outside the top row on the right or left side of the row until the black arrow appears. With the row selected, choose Item/Table/Combine Cells. Click OK. The alert warns you that this will combine all the cells into one cell that spans the width of the column. If cells contain data when you combine them, only the data in the cell at the left or the top of the selection is retained.

To revert to the original number of cells in the row, click anywhere inside the merged cell and choose Item/Table/Split Cells. The original cells appear, but any text or pictures they once contained are deleted.

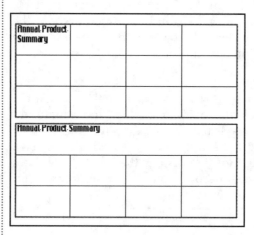

Figure 13.5. The cells in the first row of the top table were combined to create a single row running the width of the table.

EXERCISE B

1. If necessary, open the *FabricTable.qxd* file you created earlier or open the *FabricTable.qxd* file in the Unit 13 folder in the Student Files folder on the CD-ROM. It contains 3 rows and 1 column. Click inside the first cell in the first row, the Fabric cell, release the mouse button, and click outside the row to display the black arrow. You can click to the left of the Fabric cell or to the right of the Use cell to select the entire row.

2. Choose Item/Table/Insert Rows to display the Insert Table Rows dialog box. Type 1 in the Number of Rows field and click the Insert Above Selection button. Click OK. A new row with five cells appears above the first row (Figure 13.6).

Fabric	Type	Color	Price per Yard	Use
	Denim	Blue	$9.95	General clothing and jeans
	Wool	Red/Green	$10.95	Blankets

Figure 13.6. A fourth row is inserted above the first row in the table.

Clicking on a row or on a column with the black arrow selects the whole row or column.

3. To merge these cells into one row, click inside the new row to select it and click outside the row to select the entire row. Choose Item/Table/Combine Cells. The five cells are combined into one cell. Type a heading in that cell and format it.

4. Click inside the bottom row and click outside the row to select the entire row. Choose Item/Table/Delete Row to delete the row. If you had Shift-selected another row, the Item/Table menu would have read "Delete Rows." You can move the black arrow up and down while pressing the Shift key to select additional rows to delete.

5. Close this file. Don't save your changes.

FORMATTING TABLES

Up to now we've been modifying individual cells, rows, and columns by selecting them with the Content tool. But a table is an *item*, and when selected with the Item tool, we can modify the entire table from the Table Modify dialog box. Here we can use the Table tab of the Modify dialog box to:

▲ Change the dimensions and location of the table.

▲ Specify the way text behind the table wraps around it.

▲ Format the gridlines for the table.

CHANGING TABLE DIMENSIONS

You can always drag a corner handle of a selected table to resize it, just as you would do with any other item. Or you can use the Table tab to change the height and width of the entire table and to position it at a different location on the page. Leave Maintain Geometry unchecked (the default setting) if you want the table to become wider or taller as necessary to accommodate the size values. Check Maintain Geometry to resize the rows and columns proportionally to accommodate the change in table size. Click the Apply button in the Table Modify dialog box to see how the table will look with Maintain Geometry selected. Maintain Geometry also affects how the cells appear when you add and/or delete columns and rows. For example, if you need to add another row or column to a table that must fit in a specified space on the page, check Maintain Geometry; XPress then inserts the additional cells without changing the dimensions of the table.

RUNAROUND

The Runaround tab in the Modify dialog box for tables works the same as for text and picture boxes, except you can only apply a runaround of Item to a table. You can't apply a runaround of None to a table.

GRIDLINE FORMATTING

The Grid tab controls affect the gridlines of the table. Format the gridlines just as you would any other line in the document. Click the icon on the right side of the Grid Modify dialog box (Figure 13.7) to specify whether the selected formatting applies to both the horizontal and vertical gridlines, only the horizontal lines, or only the vertical lines.

Sorry!

You can't apply a color or blend to a table background unless you select individual cells and apply the color. When the table is selected with the Item tool, the Colors palette isn't available.

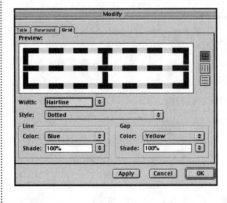

Figure 13.7. The Grid Modify dialog box is available when you select the table with the Item tool.

RESIZING ROWS OR COLUMNS

You can precisely resize selected rows and columns by inputting values in the Cell tab of the Modify dialog box. For example, if you've manually resized several columns in a table, and want to restore all the columns to the same width, you can do so automatically. To resize rows or columns: Select the entire row or column you want to edit and choose Item/Modify. Click the Cell tab and specify a value in the Height and/or Width fields. To create rows or columns of equal size that fit within the selected area, click the Distribute Evenly button.

RESIZING TABLES MANUALLY

As with other items in QuarkXPress, you can interactively resize rows, columns, and tables by dragging the item's (table's) handle.

▲ To resize a row or column, click a gridline to display the Resize pointer. Drag the pointer up or down to resize a row and left or right to resize a column.

▲ To resize an entire table, press one of the following keyboard commands while you drag a resize handle:

In Mac OS, **Command-drag** to resize all the rows and columns. **Command-Shift-drag** to constrain the resized table to a square. **Command-Option-Shift-drag** to resize rows and columns proportionally.

In Windows, **Ctrl-drag** to resize all the rows and columns. **Ctrl-Shift-drag** to constrain the resized table to a square. **Ctrl-Alt-Shift-drag** to resize rows and columns proportionally.

CONVERTING TEXT TO TABLES

To convert text to a table, first select all the text with the Content tool. Then choose Item/Convert Text to Table. The following rules apply to the conversion:

▲ Character formatting and styles are maintained.

▲ Some paragraph attributes are maintained; others, such as tabs and rules, are not maintained.

▲ You can specify the number of rows and columns to create placeholder cells.

▲ You can specify how the rows and columns are currently separated, usually by tabs and paragraph returns (¶).

▲ You can specify the order in which the table text will flow.

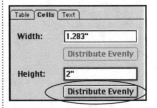

Click Distribute Evenly to edit rows and/or columns of equal size that fit within the table framework.

COPYING CELL CONTENT

To copy content from one cell to another, select it with the Copy command (**Command-C**/Macintosh or **Ctrl-C**/Windows) and paste it into the new cell with the Paste command (**Command-V**/Macintosh or **Ctrl-V**/Windows). To select content in more than one cell, Shift-select each cell with the Content tool. When you do this, you will replace the contents of all the target cell(s) with the pasted contents.

CONVERTING TABLES TO TEXT

To remove the table but keep the text in the table cells, convert the table to text. When converting a table, you choose the separation characters that are placed between the columns and rows of information that were in the table. To convert a table to text, select the table with either the Content tool or the Item tool and choose Item/Table/Convert Table to Text.

In the Convert Table to Text dialog box, specify how you want the text delineated. Separate the rows with paragraph returns and the columns with tabs unless you have a better idea. The Text Extraction Order menu defaults to Left to Right/Top Down, which is the usual order for table text. If you select the Delete table option, XPress will convert the table to text *and* delete the table. Click OK to display the text in a separate text box on the page.

EXERCISE C

1. Open the *Convert.qxd* file in the Unit 13 folder in the Student Files folder on the CD-ROM. Choose View/Show Invisibles (**Command-I**/Macintosh or **Ctrl-I**/Windows). It displays 4 lines of text with text in each line separated by tabs and with a paragraph return at the end of each line.

2. Select the heading text and format it. Select the table text and format it, giving it 6 points of spacing after each line (paragraph) from the Paragraph Formats dialog box (Style/Formats).

3. Select all the text and choose Item/Convert Text to Table to display the Convert Text to Table dialog box. It suggests that rows be separated with paragraph returns and columns separated with tabs. It also recognizes that there are 5 rows and 5 columns currently in the selected text and it recommends that you create 5 rows with 5 columns. The Cell Fill Order menu displays from left to right, moving from the top of the table to the bottom (Figure 13.8). Click OK to accept these values.

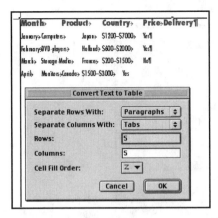

Figure 13.8. The selected text is converted to a table with 5 rows and 5 columns.

4. The table appears as a separate item in the center of the page. Move it with the Item tool and delete the original table text behind it. Position the table on the page.

5. Double-click the table with the Item tool to select it and display the Table Modify dialog box. Change the Width and Height values and click the Apply button to see the effect of your changes on the table. When you're satisfied, click OK

6. Select the Content tool and click on the second gridline, the one under the headings, to display the double-arrow pointer, the same pointer that appears when you drag a ruler guide. Drag the gridline up to reduce the height of the cells in the first rows (Figure 13.9).

Month	Product	Country	Price	Delivery
January	Computers	Japan	$1200–$7000	Yes

Figure 13.9. Drag a gridline up or down to resize all the cells in that row.

7. Use the Content tool and drag to select the four rows and columns below the heading row. Choose Item/Modify (**Command-M**/Macintosh or **Ctrl-M**/Windows) and click the Cells tab. In the Cells Modify dialog box, assign the color values in Figure 13.10 to give the cells a linear gradient background. Click OK.

Default cells

When text is converted to a table, the cells in the resulting table default to .25" high and 1" wide. You can change the size of the table cells by doing one of the following:

Use the **Cells tab** of the Modify dialog box.
Or
Manually resize the cells using the Content tool.
Or
Use the **Table Modify dialog box** to change the width and height values of the table, thereby resizing the cells.

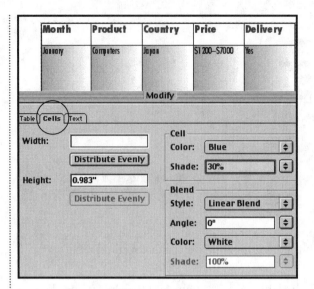

Figure 13.10.
Assign the cells a gradient background in the Cells Modify dialog box.

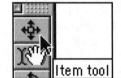

Item tool

8. With the cells still selected, drag the bottom right handle out to enlarge the table.

9. Select the table with the Item tool and choose Item/Table/ Convert Table to Text. Leave the default values and don't select the Delete Table option. Click OK. The original text appears as tab-delineated with paragraph returns after the original table rows.

10. Save the file as *Table.Web.qxd* in your Projects folder and close the file or leave it open for the next exercise.

LESSON 2: TABLES IN WEB DOCUMENTS

TABLES ON THE WEB

Any table you create in a QuarkXPress print document can be used on the Web. However, some table features are only available in print documents. These include blends for cell backgrounds, dashes and stripes in gridlines and varying widths for gridlines, text offset and Inter-paragraph Max values, multiple text inset values, and some runaround and text flip and rotated values. If you want to use these features in a Web document, you must convert the table to a graphic. We cover Web documents in Unit 16.

EXPORTING TABLES IN WEB DOCUMENTS

To maintain all the table formatting available in a print document, export the table as an image. This rasterizes the table and makes it unavailable for editing. This feature is available in a Web document that has been saved as such.

EXERCISE D

1. If necessary, open the *Table.Web.qxd* document you created earlier or open the *Table.Web.qxd* file in the Unit 13 folder in the Student Files folder on the CD-ROM. It displays the converted table as text in a separate text box. Delete this text box.

2. Choose File/New/Web Document. Accept the defaults and click OK to create a one-page document. Use the Item tool to drag the table from the QuarkXPress print document onto the Web document's page. Save the Web document as *WebDocument1* and select Web Document from the Type menu in the Save As dialog box.

3. Double-click with the Item tool to display the Table Modify dialog box. Select Convert Table to Graphic on Export at the bottom of the dialog box (Figure 13.11). When this box is checked, the selected table will be treated as an image upon export. If this box is not checked, the table will be converted to HTML. We'll do that later.

You can save a Web document as a document or as a template for use with other print material.

FYI

Convert Table to Graphic on Export is not a document-wide setting; you must check it for each table that you want to rasterize.

The Text Extraction Order menu lets you decide how you want the table contents to flow.

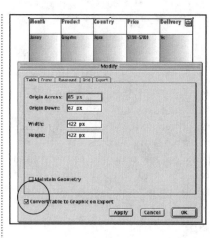

Naming Web export files

To name the Web document file other than Export1, choose Page/Page Properties and type a name in the Export File Name field. You don't have to add the .htm extension. XPress does that automatically when it exports the file.

Figure 13.11. Once a Web document is saved, selecting the table with the Item tool displays the Convert Table to Graphic on Export option in the Table Modify dialog box.

4. Choose File/Export/HTML. If you want to display the table in your Web browser, leave that option checked. Navigate to your Projects folder and click Export. The table opens in your browser (Figure 13.12).

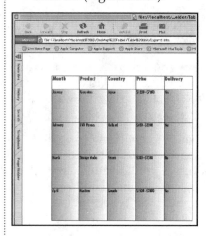

Figure 13.12. The table appears as a graphic in the Web browser (Internet Explorer here or in Netscape).

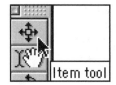

5. Double-click with the Item tool on the table in the Web document. In the Table Modify dialog box, deselect the Convert Table to Graphic on Export at the bottom of the dialog box. Click OK to export the file. You should be able to open the *WebDocument1.htm* file in a browser editor and edit it.

6. Close this file. Don't save your changes.

For this project you'll create a table with text and graphics to display information about personal digital assistants (PDAs), as shown in Figure 13.13.

Product	Company	Part Number	Price	Memory	Features	Product Shot
Palm VII	3COM	3C80501U	$199.00	8 MB	wireless	
Palm IIIC	3COM	3C80600U	$299.00	8MB	Color	
Jordana 547	Hewlett Packard	F1847A	$449.00	32MG	Color	
Clié	Sony	PEG-N710C	$499.95	8MG	Built-in MP3 player	

Figure 13.13. The formatted table contains text and graphics.

Reverse text

Reverse text is light text, usually white text, on a dark, usually black, background. In QuarkXPress, create reverse text by making the text box black and the type white.

1. In a new document with an automatic text box, select the text box and choose File/Get Text (**Command-E**/Macintosh or **Ctrl-E**/Windows). Import the *PDA.text* file from the Unit 13 folder in the Student Files folder on the CD-ROM.

2. Turn on Invisibles (View/Show Invisibles) and notice that the text is tab-delineated. Choose Edit/Select All (**Command-A**/Macintosh or **Ctrl-A**/Windows) to select all the text. Choose Item/Convert Text to Table. Accept the default values and click OK to convert the text to a table with 5 rows and 7 columns.

3. Format the heads (we used reverse text), change the Product Shot cells to picture boxes (Item/Content/Picture), and import the *Palm7x.jpg*, *Palm3c.jpg*, *Jordana.jpg*, and *Sony.jpg* files from the Unit 13 folder in the Student Files folder on the CD-ROM.

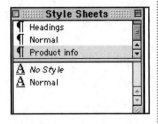

Styles work!

Create paragraph styles for the different cells to apply text formatting quickly and consistently.

4. Apply color to the text cells. Format the text and create style sheets for the headings and product info text. You may want to track the text to make it fit in the cells, or you can enlarge the table to accommodate the text.

5. Export the table to a browser by creating a new Web document (File/New Web Document) and dragging the table from the print document to the Web document. Then convert the table to a graphic in the Table Modify dialog box.

6. Close the file and save the document.

Unit 14
Color

OVERVIEW
In this unit you will learn how to:
Specify, apply, edit, append, and delete colors
Use different color models
Create gradients
Specify trapping values
Work with Quark's color management system
Trap colors to avoid misregistration on press
Use the Web color libraries
Import color from Photoshop and Illustrator files

TERMS
blend (gradient)
choke
color gamut
Color Management System (CMS)
color models
device-dependent color
device-independent color
Hexachrome color system
ICC (International Color Consortium)
 profiles
knockout
misregistration
Multi-Ink color system
overprint
process color
spot color
spread
trapping

LESSON 1: COLOR PRINCIPLES

WHAT YOU KNOW ALREADY

We've been creating and editing color in several earlier units, so by now you should be familiar with some of the basic principles that apply to color. You know that:

▲ Color can be either **process color**, made up of percentages of cyan, magenta, yellow, and black, or that it can be **spot color**, a custom color printed with only one ink on a separate plate.

▲ You should always specify color from the **swatch book** that matches the color system you have selected.

▲ Colors must be created in the Edit/Colors dialog box and **added to a document's color list** before they can be accessed from any of the menus, dialog boxes, or from the Colors palette.

▲ Selecting the **Spot Color check box** in the Edit Color dialog box will print that color on a separate plate; deselecting the Spot Color check box will separate the color onto four plates.

And perhaps by now you also know that there's a lot of voodoo in color work. The type of press, the pressperson's skill, the weight and coating of the paper, the quality of the inks—all these contribute to producing print documents that, we hope, resemble what we call "living color."

ADDING AND EDITING COLORS

QuarkXPress 5.0 ships with many color libraries, including the popular PANTONE and TRUMATCH systems as well as the new Multi-Ink and Hexachrome color systems. It also includes two Web color libraries. However, before you can apply a color to an item, to a frame, to text, to Bézier paths, or to certain graphic files, that color must be selected and named in the Edit Color dialog box. Once that's done, the color becomes part of that document's color list and is available for you to apply from either the Style menu, the Colors palette, or from several dialog boxes. If you select and name a color when no documents are open, that color becomes part of the default QuarkXPress color list, and you can access it from any document. You can always delete an added color.

HIGH-END COLOR MODELS

QuarkXPress 5.0 includes two high-end color models, Multi-Ink and Hexachrome Uncoated and Hexachrome Coated. The Multi-ink model lets you create a single ink color based on screen percentages

Colorizing TIFF files

Color can be applied to 1-bit and grayscale TIFF images, not to color TIFFs.

```
✓ RGB
  HSB
  LAB
  CMYK
  Multi-Ink
  DIC
  PANTONE® Coated
  PANTONE® Matte
  PANTONE® Uncoated
  PANTONE® Solid to Process
  PANTONE® Process
  PANTONE® Process Uncoated
  Hexachrome® Coated
  Hexachrome® Uncoated
  TOYO
  TRUMATCH
  Web Named Colors
  Web Safe Colors
```

The QuarkXPress 5.0 color libraries include two Web color libraries.

of existing process tints and/or spot color inks. The Hexachrome models, sometimes called "HiFi color," are color matching systems developed by Pantone, Inc., that consist of process colors printed with six plates instead of with the traditional four plates. By adding orange and green to the four CMYK plates, you can create brighter colors and increase the range of reproducible colors. Before specifying either of these colors, check with your printer, as these colors have special press requirements and are expensive to print.

WEB-SAFE COLORS

A *Web-safe color* is one that will display the same across Macintosh and Windows platforms and in any Web browser. There are 216 colors that fall into this category and are listed in the Web Safe library. Designing pages with Web-safe colors lets you see what your viewers will see with no unpleasant (ugly) surprises.

WEB-NAMED COLORS

Web-Safe and Web-Named Colors are two distinct color models, with different colors included in their libraries. Not all Web-safe colors are included in the Web-Named Colors palette, but all the Web-named colors are Web-safe.

EDITING COLORS

There are several ways to edit a color that has been added to the document's color list. You can change the color model, for example, from Pantone Coated to CMYK. You can then edit the CMYK color, by increasing or decreasing the percentages of any or all of the four process colors, cyan, magenta, yellow, and black. You can also change a color from spot color to process color or vice versa. The only thing you should not edit is a color's name/number if the color was selected from a color model like Pantone or TRU-MATCH. A color's name/number in the QuarkXPress library is the same name/number for that library in Adobe Photoshop, Adobe Illustrator, and many other graphics applications. If you change the number, other applications won't be able to apply it when you move text and images across applications and across computer platforms.

CMS XTension

QuarkXPress 5.0 ships with CMS, a color management XTension. This XTension checks the colors in the source image against the colors displayed by the monitor profile you select and against the printer profile you select. If your monitor or printer can't support a color specified in the document, Quark CMS changes the offending color to the closest matching color. To use Quark CMS, the XTension must be loaded via the XTensions Manager and the Color Management Active check box must be selected in the Color Management Preferences dialog box.

Easy access

Command-click or Ctrl-click on any color in the Colors palette to display the color selected in the Colors dialog box for the document.

EXERCISE A

1. Create a new document without an automatic text box (File/New/Document). Display the Colors palette (**F12**). Choose Edit/Colors (**Shift-F12**) and click on New. Choose Pantone Process from the Model pull-down menu.

2. Scroll to locate color 111-1 or type 111-1 in the PANTONE field beneath the swatch library. A warm red appears in the New field on the left side of the dialog box. Be sure that the Spot Color check box is deselected, because this color will be separated and printed on four plates. Click OK. Pantone S-111-1 appears in the color list for the active document. Click on Save.

3. Use any of the picture box tools to draw a picture box. The new color appears in the Colors palette, indicating that it's available for use. With the picture box still selected and the Background icon selected on the Colors palette, click on the name of the Pantone color or drag the swatch for PANTONE S-111-1 onto the selected picture box to fill the box with the background color.

4. Command-click (Macintosh) or Ctrl-click (Windows) on the Pantone color in the Colors palette to display the Colors for [file name] dialog box. Click on Edit. Choose CMYK from the Model pull-down menu. The Pantone color's name appears in the Name field (Figure 14.1), and the CMYK percentage fields display the values used to create the color. The new color appears above the original color on the left side of the dialog box.

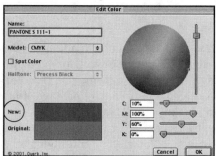

Figure 14.1. When you change a color model, the new color appears in the New field above the original color.

5. Type *CMYK Red* in the Name field and move the CMYK sliders to change the color to a different color red. The new color appears in the New field in the dialog box. Click on OK and notice that CMYK Red replaces the original PANTONE color in the list of colors for the document (Figure 14.2). Click on Save.

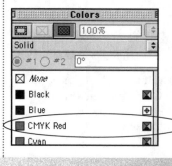

Figure 14.2. When you edit a color, its new name appears in the document's color palette. The new process color also displays the Process Color icon next to its name. We'll change this to a spot color, because we changed the color's name.

CMYK Red appears in the Colors palette instead of PANTONE S-111-1 and replaces the Pantone color in the picture box.

6. Choose Edit/Colors (**Shift-F12**). Use the Show menu to display Process Colors. Click on CMYK Red to select it and click on Edit. Click to select the Spot Color option so that this color will print as a spot color on one plate instead of as a process color on four plates. Change its name to Spot Red. Click OK. Because the Show Menu lists only process colors, the edited color, Spot Red, doesn't appear. Click Save. The edited color now displays a Spot Color icon next to its name in the Colors palette.

7. Save the file as *Color.qxd* in your Projects folder. You'll need it for the next exercise.

DELETING COLORS

You can always delete any color from the document's color list. If you've applied that color to text or to an item, an alert will appear, giving you the opportunity to substitute another color for the color you're deleting. The Delete Color command is an easy way to globally substitute one color for another in a document without selecting items and text and reapplying the new color.

EXERCISE B

1. If necessary, open your *Color.qxd* file or open the *Color.qxd* file in the Unit 14 folder in the Student Files folder on the CD-ROM. Display the Colors palette (**F12**). Choose Edit/Colors (**Shift-F12**).

2. Click on New and select Pantone Uncoated from the Model pull-down menu. Select Pantone 166 from the swatch library or type 166 in the Pantone field below the library. Make sure the Spot Color check box is selected so the color will print on only one plate instead of on four plates. Click OK. Click Save to add the new color to the document's color list and to the Colors palette.

3. Choose Edit/Colors (**Shift-F12**). Select Spot Colors from the Show menu. Both Spot Red and Pantone 166 appear, along with the default RGB colors. The Colors palette should also display CMYK Red and PANTONE 166 along with the default process and spot colors.

The Spot Color icon appears next to a spot color's name in the Colors palette.

Printing color from plates

To reproduce color on-press, the commercial printer creates a press plate from each of the QuarkXPress spot color and process ink separations. If the job is a process color job, four plates are created. If the process job includes spot colors, an additional plate is created for each spot color. The colored ink is then used to transfer the image from the press plate to the paper.

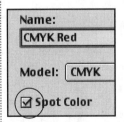

Select the Spot Color check box to specify a color that prints on only one plate.

4. Click on Spot Red to select it and click on Delete. An alert appears, asking you what color you want to use as a replacement for CMYK Red. Use the pull-down menu to select Pantone 166 (Figure 14.3). Click OK. Click Save. CMYK Red is removed from the document's color list and Colors palette, and the background color of the picture box changes to Pantone 166.

5. Close this file. Don't save your changes.

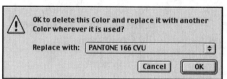

Figure 14.3. When a color that has been used in the document is deleted, you must choose a replacement color for the deleted color.

Model: PANTONE® Uncoated

Printing on paper

The kind of paper you use affects color output. Use the Pantone Uncoated color model when printing with genuine Pantone inks on (less expensive) uncoated paper; use the Pantone Process color model when printing color separations with Pantone inks. The Pantone ProSim model is used when printing color separations with inks not manufactured by Pantone, Inc.

DUPLICATING AND APPENDING COLORS

If you don't want to bother creating new colors, you can duplicate an existing color and edit the copy, or you can append one or all of any spot or process colors you created previously from any other XPress document. Just remember that when you duplicate and append colors, the spot color or process color designation stays with the color. If you have three or more spot colors in a document, you should convert all the spot colors to process colors so that you won't print more than four plates.

EXERCISE C

1. Create a new document (File/New/Document). Choose Edit/Colors (**Shift-F12**) and click on New. Choose Pantone Uncoated and select a color. Specify it as a spot color by selecting the Spot Color check box in the Edit Color dialog box. Click OK.

2. Click on New again and create another Pantone Uncoated spot color. Click OK. Use the Show menu to display Spot Colors. Your two new colors should appear along with the default RGB colors. Click on Save. The colors appear in the Colors palette, displaying the Spot Color icon next to their names. Save the file as *Color1.qxd* in your Projects folder.

3. Open the *Color.qxd* file in the Unit 14 folder in the Student Files folder on the CD-ROM. Choose Edit/Colors (**Shift-F12**). Click on Append. Navigate to the *Color1.qxd* file in your Projects folder and click on Open.

4. In the Append Colors to [file name] dialog box, click on the first Pantone color in the Available panel and click on the black forward arrow to add it to the Including panel. Repeat for the second Pantone color. Click OK. Click Save. The two new colors are added to the Colors palette for the *Color.qxd* document (Figure 14.4).

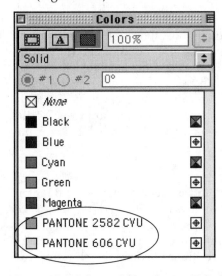

Figure 14.4. The two Pantone colors are appended to the Colors palette of the *Color.qxd* file.

5. In the *Color.qxd* file, choose Edit/Colors. Choose Spot Colors from the Show menu. Click on CMYK Red. Click on the Duplicate button to display the Edit Color dialog box. CMYK Red copy appears in the name field.

6. Move the CMYK sliders to change the color, type a new name for the new color, and click on OK. Click on Save. CMYK Red copy is replaced by the new color.

7. Close this file. Don't save your changes.

LESSON 2: CREATING BLENDS

BLENDS (GRADIENTS)

The Blend pull-down menu in the Colors palette defaults to Solid.

A *blend*, or as it is more properly called, a *graduated fill* or *gradient*, is comprised of two colors from the document's color list. You can create a blend or transition from one color to another in the Colors palette or in the Box Modify dialog box. QuarkXPress ships many different styles of blends, giving you unlimited design opportunities. Remember, however, that you must have created the colors you want to blend before you can create the blend. Never use any of the RGB colors for a blend in a print document. If you want to use any of the four process colors, select them from one of the libraries in the Edit Color dialog box. You'll get much better printing results.

ACCURATE BLENDS

The Accurate Blends check box in the General pane of the Preferences dialog box lets you control how the two-color blend *displays* on a monitor set to 256 colors. This is a faster way of viewing a blend, but doesn't make any difference with monitors set to thousands of colors (16-bit color) or millions of colors (24-bit color).

EXERCISE D

1. Create a new document without an automatic text box. Use any of the picture box tools to draw a picture box. Display the Colors palette (**F12**).

2. Choose Edit/Colors (**Shift-F12**) and click on New. Create two Pantone Uncoated colors, Pantone 396 and Pantone 2602. The easiest way to find these colors is to type the number in the Pantone box below the library. Specify both colors as spot colors by selecting the Spot Color check box in the Edit Color dialog box. Click OK and click on Save to add those two spot colors to the Colors palette.

3. Select the picture box and click the Background icon in the Colors palette. Use the Blend pull-down menu to select Linear Blend. Click on button #1 and click on Pantone 2602. The box is filled with a blend of the purple color and black, with the purple replacing the white in the default white-to-black gradient (Figure 14.5).

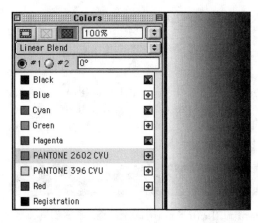

Figure 14.5. Use the Blend menu to select Linear Blend. Pantone 2602 replaces the default white color in the original blend.

4. Click on button #2 and click on Pantone 396. The box is filled with a linear blend of the two Pantone colors. With the box still selected, use the Blend pull-down menu to select another blend style.

5. With the box still selected, choose Item/Modify (**Command-M**/ Macintosh or **Ctrl-M**/Windows) to display the Box Modify dialog box. Use the Color pull-down menu in the Box field to select Pantone 396 as the first color. Use the Color menu in the Blend field to select Pantone 2602. Choose Full Circular Blend from the Style menu. Change the angle of the second color to 45 degrees (Figure 14.6). Click on OK to apply the new blend style.

6. Close this file or leave it open to use with the next exercise.

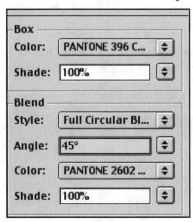

Figure 14.6. Use the Box Modify dialog box to apply blends from any two available colors.

LESSON 3: COLOR TRANSPARENCY

MAKING BOXES TRANSPARENT

A frequently used design technique is to overlay text on top of a graphic. If you want the graphic to show through the text box, you must make the text box transparent. To make any box transparent, choose a background color of None.

Colored text

Any color in the Colors palette can be applied to selected text if you click the Text icon on the Colors palette. You can't apply blends to text unless you first convert the text to a box. Of course, if you do that, you won't be able to edit the text.

Rectangle Text Box tool

EXERCISE E

1. Create a new document without an automatic text box (File/New/Document). Display the Measurements palette (**F9**).

2. Use the Rectangle picture box tool to draw a picture box about 7 inches wide and 2 inches high. Choose File/Get Picture (**Command-E**/Macintosh or **Ctrl-E**/Windows) and navigate to the Unit 14 folder in the Student Files folder on the CD-ROM. Open the *Pencil.eps* file. To fit the image in the picture box, do one of the following:

 ▲ Press **Command-Option-Shift-F** (Macintosh) or **Ctrl-Alt-Shift-F** (Windows) to fit the pencil in the box. *Or*

 ▲ Choose Style/Fit Picture in Box (Proportionally).

3. Draw a text box over the yellow area of the pencil. Type No. 2 and use the Measurements palette to align the type to the right side of the box.

4. With the text box still selected, do one of the following:

 ▲ Choose Item/Modify (**Command-M**/Macintosh or **Ctrl-M**/Windows). Use the Color pull-down menu in the Box field to select None (Figure 14.7). *Or*

 ▲ Click the Background icon on the Colors palette and click None, the first color option in the palette.

Figure 14.7. Select None in the Color field of the Box Modify dialog box or from the color list in the Colors palette to make the box transparent against any background.

5. If you're not in the Modify dialog box, choose Item/Modify again. Click on the Text tab and use the Type Menu in the Vertical Alignment field to select Centered (Figure 14.8).

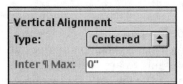

Figure 14.8. Center the text vertically in the text box by choosing Centered from the Vertical Alignment pull-down menu in the Text Modify dialog box.

6. Click OK. Deselect the box by clicking on an empty area of the page. Press **F7** to hide the guides. The text is centered next to the eraser directly on the pencil, because the text box is transparent against it (Figure 14.9).

7. Close this file. Don't save your changes.

Figure 14.9. The text appears directly on the background, because the text box has a background color of None.

LESSON 4: TRAPPING

COLOR TRAPPING

Not your problem

If you're printing to a low-resolution printer like an ink jet, color laser, or dye-sublimation printer, you don't have to deal with trapping issues.

Each time a sheet of paper slip-slides under a different printing plate in a multi-colored job, it shimmies just a fraction of a decimal of an inch. This causes tiny shifts of color to appear between the cyan, magenta, yellow, or black plates. If the job calls for printing a spot color, the white paper shows beneath the single color. This shift is called *misregistration*, and the problem is solved by trapping the colors (Figure 14.10). QuarkXPress provides sophisticated trapping controls, although it is always better to trap in a dedicated trapping program, an application most printers and imagesetters use.

Figure 14.10. The white area between the colored foreground object and the background color (made larger than normal for emphasis) is the "peek" and results when the paper misregisters on the press.

SPREAD

Spread or choke?

A general rule when trapping objects is to spread the lighter foreground object against a darker background. You should also choke a dark object against a lighter background.

Trapping compensates for these unwanted displays of color (misregistration) by extending the lighter colors very slightly over the darker ones in a process called *spreading*. If you have a light object on a dark background, expand the lighter object to create a spread. The spread traps or overlaps the darker background and prevents the darker color from "peeking" through the gap left by the paper shift (Figure 14.11).

Figure 14.11. A spread (dark line made darker for emphasis) prevents the "peek" from showing when a lighter object overlaps a darker background.

CHOKE

If you have a dark object overlapping a lighter background object, the darker color is choked, that is, the knockout area beneath the darker object is reduced, thus avoiding the "peek-a-boo" effect. (Figure 14.12).

Figure 14.12. The light background is choked to allow the darker foreground object to overlap the knockout when the paper misregisters on the press.

OVERPRINT

If you specify that the object is to overprint the background, there is no knockout area and nothing is erased. There is no spreading or choking. Color A is printed directly on color B. Unless Color A is black, or unless the overlapping colors contain percentages of the same process color, pray that the two colors don't bleed at the edges.

KNOCKOUT

Knockout works like a cookie cutter. When a foreground object knocks out the background object, it leaves a space for the foreground object to "fit." When misregistration occurs because of the paper shifting, the foreground object doesn't always fit perfectly into the knockout area and "peeks" can occur.

HOW MUCH TRAPPING?

Let's be very clear about this. Creating color traps is complicated, technical work best done by professional color strippers. No matter how sophisticated the computer program, trapping is still difficult and should be left to a professional or to dedicated trapping programs used by the imagesetter or printer. If you are doing your own trapping in XPress, ask your printer how much trapping you should apply. QuarkXPress defaults to .144-point of trapping which is a very conservative amount. Most printers will recommend .25-point of trapping, but always ask before applying traps.

TRAPPING TYPE

Try to use black or other dark colors for text and specify that they overprint the lighter backgrounds. Text characters, with their serifs and specialized shapes, are very difficult to trap and it is rarely done successfully.

For trapping purposes, the foreground item is called the *object*; the backmost item is called the *background*. You trap the object against the background. Below, the lighter circle is the object that traps against the darker background, the square.

DEFAULT TRAPPING

QuarkXPress 5.0 provides a default trap. You set the value in the Trapping Preferences dialog box and whenever XPress feels you need to trap, it applies that default value.

TRAPPING METHOD

The Trapping Preferences dialog box provides three kinds of default trapping: Absolute, Proportional, and Knockout All (Figure 14.13). **Absolute** trapping uses the values in the **Auto Amount** and **Indeterminate** fields in the Trapping dialog box. The default value is 0.144, but you can change that value to whatever your printer tells you should be the trap value. The **Proportional** option compares luminance and decides what should be trapped based on the how light or dark the background and foreground objects are. Proportional trapping multiplies the value in the **Auto Amount** field by the difference between the luminance of the object color and background color. Use the **Knockout All** option to turn off all trapping in the document. No chokes or spreads are applied; all foreground objects have a trap value of zero. Knockout All is your best option when printing a color composite or when printing to a laser printer, as traps are only visible on color separations.

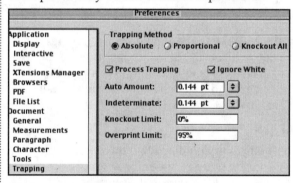

Figure 14.13.
The Trapping Preferences dialog box

PROCESS TRAPPING

If you turn Process Trapping on, XPress will trap each process separation plate individually if a document page contains process colors that overlap. If you are using trapping values in a document, turn Process Trapping on.

AUTO AMOUNT

Auto Amount is the value XPress will use when choking and spreading objects. This value is dictated by the printer and should be the first question you ask before you apply any traps. Choose

Overprint to cause any object and background colors trapped with the Auto Amount value in the Trapping Preferences dialog box or with an Auto Amount (+) or (-) value in the Trapping palette to overprint (Figure 14.14).

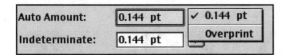

Figure 14.14. Specify the amount of spreading and choking XPress applies when it traps objects. Choose the Overprint option to automatically overprint objects instead of choking or spreading them.

INDETERMINATE

Sometimes an object must be trapped against a background with multiple colors, such as a gradient fill. The Indeterminate value specifies how much trapping should be applied when there are conflicting color relationships. You can also choose Overprint to override the trapping and print the foreground object directly on top of the multiple-color background.

KNOCKOUT LIMIT

The Knockout Limit value is a percentage of the darkness of the foreground object compared with the darkness of the background. If you leave this value at the default 0%, then a foreground object with a shade less than 0%—which is always white—will knock out the background. This lets the user set a percentage so that very light colors don't trap to dark colors; instead, they knock out the darker colors.

OVERPRINT LIMIT

The Overprint Limit value determines how dark an object to which you have applied the Overprint command must be before it overprints. If you specify 95% in the Overprint Limit field, for example, a foreground object that is shaded 80% and set to overprint will not overprint, because its 80% shade is less than the Overprint Limit value. Instead, it will trap according to the value in the Auto Amount field.

IGNORE WHITE

Check the Ignore White option to specify that a foreground object on a multicolored background that includes white does not factor in the white in the background when trapping. As with this and all of these options, check with your printer before specifying values and applying traps.

Indeterminate

An object positioned on top of a continuous-tone image such as a photograph reads that background as indeterminate.

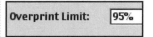

A 95% Overprint Limit value tells XPress to overprint any color that is (1) specified to Overprint in any trapping dialog box, and (2) with a shade value of 95% or greater.

COLOR-SPECIFIC TRAPPING

In QuarkXPress you can use the Trap Information palette to override the default trapping specifications in the Trapping Preferences dialog box. This lets you apply the same trapping values to any foreground color relative to any background color.

EXERCISE F

1. Create a new document without an automatic text box (File/New/Document). Draw a picture box on the page. Display the Colors palette (**F12**).

2. Choose Edit/Colors (**Shift-F12**) to display the Edit Colors dialog box. The first thing you should do when working with color for a print document is delete the three RGB colors, because they're never used in print work. Click on Red and click Delete. Repeat for the Blue and Green colors.

3. Now click on New. Choose Pantone Process from the Model pull-down menu. Type 186-2 in the Pantone S field below the swatch library. Make sure the Spot Color check box is deselected, because this color is being defined as a process color. Click OK to add the dark blue color to the document's color list.

4. Click on New again, and repeat to add Pantone Process color S1-6, a pale yellow, to the document's color list. Click on OK. Click on Save. Your Colors palette should resemble Figure 14.15.

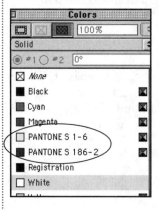

Figure 14.15. The three RGB colors have been deleted from the Colors palette, and two Pantone process colors have been added.

5. Make sure the Background icon is selected in the Colors palette and click on the Pantone 186-1 name or color swatch in the Colors palette to apply the blue to the background of the picture box.

6. Use the Oval Picture Box tool to draw a circle on top of the purple box. Fill its background with Pantone S1-6.

7. Choose Edit/Preferences/Preferences and click on Trapping. Leave the default values, choosing Absolute as the trapping method. Click OK.

8. Choose Edit/Colors (**Shift-F12**) and choose Process Colors from the Show Menu. Only the four default process colors (cyan, magenta, yellow, and black) and the two Pantone colors are listed. Click on Pantone S1-6, the foreground object color, and click on the Edit Trap button. The Trap Specifications dialog box for Pantone S1-6 appears (Figure 14.16).

Background Color	Trap ▼	↵?↦ ▼	Reverse ▼
■ *Indeterminate*	0.144 pt		
■ Black	0.144 pt	↵↦	Overprint
▨ Cyan	0.144 pt	↵↦	-0.144 pt
▨ Magenta	0.144 pt	↵↦	-0.144 pt
■ PANTONE S 186-2	0.144 pt	↵↦	-0.144 pt
□ Yellow	0.144 pt	↵↦	-0.144 pt

Figure 14.16. Selecting a color and clicking Edit Trap displays the Trap Specifications dialog box for that color.

9. Click on the background color, Pantone 186-2, the dark blue color, to select it. Use the Trap pull-down menu to select Default. This tells XPress to decide which color will choke or which color will spread according to the value specified in the Auto-Amount field of the Trapping Preferences dialog box. But, to have more control over the trap, use the Trap pull-down menu to select Auto Amount (+). This takes the decision away from XPress and specifies that the yellow circle will spread over the purple background using the value in the Auto Amount field. The asterisk after the 0.144 value indicates that Auto Amount (+) has been selected.

10. In the Dependent/Independent column, leave the current trapping relationship between the yellow and blue set to Dependent Traps. This option deals with inversing two colors and tells XPress to reverse the trap. Unless you know what you're doing, leave this set to Dependent. Click OK. Click Save.

11. Save this file as *Trap.qxd* in your Projects folder. You will need it for the next exercise.

Oval Picture Box tool

Dependent/Independent column

The Dependent and Independent Traps options are located under the trap symbol in the Trap Specifications dialog box.

ITEM-SPECIFIC TRAPPING

Even when you specify automatic trapping in the Trapping Preferences dialog box, there may be times when you want to customize the trapping specifications for a particular object. You do this in the Trap Information palette. You can use this palette to set trapping values for text, pictures, lines, and frames as well as for the backgrounds of boxes.

EXERCISE G

1. If necessary, open the *Trap.qxd* file you created in the last exercise or open the *Trap.qxd* file in the Unit 14 folder in the Student Files folder on the CD-ROM. Choose View/Show Trap Information to display the Trap Information palette. Click the yellow circle to select it. The Trap Information palette displays Default as the current trapping specification. Click the Information (**i**) icon on the right side of the palette to display the current trapping values (Figure 14.17).

Click the **i** for specific trap information.

FYI

Any grayed-out options in the Trap Information palette don't relate to the selected object you are trapping.

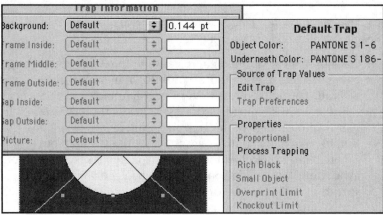

Figure 14.17. Clicking on the Information icon in the Trap Information palette gives you information about the trapping specifications for the selected object.

2. With the circle still selected, choose Item/Frame (**Command-B**/Macintosh or **Ctrl-B**/Windows). Apply a 6-point cyan frame. Choose Dotted from the Style menu. Choose yellow for the Gap color. Click OK to apply the frame. Now the Trap Information palette allows you to specify trapping values for the frame and the gap.

3. Close this file. Don't save your changes.

LESSON 5: COLOR MANAGEMENT

PRINTING IN COLOR

One of the problems with printing color is that the original version of an image used in the document often contains a wider range of color (color gamut) than the final output can represent. However, if you use the color management software in QuarkXPress 5.0, you will be able to ensure consistent color from your monitor, proofing device (such as an ink jet printer), and final output. QuarkXPress for the Macintosh OS works with Apple's ColorSync™ software. QuarkXPress for Windows can take advantage of various proprietary system-level color management systems, including Kodak Color Management.

DEVICE-DEPENDENT COLOR

Color reproduction depends on the devices used to display and produce color. Every color printing device, scanner, and computer monitor is capable of displaying or producing a specific range of colors, called a *gamut* or *color gamut*. Each device has a different color gamut, and therefore each device has its own way of assigning meaning to a color, called *rendering*. For example, a monitor from one vendor renders red using particular colored phosphors. A monitor from a different vendor might use different phosphors to define red, thereby displaying a slightly different color. When that same color is printed, yet another red may be output. This is what we mean by device-dependent color.

CREATING DEVICE-INDEPENDENT COLOR

Quark's CMS (Color Management System) defines colors so they display or output consistently across all devices. This is called *device-independent color*. The International Color Consortium (ICC) is an organization that provides a standard for characterizing device gamuts in a device-independent environment. Following the ICC standards, manufacturers and software developers then create profiles for specific devices called ICC profiles. These profiles on your computer provide the basis for effective color management.

SOURCE PROFILES AND DESTINATION PROFILES

Color management requires a formula for a source profile and another for a destination profile. You can use profiles provided by

device manufacturers, such as Kodak, or you can create your own profile.

Like PostScript printer drivers, ICC profiles are designed with the assumption that the devices are properly calibrated. If you want color management to work for you, you must adjust your monitor, scanner, and output devices according to design specifications.

RENDERING INTENTS

Quark's color management system (CMM) uses system-level color engine files, called Color Management Modules (CMM), to translate colors from a source profile's color gamut to a destination's color gamut profile. A rendering intent tells the CMM what color properties it should preserve when it performs this translation from one device to another. Quark CMS lets you choose from the following rendering intents:

▲ **Perceptual** scales all the colors in the source gamut (such as the scanner) so that they all fit within the destination gamut.

▲ **Relative Colorimetric** retains colors that are in both the source gamut (such as the scanner and monitor) and the destination gamut (such as the color printer). The only source colors that are changed are those that are not within the destination gamut.

▲ **Saturation** considers the saturation of source colors, and changes them to colors with the same relative saturation in the destination gamut.

▲ **Absolute Colorimetric** retains colors that are in both the source gamut and the destination gamut. Colors that are outside the destination gamut are adjusted in relation to how they would look when printed on white paper.

INSTALLING QUARK CMS COMPONENTS

Before you use Quark CMS, you must install the Quark CMS xtensions software to supply the color management user interface in QuarkXPress, as well as the ICC profiles to identify different devices you're using, such as monitors, composite printers, and separation devices. Additionally, the system-level color management requires ColorSync files on Mac OS, or proprietary color management files on Windows. To do this properly, check the QuarkXPress documentation, which takes you through all the steps of installing and configuring Quark's color management system. Once that's done, you can use the Profile Manager dialog box (Utilities/Profile Manager) to select the profiles you want Quark CMS to use.

The Quark CMS xtension must be active in the XTension folder if you want to use Quark's color management system.

WEB-SAFE AND WEB-NAMED COLORS

Both of these libraries are in print and Web documents, but should be used only with documents that will be converted to HTML or to PDF files for display on monitors or video screens, as they are RGB colors. When you select a color from the Web-Safe library, its Hex value appears next to its name (Figure 14.18). You need this value when editing HTML documents because early versions of HTML recognize a color only by its Hex value, not by its name. The difference between the two libraries is that later versions of HTML can deal with color names as well as with Hex values. The Web-Named library contains Web-safe colors, but it's frequently easier to select a color by name than by number.

Tip

To see how your Web pages will look on a standard color monitor, set your monitor for 256 colors and view the page in your Web browser.

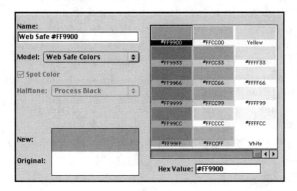

Figure 14.18.
Select one of 216 Web-safe colors from the Web-Safe library.

LESSON 6: COLOR FROM ILLUSTRATOR AND PHOTOSHOP

COLOR FROM PHOTOSHOP FILES

When you save a Photoshop CMYK file as a TIFF file and import it into QuarkXPress, the colors are automatically separated at print when you select the Separations option in the Print dialog box. No new colors appear in the Colors palette. You can also make tonal adjustments to the image from the Style menu.

When printing color separations for an XPress file that contains Photoshop images, always check the Separations box in the Document tab of the Print dialog box.

If you import a Photoshop EPS file (a duotone, for example) into QuarkXPress, that second color is added to the QuarkXPress Colors palette, because it's treated as a spot color. For example, in Figure 14.19, a Pantone color was used with black to create the duotone. When the Photoshop file is saved as a Photoshop EPS file and imported into the QuarkXPress picture box, that Pantone color appears as a spot color in the Colors palette. To print the file as a process color, convert the Pantone spot color to a process color in Quark's Edit Color dialog box, or you'll get an extra (costly) plate when you go to press.

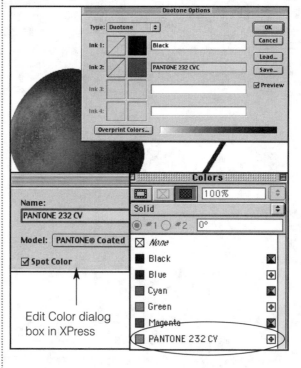

Edit Color dialog box in XPress

Figure 14.19. The Pantone color used for the duotone in a Photoshop EPS file appears as a separate RGB color in the QuarkXPress Colors palette.

COLOR FROM ILLUSTRATOR EPS FILES

As with Photoshop EPS files, any spot color used in an Illustrator file will appear in the QuarkXPress Colors palette. It's very important that the name of the color appear in XPress exactly as it appeared in Illustrator, or there will be problems when you print the file. And because that spot color comes in as an RGB color, you must convert it in XPress to a process color to avoid printing the extra spot color plate.

TRAPPING PHOTOSHOP AND ILLUSTRATOR FILES

You can't trap anything in a Photoshop TIFF, EPS, or Illustrator EPS file in XPress. However, if you know you're going to place those images against a colored XPress item, you can create the traps in Photoshop and Illustrator and then trap them in XPress.

In Figure 14.20, an Illustrator EPS file was imported into a QuarkXPress picture box. The yellow star was trapped against the blue background in Illustrator, but once the image comes into XPress and is placed against a yellow background, you have to trap the blue star box against the yellow XPress item.

Figure 14.20. The yellow star is trapped against the blue background in Illustrator. When the Illustrator file is saved as an EPS file and imported into an unframed QuarkXPress picture box, the blue background defaults to overprinting against the yellow box in XPress. You could also set the blue box to trap (spread) against the yellow background in the Trap Information palette.

To trap an EPS image with strokes to a QuarkXPress background color, add the strokes to the edges of the EPS image in Illustrator or in any other illustration application. Make those strokes twice the width of the trapping value you're using in XPress. For example, if you're using the default trapping value of .144-point in XPress, specify strokes that are .288 points in the illustration program.

Design a CD cover that incorporates CMYK TIFF images created in Photoshop and CMYK EPS images created in Illustrator. Import them into the QuarkXPress document and apply any necessary trapping. Be sure that all the colors are process colors and that any spot colors you use appear with the same name in Illustrator and in the QuarkXPress Colors palette. You may want to use the files in the CD Project folder in the Unit 14 folder in the Student Files folder as a start. Figure 14.21 shows you what that two-page file might look like.

Figure 14.21. A CD cover includes two pages, one for the cover and one for the insert. An additional image is used for the spine on the outside page. Use style sheets for the songs and song titles and runaround for the image on the right side of the insert page.

Unit 15
Printing

OVERVIEW

In this unit you will learn about:

Linescreen values
Device and image resolution
Printing bleeds
Crop marks and registration marks
Tiling
Output settings
Halftoning
Printing color separations
Print dialog box
Creating a PostScript file
Confirming fonts
Collect for Output

TERMS

bleed
color separations
crop marks
linescreeen
PostScript Printer Description files (PPDs)
registration marks
resolution

LESSON 1: PRINTING DOCUMENTS

HOW PRINTING HAPPENS

Electronic publishing is based on dots: machine dots made by a laser printer or imagesetter, which are the basis of all digitally generated documents, and halftone dots, which appear when creating process-color or grayscale documents for printing. In other words, machine dots are created by the printer; halftone dots are generated by the digital image when printing color images and black-and-white images that include levels of gray. It's the halftone dots that, in different sizes, reproduce differences in tones in a continuous-tone image like a scanned photograph. To create these different tones, the image is transformed into variable-sized dots by projecting light through a negative and a transparent "line screen." QuarkXPress and any raster image processor (RIP) will do this automatically. For a black-and-white picture, a 20% black area would ultimately be composed of dots that are half the size of the dots in a 40% black area. This technique tricks your eyes into seeing shades of gray.

CREATING THE ILLUSION OF COLOR

For a process color picture, one comprised of percentages of cyan, magenta, yellow, and black, the halftone dots are cyan, magenta, yellow, or black, in different sizes. Sometimes they're placed side by side; sometimes they overlap. It's in their size and positioning that the illusion of color, especially in complex colors and shades, is created. In QuarkXPress, the size and number of these halftone dots are determined by the lines per inch (lpi) setting (halftone screen frequency); the higher that lpi setting, the smaller and more plentiful the dots, and therefore the more detailed the image.

LINESCREEN VALUES

Lines per inch (lpi) refers to the resolution of a halftone screen in printing. Lpi is different from dpi (dots per inch), which refers to the resolution of the output device or to the image. In both cases, however, a higher value yields dots that are smaller and more plentiful. If you increase your frequency (lpi) without increasing your imagesetter resolution (dpi), there may not be enough "dots per cell" to allow the output of an adequate number of shades. In a perfect world, there should be about 256 levels of gray, or 256 possible ways of creating a halftone dot from machine dots—about the highest number of levels the eye can differentiate and the maximum number that PostScript Level 1 can generate.

What's a RIP?

A RIP (raster image processor) converts images described in the form of vector statements to rasterized images or bitmaps. For example, laser printers use built-in RIPs to convert vector data, such as text in a particular font, to rasterized data that the printer can then print. RIPs frequently perform trapping, job queuing, and other output-oriented tasks. A hardware RIP is a proprietary piece of machinery that runs RIP software designed specifically for that machine. Some RIP software is designed to be run on an ordinary computer that runs Mac OS or Windows.

DEVICE AND IMAGE RESOLUTION

The term *resolution* refers to the degree of detail in an image or in the quality of text output. Different output devices have different resolutions, usually measured in dots per inch. Images, depending on how they were created and saved in the graphics program, have image resolution.

300 pixels per inch

OUTPUT RESOLUTION

Output devices such as laser printers and Linotronic imagesetters have various output resolutions. A laser printer, for example, can have an output resolution of 300 dots per inch or 600 dots per inch. An imagesetter, however, can have output resolutions of 1240, 1500, or more dots per inch.

IMAGE RESOLUTION

There are two basic kinds of graphic files: bitmap files created in programs like Adobe Photoshop and Fractal Design Painter, and object-oriented images created in PostScript illustration programs like Adobe Illustrator, Macromedia FreeHand, and Corel Draw. Bitmap images are composed of pixels. Image resolution for bitmap images is usually measured in pixels per inch. The more pixels in the image, the larger the image resolution and the greater the detail and color fidelity. Object-oriented images are composed of paths drawn on X and Y coordinates.

150 pixels per inch

FILE FORMATS

Bitmap graphics are usually saved in TIFF (Tagged Image File Format), PICT, Paint, JPEG (Joint Photographic Expert Group), or PhotoCD formats, whereas object-oriented images, sometimes called vector images, are usually saved in EPS (Encapsulated PostScript) format. When you import a bitmap image into a QuarkXPress picture box, it comes in at the exact size and resolution that it was saved in the graphics program. If you enlarge a bitmap image in XPress, you arbitrarily enlarge pixels and therefore reduce the resolution or detail in the image. For example, if you import a 1" x 1" image with a resolution of 200 pixels per inch (ppi) and scale it to 2" x 2", its effective resolution drops to 100 pixels per inch, because you enlarged the pixels to create the larger image. Try not to enlarge bitmap images. You can reduce them without losing detail, but enlarging them beyond 10% of their original size can cause problems. EPS images, however, can be resized to any dimension, because they aren't composed of pixels, but rather of mathematical algorithms.

72 pixels per inch

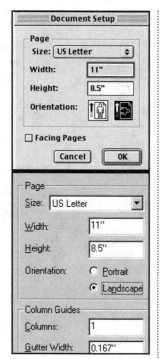

Select a vertical or horizontal Orientation in the Macintosh (top) or Windows (bottom) Document Setup dialog box.

Important info!

You must press the Return/Enter key to execute any command you type in the Measurements palette. Until you press Return/Enter, the new values do not take effect.

POSTSCRIPT PRINTER DESCRIPTION FILES (PPDS)

PPDs are PostScript Printer Description files. Select the appropriate PPD for your printer to ensure that the default information in the Print dialog box matches your output device. You can customize this list of PPDs by selecting PPD Manager from the Utilities menu and clicking on the check mark for any unneeded devices to remove them from the Include field. Click the Update button to execute the command (Figure 15.1).

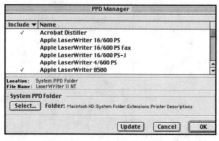

Figure 15.1. Specify which PostScript Printer Description files are active in the PPD Manager dialog box.

EXERCISE

1. Create a new file (File/New/Document) with 1-inch margins and without an automatic text box. Display the Measurements palette (**F9**). Use any standard-shape picture box tool to draw a picture box on the page. Choose File/Get Picture. Navigate to the Unit 16 folder in the Student Files folder on the CD-ROM and open the *Star.tif* image to import it into the picture box. Resize the picture box to accommodate the image by dragging on the box's resizing handles.

2. With the picture box selected, choose Item/Duplicate twice (**Command-D**/Macintosh or **Ctrl-D**/Windows) to create two copies of the image. Use the Item tool to position them one next to the other. Choose File/Document Setup (**Command-Option-Shift-P**/Macintosh or **Ctrl-Alt-Shift-P**/Windows). Click the Landscape icon (right) in the Orientation field to position the page horizontally in the file. Click OK.

3. Click on the second image and use the X% and Y% fields in the Measurements palette to enlarge the image to 150%. Typing this same value in both the X% and Y% field enlarges the image proportionally. Press Return/Enter after typing the values.

4. Click in the third image and use the X% and Y% fields to proportionally reduce the image to 50% of its original size. Press Return/Enter.

5. Choose File/Print (**Command-P**/Macintosh or **Ctrl-P**/Windows). Make sure the correct options, especially the Printer Description option, are selected in the Setup tab. Click the Setup tab and click the Landscape icon (right) in the Orientation field in the lower right corner of the dialog box.

6. Click the Output tab and select **Composite Color** (if you have a color printer selected) or **Grayscale** from the Print Colors pull-down menu. If you selected the correct PPD in the Setup tab, the Resolution field for that output device displays the maximum dots per inch the selected device can print. Below it, the lpi (lines per inch) value is displayed for the selected printer.

7. Choose **Printer** for the Halftoning option to use the selected printer's calculated halftone screen values. Make sure that the **Process Black plate** is selected in the Plate area. Usually the default values in the Plate fields are correct. Click on Print. This image may take a while to print because the printer has to process the image three times.

PRINTING BLEEDS

Use the Bleed tab (Figure 15.2) to specify bleed values for a document. A *bleed value* is the distance that an item can extend beyond the edge of a page. Input this value in the Amount field. Discuss these values with your printer, as they are determined by the kind of binding the publication will have.

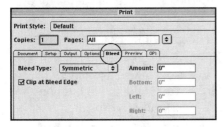

Figure 15.2. Make selections about how the bleed extends beyond the edge of the printed page in the Bleed tab of the Print dialog box.

The gradient bleeds off the top, bottom, and right sides of the page.

CROP MARKS AND REGISTRATION MARKS

Crop marks, also called *cut marks* or *trim marks*, are short horizontal and vertical lines printed outside the page's final trim size, indicating where to cut the page. Registration marks are symbols that are used to align overlaying plates.

TILING

Tiling prints a large document in sections (tiles). This is particularly helpful when printing oversized pages on a desktop printer. When you specify tiling, QuarkXPress prints portions of each document page in two or more overlapping tiles that create the complete page when laid side-by-side.

MANUAL TILING

This option lets you control the way in which a page is tiled, by positioning the Ruler Origin on the page.

AUTOMATIC TILING

Selecting the Automatic option lets QuarkXPress determine the number of tiles that are needed to print each document page. XPress decides this by calculating the document size, paper size, and crop mark and registration marks selections you made earlier.

OUTPUT SETTINGS

Once you select the printer and select the general specifications, use the Output tab to specify color, resolution, and halftone screen and angle settings. To specify Output tab settings for printing with color separations off, do the following:

1. Choose File/Print and click the Output tab. It defaults to black-and-white printing.
2. From the Print Colors pop-up menu, choose one of the following options:

 ▲ **Black & White** to print all document items as black and white with no shades of gray to a black-and white printer.

 ▲ **Grayscale** to print colors in the document as shades of gray to a black-and-white printer. This is the most common choice when printing to a black-and-white printer.

 ▲ **Composite CMYK** to print composite CMYK color when a color printer is selected in the Setup tab for the Printer Description pop-up menu.

 ▲ **Composite RGB** to print composite RGB color to a color printer when a color printer is selected in the Setup tab for the Printer Description pop-up menu.

If you choose a Printer Description for a CMYK device in the Setup tab of the Print dialog box, the Print Colors pop-up menu defaults to Composite CMYK. If you choose a Printer Description for an RGB device in the Setup tab of the Print dialog box (File/Page Setup), the Print Colors pop-up menu defaults to Composite RGB.

Black-and-white printing

Box backgrounds will print as black or white only. Any imported pictures may print with shades of gray.

Grayscale printing

A box with a yellow background will print as a light shade of gray. Darker colors will print as darker shades of gray.

HALFTONING

How QuarkXPress handles the halftone dots is determined by the Halftoning options. Choose one of the following:

▲ **Conventional** to let QuarkXPress calculate the halftone screen values;

▲ **Printer** to use the halftone screen values provided by the selected printer.

Once you select a Halftoning option, the default resolution for the selected PPD is automatically entered in the Resolution field. To specify a resolution other than the default value, you can enter a dots per inch (dpi) value in the Resolution field, or choose an option from the Resolution menu.

LPI VALUES

The default line frequency for the selected PPD is entered automatically in the Frequency field. To specify a line frequency other than the default value, enter a lines per inch (lpi) value in the Frequency field, or choose an option from the Frequency pop-up menu.

PRINTING COLOR SEPARATIONS

To turn color separations on and off, use the Separations check box in the Document tab of the Print dialog box. Use the Output tab (Figure 15.3) to specify color, resolution, and halftone screen and angle settings. To specify Output tab settings for printing with color separations on, do the following:

1. Choose File/Print. Click the Document tab. Check Separations.

2. Click the Output tab. Make the following selections from the Plates menu:

▲ **Used Process & Spot** to print plates for process and spot colors used in the document. *Or*

▲ **Convert to Process** to convert all colors in the file to process colors (at print time only) and print process separation plates. *Or*

▲ **All Process & Spot** to print all process and spot color plates.

FYI

When a black-and-white PPD is selected (like a black-and-white laser printer), the list at the bottom of the Output tab lists Process Black as the only color used to print the document. If you selected a color PPD, the appropriate color plates display in the list.

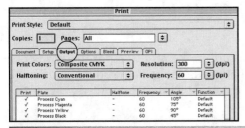

Figure 15.3. The Output tab of the Print dialog box is where you select color separation options.

PLATE LIST

At the bottom of the Output tab is a list of all the plates used in the document, as well as the default Halftone, Frequency, Angle, and Function settings. In most cases, these default settings in the plate list are the best for printing. You can, however, adjust them if you find the default values give you moiré patterns—undesirable patterns that can result when two or more halftone screens are improperly superimposed on press.

PRINT COLUMN

A check mark (default setting) in the Print column indicates that a plate will be printed. Click a check mark to uncheck the plate and cancel printing for that plate in the Print column. Or, select No from the Print column.

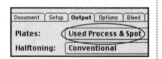

PLATE COLUMN

The Plate column lists spot colors and process inks in the document when Separations is checked in the Document tab. The Plates menu at the top of the Output tab specifies which document plates are listed if you select the Separations option in the Document tab.

The Plates menu appears if you select the Separations option in the Document tab.

HALFTONING FOR SPOT COLORS

Use the Halftone pop-up menu to assign a different screen angle to a spot color. You can choose C, M, Y, or K in the Halftone pop-up menu to produce the current angle, frequency, and dot function for the corresponding process color. The default screen values for spot colors are specified in the Halftone pop-up menu in the Edit Colors dialog box (Edit/Colors/New). Don't play with this option unless you talk to your printer first.

FREQUENCY AND ANGLE COLUMNS

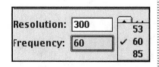

Select a Frequency (linescreen frequency) value from the Frequency menu if you don't want to use the default value. The Frequency value is specified in lines per inch (lpi).

The Angle column lists the screen angle for each color plate. You can choose a custom angle from the Angle menu, but check with your printer first.

OPTIONS TAB

The settings in this dialog box are helpful in reporting PostScript errors and for printing negatives. Settings in the bottom half of the dialog box let you control the way pictures are printed.

POSTSCRIPT ERROR HANDLER

This utility in the Options tab (designed only for PostScript printing) provides, in addition to PostScript error handling, information about where on a page the PostScript error occurs. For example, if the error occurs when printing a text box, the Postscript Error Handler will print the page containing the items that performed successfully up to the point of the error. The utility then prints an error report containing the bounding box of the item in which the error occurred. This box is identified by a black border and a 50% black background. A message at the top left of the page specifies the type of item that caused the error. All you have to do is lay the error report on top of the partially printed page to isolate the offending item. The bounding box on the error report indicates the location of the object causing the error.

PAGE FLIP

Select an option from the Page Flip pop-up menu:

▲ **Horizontal** to reverse the printing of page images from left to right.

▲ **Vertical** to print page images upside down.

▲ **Horizontal & Vertical** to print page images from left to right, upside down. When you choose Horizontal & Vertical, the image is right-reading, but the page feeds in the opposite direction of the None setting. Check with your printer before making selections from this menu.

NEGATIVE PRINT

When printing to a commercial printer, to print negative page images, check Negative Print. When Negative Print is checked, flipping a page horizontally or vertically will produce right-reading, emulsion-down film output, which is a common standard for commercial printers in the United States.

PICTURES

Here you specify the way pictures are printed. Choose one of the following options from the Output menu:

▲ **Normal** (default) to print high-resolution output of pictures using the data from the pictures' source files.

▲ **Low Resolution** to print pictures at screen preview resolution. This causes the file to print faster.

▲ **Rough** suppresses printout of pictures and box frames and prints a box with an X in it, like an empty picture box on-screen. This is a handy option when want to proof a file just for text.

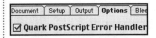

Select this option to learn which XPress items are causing PostScript printing problems.

Overprint EPS Black

Select this option to force all black elements in imported EPS pictures to overprint regardless of their overprint settings.

Data options

Choose ASCII from the Data menu for the standard format read by a wide range of printers and print spoolers. The Clean 8-bit option combines the ASCII and Binary formats. Binary is the fastest format but is not as widely used.

Below the graphic preview

are two smaller icons, the

cut sheet icon 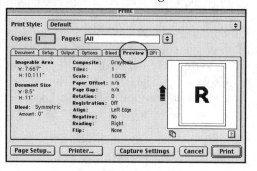 and

the roll-fed icons:

The cut sheet icon on the left indicates that you've selected a cut sheet output device, such as a laser printer, from the Printer Description menu in the Setup tab.

A roll-fed icon indicates that you selected a roll-fed output device, such as an imagesetter, from the Printer Description pop-up menu.

The question mark is a pop-up button that displays a legend of the different colors used in the graphic preview (in case you don't have your book handy!).

PREVIEW TAB

Click the Preview tab (Figure 15.4) to view the effect of the settings you selected for a print job before you output it. You can view the placement of the page on the selected print medium before you output it. Statistical information about the document page is listed on the left half of the dialog box.

Figure 15.4. The Preview tab of the Print dialog box is where it all comes together.

▲ The **blue rectangle** represents the document page.

▲ The **green rectangle** represents the imageable area for the selected medium. If you selected a Tiling option in the Document tab, the green rectangles indicate the imageable areas of individual pages, which lets you preview how the tiled pages will overlap at output.

▲ A **black rectangle** in the graphic preview represents the media area when a sheet-fed device is chosen in the Printer Description pop-up menu in the Setup tab.

▲ Any **gray area** surrounding the document represents bleeds if you entered a bleed value in the Bleed field of the Document tab.

▲ A **red area** indicates parts of the document that are outside the imageable area if the page size, including crop marks and/or bleed, is greater than the imageable area of the print medium and will be clipped. (If you selected Automatic tiling in the Document tab, the red area doesn't display.)

▲ **Registration marks display in black** when a Registration option is chosen in the Document tab.

▲ The **R** in the graphic preview displays the page's rotation: positive/negative, flip, and reading.

▲ The **arrow** to the left of the graphic preview indicates the direction the film or paper feeds into the output device.

LESSON 2: PRINT STYLES

CREATING PRINT STYLES

Use Print Styles to print a document quickly without making selections in the different tabs of the Print dialog box. To create a print style, choose Edit/Print styles to display the Print Styles dialog box (Figure 15.5).

Figure 15.5. Create and edit print styles in the Edit Print Style dialog box.

Make your selections in the different tabs and click Save. Click OK. Then choose that print style from the Print Styles menu in the Print dialog box. The Default print style is applied to every new document, but you can customize the Default print style to suit your specific printing needs for all new documents.

CREATING A POSTSCRIPT FILE

Frequently, a service bureau or the client will request a PostScript file, rather than a collection of QuarkXPress documents with their fonts, and picture files gathered together in a single file for printing. The advantage of a PostScript file is that all the high-resolution images and fonts are encapsulated in that file. The disadvantage is that unless you prepare the PostScript file properly, it won't print accurately.

When printing to a PostScript file, check all tabs in the Print dialog box, to confirm that the settings are correct for final output of the document. For example, if the document will be output to film separations from an imagesetter, check Separations in the Document tab. Choose the correct imagesetter PPD from the Printer Description pop-up menu in the Setup tab, and enter the correct linescreen in the Frequency field in the Output tab. Confirm these and any other settings with your printer.

From PostScript to PDF

Acrobat Distiller will create a PDF (Portable Document Format) file from a QuarkXPress PostScript file. You can then edit the PDF file in Adobe Acrobat or view it in Acrobat Reader.

To convert a QuarkXPress file to a PDF document:

1. Choose File/Export Document as PDF.
2. Click the Options button in the Export as PDF dialog box, select your options for saving lists and index entries as bookmarks and hyperlinks, and click OK.
3. Click Save. You may be asked to locate Acrobat Distiller if XPress can't find it on your hard drive.

Select Acrobat Distiller in the Printer Description menu of the PDF Export Options dialog box.

To create a PostScript file from a document on **Mac OS**:

1. Confirm that a PostScript driver is selected in the Chooser under the Apple menu.

2. Open the document, and then display the Font Usage dialog box (Utilities/Usage) to make sure all the fonts are available and that all imported pictures display a status of OK.

3. Choose File/Print, and then click the Printer button to display the Printer Driver dialog box. Before the Printer Driver dialog box displays, a message may display to inform you that changes will affect the setup of your printer driver rather than simply affecting the options within QuarkXPress. Choose File from the Destination menu and click Save.

4. Use the controls in the dialog box to specify a name and location for the file. Click Save to return to the QuarkXPress Print dialog box.

5. Click Print to save the document as a PostScript file.

To create a PostScript file from a document on **Windows**:

1. Set up a printer that is mapped to a file.

2. Open the document, and then display the Font Usage dialog box (Utilities/Usage) to confirm that all fonts are available and that all imported pictures display a status of OK.

3. Choose File/Print, and then choose the printer that is mapped to a file from the Printer pop-up menu in the Print dialog box.

4. Click Print to save the document as a PostScript file.

CONFIRMING FONTS

Fonts come in two flavors: Type 1 PostScript fonts and TrueType fonts. Type 1 Postscript fonts consist of screen fonts (bitmap) fonts and Printer (PostScript) fonts. The screen/bitmap fonts are used only to display the font on the screen. If you have Adobe ATM installed, the pixel outline of the display fonts will be smoothed for easier reading on the screen. The printer/PostScript fonts are downloaded to the PostScript printer to create the mathematically smooth curves and lines built into the PostScript fonts. If the printer can't access the printer/Postscript font, you'll end up with jagged type on the printed page.

TrueType fonts, in contrast, have both the screen/bitmap and printer/Postscript information built into one font. When you use TrueType fonts in your document, the PostScript information is built into the screen font and automatically goes to the printer.

Mapping a Windows printer

To map a printer to a file, add a PostScript printer (Start/Settings/Printers/ Add Printer). Then set the properties of the printer to print to file

Once you use text in any document, printing that document requires that the printer or imagesetter have access to the typefaces used in the document. If you create a file using Times New Roman and Futura Extended Bold, the printer must be able to access those fonts. If it can't, it will substitute (ugly) system fonts, causing text to reflow. That's the good news. The bad news is that the client won't pay for the job.

XPress has three ways of safeguarding against type disasters: An alert, the Font Usage dialog box, and the Collect for Output command. When you open a document that uses fonts not installed in your system, an alert appears telling you so and giving you the opportunity to substitute installed fonts for the missing fonts. Click on a font and click the Replace button to replace the missing font with one installed in your system.

FONTS USAGE DIALOG BOX

Another safeguard is the Fonts Usage dialog box. Choose Utilities/Usage and click the Fonts tab. The Fonts Usage dialog box lists every font in every font style used in the document. Any font or font style that can't be accessed by the system is displayed with a negative number. Click the Show First button to scroll to the first instance of that font in the document. Then click Replace and select a replacement font from one installed in your system.

COLLECT FOR OUTPUT

As a final precaution before sending the file to the imagesetter or printer, use the Collect for Output command under the File menu. Collect for Output creates a report listing every component in your document, including fonts used in any EPS files imported into the document with the Get Picture command. For example, if you used Minion Bold in an EPS image created in Illustrator or FreeHand and import that picture into an XPress document, the Collect for Output Report will tell you that Minion Bold was used in a picture file. Make sure all fonts listed in the Report are available to the printer.

It's a good idea to create a Collect for Output *report* before you actually collect the files. This lets you fix any problems you find before collection. Report Only is unchecked by default.

To open the Collect for Output dialog box and automatically check Report Only, press **Option** (Mac OS) or **Alt** (Windows) while choosing File/Collect for Output. Then check the files you want to collect in the Collect area and click Save. The Document option copies the document to the specified target folder. Select from the following options:

Substituting fonts

If you choose to substitute fonts for missing fonts, you may cause a reflow of the document.

Click the Replace button in the Fonts Usage dialog box to display the Replace Font dialog box, where you can select a replacement font from those installed in your system.

▲ **Linked Pictures** to copy imported picture files that must remain linked to the document for high-resolution output. These pictures will be placed in the "Pictures" subfolder within the target collection folder.

▲ **Embedded Pictures** to copy pictures that are embedded in the document upon import, such as PICT files (Mac OS) or BMP and WMF files (Windows). Including copies of embedded pictures in the collection doesn't affect output resolution of the pictures, but you may find it useful to keep copies of these pictures with the collected document items. These pictures are also placed in the "Pictures" subfolder within the target folder.

▲ **Color Profiles** to copy any International Color Consortium (ICC) profiles associated with the document or imported pictures. These profiles will be placed in the "Color Profiles" subfolder inside the target folder. (The Color Profiles check box is available only when the Quark CMS QuarkXTensions software is loaded.)

Good news!

When you select Collect Fonts, QuarkXPress will also collect fonts within imported EPS files—if those fonts are active on your computer.

▲ **Printer Fonts (Mac OS only)** to copy any printer fonts required for printing the document. These font files will be placed in the "Fonts" subfolder inside the target folder. Likewise, TrueType fonts function as both screen fonts and printer fonts. If your document uses only TrueType fonts (**Mac OS only**), QuarkXPress will collect them either when you check Screen Fonts or when you check Printer Fonts. If your document uses a combination of TrueType and Type 1 fonts, such as Adobe PostScript fonts, or uses only Type 1 fonts, all the fonts are collected completely. For **Windows only,** the Fonts option copies any fonts required for printing the document. These fonts will be placed in the "Fonts" subfolder within the target folder.

REVIEW PROJECT

Open any file you have created (the CD cover you created in the Unit 14 Review Project, for example), make sure it contains high-resolution images with process color, and print a composite and then print it with separations. Make sure to check all the appropriate options in the Print dialog box. Then use the Collect for Output command to create a report on the file before collecting the images and fonts in the file.

Unit 16

QuarkXPress on the Internet

OVERVIEW

In this unit you will learn how to:

Create Web documents

Set Web Preferences

Rasterize text boxes

Create HTML text boxes

Create and edit interactive elements

Create hyperlinks and use the Hyperlinks palette

Create rollovers

Set and edit anchors

Create image maps

Create forms

Use form controls in the Web Tools palette

TERMS

anchor

Cascading Style Sheets (CSS)

destination

form controls

HTML (HyperText Markup Language)

hyperlink

image map

PDF (Portable Document Format)

rollover

URL (Uniform Resource Locator)

XML (Extensible Markup Language)

LESSON 1: CREATING INTERACTIVE WEB DOCUMENTS

WEB DOCUMENTS

QuarkXPress 5.0 is used to create both print documents and Web documents. A print document spends its life going from press to paper—it's printed. A Web document is exported as an HTML (HyperText Markup Language) file and may never see a printer except for proofing purposes—it's exported. An HTML file is generated from a text file that contains a series of codes; that is, when you export the document in QuarkXPress 5.0 as HTML, the Web document is converted to an HTML document.

You can add interactive features to a Web document, such as hyperlinks, anchors, rollovers, image maps, forms, buttons, check boxes, and menus. These are tools that encourage viewers to look at your pages, stay on your site, and buy your products. They are also features that are not available to QuarkXPress print documents. Likewise, precision typography, color trapping, and specialized fonts are QuarkXPress print document features not available in a Web document.

CREATING A WEB DOCUMENT

FYI

Web documents are usually measured in pixels, so as soon as you select Web Document from the New menu, XPress automatically displays pixels as the unit of measure.

Choose File/New/Web Document (**Command-Option-Shift-N**/Macintosh or **Ctrl-Alt-Shift-N**/Windows) to display the new Web Document dialog box (Figure 16.1). Here you select default colors for the Web elements, a page size (really viewing dimensions), and a background color for the page. Right away you're making many design decisions that you don't make this early in the layout process with a print piece. Any options you select automatically appear on the master page for the Web document. If you want to change any of these options on individual pages once the Web document is created, go to the page you want to change, choose Page/Page Properties, and make your changes in the Page Properties dialog box. To reapply all the original master items to the document pages, just drag the Master Page A icon down over the document pages.

When you export this file, an HTML document is created. It's this HTML file that the Web browser reads. If you simply save the Web document, it can't be read by the browser.

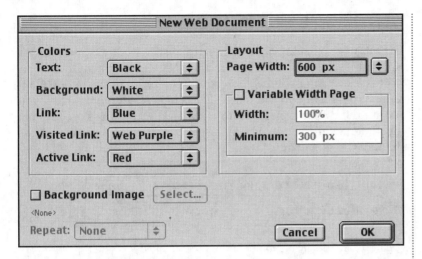

Figure 16.1. The New Web Document dialog box is where you set options for the Web pages.

PAGE WIDTH

The page defaults to 600 pixels (px) wide, a standard width. To make the page a variable-width page, check Variable Width Page and enter a percentage in the Width field and a minimum page width in the Minimum field. Selecting this option "stretches" the objects on the page as the user widens or narrows the browser window—as long as the width of the browser window is greater than the value in the Minimum field.

BACKGROUND PICTURE

This is like putting a picture box on a master page of a print document. If you select this option, the image appears behind all the other elements on every page in the Web document. To specify a background picture for the page, check Background Image, then click Select (Mac OS) or Browse (Windows) and locate the picture file. Choose an option from the Repeat pop-up menu:

▲ **Tile** to continuously repeat the picture both horizontally and vertically.

▲ **Horizontally** to continuously repeat the picture horizontally but not vertically.

▲ **Vertically** to continuously repeat the picture vertically but not horizontally.

▲ **None** to show the picture only once, in the upper left corner of the browser window.

FYI

You can drag items from any QuarkXPress print document onto a Web document page.

FYI

The background graphic on a Web document page should be a low-resolution (72 ppi) image.

SETTING WEB PREFERENCES

FYI

The Preferences panel for a Web document is slightly different than those for print documents.

HTML files are fussy about where they search for graphic files, so set your Web Preferences to direct the HTML document to the correct folder. Choose Edit/Preferences/Preferences and click General. Type a name in the Image Export Directory field. When you export the Web document as an HTML file, any images used in that document will be placed in this folder. If you don't create the folder, XPress will automatically create it for you (Figure 16.2).

Image Export Directory:	MyWebPix	
Site Root Directory:	Macintosh HD:De	Select...

Figure 16.2. Specify the folder and path to the folder where the Web document graphics are located.

To specify a path to that Image Export Directory, type a file path in the Site Root Directory field or click the Select button (Macintosh) or Browse button (Windows) to navigate to the folder you want to use. It's this folder that your Web document must find when exported as an HTML document and where XPress stores the graphics in that HTML document.

RASTER TEXT BOXES

A *raster text box* is a text box for which you check the Convert to Graphic on Export box in any tab of the Modify dialog box (Figure 16.3). The advantage of rasterizing a text box is that it (and its contents) won't change when viewed in a Web browser. In Figure 16.3 the specialty type used in the Web document displays as it was set, even though viewers may not have that typeface on their systems. That's the good news.

Figure 16.3. The text box was converted to a graphic when the Web document was exported as HTML.

The bad news is that too many raster text boxes in the HTML file increase download time, especially with a slower connection. This frustrates users who rarely wait more than 12 seconds for a page to load. Frustrated users do not hang around on your page buying stuff. More bad news: Unlike HTML text, rasterized text boxes can't be indexed by Web search engines, copied, pasted as text, or searched. The worst news is that these rasterized text boxes are exported at a monitor resolution of 72 dpi, which works fine for headline type but makes most body type difficult if not impossible to read. If you're just interested in the artistic integrity of your pages and want to provide a visual playground for viewers, then convert text boxes to graphics all the time. But beware of the limitations!

HTML TEXT BOXES

You create and manipulate HTML text boxes in a Web document just as you do in a print document, with the following exceptions:

▲ HTML text boxes must be rectangular. If you draw a nonrectangular text box, QuarkXPress automatically converts to a graphic when you export the Web document.

▲ HTML text boxes can't be rotated.

▲ HTML text boxes can contain columns, but QuarkXPress automatically converts columns to an HTML table when you export the document.

▲ You can dynamically resize an HTML text box and its text, but only if you resize it proportionally. You can't disproportionately resize an HTML text box.

▲ You can't use fractional point sizes like 10.2 for text in an HTML text box.

▲ Any items placed in front of an HTML text box that extend beyond the bounds of the HTML text box cause the HTML text box to behave as though the items in front have a runaround setting of None (Figure 16.4). Otherwise, items placed in front of, and totally inside, the HTML text box will display the assigned runaround option.

▲ You can't link HTML text boxes across pages.

▲ You can't use the following features in an HTML text box: Forced or Justified alignment, Hyphenation and Justification specifications (H&Js), First Line indentation, Lock to Baseline Grid, Tabs, First Baseline and Inter-Paragraph Max settings, Baseline Shift, kerning and tracking values, horizontal and vertical scaling, or Outline, Shadow, Small Caps, Superior, and Word Underline type styles. You can't flip text in an HTML

Time out!

In the year 2000 the average viewer wait for a page to download was only15 seconds. Now it's down to 12 seconds or even less. By the time you read this, it will probably be the blink of an eye. This means that you must create Web pages that load quickly if you expect anyone to view them.

text box either. If you really must use any of these typographic features, select the HTML text box and select the Convert to Graphic on Export option in the Text Modify dialog box.

Figure 16.4. Because the circle in the lower box extends beyond the HTML box, it displays a runaround value of None.

INTERACTIVE ELEMENTS

To make your Web page interactive, that is, to allow users to move from one page to another or from one place on a page to another spot on that page, or to submit or retrieve information to and from your Web site, use the interactive elements in the QuarkXPress Web document. You create these interactive elements using the Web Tools palette (Figure 16.5). This palette displays only when a Web document is active.

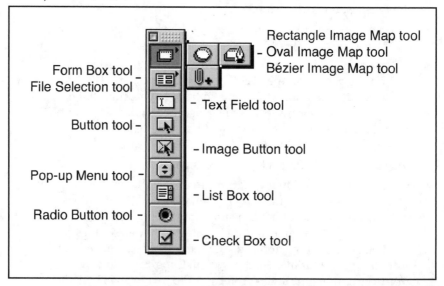

Figure 16.5. The Web Tools palette displays only when a Web document is active.

HYPERLINKS

Use hyperlinks to jump to another page, scroll to another part of the same page, or even to download a file. If you export the document as a PDF (Portable Document Format) file, you can use the hyperlink to print the document or to navigate the PDF file. You create hyperlinks in a QuarkXPress Web document using the Hyperlinks palette and the image map feature.

ABSOLUTE AND RELATIVE HYPERLINKS

An *absolute hyperlink* is a complete URL that contains a Web server address, such as **http://www.quark.com/sales/joe.html**. An absolute hyperlink requires the browser to search the Web and find a server. Also, absolute hyperlinks require you to update every link on a site when you update one link. Relative hyperlinks, in contrast, use the folders within a Web site to link those files on the same site.

A relative hyperlink looks more like this: **../sales/joe.html**. The **../** in the URL tells the browser to confine its search to the parent folder of the indicated path. This is much faster than scurrying all over the Web looking for the address.

HYPERLINKS PALETTE

To display the Hyperlinks palette, you must be in a Web document. Choose View/Show Hyperlinks. This palette is similar to the Style Sheets palette or the Colors palette. Here, you can create multiple destinations to other Web pages, other areas on the same page, hot spots on an image map, and even e-mail addresses. The Hyperlinks palette displays destinations (including anchors). These hyperlinks are stored with the active document. The top-level items are destinations; the indented items are the text or image hyperlinks in the active document (Figure 16.6).

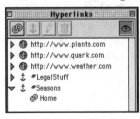

What's a destination?

A destination can be a link to other Web pages, to a "hot spot" on an image map, an e-mail address, or an anchored location.

Figure 16.6. The Hyperlinks palette displays URL destinations on the Internet and anchors to other items on the Web page.

ROLLOVERS

A *rollover* is a picture on an HTML page that changes when you move (roll) the cursor over it. Rollovers are commonly used as "buttons" that let users link to a different page or download a file. That's the good news. The bad news is that using very large images as rollovers will significantly increase download time, especially over a slow connection. Also, rollovers are not supported by every Web browser. They are, however, supported by Microsoft Internet Explorer 3.x and later and by Netscape Navigator. Rollovers are created from the Item menu when a picture box is selected.

EDITING ROLLOVERS

Once a rollover is assigned to a picture box, you can edit it by selecting the picture box and choosing Item/Edit Rollover. To change the rollover image, enter the path and name of a new picture file in the Rollover Image field, or click Select (Mac OS) or Browse (Windows) to locate the file manually. To change the hyperlink, enter a new URL in the Hyperlink field, choose a URL from the Hyperlink pop-up menu, or click Select (Mac OS) or Browse (Windows) to locate the file manually. To delete a rollover, select a picture box that has a rollover and choose Item/Rollover/Delete Rollover.

ANCHORS

An *anchor* is a marker attached to a specific spot in a document. When a hyperlink points to something on a document page or section in a Web page, it's pointing to an anchor.

IMAGE MAPS

An *image map* is an HTML feature that lets you link to different URLs by clicking on different parts of a picture in a Web page. Because Web browsers that display image maps give the user the option of turning off the graphic for faster browsing, it's a good idea to add regular textual hyperlinks for those users whose browsers aren't set to show images.

These five buttons are rollovers. When you move (roll) the cursor over any of the buttons (above), they morph into lighted buttons (below).

Find the Java script for rollovers at
http://www.handson.nu/ CODING/javascript.html

META TAGS

Meta tags contain information about a Web page. They're not displayed in a Web browser, but their insertion into a Web document makes it easier for a search engine to index your pages. To see which meta tags to use for your pages, view a Web page's source code. Before adding meta tags to your HTML document, check with your Internet service provider to acquire the necessary CGI (Common Gateway Interface) script information.

EXERCISE A

1. Create a new folder on your hard drive named *Web Document Files*. You'll use this folder to hold all your graphic images for the exported HTML document. Drag the image files from the Web Document Graphics folder in the Student Files folder in the Unit 16 folder on the CD-ROM into that new folder on the hard drive. In this exercise we'll create a Web document that contains hyperlinks, anchors, a rollover, and image maps.

2. Create a new Web document (File/New/Web Document [**Command-Option-Shift-N**/Macintosh or **Ctrl-Alt-Shift-N**/Windows]). In the New Web Document dialog box, leave the default values. In the Background Image area, click the Select button (Macintosh) or Browse button (Windows) and navigate to the Web Document Files folder you created earlier. Open the folder and click the *Background.gif* file to highlight it. Click Open. Back in the New Web Document dialog box, select Tile from the Repeat menu. Click OK to display the page.

3. Draw a text box on the top of the page and type *Seasons*. Format it in Helvetica bold at 36 points. Most computers have the Helvetica family active on their systems. Give it a centered paragraph alignment. Then choose Item/Modify (**Command-M**/Macintosh or **Ctrl-M**/Windows), click the Text tab, and choose Centered from the Vertical Alignment menu. Keep the text selected and display the Colors palette (**F12**). Assign the text one of the Web colors and the background a color of None to make it transparent against the page (Figure 16.7).

Select a Repeat option for a background image. The one-inch tile created in Photoshop and saved as a JPEG covers the entire Web document page when the Tile option is selected.

Figure 16.7. The text is formatted with a Web color and the box is assigned a background color of None to make it transparent against the page.

Color preview

If you're worried about how your color choices will display on readers' monitors, drop your own monitor resolution to 256 colors in the Monitors Control panel (Macintosh) or in the Display Properties control panel (Windows). You can also check the Web page preview in the Web browsers your readers will most likely use. There are two ways to do this:

1. Click the HTML Preview button at the bottom of the Web document window to preview the document in your system's default (or specified) Web browser. Or
2. Choose an option from the HTML Preview popup menu at the bottom of the Web document window.

4. Draw four picture boxes about 2 inches square and import the *Summer.jpg*, *Fall.gif*, *Winter.gif*, and *Spring.gif* files into them from the Web Document Files folder. Draw a text box next to each picture box and type *Summer Plants*, *Fall Plants*, etc. Format the type and vertically align it in the text box. Give each text box a background of None to make it transparent against the Web page (Figure 16.8).

Figure 16.8. Each picture box has an explanatory text box. Giving each box a background of None makes it transparent against the Web page.

CREATING THE ROLLOVER

To create a rollover, draw a small picture box on the page and import the *CatalogRoll.gif* file into it. Fit the picture in the box and resize the box. Keep the picture box selected. Do one of the following:

▲ Choose Item/Rollover/Create Rollover to display the Rollover dialog box. *Or*

▲ Display the context menu (**Control-click**/Macintosh or **right-click**/Windows) and choose Create Rollover to display the Rollover dialog box.

You need to assign two images to create the rollover. Click the Select button (Macintosh) or Browse button (Windows) next to Default Image. Navigate to the Web Document Files folder and open the Web Document Graphics folder.

▲ The **Default Image** is the picture that displays when the cursor *isn't over the rollover*. In this case, it's the *CatalogRoll.gif* image. Leave this in the Default Image field.

▲ The **Rollover Image** is the picture that displays when the cursor *is over the rollover*. To specify the rollover image, click the Select or Browse button next to Rollover Image. Open the *HomeRoll.gif* image in the Web Document Files folder.

▲ To add a hyperlink to the rollover, enter a URL in the Hyperlink field (Figure 16.9). We entered **http://www.quark.com**. This means that when we click on the picture box displaying the *CatalogRoll.gif* image, two things will happen:

1. The image will roll over to the *HomeRoll.gif* image. *And*

2. The **http://www.quark.com** page will open in the same browser window.

5. Click OK. When you create a hyperlink with a rollover, two icons appear in the corner of the picture box. The one on the left specifies the path to the image. The one on the right includes the URL. Move the cursor over each icon to see the information displayed.

FYI

To specify a default image for a rollover, enter the path and name of a picture file in the Default Image field, or click Select (Mac OS) or Browse (Windows) to locate the file manually.

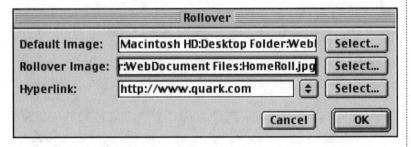

Figure 16.9. Enter the Default and Rollover image information in the Rollover dialog box.

CREATING THE HYPERLINKS

6. To create hyperlinks between the small text boxes and their picture boxes, display the Hyperlinks palette (View/Show Hyperlinks).

7. Select the text in the first text box, *Summer Plants*. To specify the destination for the hyperlink, do one of the following:

▲ Click a destination in the Hyperlinks palette. Currently, the only destination is **www.quark.com**, which is not the destination we want. *Or*

▲ Click the New Hyperlink button in the Hyperlinks palette to display the New Hyperlink dialog box, and then enter a destination in the URL field. *Or*

▲ Choose Style/Hyperlink/New to display the New Hyperlink dialog box, and then enter a destination in the URL field. *Or*

▲ Choose Style/Hyperlink/[destination]. Because the only available destination is **http://www.quark.com**, we'll need to use the second or third method.

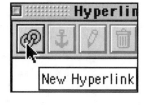

8. Click the New Hyperlink button in the Hyperlinks palette to display the New Hyperlink dialog box, use the menu next to the URL to select **http://** and then enter **www.plants.com** to set the URL. The URL now appears as a destination in the menu list (Figure 16.10) and in the Hyperlinks palette.

Figure 16.10. The Link icon on the right indicates the path to the graphic. The icon on the left displays the URL entered in the Hyperlinks palette.

9. Repeat this process to assign the **www.plants.com** destination to the other three seasonal text boxes. Because the destination (**http://www.plants.com**) already exists, you just have to select it from the URL menu in the New Hyperlink dialog box (Figure 16.11).

Figure 16.11. Once you add a destination in the URL field, it appears in the URL menu.

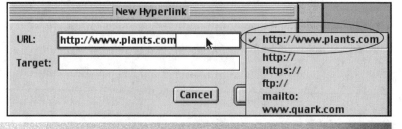

CREATING AN IMAGE MAP

10. To create an image map from the four picture boxes, display the Web Tools palette if it isn't already displayed (View/Show Tools/Show Web Tools). Make sure that the guides are displayed (View/Show Guides). Select an Image Map tool from the palette, in this case, the Rectangle Image Map tool. Draw a rectangle around the *Summer.gif* picture box. A red box with eight handles appears around the selected picture box, indicating the "hot area" that can be triggered by clicking on it once the document is exported. An icon appears in the upper right corner of the picture box, indicating that this box is an image map (Figure 16.12).

Figure 16.12. When you draw an image map box, the hot area appears inside the red lines when the picture box is selected.

11. Now we'll add a hyperlink to the image map. Make sure the picture box containing the image map is selected and that the Guides and Hyperlinks palette, are displayed. Click the New Hyperlink button on the Hyperlinks palette to display the New Hyperlink dialog box. Select **http://** from the URL menu and type **www.weather.com** to complete the URL (destination). Click OK. The new hyperlink appears in the Hyperlinks palette (Figure 16.13).

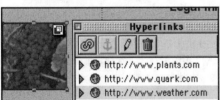

Figure 16.13. The hyperlink to an image map appears in the Hyperlinks palette.

12. Repeat this process to create image maps for the remaining three seasonal picture boxes, and add the same hyperlink to them from the URL menu in the New Hyperlink dialog box.

ADDING ANCHORS

An anchor points to a place in the HTML document and is created in the Hyperlinks palette. For example, you may want users to go to a picture or hyperlink in the Web document when they click on another picture or text box. By creating an anchor, you can help users navigate quickly and efficiently around your Web pages.

13. Draw a text box under the heading and type *Legal Information*. Give the text box a background of None to make it transparent against the Web page. We'll anchor this text box to another text box on another Web page.

14. Display the Document Layout palette (**F10**/Macintosh or **F4**/Windows). Drag the Master Page A icon down below document page 1 to create a second document page. On that new document page, draw a text box and type *Don't copy this Web page or we'll sue you.*

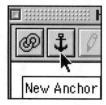

15. With the warning box still selected, click the New Anchor icon in the Hyperlinks palette to display the New Anchor dialog box. Type *LegalStuff* (no spaces or special characters are allowed) and click OK. The anchor appears in the Hyperlinks palette and an arrow displays in the upper right corner of the text box (Figure 16.14).

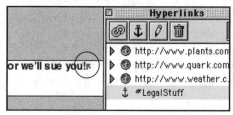

Figure 16.14. An arrow icon appears on an item that is anchored in the Web document.

16. Select the text in the *Legal Information* text box on the first page and click the Anchor icon next to **#LegalStuff** in the Hyperlinks palette to set the anchor. Drop the **#LegalStuff** anchor by clicking on the Disclosure Triangle (Macintosh) or + icon next to the anchor in the Hyperlinks palette to see what it's anchored to. Now, when the file is exported and you click on the Legal Information text box, you'll move directly to the text box on the second page.

17. Save the file in the Web Document Files folder, but keep it open if you have enough memory. If not, close the saved file.

EXPORTING THE FILE

Once all the image maps, hyperlinks, and anchors are set, it's time to export the file. Choose File/Export/HTML.

18. Make sure you're in the Web Document Files folder where all the graphics are stored. Launch Browser should be checked. Click Export. If you exported this file earlier, click the Yes All button to replace everything. The page opens in your default browser.

19. Click the *Legal Information* text box, which takes you to page 2 and the warning text box. Very nice, but there's no way to get back to the first page. We'll fix that now.

20. The Web document should still be open. If it isn't, open the file. Select the *Seasons* text in the heading box and click the New Anchor icon in the Hyperlinks palette. It displays **Seasons**. Click OK. The **Seasons** anchor appears in the Hyperlinks palette (Figure 16.15).

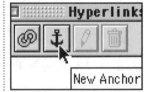

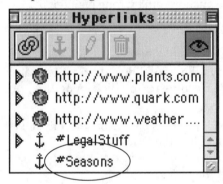

Figure 16.15. The *Seasons* anchor appears in the Hyperlinks palette.

21. Double-click on document page 2 to get there. Draw another text box under the warning text box and type *Home*. Select the text and click the Seasons anchor in the Hyperlinks palette. The Home text is now anchored to the Seasons text (Figure Figure 16.16).

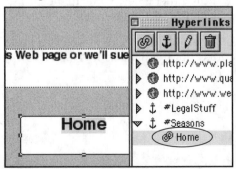

Figure 16.16. Select the text to be anchored and click the appropriate anchor in the Hyperlinks palette to set the anchor.

22. Save the file. Choose File/Export/HTML. Make sure you're in the Web Documents Files folder and click Export. Click Yes All to replace all the items. When the document appears in the browser window, click Legal Information to get to the warning text on page 2. Then click the Home text to get back to the top of page 1.

23. If you're connected to the Internet, click on the image maps and hyperlinks to get to the various sites.

24. Close these files. Don't save your changes.

EDITING INTERACTIVE ELEMENTS

Hyperlinks, anchors, and destinations can always be edited from the Hyperlinks palette. For example, if a URL changes, you will have to change that destination in the Web document. Or, when proofing links in the Browser, you may realize you've typed the URL incorrectly or that you've anchored the wrong elements.

EDITING A HYPERLINK

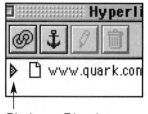

Disclosure Triangle

The Hyperlinks palette displays the hyperlinks, destinations, and anchors stored with the active document. To edit a hyperlink, do the following:

1. Select the hyperlink in the Hyperlinks palette or select the text or picture in the document. (Click the Disclosure Triangle/Macintosh or + icon/Windows next to the hyperlink destination and then select the hyperlink there.)

2. Display the Edit Hyperlink dialog box in one of the following ways:

▲ Click the Edit button in the Hyperlinks palette. *Or*

▲ Display the Hyperlink context menu and choose Edit. *Or*

▲ Choose Style/Hyperlink/Edit. Enter a new value in the URL field or choose an option from the URL pop-up menu. Click OK.

The new destination is added to the Hyperlinks palette and applied to the selected reference.

DELETING HYPERLINKS

Deleting a hyperlink means that you're removing its destination or changing it back to regular text, or to a regular picture. To delete a hyperlink, do the following:

1. Choose View/Show Hyperlinks to display the Hyperlinks palette.

2. Select the reference in one of the following ways:

▲ Select the reference text or picture in the document. *Or*

▲ In the Hyperlinks palette, click the Disclosure Triangle/Macintosh or + icon/Windows next to the hyperlink's destination and then select the hyperlink there.

3. Remove the destination in one of the following ways:

▲ Click the Delete button in the Hyperlinks palette. *Or*

▲ Display the Hyperlink context menu and choose Delete. *Or*

▲ Choose Style/Hyperlink/Delete. *Or*

▲ Display the context menu and choose Hyperlink. Then choose Delete from the Hyperlink submenu.

If you delete text or a picture box that is used as the source of a hyperlink reference, the reference is automatically deleted from the Hyperlinks palette.

STYLING HYPERLINKS

By default, hyperlinked text is underlined and colored according to the colors you selected in the New Web Document dialog box or as you later defined them in the Page Properties dialog box (Page/Page Properties). You can override the default appearance of individual hyperlinks by selecting the specific word(s) in the hyperlink and applying the desired styling (color, size, font, and text format). If you change the styling of a paragraph that contains hyperlinked text, the hyperlinks will reflect the font and font size changes of the paragraph, while retaining their default color and underlined text formatting. This way the hyperlinked text continues to be differentiated from the other text in the paragraph.

PAGE PROPERTIES

To specify a name for the exported file, choose Page/Page Properties (**Command-Option-Shift-A**/Macintosh or **Ctrl-Alt-Shift-A**/Windows). You can change hyperlink colors, page background color, and other page attributes in this dialog box.

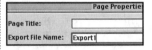

Specify a name for the exported HTML document in the Page Properties dialog box.

EDITING ANCHORS

Anchors are edited in the Anchor dialog box. To edit an anchor or to edit its name, do one of the following to display the Edit Anchor dialog box:

▲ Click the Edit button in the Hyperlinks palette. *Or*

▲ Click on the anchor in the Hyperlinks palette to display the Hyperlink context menu (**Control-click**/Macintosh or **right-click**/Windows), and choose Edit to display the Edit Anchor dialog box. *Or*

▲ Edit the text in the Anchor Name field. To do this, select the anchor in the Hyperlinks palette and click the Edit button at the top of the Hyperlinks palette to display the Edit Name dialog box (Figure 16.17).

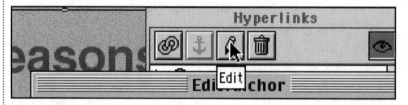

Figure 16.17. To edit an anchor, select the anchor in the Hyperlinks palette and click the Edit button.

DELETING AN ANCHOR

To delete an anchor, select it in the Hyperlinks palette and do one of the following:

▲ Click the Delete button at the top of the palette. *Or*

▲ Display the Hyperlinks context menu and choose Remove.

EDITING A DESTINATION

What's a destination?

A destination is where an anchor or hyperlink sends you.

Editing a destination changes all the hyperlinks that point to that destination, so be careful before doing this. To change the target URL of a destination, do one of the following:

▲ Select the destination in the Hyperlinks palette and click the Edit button to display the Edit Hyperlink dialog box where you can make the changes. *Or*

▲ Display the Hyperlink context menu and choose Edit from the context menu. Then edit the text in the URL field, select a different URL from the URL pop-up menu, or use the Browse button to locate a new file.

LESSON 2: FORMS

WHY FORMS?

We've all filled out forms on a Web site, some that search databases or others that let us order (frequently useless) goods over the Internet. Other uses for forms include inserting passwords to gain access to sites or to accounts stored on those sites. Forwarding information through e-mail is also a common use for forms. In this lesson we'll work with the powerful forms tools in QuarkXPress 5.0 to create HTML forms that perform some of these functions.

HOW AN HTML FORM WORKS

Like everything else on a Web page, an HTML form consists of HTML tags. Web browsers read these tags and convert them into text fields, buttons, check boxes, pop-up menus, and lists. Visitors to a Web site use these controls to enter information into the various form fields, then click a Submit button to send the contents of the form to a database on the Web site. However, although it's easy to build an HTML form, its usefulness depends on the CGI (Common Gateway Interface) script that receives, stores, and catalogs the form information. These scripts are usually written in languages such as Perl, C, and Java, depending on the server platform. For the purposes of this book, we'll create forms, but they won't go anywhere because we're not connected to any server. This is, after all, a *book*!

A form can be created only in a QuarkXPress Web document, because the Web Tools palette displays only in that mode. The Web Tools palette displays along with the standard Tools palette. You can use many of the standard tools to modify a form. For example, use the Item tool to position a form box on the page and the Content tool to type button names.

FORM CONTROLS

Once you create the form box, you have to do something with it. A form box is just a (required) placeholder for buttons and boxes (Figure 16.18). You add different controls to create an interface that visitors to your site will use to send you money and/or information. These controls—text fields, check boxes, radio buttons, submit and reset buttons, list controls, pop-up menus, and fields—let users send information to your site. You can also control a form's functions in the form in the Form Modify dialog box.

Target options in the Form Modify dialog box

None or Self to specify the same frame or window as the form.

Blank to specify the target as a new, unnamed window.

Self to specify the target as the same frame or window as the form.

Parent to specify the target as the frame or window that is a parent to the form. If there is no parent window, the form data will be displayed in the same window as the form (as if None or Self has been specified in the Target field).

Top to specify the target as the first window that does not contain frames, usually the page that introduces the form.

Action field in the Form Modify dialog box

Here you specify the script or application that will process submissions from the active form box. To specify a target script or application, enter its URL in the Action field, or click Select (Mac OS) or Browse (Windows) and then navigate to the script or application.

Type options for form controls

Text-Single Line for a control that can contain only one line of text.

Text-Multi Line for a control that can contain multiple lines of text.

Password for a control where all characters are displayed as asterisks or bullets.

Hidden Field for a control that will be submitted with the form, but will not display in the reader's Web browser. You can use a hidden field to send calculated data that the reader will not see. If Hidden Field is chosen, the Max Chars, Wrap/Wrap Text, Read Only, and Required fields will not be available.

Wrap options for form controls

Check the **Wrap**/Macintosh or **Wrap Text**/Windows check box to specify that multiple lines of text in the control should automatically wrap from one line to the next. (This check box is available only if Text-Multi Line is chosen in the Type pop-up menu.)

A password control lets users enter plain text, but displays that text only as a series of asterisks (or other special characters). A hidden field control submits a value when the form is submitted, but doesn't display that value to the reader. The Text Field control creates a field in which users can enter text, such as an address or password.

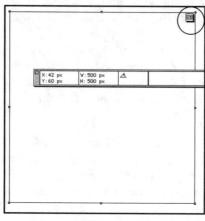

Figure 16.18. A form box can be resized from the Measurements palette. Notice the Form Box icon in the upper right corner of the form box.

FORM CONTROLS IN THE WEB TOOLS PALETTE

All the form controls are available from the Web Tools palette (Figure 16.5). This palette displays only when a Web document is active. When you draw with these tools, the item appears small, and in most cases can't be resized. That's because the tool creates the initial item. Its size is controlled by the form information you add in the item's Modify dialog box, not by dragging the box handles. For example, if you create a text control inside a form box, you can make it only wide enough to fit inside the form box. You can't adjust its height, because height is affected by the text information you add to the box. Likewise, when you draw a button control with the Button tool, only a tiny gray box appears. You can change its position by dragging the button or by changing the Origin Across and Origin Down values in the Box Modify dialog box, but you can't change its size. Its size is affected by the text you add to the button. Typing *Get More Information* will create a bigger button than if you type *Info*.

IMAGE MAP TOOLS

There are three Image Map tools:

▲ **Rectangle Image Map tool** to draw rectangle and square image maps on and/or around a graphic. The area within the image map is a "hot spot." Clicking anywhere on the hot spot takes you to a link on another Web page.

▲ **Oval Image Map** tool creates circles and ellipses. The interior of such circles and ellipses is the hot spot. Click anywhere inside the circular image map to go to the linked page.

▲ **Bézier Image Map tool** draws irregular shapes around a graphic and creates the hot spot within that shape.

FORM BOX TOOL

This tool is used to draw a rectangle form box. A form box just holds the form controls. All the form controls must fit inside the form box to be operable. You can resize a form box just as you would any other box. Entering values in the box's Form Modify dialog box is what makes it capable of sending information to the Web server.

FILE SELECTION TOOL

Use this tool to create a file submission control when you want the user to specify the path to a local file that will be uploaded when a form is submitted. When you draw with this tool, a Browse button is created. The reader can enter the file path or click this Browse button and navigate to the file. Use the Form Modify dialog box to name the File Submission control and specify a list of acceptable MIME (Multi-purpose Internet Mail Extensions) types.

TEXT FIELD TOOL

The Text Field tool adds a text field control to a form box. This lets the user enter text. A text field control can be used to enter plain text or a password. The password can be protected by displaying as special characters (usually bullets). A hidden text control field control submits a value when the form is submitted, but doesn't display the value to the user.

BUTTON TOOL

The Button tool creates Submit and Reset buttons. A submit button control lets users submit the form to the target script or to a designated application. A reset button control returns all fields and buttons in the form to their default values. This is handy if the user inputs incorrect material in any or all of the fields. Without a Submit button, the information a user types into any of the fields will never be transmitted to your Web site.

Form Validation in Form Modify dialog box

This area is where you specify what happens if a user tries to submit a form without entering information in a required field. **Error Page** specifies that a different HTML page should display.

URL of the page, or click Select (Macintosh) or Browse (Windows) to navigate to the page.

Dialog Message specifies that an alert should be displayed. Enter an alert message in the text box. To include the name of the first empty required field in the alert, use <missing field>. When the alert displays, this tag will be replaced with the names of the empty required fields.

Navigation menu in Edit Menu dialog box

To specify a menu as a navigation menu, check Navigation Menu in the Edit Menu dialog box. If a user chooses an item from a navigation menu, the Web browser will try to to open the URL specified as the value for that item. If you make the menu a navigation menu, be sure that the destination in the URL field is a valid (active) location.

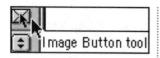

An image button should contain some identifying text.

IMAGE BUTTON TOOL

You can create image button controls that will submit or reset a form just as Submit and Reset buttons do, except the button is a graphic. To make the graphic user-friendly, include some text in the graphic so the users know what will happen when they click on it.

POP-UP MENU TOOL

Use this tool to create a pop-up menu that allows the user to select only one item from the menu. You can have multiple menu items, but only one can be selected.

LIST BOX TOOL

List controls let a user select one or more items from a pop-up menu. Once a list or menu is created and even exported, you can edit that menu in the Web document by selecting the list or menu and choosing Item/Modify. Make your changes, save the file, and export it again to display the edited list or menu.

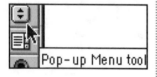

RADIO BUTTON TOOL

A group of radio button controls lets a user choose only one value from a selection of options. When a reader clicks one radio button, it deselects all the other radio buttons in the group. For example, if you wanted the user to rate your Web site on a scale of one to five, you could have five radio buttons, but the user would be able to select only one. You must draw each radio button separately. Duplicating a radio button box doesn't create another radio button. When you draw the button, you can resize it, but the size of the box won't affect the button's appearance. All buttons look alike.

CHECK BOX TOOL

A check box control can be either checked or unchecked by the user, and multiple check boxes can be selected. When you draw a check box, a small box appears in the upper left corner of the box, indicating that it's a check box. You must add the necessary text using the text tools in the default Tool palette, as there are no text tools in the Web Tools palette.

1. Create a new folder on your hard drive or in your Projects folder. Name it *Form Files*. Create a new Web document (File/New/Web Document) (**Command-Option-Shift-N**/Macintosh or **Ctrl-Alt-Shift-N**/Windows). Accept the default values and click OK. If the Web Tools palette isn't displayed, choose View/Show Tools/Show Web Tools. We're not going to pay any attention to Web page design in this exercise, just to working with the Web Tools palette.

2. Select the Form Box tool from the Web Tools palette. Drag the crosshair pointer to create a form box on the page. You can resize the form box using the box handles or the Measurements palette. With the form box still selected, type 500 (px) in the W field and 500 (px) in the H field of the Measurements palette. Press Return (Macintosh) or Enter (Windows) or click on the page to execute the changes.

3. With the form box still selected, choose Item/Modify (**Command-M**/Macintosh or **Ctrl-M**/Windows) and click the Form tab. Type a name for the form in the Name field. We typed *Sweaters,* because this form will list sweaters from a clothing catalog.

4. Choose a method of submission from the Method pop-up menu. The Get method puts the submitted material at the end of the URL. The Post method tells the Web browser to send the form data to a target script or application as a separate transaction. This is a preferred method because it doesn't limit the amount of data the user can submit. Choose Post from the Method menu.

5. To specify where the CGI application should display its reply (if any), choose None from the Target menu to specify the same frame or window as the form. Leave the other options at their default values and click OK.

6. Specify a MIME (Multipurpose Internet Mail Extensions) type for the form data by choosing an option from the Encoding pop-up menu. Choose urlencoded to specify that the form data the user submits to the Web server should be URL-encoded. This is a standard specification used on most hardware platforms and with most software applications.

7. Leave the rest of the fields at their default value and click OK.

Sorry!

Web documents don't allow facing pages, automatic text boxes, or page spreads.

Text Field tool

Oops!

Form boxes can't overlap other form boxes.

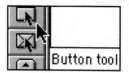
Button tool

8. Now we'll add a text field. Select the Text Field tool from the Web Tools palette. Click and drag the crosshair cursor inside the form box to create the text control box. The text control box must be entirely within the form box. With the text control box still selected, choose Item/Modify (**Command-M**/Macintosh or **Ctrl-M**/Windows) and click the Form tab. Type *Password Control* in the Name field. Select Password from the Type menu.

9. Type 10 in the Max Chars field to specify the maximum number of characters that the control will accept (no one is going to remember more than 10 characters, anyway!).

10. Leave Read Only unchecked to allow the user to edit the contents of the control. In this case, the user should be able to correct the password if he or she inputs the wrong characters.

11. Check the Required box to indicate that this control must contain a value before the form can be submitted. Click OK to return to the document.

12. Save the document as *WebDocument1* in the Form Files folder.

13. Once the text field is created, we'll create a Submit button to transfer the information to the Web server. Select the Button tool from the Web Tools palette and drag the crosshair cursor inside the form box to draw a button. It's tiny and you can't resize it, because a button automatically adjusts itself to accommodate the text.

14. Choose Item/Modify (**Command-M**/Macintosh or **Ctrl-M**/Windows) and click the Form tab to display the Form Modify dialog box *for the selected button*. Type *Submit Button* in the Name field and choose Submit from the Type menu. This tells the button control to submit the form data to the target script or application. Click OK.

15. Select the Content tool and click on the button. Type *Submit* and watch the button enlarge to fit the text (Figure 16.19).

Figure 16.19. The original button (Top) automatically resizes to accommodate the text.

16. Select the Button tool again, draw another box, and choose Item/Modify. Type *Reset Button* in the Name field and select Reset from the Type menu to configure the button control to return all the fields in the form to the default values. Click OK.

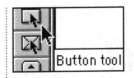
Button tool

17. Use the Content tool and type *Reset* on the button. It enlarges to fit the text.

18. To see how these buttons work, choose File/Export/HTML. Export the file to the Form Files folder. Make sure Launch Browser is checked and click Export. In the browser, the two buttons appear under the text control box (Figure 16.20). Click the Submit button and an alert tells you that you must enter information in that field. Type a few characters in the box, then click the Reset button to clear the field.

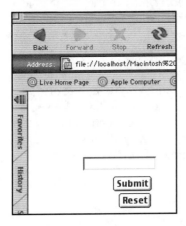

List Box tool

Figure 16.20. The text field and two buttons appear in the browser window as part of the form.

19. Now we'll add a list control and a pop-up menu to the form. The list control allows the user to select only one item from a menu. Select the List Box tool from the Web Tools palette and click and drag the crosshair cursor anywhere inside the form box. It creates a vertical box. Choose Item/Modify (**Command-M**/Macintosh or **Ctrl-M**/Windows) and click the Form tab to display the Form dialog box for the list box.

20. Type *Sweater List* in the Name field. Select Pop-up Menu from the Type field to make the list appear in a pop-up menu in the browser. If you prefer a scrollable list, select the List option.

21. To specify a menu, do one of the following:
 ▲ Select a menu that you've already created from the Menu pop-up menu. *Or*
 ▲ Create a new menu by clicking New to display the Edit Menu dialog box.

List Box tool

Naming files for export

Choose Page/Page Properties and type a name for the exported file in the Export File Name field.

Pop-up Menu tool

22. Since we haven't created a menu, click on New. In the Edit Menu dialog box, click the Add button to display the Menu Item dialog box. Type *Red sweater* in the name field. This is the name that displays in the menu.

23. Since this menu wasn't designated as a navigation menu, leave the value empty. This tells the form to send just the information selected in the Name field. If you want this menu item to be selected by default, check Use As Default. This way, if the red sweater costs $500 and the other items cost $29.99, users might just accept the default product. Sure!

24. Click Add again and type *Blue sweater* in the Name field. Click OK.

25. Click Add once more and type *Black sweater* in the Name field. Click OK to return to the Edit Menu dialog box. Click OK again to close the Edit Menu dialog box and click Save to close the menu's dialog box. Only the first item in the menu, *Red sweater*, appears in the Form box.

26. Choose File/Export/HTML. Make sure you're in the Form Files folder and that Launch Browser is checked. Click Export. At the alert, click Yes All to replace all the elements in the form. When the browser launches, use the pull-down menu (Figure 16.21) and select a single item. If you try to select another item, the first item is deselected.

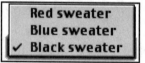

Figure 16.21. Only one item can be selected in a list box.

27. Now we'll create a pop-up menu that allows us to select more than one item. Click the Pop-up Menu tool and drag to create a box inside the form box. It displays as just the up and down scroll arrows.

28. With the menu still selected, choose Item/Modify and click the Form tab. Type *Sweater menu* in the Name field. Choose List from the Type menu. Use the Menu menu to select Sweater List Menu, the one you created earlier. Check Allow Multiple Selections to allow users to select more than one (expensive) sweater (Figure 16.22).

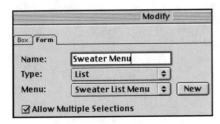

Figure 16.22. A pop-up menu can be displayed as a list or as a menu.

29. Export the file (File/Export/HTML) to the Form Files folder. Click Yes All at the alert. When the form opens in the browser, Shift-select more than one item in the menu (Figure 16.23).

30. Close this file. Don't save your changes.

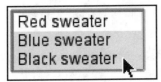

Figure 16.23. A pop-up menu allows you to Shift-select multiple items in the browser.

RADIO BUTTONS AND CHECK BOXES

Whenever you create buttons and check boxes, you have to provide some kind of text indicator. You can't splash buttons and boxes around a Web page without letting users know what they're clicking (or not clicking). To do this, use any of the text tools in the default Tools palette, but remember to use text formatting that won't change across computer platforms and systems.

EXERCISE C

1. Create a new Web document (File/New/Web Document) (**Command-Option-Shift-N**/Macintosh or **Ctrl-Alt-Shift-N**/Windows). Accept the default values in the New Web Document dialog box and click OK.

2. Use the Form Box tool to draw a large form box on the page.

3. Select the Radio Button tool and click and drag with the crosshair cursor to create three boxes, one underneath the other, inside the form box (Figure 16.24). Notice that no matter what size you draw the box, the buttons are all the same size.

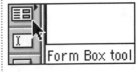

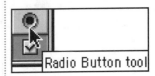

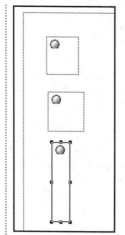

Figure 16.24. Use the Radio Button tool to create buttons.

4. Shift-select all three boxes and choose Item/Space Align (**Command-comma**/Macintosh or **Ctrl-comma**/Windows) and apply the Horizontal and Vertical values in Figure 16.25. Click OK.

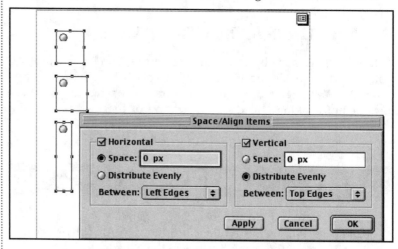

Figure 16.25. Use the Space/Align Items dialog box to position the three buttons.

5. If necessary, display the guides (View/Show Guides or **F7**). Draw a text box next to each button and type a few words in each box. Make sure that the text box doesn't overlap the button box, or you'll throw off the alignment in the browser.

6. Shift-select the three boxes and use the Item/Space Align command to align them vertically along their left edges. Click OK.

7. Choose View/Hide Guides (**F7**) to see how the buttons and boxes look.

8. Choose File/Export/HTML and export the file. Make sure Launch Browser is checked and click Export. Your screen should resemble Figure 16.26. Click the buttons and notice that you can click more than one button.

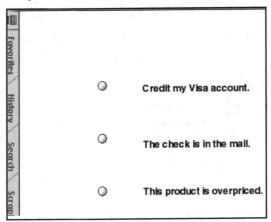

○ **Credit my Visa account.**

○ **The check is in the mail.**

○ **This product is overpriced.**

Figure 16.26. The three buttons appear aligned next to the three aligned text boxes in the browser window.

9. Back in the Web document, click the Check Box tool and drag the crosshair cursor to create three boxes, one below the other. Select the top check box and choose Item/Modify (**Command-M**/Macintosh or **Ctrl-M**/Windows). Click the Form tab and type *Credit Visa* in the Name field. Make sure Check Box is selected from the Type menu. Leave the Value field empty. Select the Initially Checked and Required check boxes. This tells the form to check this box in the browser and to make it a required selection (Figure 16.27). Click OK.

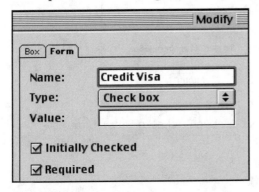

Figure 16.27. Specify options for a check box in its Form Modify dialog box.

FYI

A check box control can't have the same name as a button control in the same form box.

10. Drag the three text boxes next to the check boxes and align everything properly, making sure no boxes overlap.

11. Select the Button tool and draw a box under the three check boxes. Choose Item/Modify (**Command-M**/Macintosh or **Ctrl-M**/Windows), click the Form tab, and select Submit from the Type menu. Click OK.

12. Choose File/Export/HTML. Click Yes All at the alert. Your browser screen should resemble Figure 16.28.

13. Deselect the top check box and click the Submit button. An alert tells you a check box must be selected.

14. Back in the document, close the file. Don't save your changes.

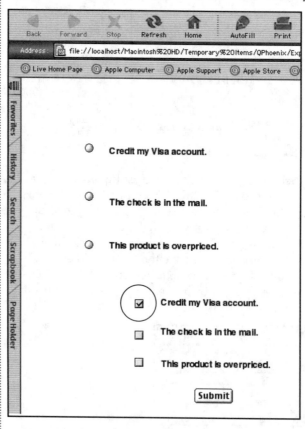

Figure 16.28. The top check box appears checked in the browser window, because you selected that option in its Form Modify dialog box.

IMAGE BUTTON CONTROL

An image button control will submit a form, but instead of the usual Submit button, you use a graphic. Again, you will need to add text to the graphic so the user will know what clicking the graphic does.

EXERCISE D

1. Create a new Web document (File/New/Web Document [**Command-Option-Shift-N**/Macintosh or **Ctrl-Alt-Shift-N**/Windows]). Use the Form Box tool in the Web Tools palette to draw a form box on the page. Even though you're going to use the Image Button tool, you still need a form placeholder for the button. If you don't draw a form placeholder before drawing the button, XPress will automatically draw a form placeholder for you.

2. Select the Image Button tool in the Web Tools palette and draw a box. You can resize the box and/or graphic later.

3. Choose File/Get Picture (**Command-E**/Macintosh or **Ctrl-E**/Windows) and navigate to the Web Images folder you created earlier. Import the *Clock.tif* picture into the image button box (Figure 16.29). Use the Style menu to resize the picture or resize the image button box. You can resize an image button box manually by dragging its handles or by using the Form tab in the box's Modify dialog box.

4. Close this file. Don't save your changes.

Figure 16.29. The Form Box contains an image button box.

5. Select the image button and choose Item/Modify (**Command-M**/Macintosh or **Ctrl-M**/Windows). Click the Export tab and select an image export option from the Export As menu (Figure 16.30):

Progressive and Interlacing

A progressive JPEG file or an interlaced GIF file displays quickly at a low resolution, followed by a gradual download of the full-resolution image.

Figure 16.30. Select an image export format in the image button's Export Modify dialog box.

▲ **JPEG** (Joint Photographic Experts Group) to export a continuous-tone image such as a scanned photograph. Select an option from the Image Quality menu (lower is faster).

▲ **GIF** (Graphics Interchange Format) to export a flat color image. Check the Use Dithering box to display the image using simulated colors for missing colors. Use the Color Palette menu to select an appropriate color palette (Web-safe is safest).

▲ **PNG** (Portable Network Graphics) to export the image button control in that format. Select color options, but be aware that not all browsers support this graphic format. Click OK.

6. Export the file (File/Export/HTML) to open the file in your browser. Drag the cursor over the image button and notice the traditional pointer. Click the image to execute the Submit action.

7. Close this file. Don't save your changes.

LESSON 3: AVENUE.QUARK

REPURPOSING QUARKXPRESS DOCUMENTS

avenue.quark (yes, it's lowercase *a* and *q*) is a powerful xtension that lets you extract the content of a QuarkXPress document (text and graphics) and save that content in XML format. You can then easily repurpose that content in a variety of ways, especially for the Internet.

XML

The XML (Extensible Markup Language) format lets you specify structure of content and label the pieces of that content in a meaningful way. Although HTML is the most widely used format for creating Web graphics, it's limited in how it lets you approximate your carefully designed QuarkXPress pages for display on an Internet browser such as Netscape Navigator or Microsoft Explorer. However, HTML describes only the formatting of data, not its meaning, and you can't create new HTML tags. XML, however, lets you label data in an XML document so you can then base the HTML formatting on those labels. For example, if you have an XML document that includes a list of catalog products and some information about each of those products, you can transform that text into an HTML Web page in which every product name is bold. To do this, you simply use an XML-to-HTML converter and instruct the converter to bold every line that's tagged as a **\<product name\>**. This means that you no longer have to go through the document and format each product name manually. For Web site creators, this represents a significant savings in time and effort.

DOCUMENT TYPE DEFINITIONS

XML lets you describe the structure of your documents with DTDs (Document Type Definitions). A DTD specifies that the information in a document will use a particular set of tags and follow a specific set of structural rules. By consistently adhering to the rules of a DTD, you can ensure that all the documents for a particular organization are structured predictably and consistently. This makes it easier for an organization to move content from one medium to another (for example, from print to Web).

DTDs are important because they create a reliable method for multiple organizations that work together to structure and tag their XML documents in the same way, thus keeping their data compati-

ble. Organizations can develop their own DTDs, something that can't be done in HTML.

CASCADING STYLE SHEETS (CSS)

Use cascading style sheets to apply styles to tagged HTML and XML content. This kind of style is flexible in that it lets you change the formatting of multiple documents by updating a single CSS file.

ON YOUR OWN

Programming an XML document is beyond the scope of this book and is something you need to know only if you're translating existing QuarkXPress documents for Internet applications. As with HTML editors, working with XML requires you to understand the programming language that underlies the HTML page. This lets you edit your pages and maintain consistency, especially in multiple documents on large Web sites.

REVIEW PROJECT

Create a new Web document and use the tools in the Web Tools palette to create different form controls. If you're familiar with the basics of Web page design, you might want to apply those principles to this page. Position the buttons, menus, text controls, and text boxes on one or more pages and then use the Hyperlinks palette to create links from one page to another and from items on the Web pages to destinations on the Internet.

In selecting graphics, make sure that you've reduced them to 72 ppi before importing them into picture boxes in the Web document.

XML documents

To create an XML document, choose File/New/XML and select a DTD template. This automatically displays the XML palette.

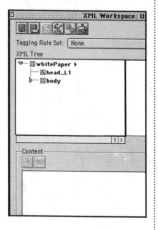

Unit 17

Long Document Construction

OVERVIEW

In this unit you will learn how to:
Create, display, and edit a List
Use the Book palette to synchronize documents
Compile an index of terms in one document
Compile an index of terms over multiple documents

TERMS
Book
Chapter
List
Master Chapter
nested index
run-in index
synchronize

LESSON 1: CREATING COMPLEX DOCUMENTS

LONG DOCUMENT COMPONENTS

Very often a long document like a book or magazine is comprised of several QuarkXPress files. You can hope that each file will use the same style sheets, the same H&J values, the same dashes and stripes, and the same lists, but frequently each file reflects a subtle change in these attributes. You may have changed the Heading 3 style, for example, in one file and not changed it in all the other files for the same project. This omission can cause serious problems at the print level or when the book is published and your client/boss fires you. To avoid these synchronization errors, use the Book command in QuarkXPress 5.0.

The Book command begins by creating a Book. A *Book* is simply a collection of QuarkXPress documents related to one project. There are almost 30 separate QuarkXPress files for the book you're reading now. This collection of files related to a single project is called a Book. The document files, the separate QuarkXPress files that constitute the longer Book, are called Chapters. In creating a Book, one Chapter is designated as a Master Chapter, and its specifications are used to override any differing specifications in the other Chapters in the Book. So, if the Heading 3 style calls for yellow type reversed on a blue rule in the Master Chapter, once the Book is synchronized, the Heading 3 style in every Chapter in the Book will display yellow type reversed on a blue rule.

LISTS

Before you begin creating Books, you have to understand what a List is in XPress. A *List* is a group of one or more paragraph and/or character style sheets specified by the user, and imported into the Lists palette in order to gather the text in those paragraphs for a particular purpose. For example, all the chapter titles, lesson titles, and lesson subheads in this book were tagged in the Lists palette and then assembled to create the table of contents for the book you're reading.

Creating a List is a three-step process:

1. **Create the List** in the Lists dialog box.
2. **Generate (update) the List** in the Lists palette.
3. **Flow (build) the List** into a selected text box.

Because you don't usually need all the styles in a document's Style Sheets palette for a List, you have the opportunity to select which paragraph styles, and hence which paragraphs, will be part of your List.

The Lists dialog box is where paragraphs with different styles are compiled before being updated and built in the Lists palette.

1. Open the *List1.qxd* file and the *List2.qxd* files in the Unit 17 folder in the Student Files folder on the CD-ROM. Click on the *List1.qxd* file to activate it. If you get an alert telling you that these files use fonts not installed in your system, click OK at the alert.

2. Choose Edit/Lists to display the Edit List dialog box. Click New. Type *TOC List* in the Name field. Because you don't need the Body style in the table of contents, ignore the Body style, but click on the Chapter # style below it, and click on the forward black arrow to add that style to the Styles in List panel (Figure 17.1). If you make a mistake, click on the style in the Styles in List panel, and click on the backward black arrow to remove it from the List.

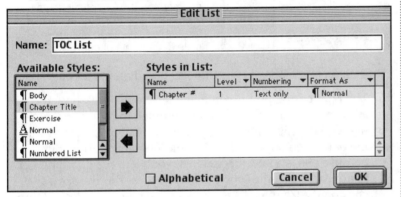

Figure 17.1. Select a paragraph style and click the black arrow to add that style to the List.

3. Repeat to add the Chapter Title and Subhead styles to the Styles in List panel (Figure 17.2). Click OK and click on Save. Choose File/Save as (**Command-Option-S**/Macintosh or **Ctrl-Alt-S**/Windows) and save the file with its current name in your Projects folder.

Select the Alphabetical option in the Edit Lists dialog box to display the List items in alphabetical order rather than in the order that they occur in the document.

Figure 17.2. Add the three styles necessary to create the table of contents to the Styles in List panel.

4. Choose Edit/Lists, highlight the *TOC List*, and click on Edit. You must now specify a Level, or the order in which these styles will appear in the table of contents. The chapter number is the first paragraph that should appear, so leave its Level at 1. Click on Chapter Title in the Name field to select it. Use the Level pull-down menu to select 2, thus making all the paragraphs tagged with the Chapter Title style appear under the paragraph tagged with the Chapter # style (Figure 17.3).

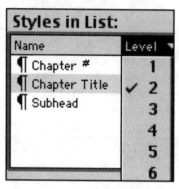

Figure 17.3. Use the Level menu to specify that the Chapter Title style will be the second level in the List and appear under the Chapter # style in the table of contents.

5. Click on the Subhead style to select it and assign it Level 3.

6. The Numbering pull-down menu lets you specify how the text appears in reference to the page number. In a list of people's names, you might not want a page number to appear next to the name, so you would choose the Text only option. But because this is a table of contents, you want the page number to appear. Select the Chapter # style, press the Shift key, and click on the Chapter Title and Subhead styles to select all three styles. Use the Numbering pull-down menu to choose the Text...Page# option for all three styles (Figure 17.4). Click on an empty area of the palette to deselect all the styles.

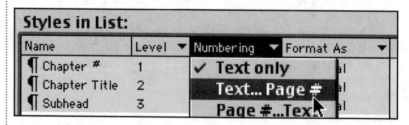

Figure 17.4. Shift-select all the paragraph styles and use the Numbering pull-down menu to specify that the page number will appear to the right of the text.

7. The last formatting task is to apply a paragraph style to each Name [of style] in the list. Click on the Chapter # style to select it. Use the Format As pull-down menu to select the Chapter # paragraph style. You could, of course, apply any paragraph style listed in the Style Sheets palette, like a special style you created just for the table of contents.

8. Select Chapter Title in the Name field and choose Chapter Title from the Format As menu. Select Subhead in the Name field and choose Subhead from the Format As menu (Figure 17.5).

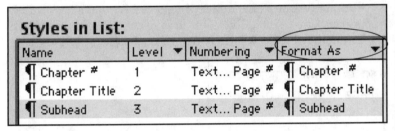

Figure 17.5. Select a paragraph style for each item in the List from the Format As pull-down menu.

9. Click OK. Click Save. You've completed Step 1 of the three-step List-generation process.

10. Now that the List options are specified, you can build the List. Choose View/Show Lists (**Option-F11**/Macintosh or **Ctrl-F11**/Windows) to display the Lists palette. Choose Current Document from the Show List pull-down menu. Choose TOC List from the List Name pull-down menu. Click the Update button to add the paragraphs styled with the selections you made earlier in the Lists dialog box (Figure 17.6). You've completed the second step in generating a List.

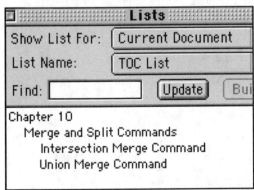

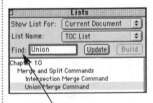

Update info

Update frequently if you are making any changes to the text.

Type a word in the Find field to highlight that word in the row of List entries. This Find command does not find words in the document, only in the List displayed in the List Name field.

Figure 17.6. The Lists palette displays the list elements for the List selected in the List Name field.

11. Press the Option or Alt key and use the Grabber Hand to drag the page to the right or left so that the pasteboard appears. Use the Rectangle Text Box tool to draw a text box a few inches long. Don't worry about the size of the text box; you can resize it later. For the third and final step, you'll generate (build) the list.

12. With the text box selected, click on the Build button in the Lists palette. The table of contents (List) appears in the selected text box (Figure 17.7). Choose File/Save as. Navigate to your Projects folder. In the Save as dialog box, click on the New [folder] button to create a new folder. Type *Book Files* in the Name field and click on Create. Click Save to save the *List1.qxd* file with its List in the new Book Files folder. Close the file (File/Close).

Figure 17.7. Select a text box and click the Build button to generate the table of contents.

13. Click on the *List2.qxd* file to activate it. Choose File/Append. Highlight the *List1.qxd* file in the Student Files folder in the Unit 17 folder on the CD-ROM. Click on Open. In the Append dialog box, click the Chapter # style and click on the forward arrow to append it to the *List2.qxd* file. Repeat for the Chapter Title and Subhead styles (Figure 17.8). Click OK. Click OK at the alert.

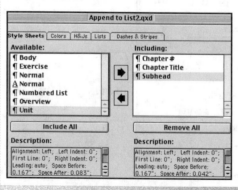

Figure 17.8. Select the paragraph styles and click the forward arrow to append that style in the *List1.qxd* file to the *List2.qxd* file.

14. Once you've appended the style sheets, you can append the List that you created in the *List1.qxd* file. Still in the *List2.qxd* file, choose Edit/Lists. Click on the Append button. Navigate to the *List1.qxd* file in the Book Files folder, highlight it, and click on Open.

15. The Append Lists dialog box tells you that only one List exists for the *List1.qxd* file, the TOC list. Click to select it and click the forward arrow to add it to the Including panel. Click OK twice and click Save. The TOC List is now added to the *List2.qxd* file.

16. Choose View/Show Lists. Click the Update button in the Lists palette to display the List. Draw a text box on the pasteboard, and with the text box selected, click the Build button on the Lists palette to flow the list. Close the Lists palette by clicking on its Close box.

17. Choose File/Save as (**Command-Option-S**/Macintosh or **Ctrl-Alt-S**/Windows). Navigate to the Book Files folder in your Projects folder and click on Open. Click Save to save the *List2.qxd* file with its List in the Book Files folder. Close the file (File/Close).

Lists palette Close box

The Close box is in the upper left corner of the palette (Macintosh) and in the upper right corner (Windows).

LESSON 2: CREATING A BOOK

WHAT IS A BOOK?

A *Book* is a collection of documents called *Chapters*, with one document designated as the Master Chapter. It is the specifications of this Master Chapter that determine the styles, lists, H&Js, and dashes and stripes in every Chapter of the Book. The Chapters are compiled and synchronized in the Book palette.

Long documents such as books and journals are never (or never should be) created in a single file. If that file is damaged, the entire project is lost. A single large file, especially if it's graphics-intensive, makes heavy demands on computer processing power and memory. It's always easier to make a long document manageable by splitting it into multiple files. To maintain consistency among all the elements in multiple files, we use the Book function.

EXERCISE B

1. Make sure no files are open and only the QuarkXPress menu and Tool palette are displayed. Choose File/New/Book. Navigate to the Book Files folder you created in the last exercise and type *My First Book* in the Book Name field. Click Create. The Book palette appears and displays the name of the Book, *My First Book*. Notice that no document is open, just the Book palette.

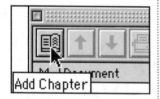

2. Because Books are made up of Chapters and Chapters are just QuarkXPress documents, you must open those documents in the Books palette. Click the Add Chapter icon on the Book palette. Navigate to the Book Files folder you created in the last exercise and click on the *List1.qxd* file to select it. Click the Add button to import it into the Book palette.

3. Click on the Add Chapter icon again and add the *List2.qxd* file in the *Book Files* folder. Your screen should resemble Figure 17.9.

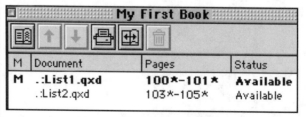

Figure 17.9. Chapters appear in the order in which they are opened in the Book palette.

4. By default, the first file you open in the Book palette appears in boldface because it's the Master Chapter. You can select any file and click the up or down Reorder arrows to move the file to a new position in the palette. However, the first file in the palette is always the Master Chapter and displays an **M** to the left of its name. To specify another Chapter as the Master Chapter, click on the Chapter to select it and use the Reorder arrows in the Book palette to move it to the first position in the palette. Then click on **M** at the left side of the palette to make the Chapter you moved the new Master Chapter.

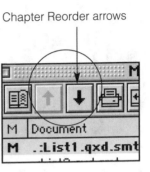

Chapter Reorder arrows

5. The Pages column in the Book palette displays the page sequence of each Chapter. In this Book, both Chapters display an asterisk before and after each page number indicating that these page numbers were created using the Section command. If these Chapters did not have sectioned pages, XPress would create a "Chapter Start" page number. To override this (and keep control of the page numbering sequence), override the automatic page numbering by using the Section command. Choose File/Open and open the *List1.qxd* file in the Book Files folder in your Projects folder. This is the file that contains the list. Display the Page Layout palette (**F10**/Macintosh or **F4**/Windows).

6. In the *List1.qxd* file, double-click the Page 1 icon in the Document Layout palette to go to that page. Choose Page/Section to display the Section dialog box. In the Number field, type 90 to change the start of the section from page 100 to page 90. Click OK.

7. When you do this, two things happen in the Book palette:

 ▲ The **page sequence** for the *List1.qxd* file **displays 90*-91***. *And*

 ▲ The **status for that file changes from Available to Open** (Figure 17.10).

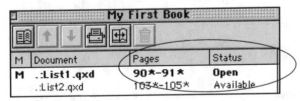

Figure 17.10. Changing a page numbering sequence in the Section dialog box causes the Book palette to update and reflect that change.

8. Choose File/Close, save the changes, and notice that the Status line for the *List1.qxd* file changes from Open to Available.

9. Leave the Book palette open for use in the next exercise.

LESSON 3: SYNCHRONIZING CHAPTERS

PUTTING IT ALL TOGETHER

The process of synchronizing the Chapters in a Book takes place in the Book palette. This ensures that any of the selected styles, H&Js, Lists, and dashes and stripes are consistent across all the Chapters (files) in the Book (long document). Once you have specified a Chapter as a Master Chapter, all the other Chapters in the book will display the specifications of that Master Chapter.

EXERCISE C

Opening a Book

Choose File/Open and navigate to the folder where you stored the Book. Open it as you would any QuarkXPress file.

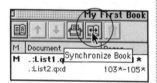

Click the Synch All button at the bottom of the Synchronize Selected Chapters dialog box to synchronize all the specifications in the five tabs of the Synchronize Selected Chapters dialog box. If you want to select only certain specifications, click each specification in the Available panel and click the Forward arrow to move it to the Including panel.

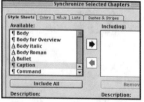

1. Open the *List2.qxd* file in the Books Files folder you created earlier. Display the Style Sheets palette (**F11**). Click in the text box and Control-click (Macintosh) or right-click (Windows) on the Chapter Title style in the Style Sheets palette and drag to select Edit Chapter Title. Click on the Formats tab and change the Alignment from Left to Centered. Click OK. Save the File (File/Save) and close it.

2. If necessary, open the *My First Book* Book. Make sure that the *List1.qxd* file is the Master file. Also make sure that the Status line for both files reads Available (Figure 17.11). If a Chapter is not available, it can't be synchronized.

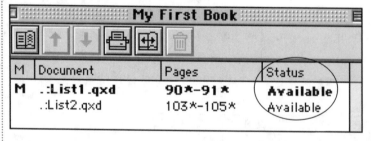

Figure 17.11. The status of any Chapter you are going to synchronize must display Available.

3. Shift-select the two files in the book. Click the Synchronize Book button on the Book palette to display the Synchronize Selected Chapters dialog box. The Style Sheets tab is active. Click the Include All button to synchronize all the style sheets. Repeat for the Colors, H&Js, and Lists tabs to move all these specifications from the Available column into the Including column. Click OK. Click OK at the alert.

4. When you do this, three things happen:

 ▲ **Specifications with the same name are compared, and chapter specifications are edited if necessary to match the specifications in the Master Chapter.** In the case of this Book, the center alignment of the Chapter Title style in the *List2.qxd* Chapter is changed to left-aligned to match the Chapter Title style in the Master Chapter.

 ▲ **Specifications in the Master Chapter that are missing from other Chapters are added to those Chapters**. This means that any style sheets, lists, or H&J specifications not present in a Chapter are added to a Chapter if those specifications exist in the Master Chapter.

 ▲ **Specifications in other Chapters that are not defined in the Master Chapter remain untouched**.

5. The *List2.qxd* Chapter briefly displays Open on the Status line while XPress changes its alignment from centered to left-aligned. Choose File/Open and open the *List2.qxd* file in the Book Files folder. Notice that the paragraph tagged with the Chapter Title style is now left-aligned. Both Chapters are synchronized and the project is consistently formatted.

6. Open the *List1.qxd* file, go to page 1, and choose Page/Section. Deselect the Section Start option to start the page numbering from page 1. Click OK. Save the file.

7. In the *List2.qxd* file, go to page 1 and choose Page/Section. Deselect the Section Start option and click OK. Save the file. The Book palette now displays page numbering from 1–5 (Figure 17.12).

8. Close these files (File/Close). Don't save your changes.

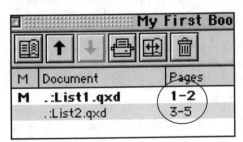

Figure 17.12. Removing the Section command causes the synchronized Chapters to display consecutive page numbers.

FYI

One of the advantages of the synchronization command is that it allows you to make global changes to any of the styles in a Book. For example, if you decide to change the width of a rule or the size of a paragraph's text characters in all the Chapters, you can change the specification in the Master Chapter, then synchronize the Book again.

Synchronizing different chapters

To select a range of Chapters, click the first Chapter and press Shift while you click the last Chapter in the range.

To select nonconsecutive Chapters, press the Command key (Mac OS) or the Ctrl key (Windows) while you click the Chapters.

LESSON 4: CREATING AN INDEX

TYPES OF INDEXES

Creating an index is a tedious, time-consuming process. In most cases the author will provide an index or a professional indexer will be engaged to create an alphabetical listing of every relevant term in the book with its corresponding page number. Unless the book is a "bodice-ripper" or other work of fiction, it will need an index to guide the reader to the appropriate pages.

The Index XTension in QuarkXPress 5.0 lets you create two kinds of indexes, a run-in index or a nested index. A run-in index might read

QuarkXPress 5.0, Style sheets, 76.

This is a **two-level index** with the first level "QuarkXPress 5.0" arranged alphabetically and "Style sheets" as the second level appearing immediately after the first level.

The other kind of index is a **nested index**. A nested index can have up to four levels and might read

QuarkXPress 5.0 (First Level entry)

 Style sheets, 66 (Second Level entry)

 Character styles, 77–82 (Third Level entry)

 Paragraph styles 66–76

 deleting, 70 (Fourth Level entry)

 editing 69, 73

CROSS REFERENCES

You can create a cross-referenced index, one that lets the reader refer to other topics listed in the index. For example, in the chapter on QuarkXPress 5.0, you might list as a cross-reference *See compatibility with version 4.x*. The cross-reference can be to an existing index entry, or you can add a new entry, *Compatibility with version 4.x*, specifically for the cross-reference.

INDEX OPTIONS

Other indexing options include specifying whether an index entry will cover a word, a number of paragraphs, a text selection, or all of the text until the index encounters another style sheet. There are many formatting options for the index, and by using master pages and style sheets, you can build an index quickly and efficiently.

No matter how you design your index, generating an index is a two-step process:

1. **Tag the entries** in the Index palette. *And*
2. **Build the index** from the Build Index command under the Utilities menu.

INDEX PREPARATION

Before you generate the index, you must set your preferences for the way the index entries will appear when you build the index. You should also create any style sheets you want applied to the different levels in the index. This makes the styles available from the Index palette, which means you don't have to format each entry in the index separately. You should also make sure that you have a linked automatic text box on the master page of your document.

INDEX PREFERENCES

Choose Edit/Preferences/Index (Figure 17.13) to display the Index Preferences dialog box. Specify the character you want to appear following an entry (usually a comma) in the Following Entry field. To do this, press the Spacebar after that comma to create a space between the comma and the page number. Unless you delete or change any of the separation characters, a comma will appear between the page numbers, an en dash will appear between a range of pages like 64–67, and a period will appear before a cross-reference such as *QuarkXPress. See also QuarkImmedia.* Click OK to exit the dialog box and save your preferences.

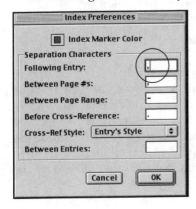

Figure 17.13. The Index Preferences dialog box is where you specify which characters will appear between entries and page numbers. We added a comma followed by a space after each entry.

A

absolute and relative, Hyperlinks, 435
absolute leading, 61, 212
absolute page numbers, 113, 138
Accurate Blends, 398
Action field, Form Modify dialog box,
 Web Document, 447
add
 Bézier points, 285
 Chapter, 470
 index entry, 479
Add, spell check, 265
Add All, index, 484
Align On, tabs, 225
alignment
 anchored items, 354
 item, 370
 paragraph, 58, 204
 text path, 326
 vertical, 101
Alpha Channel, runaround, 360
anchored items, 352
 alignment, 354
 rules, 350
anchors, Web document, 436
 adding, 442
 delete, 446
 editing, 446

The index for this book is a nested index.

INDEX STYLES

You can apply one style sheet to the index entry and another style to the page number following the entry. Format the index entries in any paragraph style available in the current document, and format the page numbers in any character style available in the current document. You can also specify that the page numbers display the same style as the entry style. Because this can get complicated, especially if you don't want all the formatting connected with a paragraph style to be attached to the index entry, it's a good idea to create a new index entry style, and then either apply that same entry style to the page numbers or create a separate character style for the page numbers.

LINKED MASTER PAGES

It's unlikely that you would create an index in a document or for a Book (synchronized Chapters in the Book palette) that did not contain an automatic text box. If you create a new document with the Automatic Text Box option selected, that text box appears on every document page based on Master Page A, because the Automatic Text Box option creates a text box on Master Page A and on every document page based on that master page. If for some reason that automatic text box has been unlinked, then when you go to build the index, an alert appears.

It's always a good idea to check your master page before building the document and make sure the automatic text box is linked to the Intact Chain icon (Figure 17.14).

Figure 17.14 displays the Intact Chain icon in the upper left corner of the master page (left) and the Broken Chain icon (right).

To establish a linked text box on the master page, go to the master page. If there is no automatic text box on the page, use any text box tool to draw a text box on the master page. Click the Linking tool in the Tool palette to select it. Then click once on the Broken Chain icon in the upper left corner of the master page and click inside the text box you just created. An arrow will appear connecting the icon to the text box and the Broken Chain icon will be replaced by the Intact Chain icon (Figure 17.15).

Figure 17.15. Select the Linking tool. Click the Broken Chain icon to change it to the Intact Chain icon and create a linked text box on the master page.

THE INDEX PALETTE

The Index palette is available only when the Index XTension is loaded. To load the Index XTension, make sure the Index XTension is in the XTensions folder in the QuarkXPress 5.0 folder. Choose XTensions Manager from the Utilities menu to display the XTensions Manager dialog box. Use the Set pull-down menu to select a set, or just click in front of Index in the Enable column. You have to quit out of QuarkXPress and then relaunch the application for any newly enabled XTension to load.

EXERCISE D

1. Open the QuarkXPress 5.0 folder on your hard drive. Open the Xtension folder and make sure the Index xtension is in that folder. If it isn't, (1) open the XTensions disabled folder and drag the Index xtension into the Xtension folder. (2) Quit and relaunch QuarkXPress.

2. Open the *Ch01.qxd* file in the Unit 17 folder in the Student Files folder on the CD-ROM. Display the Document Layout palette (**F10**/Macintosh or **F4**/Windows).

3. Double-click on document page 1 to get to that page. Choose Edit/Style Sheets (**Shift-F11**). Use the New pull-down menu to select Paragraph. Type *First Level index* in the Name field. Click on the Edit button in the Character Attributes field and assign it any typeface in size 14 points. Assign the type a color. Click OK.

4. Click on the Formats tab and select the Keep with next ¶ check box so the First Level entry will always be followed by a Second Level entry. Click OK.

5. Choose Paragraph from the New menu and type *Second Level index* in the Name field. Click on the Edit in the Character Attributes field. Assign the style a typeface, 12 points from the Size menu, and another color from the Color pull-down menu. Click OK. Click on the Formats tab and type 1p (1 pica) in the First Line field to indent the entry one pica from the page margin. Click OK.

6. In the Edit Style Sheets dialog box (**Shift-F11**), choose Character from the New pull-down menu. Type *Page Number style* in the Name field and choose any typeface at 9 points for the Second Level style. Click OK. Click on Save. Display the Style Sheets palette (**F11**). It should resemble Figure 17.16.

FYI

You must have the Index palette open to activate the Build Index command from the Utilities menu.

ABC

When you add a First Level entry to the Index palette, it's listed alphabetically with the other First Level headings. You can only use the arrow to specify a location for a secondary (Second, Third, and Fourth Levels) heading, not for a First Level heading.

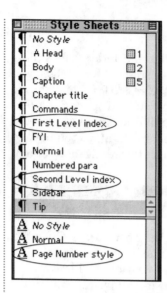

Figure 17.16. We created two new paragraph styles, First Level index and Second Level index, and one character style, Page number style.

7. Choose Edit/Preferences/Index. In the Following Entry field, type a comma and press the Spacebar. Click on OK.

8. Now that the index preparation is complete, choose View/ Show Index to display the Index palette. Make sure you're on document page 1, the Introduction page. Double-click on Introduction and notice that it appears in the Entry area on the Index palette in the Text field.

9. Use the Level pull-down menu to select First Level, because this is the primary index entry.

10. In the Reference area, use the Style pull-down menu to select the character style sheet, Page Number style. This will format only the page numbers in the Page Number style.

11. Use the Scope pull-down menu to select Selection Text. This will create the index entry from the selected text.

12. Click the Add button in the lower panel to add the contents of the Text field to the list of entries. The entry appears followed by the number of times it has been tagged in the document under the Occurrences menu. Notice that *Introduction* in the document is surrounded by two red brackets, indicating that it was tagged as an index entry. Your Index palette should resemble Figure 17.17.

Adding index entries

You can add an index entry by selecting the text in the document, displaying the Context menu, and choosing Add to Index. The selection is added using the current options in the Index palette.

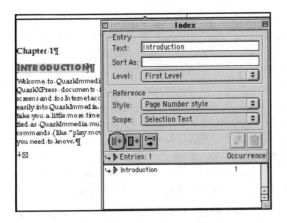

Figure 17.17. Click the Add button to add the contents of the Text field to the Entries column. The number 1 in the Occurrences column is not the page number; it's the number of times the word *Introduction* has been flagged for the index.

13. Click the Find Next button in the lower panel to move from the current Text Insertion bar (invisible on the selected text) to the next occurrence of the word *Introduction* in the Index palette. Because this word doesn't appear again *in the Index palette,* the alert beeps. Save the file as *Index1.qxd* in your Projects folder.

14. Click the Edit button (the Pencil icon) on the right side of the lower panel. The pencil changes color, indicating that you are in Edit mode. The text in the Text field is highlighted and ready for editing. Type *Introduction to This Book* and notice that the new text appears in the Entries column in the lower panel of the Index palette (Figure 17.18). When you complete the editing, click on the Edit button to leave the Edit mode.

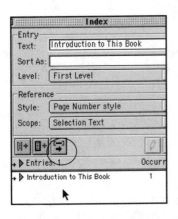

Figure 17.18. Click the Edit button (Pencil icon) to enter the Edit mode. The pencil changes color and the Text field is highlighted, allowing you to edit the index entry. Any changes to the Text field are reflected in the Entries field.

15. Click on the single entry in the Entries column to select it and click on the Trash icon (Macintosh) or ✗ button (Windows) to delete the entry. Click OK at the alert. The entry is deleted from the palette and the brackets are removed from the selection in the document.

16. Double-click on *Introduction* again on document page 1. Specify it again as a First Level entry, Selection Text, with Page number style sheet selected in the Reference field. Click on Add to add it to the list of entries in the lower panel of the Index palette.

17. Double-click on document page 2 in the Document Layout palette. Drag to select only *QuarkImmedia Palette* at the top of the page. You don't want the word *the* alphabetized in the index. Leave the other options for a First Level entry as they are in the Index palette and click the Add button to add the selection to the list of Entries in the lower panel. Save the file.

18. Scroll down to the caption for Figure 1.1 under the screen shot at the bottom of the page. Double-click the word *tabs* to select it. It appears in the Text field of the Index palette. Choose Second Level from the Level pull-down menu. Leave the Style and Scope options set as they were for the First Level entries.

19. Before you add *tabs* to the Entries list, make sure that it will appear under its proper heading, *QuarkImmedia Palette*. To do this, click to the far left of *QuarkImmedia Palette* in the Entries field. If you click the Disclosure Triangle (Macintosh) or +/- (Windows) directly to the left of the entry, the entry expands to reveal the document page number for that entry. Instead, click to the left of the triangle (Macintosh) or +/- sign (Windows) to the left of *QuarkImmedia Palette* and specify it as the primary heading.

20. With *QuarkImmedia Palette* specified as the active level and *tabs* displayed in the Text field, click the Add button to add *tabs* to the list of entries. Click the Disclosure Triangle (Macintosh) or the +/- icons (Windows) to the left of the *tabs* entry and notice that it displays 2 as the document page number for this entry (Figure 17.19).

Click the Disclosure triangle (Macintosh) or +/- (Windows) to show/hide page numbers for entries.

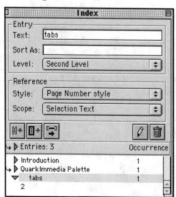

Figure 17.19. *Quarkimmedia Palette* is specified as the active First Level entry with *tabs* as a Second Level entry. Click the Disclosure triangle (Macintosh) or + (Windows) to see the entry's page number. So far, there's only one instance of a *tabs* entry in this index.

21. Double-click on the page 3 icon in the Document Layout palette. Select *Book Conventions* at the top of the page and specify it as a First Level heading, just as you did with the other First Level headings. Click the Add button and the *Book Conventions* First Level heading is listed alphabetically in the Entries column. Save the file.

22. Repeat to specify *QuarkXPress vs. QuarkImmedia* and *Saving Files* as First Level headings, and click the Add button to add them to the list of index entries (Figure 17.20).

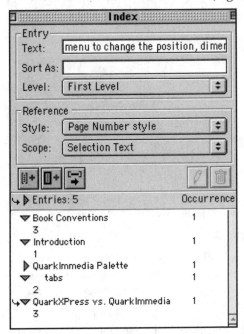

Figure 17.20. First Level headings are listed in alphabetical order in the Entries column of the Index palette. First Level headings are not indented.

Drag the arrow to the left of the Disclosure Triangle (Mac OS) or the + (Windows) to select another First Level heading in the Index palette.

23. Double-click on the page 4 icon on the Document Layout palette. Select *Unit of Measure* and specify it as a First Level heading. Click the Add button to add it to the Index palette.

24. Click to the far left of the *Unit of Measure* entry in the Index palette to move the arrow to that entry. Double-click on *points* in the Unit of Measure paragraph in the document. It appears in the Text field of the Index palette. Specify it as a Second Level heading and click the Add button to add it as a Second Level entry under the *Unit of Measure* First Level entry.

25. Select *Troubleshooting* on page 4, specify it as a First Level entry, and click on Add. Make sure the arrow appears to the left of *Troubleshooting* in the Entries column. Select *execute functions* in the second paragraph under *Troubleshooting* and specify it as a

Second Level entry under *Troubleshooting*. Repeat for *Click in check boxes* in the third paragraph under *Troubleshooting* on page four. Your Index palette should resemble Figure 17.21.

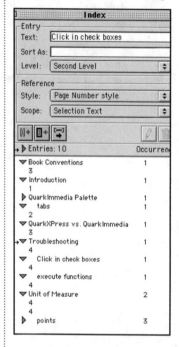

Figure 17.21. First Level entries are followed by indented Second Level entries.

26. To edit the entries before building the index, click on the *Click in check boxes* entry to select it. Click the Edit button to enter the Edit mode. Change the uppercase *C* in *Click* to lowercase. Click the Edit button to exit the Edit mode.

27. Save this file with all the changes. Don't close it. You'll need it for the next exercise.

BUILDING THE INDEX

Now that you've done all the work in tagging the index entries and selecting all the options, it's time for Quark to go to work. Before you build your index, save your file and back it up. You should be doing this all along, but it's especially critical when you're subjecting your document to a command as extensive as the Index command, which searches and acts on the entire document. Remember, you can always build the index more than once for any document, and if you've made any changes to the document after building the index, you should build it again.

1. If necessary, open the *Index1.qxd* file you created earlier or open the *Index1.qxd* file in the Unit 17 folder in the Student Files folder on the CD-ROM. Save the file under another name (File/Save as)—just in case! Display the Document Layout palette (**F10**/Macintosh or **F4**/ Windows) and the Index palette (View/Show Index).

2. Double-click on document page 4 to get to that page. Select the automatic text box on page 4. Choose Utilities/Build Index to display the Build Index dialog box. Click the Nested button to build a nested index. Click the Replace Existing Index check box, and click the Add Letter Headings check box to add the guide letters before each entry. Use the Style pull-down menu to select a paragraph style for those letters.

3. Leave the Master Page set to Master Page A. Under the Level Styles, choose First Level index for the First Level entry and Second Level index for the Second Level entry. Because you don't have any Third or Fourth Level entries, the other options won't affect the index. Click OK. In a few seconds, the index is created and appears on a new document page, page 5 (Figure 17.22).

4. You can edit the index just as you would any text by changing the style or by applying local formatting. Close this file. Don't save your changes.

B
Book Conventions, 3
I
Introduction, 1
Q
QuarkImmedia Palette, 2
 tabs, 2
QuarkXPress vs. QuarkImmedia, 3
T
Troubleshooting, 4
 click in check boxes, 4
 execute functions, 4
U
Unit of Measure, 4
 points, 4

Figure 17.22. The index is generated and all entries display the assigned styles and formats. You can then edit the entries.

ADD ALL

Clicking the Add All button (next to the Add button) on the Index palette adds every instance of the selected entry to the index. For example, if you select the word *Paris* on page 1 and it also appears on pages 4 and 5 of the document, clicking the Add All button will index it on pages 1, 4, and 5 (Figure 17.23).

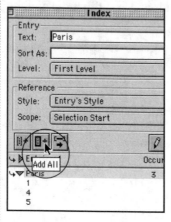

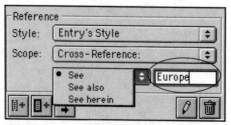

The cross-reference appears below the entry in the Index palette and doesn't display page numbers there or in the built index.

Figure 17.23. Click the Add All button to add every instance of the entry in the document to the index. The Index palette indicates that there are 3 instances of the word *Paris* occurring on pages 1, 4, and 5.

CREATING CROSS-REFERENCES

To create a cross-reference for an entry, do the following:

1. Create the entry, for example, *Paris*. Before clicking the Add button, make all the selections in the Index palette, but select Cross-Reference from the Scope menu. Select a term of reference such as *See*, *See also*, or *See herein*.

2. Type the cross-reference text in the box to the right of the Scope menu. For example, type *Europe*. Then click the Add button (Figure 17.24).

Figure 17.24. Type the cross-reference text in the field to the right of the Cross-Reference term.

3. The cross-reference appears below the entry without a page number when you click the Disclosure Triangle (Macintosh) or + (Windows) next to the entry.

REVERSING NAMES IN THE INDEX

Sometimes it's necessary to reverse an index entry. For example, a convention catalog lists all the speakers with their first names followed by their last names. This is fine for the catalog, but not for the index, where names must be listed alphabetically by last name. To reverse an entry, do the following:

1. Select the text entry and select the options in the Index palette.
2. Press the Option key (Macintosh) or Alt key (Windows) while clicking the Add button on the Index palette (Figure 17.25).
3. To add all references to the selected text in the document in reverse order, press the Option or Alt key before pressing the Add All button on the Index palette.

If you forget to press the Option or Alt key, you'll have to delete the entry and then select it again to reverse that entry in the Index.

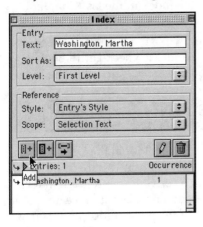

Figure 17.25. The original entry was *Martha Washington*. Pressing the Option key or Alt key while clicking the Add button reversed the name. If the original entry was *Martha A. Washington*, it would reverse to *Washington, Martha A.*

CLEANING OUT THE INDEX PALETTE

An annoying "feature" of the Index palette is that it retains any options you select until you quit a session with QuarkXPress. This means that if your last entry was a cross-reference or used a specific style, any entry you add to the Index palette will retain those attributes. To avoid any nasty surprises when you build the index, make a habit of checking every option *before* clicking the Add button. The only editing you can do once you add an entry is to edit the entry in the Text field of the Index palette. Like most of the functions in XPress, the Add command in the Index palette is not undoable.

INDEXING A BOOK

The index you generated in the last exercise compiles entries from only one document. In a long document project like a book, a convention program, or a journal, for example, you need to compile the index from all the documents that constitute the project. To do this, use the Book command.

To build an index for a Book, do the following:

1. **Create index entries** and the appropriate style sheets for all the Chapters in the Book.

2. **Create a separate Chapter for the Book index** and add it to the Book as the last Chapter in the book. Make sure it has an automatic text box.

3. **Synchronize the Chapters in the Book palette**, making sure the Index Chapter is the last Chapter in the book. The alternative is to create a separate page for the index in the last Chapter of the the Book.

4. **Choose Utilities/Build Index** and make the necessary selections in the Build Index dialog box. Be sure to **check Entire Book** to index all the Chapters in the book. Click OK to build the index.

REVIEW PROJECT

Use the original files in the Student Files folder in the Unit 17 folder to practice creating Books and generating different kinds of indexes. The *Catalog.qxd* file is from a convention program that lists speakers and abstracts of their presentations. Use it to create a table of contents list that gives the name of the presentation and its page. Then create an index of the speakers' names, listed with the last name first.

Glossary

absolute leading is an assigned leading value that remains constant regardless of the point size of any character in the paragraph. The term "12 on 14" specifies 14 points as absolute leading.

absolute page number is a page's position relative to the first page of the document, regardless of the actual **folio** (page) number. For example, the third page in the document has an absolute page number of 3 even though its folio number is 64.

anchor in a Web document is text that is linked to a particular part of the Web page by a **hyperlink**.

anchored item is a box, line, or text path pasted in a paragraph which moves with that paragraph.

anchored rule is a line set above or below a paragraph which moves with that paragraph.

Append command is used to add to the current document the colors, style sheets, or **H&J** specifications from other documents.

aspect ratio is the ratio or proportion of an item's width and height. Maintaining aspect ratio when resizing the item does not distort the item.

Auto Image Runaround value specifies how far from the picture (not the picture box) the text should wrap.

auto leading sets the leading value as a percentage (usually 20 percent greater than the font size) of the largest font size on any given line in a paragraph. If the largest font size in the paragraph is 12 points, auto leading sets the distance between baselines in that paragraph to 14.4 points.

Auto Page Insertion option in the General Document dialog box specifies whether, and if so, where, new pages will be inserted in the document when text overflows the automatic text chain.

Auto Picture Import determines whether QuarkXPress will automatically update pictures that have been modified since the document was last opened.

automatic text box automatically appears on the **master page** and on its corresponding document pages when you select the option in the New Document dialog box.

auxiliary dictionary is a dictionary of user-defined words used in conjunction with the main QuarkXPress dictionary.

baseline is the invisible horizontal line upon which characters "sit."

baseline grid is the nonprinting horizontal guide based on the **leading** value on which text is set. Baseline grid is especially important in multi-column documents

Baseline Shift command is applied to selected characters to raise or lower the text relative to their normal baseline position.

Bézier line, named after Pierre Bézier, is a mathematically defined line that uses two handles (called points in QuarkXPress) to determine where the line segment begins and ends.

Bézier point can be a corner point, smooth point, or symmetrical point. A corner point connects two straight lines, a straight line and a curved line, or two noncontinuous curved lines. A smooth point connects two curved lines to form a continuous curve. The curve handles attached to a smooth point revolve together so that they always rest on a straight line through the point, but can still be distanced independently of each other. A symmetrical point connects two curved lines to form a continuous curve. Although the curve handles move together so that they always rest on a straight line through the point, they are always equidistant from that point.

Bézier text path is created with the Bézier Text-Path tool or with the Freehand Text-Path tool and contains Bézier points that can be manipulated to reshape the path.

bitmap images, or raster images, are graphics created by a pattern of pixels in a bitmap application like Photoshop.

bleed is any page element that extends to the trimmed edge of the finished page.

blend is a color applied to a box background created by a gradual transition between two colors. Also called a **gradient**.

Book is a file displayed as a palette where you group multiple QuarkXPress documents called

Chapters. These Chapters then all assume the specifications of a **Master Chapter** using the **synchronize** command.

bounding box is a nonprinting box that appears around all the items in a group, allowing you to move the grouped items as a single unit.

cell is any of a series of grouped rectangular boxes that constitute a **table**. Cells can contain text, pictures, or a content of None.

Chapter is a QuarkXPress file opened in the Book palette.

character style sheet is a saved set of character attributes applied to selected text in a paragraph. See **paragraph style sheet**.

choke is a color-trapping command in which the **knockout** area of the background color is slightly reduced, thus allowing the foreground object to slightly overlap that area.

Clear command deletes selected text without putting it on the **Clipboard**. The Delete command under the Item menu deletes an item without putting it on the Clipboard.

Clipboard is an area of memory used to store text and items until they are replaced by other text or items via the **Cut**, **Copy**, or Delete commands.

clipping path is a Bézier path that outlines areas of an image. The area inside the clipping path is opaque; the area outside the clipping path is transparent. Clipping paths can be embedded in Photoshop images and exported with the image.

Collect for Output command creates a text file listing all the properties and collects the text, fonts, and graphic files in a QuarkXPress document in preparation for printing.

color gamut. See **gamut**.

Color Management System (CMS) uses ICC profiles to achieve consistent color across different color spaces and devices such as scanners, monitors, and printers.

color models such as PANTONE, TRUMATCH, and others define color using on-screen color swatches from that model.

color separations, sometimes called 4-color printing or process separations, print each component of a color on a separate page, or plate. Printing separations means printing a separate plate for cyan, magenta, yellow, and black and for any spot colors in the document.

Combine Merge command. See **Exclusive/Or**.

Consecutive Page Number symbol (<#>) indicates that pages in the automatic text chain are to be numbered consecutively.

Content command from the Item menu refers to the contents of a text box (text), or a picture box (graphic). The Content tool is used to manipulate the contents of an item. See **contentless box.**

contentless box is neither a text box nor a picture box. Only a background color can be applied to it.

Copy is to copy the selected text or item to the **Clipboard**.

crop marks, sometimes called cut marks or trim marks, are short horizontal and vertical lines printed beyond the page's final trim size that indicate where the page is to be cut.

Cut is to delete text or an item and place it on the **Clipboard**.

dash is a user-created broken line style that can be applied to lines, text paths, and box frames. See **stripe**.

default setting is a predetermined setting that can be changed by the user. For example, the unit of measure defaults to inches, but can be changed to another unit of measure such as picas. Changing default settings when no documents are open makes the new setting the default setting for all subsequent documents.

destination in a Web document can be a different part of the same document, a Web page with its own **URL**, or a specific area of a Web page, such as a "hot spot" on an image map.

device-dependent color is color that depends on specific colorants to define its color space. CMYK and RGB are types of device-dependent color.

device-independent color is color that doesn't rely on specific colorants or color models to define its color space. Device-independent color isn't associated with any specific input or output device. CIE LAB color space is an example of device-independent color.

Difference/Reverse Difference Merge command removes all the selected item shapes except for the backmost shape (Difference) or keeps all the shapes except for the backmost shape (Reverse Difference).

direction handles appear with Bézier points and are used to reshape the segment, especially its slope, attached to those points.

Document Layout palette is used to create, duplicate, name, and delete master pages. It's also used to create, move, and delete document pages; create multipage spreads; and apply and/or reapply a master page format (blank or formatted) to document pages.

drop cap is an initial text character or characters positioned below the first line in a paragraph that extends (drops) vertically more than one line into the paragraph.

em dash (—) is a dash the width of two zeros. Create an em dash by pressing Option-Shift-hyphen (Macintosh) or Ctrl-Shift-= (Windows).

embedded path is a Bézier path around part of an image which is embedded in the image and exported with that image from a program such as Photoshop. QuarkXPress can create a **clipping path** from that embedded path.

Endpoints mode defines a line by the position of its left (start) and right (end) points.

Entry label is used to catalog an entry in the **Library palette**.

EPS (Encapsulated PostScript) files can be imported into a QuarkXPress picture box and resized without affecting their output resolution (image detail).

Exclusive Or/Combine Merge commands keep all the selected item shapes, and cut out any overlapping areas, creating one item. No points are added where two lines cross (**Combine**); where two lines cross, points are added (**Exclusive Or**).

facing pages are alternating left and right pages. This option is always selected in the New Document dialog box when documents are being printed on both sides of the paper. Facing pages icons display turned-down corners at the top of the icon.

filters are XTensions that allow you to import text and graphic files into QuarkXPress.

Find Attributes option in the Find/Change dialog box lets you find and replace text, style sheets, fonts, font sizes, and type styles.

Find First finds the first instance in the document of the contents of the Find What field in the Find/Change dialog box. Display Find First by Alt/Option- clicking on the **Find Next** button.

Find Next finds the next instance in the document of the contents of the Find What field in the Find/Change dialog box. If the Document check box is not selected, Find Next locates the Find What text from the insertion point.

folio is the actual page number of a document page as generated by the Consecutive Page Number symbol or by the Section command. The folio number has no relation to the page's numerical position in the document.

Font Usage dialog box lists all the fonts in a document. Missing fonts display a minus sign.

form controls include the tools in the Web Tools palette for creating buttons, lists, menus, and check boxes in a Web document.

frame is a border around a box. You can apply the frames supplied with QuarkXPress or create your own in the Dashes & Stripes dialog box.

gamut is the range of colors that a device, such as a printer or a monitor, is capable of reproducing or displaying.

global formatting is character and paragraph styling as specified in a character style sheet or in a paragraph style sheet. Any change to these specifications is called **local formatting**.

gradient is a background color created by the gradual transition of two colors; in QuarkXPress called a **blend**.

greek(ed) pictures and text display as gray bars for faster screen redraw. Greeking does not affect output, only display.

gridlines are the horizontal and/or vertical lines that border a cell.

group is two or more selected items surrounded by a bounding box and moved and manipulated as one item.

guides are nonprinting lines used to position text and items. Drag horizontal and vertical guides down and out from the rulers.

Hexachrome Color System, a matching color system from Pantone, adds orange and green to the CMYK plates to create more intense colors and thus increase the range (**gamut**) of reproducible colors.

HTML (HyperText Markup Language) is a nonproprietary page-description language comprised of text and graphics tags that Web browsers can read and display.

hyperlink is an item in a Web page or PDF document that you click to perform an action. A hyperlink can be a word or phrase, a picture, or an area in a page or picture such as an **image map**.

Hyphenation and Justification (H&Js) command specifies if and how words hyphenate and the way words and characters are spaced in justified and nonjustified text.

ICC (International Color Consortium) profiles are cross-platform standards used to define the color capabilities of a device such as a scanner, monitor, or printer.

image map is a graphic on a Web page in which different parts of the image (*hot areas*) act as different hyperlinks.

image resolution is the degree of detail in a bitmap graphic, usually measured in pixels per inch.

Image Runaround value determines the distance between a graphic and the text that wraps around the image.

increment value in the Baseline Grid area of the Paragraph Preferences determines the amount of space between the grid's baselines. The Increment value should equal the paragraph's leading value when locking text to the baseline.

Intersection Merge command keeps any areas that overlap the shape in the back and cuts out the rest of the shape. This command results in one box from the two or more selected items.

Invisibles are nonprinting characters, such as tab, space, and enter characters, that display on the screen when Show/Invisibles is selected from the View menu.

Item Runaround value determines the distance between an item (box, line, or text path) and the text that wraps around the item.

jump lines are references to page numbers where a text chain is continued on a page other than the one where it began. Jump line commands are usually preceded by "Continued on page" or "Continued from page."

Keep Changes/Delete Changes apply to keeping or deleting modified master page items when a new master page is applied or when the same master page is reapplied to a document page based on any master page.

kerning is adding or deleting space between two characters, done by using the Kerning dialog box under the Style menu or by clicking on the Kerning arrows in the Measurements palette. A positive value increases space; a negative value reduces space.

knockout is created in color work when an object is placed in front of a background area. The background area "knocked out" by the foreground object is not printed on the color separation plate.

layer is a level in a QuarkXPress document on which you place specific items.

leading is the amount of space between baselines. In QuarkXPress, the leading value includes the font size plus the space between the lines.

Left Point is the tip of the line that starts a line drawn with either the Line tool or the Orthogonal Line tool.

Library palette is a file containing items that have been drag-copied from a document page. Drag-copy items out of the Library palette onto a document page.

linescreen (lpi) is a grid pattern of dots (or other shapes) of different sizes that simulates gradations of tone in a continuous-tone image such as a scanned photograph.

link with the Linking tool to join text boxes so text will automatically flow from one linked box to another.

linked image establishes a path from the low-resolution image imported into a QuarkXPress picture box to the high-resolution image at a specific location on the hard drive or external disk. The linked image, with all its modifications, must be able to follow that path in order to print the modified high-resolution image.

List is a group of one or more paragraph and/or character style sheets selected by the user for the purpose of copying and assembling the text tagged by those style sheets. A List can be created, for example, to generate a table of contents.

local formatting is any change made to text tagged with character styles or paragraph styles. See **global formatting**.

Master Chapter is the first Chapter in a Book whose styles, colors, and H&Js are applied to every other **Chapter** in the Book.

master items include text boxes, lines, picture boxes, and groups created on the **master page** and applied to every document page based on that master page. Master page items can be modified and deleted. See **Keep Changes/Delete Changes.**

master page is a nonprinting page used to automatically format document pages. Any item created on a master page appears on all document pages based on that master page.

Midpoint describes the position, angle, and length of an active line relative to its center.

misregistration occurs when the movement of paper through the printing press causes colors to be printed inaccurately. **Trapping** is used to correct for misregistration.

Multi-ink color system is a special color model in QuarkXPress that lets you create a multi-ink document using screen percentages of existing process color inks and/or spot colors.

nested group is one set of grouped items grouped with another group.

nested index contains up to four levels of entries separated by paragraph returns and different style sheets. See **run-in index.**

New Line marker appears when you press Shift/Return after any line in a paragraph. This command creates a new line in the same paragraph without ending the paragraph and applies the paragraph formatting to that new line and to subsequent lines.

No Style, when applied to a paragraph, strips it of any style sheet attributes while leaving **local formatting** intact.

Noise is any discernible part of the image eliminated by a closed path. To tighten a closed path in the Clipping dialog box, choose a higher Noise value.

None runaround allows an item to sit directly on top of text, obscuring it.

nonfacing pages are pages designed to be printed on only one side of the paper.

Normal style is the default style for text applied to every paragraph and text character in a document, unless you modify the Normal style or apply another paragraph or character style.

Offset Across/Offset Down fields in the Picture Modify dialog box specify a picture's distance relative to the left and top sides of the picture box.

Open command displays the Open dialog box from which you can select a drive or external disk and a document on that drive or disk to open.

Orientation icons for the printed page in the New Document and Page Setup dialog boxes refer to the vertical (Portrait) or horizontal (Landscape) position of the paper.

orphan is the first line of a paragraph that falls at the bottom of a column. See **widow.**

output resolution is the greatest level of detail produced by the imagesetter or printer and is usually measured in dots per inch.

Overflow Indicator, a small box with an **x** in the middle, appears in the lower right corner of a text box when more text than can fit into that text box is either typed in or imported into the box.

overprint indicates that a colored object is not knocked out of the background's color separation plate, but instead prints over the background color. See **knockout.**

Page Number box in the lower left corner of the Document Layout palette displays the current page. Highlight the number, type a new page number, and press Return/Enter to navigate to that page. If you have sectioned your document, the Page Number box displays the actual page number (**folio**), not the **absolute page number.**

paragraph alignment specifies the position of text relative to the left and right sides of the text box—standard-shape or Bézier. Paragraphs can be left, right, center, justified, and force-justified aligned. See **vertical alignment.**

paragraph style sheet is a saved set of text and paragraph format commands applied to an entire paragraph. See **character style sheet.**

Paste command places the contents of the **Clipboard** at the insertion point on the page.

pasteboard is the nonprinting area that surrounds a QuarkXPress print page.

PDF (Portable Document Format), developed by Adobe Systems, creates files that can be viewed and printed on any computer platform without having access to the application that created the document.

PostScript Printer Description file (PPD) tells an application such as QuarkXPress about the capabilities of a particular output device.

Preview option in the Save and Save as dialog boxes (Macintosh only) displays a thumbnail of a document's first page when that document is selected in the Open [document] dialog box.

process colors (4-color) are cyan, magenta, yellow, and black. A process color is a single color composed of percentages of cyan, magenta, yellow, and black. Each of these four colors is printed on its own separation plate. Overlaying these four plates in the printing process creates process color (4-color) art and text.

registration marks are symbols on pages used to align overlaying plates.

resolution is the degree of detail in an image measured in pixels per inch or ppi (image resolution) or the capabilities of the output device measured in dots per inch or dpi (device resolution).

Reverse Difference. See **Difference/Reverse Difference**.

Revert to Saved command closes the current document without saving any changes and opens the most recently saved version of that document.

Right point is the tip of the line that ends a line drawn with either the Orthogonal Line tool or the Line tool.

rollover is an image in a Web document that changes when you move the cursor over it.

rule is a line anchored to a paragraph which moves with that paragraph.

run-in index has two levels of entries in the same paragraph. See **Nested index.**

Save command saves a previously named and saved document under the name it was assigned when it was first saved and at the same location.

Save as command displays the Save as dialog box, and allows you to name or rename a document and save it at another location.

Scale Across/Scale Down values specify the size of the graphic relative to 100%. A value less than 100% reduces the horizontal (Scale Across) or vertical (Scale Down) size of the image; a value greater than 100% enlarges the image.

Section dialog box is where you specify a new section with new page numbers.

Smoothness field in the Clipping Modify tab lets you determine how accurate the clipping path is. The lower the value in the Smoothness field, the more accurate—but more complex—the **clipping path.**

Split All Paths command splits all the closed paths in the selected item, including any paths contained within other paths, such as the inside path in a donut shape.

Split Outside Paths command splits a box that consists of two or more closed paths separated by space. This command does not split closed paths contained within these paths, such as the inside of a donut shape.

spot color is a color printed with one ink; a single separation plate is produced for that color.

spread, for pages, is two or more adjacent horizontal pages. In color trapping, applying a *spread* means to enlarge the color of the foreground object to overlap the edge of the "knocked-out" area of the background. See **choke.**

story is the text in a linked chain of text boxes. Each time you import a text file or word processing file into a text box, that text becomes a new story.

stripe is a user-defined style for lines and box frames made of solid stacked bars with white or colored gaps between those bars. See **dash.**

style sheets, see **paragraph style sheet** and **character style sheet.**

synchronize is to apply the style sheets, colors, dashes and stripes, and H&J specifications of a **Master Chapter** to every **Chapter** in a **Book.**

table is a series of rectangular, grouped boxes called **cells** that can be text boxes, picture boxes, or boxes with a content of None.

text path is a straight or curved line created with any of the Text Path tools and which contains text. See also **Bézier text path**.

Threshold value in the Runaround Modify dialog box specifies how black an alpha channel must be to fall inside the initial clipping path. Only pixels darker than the Threshold value are included inside the runaround path.

thumbnails view displays a miniature view of document pages and allows you to drag-copy pages between documents and to move pages within a document.

TIFF (Tagged Image File Format) images are bitmapped black-and-white line art, grayscale, or color images created in programs such as Adobe Photoshop or Corel Painter.

tracking is adding or deleting space between selected characters and words, done by using the Tracking command under the Style menu or by clicking the Tracking arrows on the Measurements palette. A positive value adds space; a negative value reduces space.

trapping is compensating for printing **misregistration** by increasing the foreground object (**spread**) or reducing the background color (**choke**).

Undo command (available for most functions) cancels the last executed command.

Union Merge command combines all the selected objects into one shape outlined by their nonoverlapping areas.

unit of measure defines the measurements for all values in a document in the chosen system, such as in picas, inches, etc.

unlink with the Unlinking tool breaks links between text boxes. Shift-click with the Unlinking tool on a linked text box to remove the text box from the chain and force text into the next linked text box in the chain.

URL (Uniform Resource Locator) is a **destination** that includes a complete Web server address, such as http://www.quark.com.

vector images, also called object-oriented graphics, use X and Y coordinates to describe objects such as lines, curves, type, and objects. Because vector images are based on mathematical coordinates, they can be resized and reshaped without losing detail.

vertical alignment specifies the position of text relative to the top and bottom sides of the text box. Text can be top, bottom, center, and justified aligned. See **paragraph alignment**.

Visual Indicator appears as a colored box in any item moved from the Default layer to a new layer in the Layers palette. The color on the item corresponds to the color swatch next to the layer's name.

widow is the last line in a paragraph that falls at the top of a column or at the top of the next text box.

XML (Extensible Markup Language) is a system of tags used for labeling information and controlling its structure.

Index

A

absolute and relative, Hyperlinks, 435
absolute leading, 61, 212
absolute page numbers, 113, 138
Accurate Blends, 398
Action field, Form Modify dialog box,
 Web document, 447
add
 Bézier points, 285
 Chapter, 470
 index entry, 479
Add, spell check, 265
Add All, index, 484
Align On, tabs, 225
alignment
 anchored items, 354
 item, 370
 paragraph, 58, 204
 text path, 326
 vertical, 101
Alpha Channel, runaround, 360
anchored items, 352
 alignment, 354
 rules, 350
anchors, Web document, 436
 adding, 442
 deleting, 446
 editing, 446
append
 colors, 396
 H&Js, 262
 Lists, 469
 style sheets, 245
Apply button, 49, 220
Auto Amount, trapping, 404
Auto Constrain, 330
Auto Image runaround, 359
Auto Kern Above, 254
auto leading, 60, 199
Auto Page Insertion, 112, 369
Auto Picture Import, 81
Auto Rename, Append style, 246
automatic text box link, 130
Automatic Text Box option, 19, 33–34
automatic tiling, 420

New Document dialog box, 32
selecting, 34
Auxiliary dictionaries, 266
avenue.quark, 461

B

Background Image, Web document, 431
 repeat, 437
baseline grid, 212
 locking to, 210–11
Baseline Shift command, 258
 text path, 325
Bézier, 3, 16
 boxes, 280
 closing, 281
 Picture Box tool, 280, 286
 points, 283
 converting, 286
 corner, 287
 Text-Path tool, 322
bitmap images, 81
 resolution, 417
bleeds, 24, 104, 419
blends. See gradients
Book command, 464, 470
 Chapter, 470
 create, 470–73
 indexing, 486
 open, 472
 palette, 471
 synchronize, 472–73
boxes
 anchored, 352
 Bézier, 280
 contentless, 71, 248
 contents, 71
 convert to Bézier box, 282
 reshaping, 292
 splitting, 289
 transparent, 70, 400
build
 index, 482–83
 List, 467, 468
Button tool, Web Tools palette, 449

C

Cancel, spell check, 265
cascading style sheets (CSS), 462
cells, tables, 376
 default, 385
 merging, 380
center image, 85
Change All, Find/Change dialog box, 269
Change, Find/Change dialog box, 269
Change, then, Find/Change dialog box, 269
Chapter, Book command, 470
 reordering, 471
 synchronizing, 472
Character Count, 220
character spacing, 214, 262
character styles, 230
 applying, 237
Check Box tool, Web tools palette, 450
 create, 455, 457–58
choke, trapping, 403
Clear/Delete command, 46
Clipboard, 44, 45, 46, 47
Clipping command, 364
Clipping dialog box, 361
clipping path, 360, 361, 365–66
 edit, 374
Close
 Bézier box, 17, 281
 command, 21
Collect for Output, 427–28
 fonts in EPS images, 428
color, 392–413
 adding to Colors palette, 392
 appending, 396
 applying, 68–70
 deleting, 395
 device-dependent color, 409
 device-independent color, 409–10
 duplicating, 396
 edit, 393
 Hexachrome, 392
 Multi-ink, 392
 Pantone, 392–95
 process, 68
 profiles, 409–10
 separations, 412
 printing, 421
 spot color, creating, 184–85

text, 400
TIFF files, 84, 392
trapping, 402–08
Web-named, 393, 411
Web-safe, 393, 411
color management, 409–10
 Color Management System (CMS), 393, 410
color preview, Web document, 438
Colors palette, 67
column guides, 23
 changing, 34–35, 38
 New Document dialog box, 32
columns, tables, 376
 inserting, 376, 379
 resizing, 383
columns, text box, 34
 Measurements palette, 142
Combine Merge command, 296
Comma Align, tabs, 225
constrain, boxes to squares and circles, 75
Content tool, 16
contentless boxes, 71, 101, 248, 291
contents
 boxes, 71
 items, 11
Consecutive Page Number command, 118
context menus, 13, 333
 rulers, 333, 372
convert
 Bézier points, 286
 lines to Bézier box, 310
 lines to text paths, 293
 picture boxes, 291
 standard-shape boxes to Bézier boxes, 282
 table to graphic, 387
 tables to text, 384
 text to graphics, 289, 292
 text to tables, 383
Convert Table to Graphic on Export, 387
Copies, Print dialog box, 64
Copy command, 44, 328
copying
 items between documents, 162
 pages between documents, 162
 paragraph attributes, 221
context menus, 13
Corner Radius field, Measurements palette, 86
crop marks, 419

Crop to Box, runaround, 362
cropping images, 96
 cross-platform issues, 4. See also Web
 documents
 file transfer, 4–5
cross-references, index, 474, 484
Cut command, 46

D

Dashes, 314
Dashes & Stripes, 314–16
 deleting, 318
DCS (Desktop Color Separation), 78, 80
delete
 anchor, Web document, 446
 Bézier points, 285
 colors, 395
 dashes and stripes, 318
 H&Js, 262
 hyperlinks, 445
 index entry, 479
 layers, 335
 rule, 350, 352
 style sheets, 243
 tabs, 218
 text, 46
 found text, Find/Change dialog box, 274
destination, Web document, 435, 446
device-dependent color, 409
device-independent color, 409–10
Difference Merge command, 296
Disclosure Triangle, Index palette, 480, 481
discretionary hyphens, 214, 261
Distribute Evenly, Cell Modify dialog box,
 383
Document Layout palette, 106–08
 master pages, 147
Document Setup dialog box, orientation, 418
Document Type Definitions, XML, 461
documents, 11
 creating, 31–35
 multiple-page, 106
 navigating, 29, 115
 windows, 26
Done, spell check, 265
Drag and Drop Text, 43
drag-copy
 library entries, 348

linked text boxes, 163
 from print to Web document, 431
drop caps, 202
 size, 202, 203, 238
Duplicate command, 328
 Step and Repeat, 329
 Super Step and Repeat, 329
duplicating
 colors, 396
 dashes and stripes, 319
 items, 328
 layers, 334

E

edit
 anchors, Web document, 446
 Bézier text path, 322
 character styles, 229, 237
 clipping path, 374
 colors, 393
 index entries, 479
 interactive elements, Web document, 444
 layers, 334
 line text paths, 319
 paragraph styles, 235
 rollovers, 436
 table, 379
electronic typesetting, 7
ellipses, creating, 260
em dash, 267
Embedded Path, Runaround, 360
en dash, 267
en space, 261
EPS images, 78, 79
 fonts, 426
 importing, 84
 resolution, 417
 Save Page as EPS, 79
Exclusive Or Merge command, 296
Export
 tables in Web documents, 387
 Web document, 443–44
 naming, 445

F

facing pages, 24

icons, 107
file extensions, 13
File Selection tool, Web tools palette, 449
fill characters, tabs, 226
filters, import/export, 53
Find/Change command, 268–78
 Change All, Find/Change dialog box, 269
 Change, Find/Change dialog box, 269
 Change, then, Find/Change dialog box, 269
 Find First, Find/Change dialog box, 269
 Find Next, Find/Change dialog box, 268
 hidden layers, 335
 Ignore Attributes, Find/Change dialog
 box, 269, 274
 Ignore Case, Find/Change dialog box, 269
 nonprinting characters, 272
 palette, 268
 style sheets, 276
 text attributes, 274
 Whole Word, Find/Change dialog box, 269
 wild card, 273
 words, 268
Find First, Find/Change dialog box, 269
Find Next, Find Change dialog box, 268
First Baseline, 48, 49
First Line Indent, 197
Fit in Print Area, Print dialog box, 66
flipping images, 98
folio, 113
fonts, 9, 426
 choices, 6
 EPS images, 426
 printing, 426–27
 troubleshooting, 278
 TrueType, 8, 9
Fonts Usage dialog box, 427
Form Box tool, Web Tools palette, 449
Form controls, Web document, 447
 Form Validation, Form Modify dialog box,
 Type options, 448
 Web document, 449
 Wrap options, 448
forms, Web document, 447–50
 Action field, Form Modify dialog box 447
 Target field, Form Modify dialog box, 447
 Type options, Form Modify dialog box, 448
frames, 68, 312, 317
 groups, 341
 Preferences, 312

Freehand Bézier Picture Box tool, 286
Freehand Picture Box tool, 19
Freehand Text Box tool, 17
Freehand Text-Path tool, 324

G

GIF (Graphics Interchange Format) files,
 460
 Progressive and Interlacing, 460
global formatting, 231
Go to command, 138, 139
gradients, 69–70, 398
 Accurate Blends, 398
graphic file formats, 78–81
graphics. See images
greeking, 41
Grid Modify dialog box, 382
gridlines, tables, 382
Group command, 340
Group Modify dialog box, 339, 342
groups, 339–44
 framing, 341
 modifying, 339
 nested, 345
Guide Manager, 372, 373
guides. See column guides; margin guides;
 ruler guides

H

Halftoning, Print dialog box, 421
Hexachrome color, 392
Horizontal/Vertical offsets, 330
Horizontal/Vertical scale, 259
HTML
 forms, Web document, 447
 Preview, Web browser, Web document, 438
 text boxes, Web document, 433–34
Hyperlinks, 435
 absolute and relative, 435
 creating, 440
 deleting, 445
 editing, 444
 styles, 445
hyphenation, 214–15
 Hyphenation Exceptions, 263
 Method, 260
 nonbreaking, 267

Hyphenation and Justification (H&Js), 260–63
 append, 262
 delete, 262
 word spacing, 261

I

Ignore Attributes, Find/Change dialog box, 269, 274
Ignore Case, Find/Change dialog box, 269
Ignore White, trapping, 405
Illustrator files, 84
 color, 413
 trapping, 413
Image Button tool, Web Tools palette, 450
 creating button, 459–60
image maps, Web document, 436
 creating, 441
 tools, 449
image resolution, 417
images
 center in picture box, 85, 281
 cropping, 96
 displaying, 85
 flipping, 98
 linking, 88–89
 Measurements palette, 85–86
 missing, 89
 modifying, 86
 naming, 13
 positioning, 92
 resizing, 93, 149
 Style menu, 72, 149, 179
import
 pictures, 78–81, 84
 text, 40, 143
Indent Here command, 59, 223
Indents, paragraph, 197
Indeterminate, trapping, 405
index, 474–76
 Add All, 484
 Book, 486
 build, 482–83
 cross-references, 474, 484
 entries, 478
 add, 478
 delete, 479
 edit, 479
 nested, 474
 palette, 477
 Add button, 470
 Disclosure Triangle, 480, 481
 Find Next button, 479
 Preferences, 475
 run-in, 474
 reversing names, 485
 styles, 476
 types, 474
Insert (pages) command, 153
Inter (¶) Max, 50
interactive elements, Web document, 434–42
 editing, 444
Intersection Merge command, 296
Invisibles, 54–55
Item runaround, 357
Item tool, 15
 temporary tool, 95, 344
items, 11
 anchored, 350
 copying between documents, 162
 duplicating, 328
 stacking on layers, 338

J

Jabber, 267
Join Endpoints command, 306
JPEG (Joint Photographic Experts Group), 78, 80
 Progressive and Interlacing, 460
jump lines, 135

K

Keep Changes/Delete Changes, 172–73, 180
Keep Lines Together command, 207
Keep Runaround, Layers palette, 334
Keep with Next ¶ command, 309
kerning, 254
 arrows, Measurements palette, 256
 Kerning Edit dialog box, 254
keyboard shortcuts, 13
 styles, 230
keystrokes, 5
knockout, trapping, 403
 Knockout Limit, 405

L

labels, libraries, 349
layers, 332–38
 arranging, 335
 creating, 333
 deleting, 335
 duplicating, 334
 editing, 334
 Merge/Split, 295
 moving items, 336
 options, 345
 Visual Indicators, 333
Layers palette, 332
leading, 42, 59–62, 200
 absolute, 61, 212
 auto, 60, 199
libraries, 348–49
 labels, 348
Line Check, Jabber, 267
Line Modify dialog box, 308
Line tools, 18
 Line Text-Path tool, 319
lines
 Bézier, 306
 convert to Bézier box, 310
 convert to text paths, 293
 freehand, 305
 gradients, 293
 measuring, 307
 reshaping, 310
 rotating, 309
linescreen values, 416
Link to Current Text Chain, 187
linking
 images, 88–89
 text boxes, 125, 132
Linking tool, 19
List Box tool, Web Tools palette, 450
 List control, 453
Lists, 464–69
 build, 467, 468
 create, 465
 palette, 467
 update, 467
local formatting, 231, 237
Lock to Baseline Grid command, 210–11
 Locked, Layers palette, 334
Lookup, spell check, 265
LZW import, 80

M

Maintain Leading, 212
margin guides, 23
 changing, 165
master pages, 146–75
 applying, 172
 automatic text box link, 131
 copying between documents, 162
 creating, 146, 177, 181
 Document Layout palette, 147
 deleting, 157
 duplicating, 157
 editing, 165, 168, 177
 Keep Changes/Delete Changes, 172
 left and right, 160, 175
 multiple, 155
 naming, 159, 190
 page numbers, 119
 selecting, 160
 spell check, 266
Maximum value (Max), H&Js, 261
Measurements palette,
 anchored items, 354
 columns, 142
 formatting text, 41
 images, 85–86
 lines, 307
 picture box, 76
menu, Web document, 454–55
Menu Bar, 6
 context menus, 13
 multiple menus, 258
Merge and Split commands, 285–96, 298
 layers, 295
merging cells, 380
Meta tags, 437
Method, Form Modify dialog box, 451
Minimum value
 H&Js, 261
 New Web Document dialog box, 431
Miter field, Dashes & Stripes dialog box, 316
move
 document pages, 162, 164
 items on layers, 336
 picture box, 76
Move command, 162, 164
Multi-Ink color, 392
multiple text insets, 48, 197

N

navigating
document, 29, 114
Document Layout palette, 160
fields in dialog box, 77
Measurements palette, 41, 42
tables, 379
Navigation Menu, Edit Menu dialog box, Web document, 449
nested
groups, 345
index, 474
Next Style, 230
New Column marker, 273
New Document dialog box, 22, 32
New Line command, 229, 272, 275
Next Style, 230
No Style, 240
Noise, runaround, 359
nonbreaking hyphen, 267
nonfacing pages, 24
Non-White Areas, runaround, 361
None
color, 400
runaround, 356
tables, 382
Normal style, 239
edit, 242

O

offsets, 330
Open command, 11
Orientation, 35
Print dialog box, 65
Preview, 11
Optimum value, H&Js, 261
orphans, 206
Orthogonal Text-Path tool, 321
output resolution, 417
Output tab, Print dialog box, 420–21
Overflow Indicator, 57
overprint, trapping, 403
Overprint Limit, 405
Overprint EPS Black, Print dialog box, 423

P

page numbers, 113
absolute, 113, 138
displaying, 108
master pages, 119
specifying, 117
Page Properties dialog box, Web document, 445
Page Sequence, Print dialog box, 64
Page Size, 33
Page tab, Print dialog box, 65
Page Width, Web document, 431
pages
adding, 107, 150, 153
copying between documents, 162
deleting, 110
moving, 162
viewing, 25
Paint images, 81
palettes, 26–28
Book, 471
Colors, 67–68, 291
Document Layout, 106–08
Find/Change, 268–69
Hyperlinks, 435
icons, 27, 67, 107, 291, 305, 332
Index, 477
Layers, 332
Library, 348
Lists, 467
Measurements, 41–42
options, 28
Style Sheets, 230–31, 243
Trap Information, 406–08
Web Tools, 434, 448
Pantone color model, 366, 392–95
Paper Width/Paper Height, Print dialog box, 65
paragraph
alignment, 58, 204–205
attributes, 196
copying, 221
drop caps, 202
indents, 197
keeping lines together, 207
keeping paragraphs together, 209
locking to the baseline grid, 210–11
Maintain Leading, 212
selecting, 56, 197, 229

Space Before/Space After, 200
 splitting, 221
paragraph styles, 229
 edit, 235
Paste command, 44, 328
pasteboard, 24
PDF (Portable Document Format), 427, 428
PhotoCD images, 81
Photoshop files, 84
 color, 412
picas/points, specifying, 201
PICT images, 81
 display problems, 5
Picture Bounds, runaround, 362
Picture Box tools, 18
picture boxes, 74–76
 converting, 291
 drawing, 75
 importing pictures, 78–81
 Measurements palette, 77
 modifying, 75
 resizing, 75, 77
 rotating, 76
 skewing, 76
 types, 74–75
Picture Modify dialog box, 87
Picture Usage dialog box, 89, 91
Plates, Print dialog box, 422
PNG (Portable Network Graphics) files, 460
points, Bézier, 283, 286, 287
Pop-Up Menu tool, Web Tools palette, 450
 create, 453–54
PostScript Error Handler, Print dialog box, 423
PostScript files, creating, 425–26
PPD (PostScript Printer Description), 65, 418
Preferences
 Framing, 313
 Index, 475
 Layer, 333
 Table, 378
 Typographic, 254
 Web document, 432
 XPress, 10
 Zoom tool, 25
Preview, 11, 12
 HTML, Web browser, Web document, 438
Preview tab, Print dialog box, 424
Print dialog box, 63–66

 color separations, 421
 Copies, 64
 Halftoning, 421
 Options tab, 422–23
 Page Sequence, 64
 Preview tab, 424
 Setup tab, 65–66
Print Styles, 425
printing, 63, 416–428
 bleeds, 419
 color from plates, 395
 crop marks, 419
 graphics, 423
 grayscale, 420
 noncontinuous pages, 66
 options, 422–23
 plates, 422
 PostScript files, 425–26
 process color, 392
 registration marks, 419
 RIP (raster image processor), 416
 separations, 421–22
 spot color, 392
 tiling, 420
process color, 68, 392
Process Trapping, 404

QuarkXPress
 documents, 11
 launching, 11
 repurposing print documents, 461
 troubleshooting, 9

R

Radio Button tool, Web Tools palette, 450
 creating, 455
raster text boxes, Web document, 432–33
registration marks, 419
Rename, Append style, 245
Rendering Intents, color management, 410
Repeats Every, Dashes & Stripes dialog box, 315
Rescan, runaround, 359
Reset button, Web document, 453
reshaping
 Bézier points, 283

boxes, 292
resize
 picture, 93
 picture box, 75
resolution, 81, 417
 graphic in Web document, 431
 image, 417
 output, 417
Reverse Difference Merge command, 296
reverse text, 389
reversing names, index, 485
Revert to Saved command, 12
right-aligned tabs, 217
Rollover dialog box, 439
rollovers, Web document, 436
 creating, 439–39
 editing, 436
rotate
 gradient angle, 70
 line, 309
 picture box, 76
Rotation tool, 16
 rotate to right, 72
rows, tables, 376
 inserting, 376
 resizing, 383
ruler guides, 184, 372
 Guide Manager, 372, 373
rules, 352
 anchored, 350
 deleting, 350
Run Text Around All Sides, 368, 369
Runaround command, 355–368
 Alpha channel, 360
 Auto Image runaround, 359
 Crop to Box, 362
 Embedded Path, 360
 Image runaround, 358
 Item runaround, 357
 None runaround, 356
 Non-White Areas, 361
 Picture Bounds, 362
 Rescan, 359
 Same As Clipping, 361
 single-column, 368
 Smoothness, 360
 tables, 382
 Threshold, 360
Runaround Modify dialog box, 355, 358
run-in index, 474

S

Same As Clipping, runaround, 361
Save as command, 78
Save command, 12
 QuarkXPress versions, 12
Save Page as EPS command, 79
Scissors tool, 298
Section command, 117–18
 removing, 118, 140
Select All, 132, 50
selecting
 line, 57
 nonconsecutive layers, 334
 paragraph, 56, 59, 197, 229
 Shift-selecting, 98
 text, 40
 on text path, 320, 323
 word, 56
Setup tab, Print dialog box, 65–66
Shape command, boxes, 51–52
Shift-selecting, 98
 items, 341
 range of pages in Document Layout palette,
 110
Show Clipboard command, 47
single-column runaround, 368, 369
skew
 picture box, 76
 text, 48
Skip, spell check, 265
small caps, 43
Smoothness, runaround, 360
Snap Distance, General Preferences, 372
Snap to Guides, 186, 372
Space/Align command, 370–72
special text characters, 267
spell checking, 264–67
 Add, 265
 Cancel, 265
 Done, 265
 hidden layers, 335
 Lookup, 265
 master pages, 266
 selection, 265
 Skip, 265
 Word Count dialog box, 265
Split commands, 298
 All Paths command, 289, 298, 299
 Outside Paths, 289, 298, 299

splitting
 boxes, 289
 items, 295
spot color, 68, 392
 applying, 185
 check box, 395
 creating, 184–85
 icon on Colors palette, 395
 printing, 392
spread
 page, Web document, 451
 trapping, 402
stacking order, 296
 layers, 335, 338
standard em space, 257
Step and Repeat, 329
 Super Step and Repeat, 329
sticky tools, 13, 131, 133, 295
story, 53
stripes, 317
Style menu
 images, 72, 149, 179
styles, 220–39
 applying, 237, 251
 appending, 245
 by example, 232
 character styles, 230
 deleting, 243
 edit, 235, 237
 example, 232
 Find/Change, 276
 hyperlinks, 445
 index entries, 476
 new, 233
 Next Style, 230
 No Style, 240
 Normal, 239, 242
 palette, 230–31, 243
 paragraph styles, 229
 tables, 390
Submit button, Web document, 452
Suggested Hyphenation, 215
Super Step and Repeat, 329
Suppress Printout, Layers palette, 334
synchronize, Chapters in Book, 472–73
 noncontinuous Chapters, 473

T

Table Modify dialog box, 379
tables, 376–88
 columns, add, 379
 Combine Cells command, 380
 convert tables to text, 384
 convert text to tables, 383
 create, 376
 dimensions, 382
 formatting, 381
 gridlines, 382
 inserting rows and columns, 376
 merging cells, 380
 modify, 379
 Preferences, 378
 rows, add, 379
 Runaround, 382
 selecting cells, 377
 Web document, 387
tabs, 216–21
 Align On, 225
 Comma Align, 225
 fill characters, 226
 inserting, 216
 right-aligned, 217
Target field
 Form Modify dialog box, 447
 Hyperlink dialog box, 439
text
 angle, 48
 Clear/Delete, 46
 color, 400
 Copy and Paste, 44
 cutting, 46
 delete, Find/Change dialog box, 274
 Drag and Drop, 43
 editing, 44
 exporting, 54–55
 flipping, 42
 formatting, 41–42
 importing, 40, 143
 inset, 48
 path, 319
 reverse, 389
 selecting, 40
 skew, 48
 trapping, 403
text attributes, Find/Change dialog box, 274
Text Box tools, 17

linking, 125, 132
unlinking, 132
text boxes
converting, 291
HTML, 433–34
raster, Web document, 432–33
shapes, 51–52
vertical alignment, 101
Text Extraction Order menu, tables, 387
Text Field tool, Web Tools palette, 449, 452
Text Inset, Text Modify dialog box, 48
Text Modify dialog box, 47–49
Text Path Modify dialog box, 325
Text-Path tools, 19, 319–25
Line Text-Path tool, 319
Orthogonal Text-Path tool, 321
text paths, 319–25
alignment, 326
editing, 319
selecting, 320
Text Skew, 48
Text to Box command, 288, 292
Threshold, runaround, 360
thumbnails, Print dialog box, 64
TIFF images, 79–80
attributes, 80
coloring, 392
importing, 84
view, 162
tiling, printing, 420
automatic tiling, 420
manual tiling, 420
Tool Tips, 15
tools, 13
Bézier, 16
Bézier Picture Box tool, 280
Content tool, 16
convert to Item tool, 95
display hidden, 304
Freehand Bézier Picture Box tool, 286
Freehand Line tool, 305
Freehand Text-Path tool, 324
Item tool, 15
keep selected, 13, 131, 133, 295
Line Text-Path tool, 319
Line tools, 18
Linking tool, 19
Picture Box tools, 18
Rotation tool, 16
Scissors tool, 298

sticky tools, 13, 131, 295
Text Box tools, 17
Text-Path tools, 19
Tool palette, default, 14–15
Web document, 434
Unlinking tool, 19
tracking, 257
arrows, Measurements palette, 72, 100, 257
Tracking Edit dialog box, 254
transparent boxes, 70, 400
Trap Information palette, 406-08
trapping, 402–08
Auto Amount, trapping, 404
choke, 403
default, 404
Ignore White, 405
Illustrator files, 413
indeterminate, 405
items, 408
knockout, 403
Knockout Limit, 405
overprint, 403
Overprint Limit, 405
Photoshop files, 413
Process Trapping, 404
spread, 402
type, 403
troubleshooting, 9
Bézier points, 294
fonts, 278
Lists, 468
PICT preview, 4
QuarkXPress, 9
TrueType fonts, 8, 9
Type options, Form Modify dialog box,
Web document, 448

U

underline styles, custom, 238
Undo command, 45, 46
Union Merge command, 296
unit of measure, 42, 198
Context menu, 333, 372
unlinking text boxes, 135
noncontinuous text boxes, 134
Unlinking tool, 19
update
images, 89
Lists palette, 464, 467, 469

Use Existing, Append style, 246
Use New, Append style, 246

V

Vertical Alignment, 48, 49
Vertical Scale, 259
View menu, 26
View Percent field, 25, 129
Visible, Layers palette, 333
Visual Indicators, Layers palette, 333

W

Web documents, 430–62
 anchors, 436
 adding, 442
 deleting, 446
 editing, 446
 Background Image, 431
 repeat, 437
 creating, 430–31
 destination, edit, 446
 Export, 443–44
 naming, 388, 445
 forms, 447–50
 Type options, 448
 Wrap options, 448
 HTML text boxes, Web document, 433–34
 hyperlinks, 435
 creating, 440
 deleting, 445
 editing, 444
 palette, 435
 styles, 445
 image maps, 436
 creating, 441, 459–60
 tools, 449
 interactive elements, 434–42
 editing, 444
 Meta tags, 437
 Minimum (Width), 431
 naming, 388
 Preferences, 432
 raster text box, 432
 rollovers, 436
 creating, 439
 editing, 436
 tables, 387

Web Export files, 430–32, 437, 443–44
 naming, 388
Web-named color, 393, 411
Web Preferences, 432
Web-safe color, 393, 411
Web Tools palette, 434, 448

Whole Word, Find/Change dialog box, 269
widows, 206
wild card, Find/Change dialog box, 273
Windows
 Pict preview, 4
 updating images, 89
Word Count dialog box, spell check, 265
word processing, 53–62
word spacing, 261

X

XML, 461
XPress tags, 54
XTensions Manager, 53

Z

Zero Point, 184, 248
Zoom tool, 21, 25